The Guide to Photography Workshops & Schools

The Guide to Photography Workshops & Schools

Fourth Edition

Shaw Guides

NEW YORK

Copyright (c) 1989, 1990, 1992, 1995 by ShawGuides, Inc.

ShawGuides and The Guide to Photography Workshops & Schools are trademarks of ShawGuides, Inc.

Inquiries concerning this book should be addressed to: Editor, ShawGuides, P.O. Box 1295, New York, New York 10023, Phone (212) 799-6464, Fax (212) 724-9287.

Please note that the information herein has been obtained from the listed photography programs, retreats, and organizations and is subject to change. The editor and publisher accept no responsibility for inaccuracies. Programs should be contacted prior to sending money and/or making travel plans.

Library of Congress Catalog Card Number 89-61941
ISSN 1044-9108
ISBN 0-945834-19-5

Design: Joseph Santoro
Pre-press: Digital Exchange
Printed in the United States of America by
R.R. Donnelley & Sons Company

Introduction

The Guide to Photography Workshops & Schools *is the only compre-hensive resource to short-term and career programs for camera enthusi-asts of all ages and levels of experience. This fourth edition, the largest to date, contains information about 801 workshops and tours, schools and colleges, residencies and retreats, and photography organizations. Whether you take photographs for pleasure or profit, The Guide will help you find programs that fit your interests, schedule, and budget.*

Section I, Workshops, *is of interest to those who desire expert instruc-tion and individual critique, as well as the opportunity to travel to photogenic locales where they can practice their skills. Included are descriptions of short (most ranging from two days to two weeks), intensive programs offered by 319 schools, organizations, and individ-uals. Of these, 76 are new to this edition and the remaining 243 have been updated. The arrangement is geographical, by location of spon-sor, and each listing contains information about the sponsor, year the program was first held, method and scope of instruction, level of*

knowledge or experience required, student to teacher ratio, daily schedule, faculty credentials, costs and refund policies, and location or itinerary.

Section II, Schools, is for those who are considering photography as a full- or part-time career. Included are detailed descriptions of diploma, certificate and degree programs in fine art and commercial photography offered by nearly 100 trade schools, colleges, and universities that responded to our questionnaire. Arranged geographically, each listing describes the courses, faculty, enrollment, tuition, and more than 20 other facts about the school's photography curriculum. Contact information is provided for an additional 174 programs.

Section III, Residencies and Retreats, is for fine art photographers who want to live in a community with other artists and focus solely on their projects for a period of a few weeks to a few months. Some are open only to those who have achieved a measure of success, while others welcome dedicated individuals of all levels. Each of the 22 listings describes the living and working environment, admission requirements, application procedures, and costs. Because retreats usually depend upon public and private funding, they ask that inquiries be accompanied by a self-addressed, stamped envelope.

Section IV, Photography Organizations, describes 24 membership organizations that offer services to photographers. Each listing contains the statement of purpose, annual dues, and membership benefits, which may include networking, publications, career assistance, and regular meetings and conferences.

Section V, Appendix, contains several cross-indexes that direct the reader to workshops suited to a particular need: a Geographic Index to Workshop Locations; a 17-category Specialty Index, for those who want to increase their knowledge about a specific topic, such as photojournalism, the natural environment, or fine art techniques; an index of Professional Programs for aspiring to established pros; an index of workshop sponsors that offer a variety of programs for Non-Photographer family members and guests; an index of Programs Granting Academic Credit; and an index of Programs for Young People.

The content of The Guide is based on factual information obtained from questionnaires, brochures, catalogs, and personal interviews. The length of a description depends largely on the amount of information provided and is not intended to reflect the merit of the program. The workshops and schools are not endorsed by the publisher nor do sponsors pay to be listed. Each listing was sent to the sponsor for verification prior to publication and all listings that appeared in the previous edition were updated. Although every effort has been made to ensure accuracy, changes do occur. Call or write for a current catalog and confirm costs and schedules before registering.

We thank the workshop, school, retreat, and organization directors for their cooperation and assistance. Readers are invited to let us know about their experiences and to submit names and sources of additional listings. Comments and suggestions are also welcome.

We wish you success in your photographic endeavors.

*Shaw***Guides**

Ten Questions to Ask Before Enrolling in a Photography Worshop or Tour

1) Will instruction be suited to my level?

Most programs welcome photographers of all levels of expertise while some expect you to have at least basic camera knowledge. Before you leave, familiarize yourself with your equipment. If you bring along 10 or 20 of your best images, your instructor will show you how to improve your results right from the start. Programs devoted to a specific topic, such as printing, computer imaging, or the use of specialized equipment, are better suited to the experienced photographer. Find out what you're expected to know. If you're lacking certain knowledge or skills, a course at your local college, high school, or camera club can better prepare you for the trip.

2) What can I expect to learn?

A well-run photo program can give you camera-handling insights you'll retain for the rest of your life. A tour or travel workshop should cover such topics as lighting, composition, exposure, focus, film selection, lenses, filters, camera handling techniques, and the use of specialized equipment. Expect your teacher to share tips and tricks, point out the best photo opportunities, and help you capture them successfully on film. You'll also learn from other members of the group. During the time you spend traveling between destinations, you're likely to participate in lively discussions about cameras, lenses, and past workshop experiences.

3) Will on-site processing and daily critique be available?

Most domestic workshops offer on-site processing and some overseas tours do too. Prompt feedback will enable you to quickly correct your mistakes and practice new techniques before you return home.

4) What kind of equipment should I bring?

Unless you're enrolling in a specialized program, the camera and lenses you've been using are usually sufficient. Slide film is better than print film because slides can be projected and critiqued by the entire group. And, because obtaining the right contrast is trickier with slides, you'll learn more. If you can take good slides, you'll be a better photographer with any film. Find out if any specialized equipment will be available for participants to try out. You'll be able to determine what suits your needs and how to use it before making the investment.

5) How much personal attention will I receive?

Generally, the smaller the group, the more attention the instructor will be able to devote to each participant. There are other factors to consider, however. Ask if instruction is provided only during formal lectures and critique sessions or whether the teacher will be available all day and during meals to engage in discussions and answer individual questions. If learning is your primary motivation, enroll in a workshop, which will be more structured and instruction-intensive. Tours are geared to getting you to photogenic sites and instruction is more informal.

6) What are the qualifications of the instructor(s)?

Ideally, your teacher should be a good photographer, a good communicator, and have good people skills. Most instructors have book and national magazine credits and will send you a brochure containing representative work. Are these results what you hope to achieve? How long has the instructor been conducting workshops and how well acquainted is he or she with the places you'll visit? Some professionals specialize in a particular country or region. They know the local inhabitants, the seasonal variations, and the best places to capture memorable images. When you phone the instructor, try to get a feel for his or her personality and teaching philosophy.

7) What is the daily schedule?

How much of the day is devoted to formal instruction, photographing in the field, and leisure. A good photo tour moves more slowly than other group trips, allowing sufficient time to shoot and providing some insurance against bad weather. If you're enrolling in a travel program, the day should start at dawn and end after sunset, the prime times for natural light. Evenings are usually spent reviewing and critiquing the day's work and sharing experiences.

8) What does the cost of tuition cover?

Tuition usually covers instruction, some meals, transportation during the program, and entrance fees for parks and other attractions. If accommodations aren't included in the package, find out if a list of recommended lodging is provided or if the program leader will be making arrangements for the group. The schedule is likely to run more smoothly if all the participants stay in the same place. If you're traveling alone and want to avoid paying a single supplement, ask if you can share a room with another participant.

9) What is the cancellation policy?

Most sponsors will refund a large percentage of your money if you cancel at least 60 days prior to the program. All will provide a full refund if they're forced to cancel. Some tour operators invoke a surcharge if less than a minimum number of participants sign up. Determine the cancellation policy and deadline dates for your program and whether notice must be in writing. If you're planning a costly trip abroad, consider purchasing trip cancellation insurance.

10) Can references be provided?

Ask for the names and telephone numbers of two or three references, preferably students from your community or at your level of ability. Find out if the program met their expectations and whether they would return.

Contents

1

Workshops

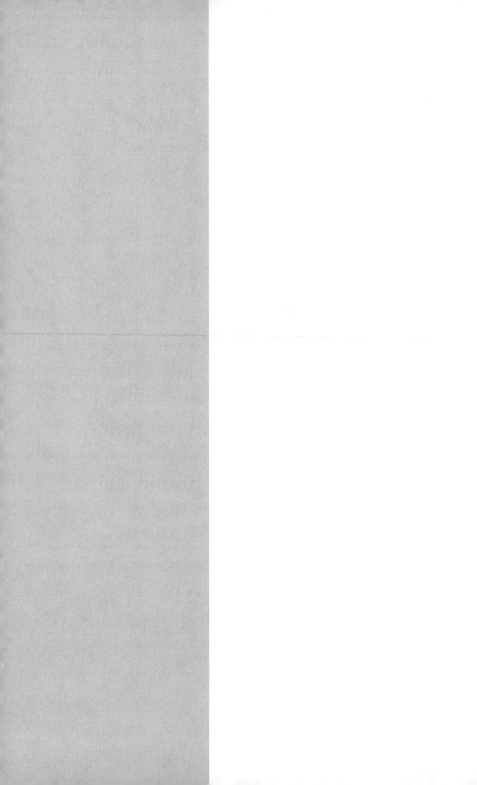

ALASKA

ALASKA PHOTO TOURS
Locations in Alaska/Year-round

Established in 1992 by professional photographer Steve Gilroy, this photo tour company offers ten 3-day to 3-week programs each year for students of all levels. Enrollment is limited to 12 participants and emphasis is on field work in wilderness settings during peak opportunities for wildlife and landscape photography. Formal and informal group discussions on-location cover composition, exposure, and macro work. One-on-one instruction is available at all times.

Specialties: Wildlife and landscape photography.

Faculty: Alaska photographer Steve Gilroy's credits include *Outdoor Photographer, Outside, Alaska Airlines, Discover,* and *Sierra.* He owns a commercial whitewater photography company and Denali Images, a publisher of calendars, notecards, and posters.

Costs, Accommodations: Costs average $350 per day, which includes lodging in hotels and lodges, most meals, and chartered local ground, boat, and air transportation. A deposit of $300 is required 90 days prior. A $100 cancellation fee is charged 60 days prior and from 50% to 75% of total thereafter.

Location: Statewide Alaska and Patagonia, including Denali, Katmai, and Kenai Fjords National Parks; Kodiak National Wildlife Refuge; and Chilkat Eagle Reserve.

Contact: Steve Gilroy, Alaska Photo Tours, P.O. Box 141, Talkeetna, AK 99676; (800) 799-3051, Fax (907) 733-3051.

ALASKA UP CLOSE
Southeast Alaska/November

Established in 1986, Alaska Up Close offers an annual 1-week workshop, led by a professional wildlife photographer, and other photo tours for independent nature photography. A Gathering of Eagles in the Chilkat Valley—site of the world's largest gathering of bald eagles—emphasizes hands-on experience and informal field instruction. Class discussion covers equipment, weather, lighting, conservation, and wildlife behavior. Enrollment is limited to 8 participants who should have basic camera knowledge. Customized fund-raising tours are available for nonprofit groups.

Specialties: Eagles in flight, natural settings.

Faculty: Cinematographer and videographer John Hyde, whose credits include *National Geographic, Outside,* and *Smithsonian.*

Costs, Accommodations: Cost of the Chilkat Valley tour is $1,659 per person, including some meals, ground transportation in Juneau and Haines, and ferry passage from Juneau. A $400 deposit is required with balance due 60 days prior. Cancellations more than 60 days prior forfeit $50.

Location: Chilkat Valley, Haines, and Juneau, Alaska.

Contact: Judy Shuler, Alaska Up Close, Box 32666, Juneau, AK 99803; (907) 789-9544, Fax (907) 789-3205.

ALASKA WILD WINGS
Cordova/June-August
Since 1987, Alaska Wild Wings has offered nature photography workshops that emphasize wildflowers, sea and shore birds, marine mammals, and geology. Three 5-day programs, each limited to 12 beginners, are scheduled annually and include a boat trip to a sea bird colony, photographing sea otters and tidepool creatures, and evening low-light scenery shoots.

Specialties: Nature and wildlife.

Faculty: Belle and Pete Mickelson and occasional guests.

Costs, Accommodations: The $1,495 fee includes food and lodging at the Goose Cove Lodge. A $500 deposit is required and is refundable up to 2 months prior.

Location: Prince William Sound and the Copper River Delta in south-central Alaska.

Contact: Pete Mickelson, Alaska Wild Wings, Box 325, Cordova, AK 99574; (907) 424-5111 (phone/fax).

DENALI NATIONAL PARK WILDERNESS CENTERS
Denali National Park/
June, August, September
Since 1985, Denali National Park has hosted nature photography workshops that emphasize field experience in a subarctic, alpine wilderness setting. Two 5-day programs are offered yearly, each limited to 16 participants and consisting of instructional outings, some early and late shoots for special lighting, and evenings devoted to natural history and photography instruction.

Specialties: Nature.

Faculty: Professional nature photographer and author Pat O'Hara, who has been recognized by Eastman Kodak's Professional Photographer's Showcase.

Costs, Accommodations: The $1,200 cost includes meals, cabin lodging, and in-park transportation. A $250 deposit is required within 10 days of booking. Refund, less $50, is granted cancellations more than 60 days prior.

Location: Denali National Park, north of Mt. McKinley.

Contact: Linda Levernoch, Reservations and Office Manager, Denali National Park Wilderness Centers, Ltd., P.O. Box 67, Denali National Park, AK 99755; summer: (907) 683-2290, Fax (907) 683-5190; winter: (603) 675-2248, Fax (603) 675-9125.

FOCUS ON PHOTOGRAPHY AT KENNICOTT
Alaska/September
Outdoor photographer/journalist Didier J. Lindsey conducts an annual program that includes field sessions, instruction on an as-needed basis, and slide presentations.

Specialties: Nature.

Faculty: Professional wildlife photographer Didier J. Lindsey, professional printer Gene Hanson.

Costs, Accommodations: Cost, which includes all meals, cabin lodging, and ground transportation, is $125 to $ 150 per day. A 50% deposit is required with balance due 30 days prior. Cancellations 30 days prior receive a full refund.

Location: Wrangell St. Elias National Park, Kennicott Glacier Lodge, site of largest ghost mine/town in the world.

Contact: Didier J. Lindsey, Alaska's View Finder, 4222 Resurrection Dr., Anchorage, AK 99504; (907) 338-5216.

JOHN FOWLER PHOTOGRAPHY AND NATURE TOURS
Professional photographer John Fowler, a graduate biologist, offers customized nature photography tours for groups of 4 or more.

Contact: John Fowler, 11620 Cobra Ave., Anchorage, AK 99516; (907) 346-3090.

ARIZONA

ANNUAL LAKE POWELL PHOTOGRAPHIC WORKSHOP
Arizona, Utah/October
This 5-day seminar, offered since 1984 and limited to 20 students, covers photography and camera formats from the basics through professional techniques. Participants live aboard houseboats that dock at field sites along Lake Powell.

Specialties: Outdoor and nature.

Faculty: Includes Lake Powell guide and photographer Steven Ward and has included professional photographers Jerry Jacka, Gary Ladd, John Telford, and Mike Stokolas.

Costs, Accommodations: Course fee includes food, lodging, and ground transportation. A deposit must accompany application with balance due on arrival. Accommodations are in 50 ft. houseboats.

Location: The red rock country of Lake Powell.

Contact: Steven Ward, Wahweap, P.O. Box 1597, Page, AZ 86040; (602) 645-1001, Fax (602) 645-5175.

ARIZONA HIGHWAYS PHOTO WORKSHOPS
Arizona/Year-round
The Friends, the nonprofit auxiliary of *Arizona Highways* magazine, offers approximately 20 photo tours of the state each year. Begun in 1988 and led by well-known photographers, these workshops feature coaching from first light to last, with instructional seminars when conditions are poor. The Friends strive to promote tourism to Arizona and also maintain a college scholarship program for in-state students of photography, raising funds by conducting scenic and photo tours.

Specialties: Outdoor and scenic photography.

Faculty: Prominent scenic photographers whose work has appeared in *Arizona Highways,*

including Jerry Jacka, Jerry Sieve, Jay Dusard, Ken Akers, and Michael Fatali.

Costs, Accommodations: Range from $500 to $2,000, which includes meals, lodging, and ground transportation. Full refund, less $100 fee, is granted cancellations more than 60 days prior.

Location: Canyon de Chelly, Monument Valley, Havasupai Canyon, Paria Canyon, and Lake Powell.

Contact: Friends Travel Desk Coordinator, Friends of Arizona Highways, P.O. Box 6106, Phoenix, AZ 85005; (602) 271-5904, Fax (602) 254-4505.

GRAND CANYON EXPEDITIONS
Grand Canyon/May-August

This tour company offers special interest expeditions that focus on the history, archaeology, astronomy, geology, ecology, and photography of the Grand Canyon. Approximately two 8-day photography expeditions are scheduled annually, traversing the 277 miles of the Canyon, beginning on Saturday at Lee's Ferry in Grand Canyon National Park and ending the following Saturday at Pearce Ferry on Lake Mead. Each trip is limited to 14 participants who are accompanied by a professional photographer on a 37-foot motorized raft developed by Grand Canyon Expeditions.

Specialties: Nature photography.

Costs, Accommodations: The cost of $1,645 per person includes round-trip transportation from Las Vegas, sleeping bag, waterproof containers for clothing and camera, and all meals.

Contact: Grand Canyon Expeditions Co., P.O. Box O, Kanab, UT 84741; (800) 544-2691 or (801) 644-2691.

PHOTOGRAPHY/SAILING WORKSHOPS
Baja California, Mexico/
June and October

Since 1988, Bob Hitchcock has offered 1-week chartering vacations, limited to 5 participants of all levels, that combine a photography course and sailing workshop. Instruction covers camera techniques, the use of existing light, and marketing.

Specialties: Outdoor photography.

Faculty: Bob Hitchcock, a Tucson studio owner, has been involved with professional photography for more than 20 years.

Costs, Accommodations: The cost includes meals and accommodations aboard "Flash", a 25-foot Oday.

Location: The Gulf of California.

Contact: Design Photography, 1615 N. Wilmot, Tucson, AZ 85712; (602) 298-3743.

SOUTHWESTERN SCENIC PHOTOGRAPHY
Copper Canyon, Mexico/
April and October

Since 1986, Joe Carder has conducted nature photo tours for photographers of all levels. Spring and fall 11-day tours of Mexico's Copper Canyon are limited to 12 participants. Daily schedule consists of morning tours and afternoon guided activities.

Specialties: Scenes and people.

Faculty: Joe Carder received his BA in Journalism from Michigan State University and was on the faculty of the University of Iowa's School of Journalism. His credits include *Arizona Highways, Outdoor Arizona,* and *Easy Living.* He designs and photographs custom slide shows and teaches for Tucson's Parks & Recreation Dept. and the University of Arizona's Elderhostel Division.

Costs, Accommodations: The $2,000 cost includes round-trip airfare from Tucson, double-occupancy lodging ($300 single supplement), ground transportation, and some meals. A $500 deposit is required with balance due 45 days prior. Full refund, less $50 handling fee, is granted cancellations 30 days prior.

Location: Copper Canyon, in Mexico's Sierra Madre Mountains, is home to the Tarahumara Indians. Tour sites include Los Mochis, Cerocahui, Posada Barrancas, Creel, and Chihuahua City.

Contact: Joe Carder, Southwest Scenic Photo, 1507 W. Sendero Seis, Tucson, AZ 85704; (602) 742-3928.

WILD HORIZONS PHOTOGRAPHIC EXCURSIONS
The American West (Arizona and Utah), Africa, Ecuador, Galápagos, Mexico/Year-round

Founded in 1985 by professional natural history photographer and filmmaker Thomas Wiewandt and offered four times a year, these 1- to 3-week instructional nature safaris are limited to 8 beginner to intermediate participants. Each program begins with formal instruction and slide presentations covering films and equipment, exposure and light, background and composition, and self critique. The major part of the week is spent in the field shooting, with individual assistance in a variety of situations. Evenings are reserved for additional instruction and participants are encouraged to bring examples of their work for critique.

Specialties: Nature.

Faculty: Thomas A. Wiewandt holds a Ph.D. in ecology from Cornell and has 23 years of field and 10 years of teaching experience. He has filmed 4 award-winning motion pictures, 3 for *National Geographic* and 1 for the *BBC*, and his credits include *Audubon, Smithsonian, Time-Life* and *National Geographic Books,* calendars, and four books.

Costs, Accommodations: Most trips in the western U.S. range from $1,285 to $1,820 per week. All trips include local ground and air transportation, guides where applicable, first-class double occupancy lodging (single supplement $210 to $255), meals, and entrance fees. A $200 deposit ($350 outside U.S.) is required with balance due 60 days prior. Cancellations more than 60 days prior or if space can be filled forfeit $50.

Location: Regularly scheduled destinations rotate from year to year, and include the Grand Canyon, Bryce and Zion National Parks, and the Galápagos. Africa, Ecuador/Galápagos, and Mexico are offered to small private groups by special arrangement.

Contact: Thomas Wiewandt, Wild Horizons, Inc., P.O. Box 5118-Dept. B, Tucson, AZ 85703-0118; (602) 622-0672, Fax (602) 798-1514.

ARKANSAS

MATT BRADLEY PHOTOGRAPHY WORKSHOPS
Arkansas and the Virgin Islands/
Spring and Fall

Begun in 1978 and limited to 14 to 16 participants, these workshops stress the specific thought patterns and sequences necessary to achieve improved images. The 3-day outdoor photography workshop, offered in April and October, is designed to maximize time outdoors with evenings devoted to slide presentations on image-making and private instruction. A 7-day Caribbean tall-ship sailing adventure, which travels to various locations in the Virgin Islands, emphasizes personal instruction and consultation.

Specialties: Outdoor photography.

Faculty: Matt Bradley, a freelance photojournalist for the National Geographic Society, has published *Arkansas, Its Land and People* and *The Hogs: Moments Remembered.* He has contributed to *Forbes, Time, Modern Maturity, American Heritage,* and *Newsweek,* and to several National Geographic Special Publications.

Costs, Accommodations: The 3-day workshops are $350, including meals and double-occupancy cabin lodging. A 50% deposit is required with balance due 30 days prior and full refund, less $25, is granted cancellations more than 30 days prior. The sailing trip is $1,900 to $2,100, which includes round-trip airfare from Little Rock, most meals, and cabin lodging aboard a 165-foot 3-masted tall ship. A $500 deposit is required with balance due 2 months prior; refund, less $25, granted cancellations 45 days prior if space can be filled.

Location: The 3-day workshops are at the Buffalo Outdoor Center in the village of Ponca, along the Buffalo National River. The sailing trip travels to Cruz Bay, St. John National Park, Magans Bay, and other locations in the Virgin Islands.

Contact: Matt Bradley, 15 Butterfield Ln., Little Rock, AR 72212; (501) 224-0692 (phone/fax).

OZARK PHOTOGRAPHY WORKSHOP/FIELD TRIP
Northwest Arkansas/Spring,
September-November,
and by appointment

Since 1979, Barney Sellers has offered weekend programs that are designed to increase visual awareness and teach outdoor photography skills. Around 6 workshops are scheduled annually, each limited to 12 participants who spend 1 or 2 days in the field shooting landscapes and structures. Emphasis is on composition, light levels, exposure, focusing, and depth of field. Students are encouraged to practice photographic creativity on the same scene at different times and seasons to capture the best light.

Specialties: Outdoor photography.

Faculty: Barney Sellers, a graduate of the old Woodard School of Photography and a journalism graduate of Arkansas State University, was a newspaper photographer with the *Memphis Commercial Appeal* for 36 years.

Costs, Accommodations: The $50 to $100 tuition is payable at workshop, but reservations should be made in advance. Credit cards accepted. Participants furnish food, lodging, and transportation.

Location: Two-day trips start in Rogers and in Batesville. The Rogers trip covers such locales as the Boston Mountains, Eureka Springs, and the Buffalo River. Batesville highlights include the White River and Calico Rock area. One-day trips include the cotton country of the Mississippi Delta.

Contact: Barney Sellers, Conductor, Ozark Photography Workshop/Field Trip, 40 Kyle St., Batesville, AR 72501; (501) 793-4552.

WAR EAGLE SEMINAR
Hindsville/June

This annual 2-week program, first held in 1969 and sponsored by the Ozark Arts and Crafts Association, Inc., consists of about a dozen courses in photography, basketry, sculpture, drawing, painting, flower arrangement, quilting, needlework, and stained glass and wood-carving. A typical photography course covers composition, lighting, and depth-of-field, and includes field trips and shooting expeditions.

Faculty: Has included Barney Sellers, former staff photographer of the Memphis.

Contact: Ozarks Arts and Crafts Fair Assn., Rte. 1, Box 157, Hindsville, AR 72738; (501) 789-5398.

CALIFORNIA

ADVENTURES IN ASIA & OCEANA
Asia, South Pacific/Year-round

Begun in 1983, these 5 to 28-day programs for photographers of all levels feature instruction and field shoots in unexploited cultures and environments.

Faculty: Biologist Peter Green, printing specialist Max T. Silverstine, and photographer and workshop director David Wallace.

Costs: Range from $20 to $45 per day plus expenses. Deposit is due 30 to 60 days prior. Full refund, less $10 fee, is granted cancellations.

Location: Worldwide, but primarily Asia and the South Pacific.

Contact: David Wallace, Box 7363, Huntington Beach, CA 92615; (714) 543-7747 (phone/fax).

AL WEBER WORKSHOPS
California and the Southwest/
Year-round

Al Weber has conducted workshops since 1968 and currently offers 6 to 10 programs annually, each limited to 6 intermediate to advanced photographers per instructor. The 2-day to 2-week workshops include such topics as color applications, the Cibachrome print, natural formations, and archaeology.

Specialties: Landscape photography with emphasis on specific techniques.

Faculty: Al Weber has been involved for more than 25 years in commercial illustration, aerial and architectural photography, and portraiture and now specializes in landscape photography. He was owner and director of the Victor School, a private center for photography education.

Costs, Accommodations: Tuition is approximately $150 to $180 for a weekend workshop and $400 for a 12-day workshop. Payment must accompany registration and full

refund is granted prior to workshop.

Location: Workshops in California are at Lake Mono, Pinnacles National Monument, and at Al Weber's home in Carmel. Workshops devoted to photographing rock art are in California, Nevada, Utah, New Mexico, and Arizona.

Contact: Al Weber, Rte. One, 145 Boyd Way, Carmel, CA 93923; (408) 624-5535

THE ANSEL ADAMS GALLERY WORKSHOPS
Yosemite National Park/
Spring, Summer, Fall

Founded in 1940 by Ansel Adams, this creative photography program for serious photographers of all levels features 4 to 6 workshops yearly in Yosemite National Park.

Contact: Workshop Coordinator, The Ansel Adams Gallery, P.O. Box 455, Yosemite National Park, CA 95389; (209) 372-4413.

ASIAN PACIFIC ADVENTURES
India/February, July, September

Since 1993, this travel organization has offered adventure tours, led by a qualified photographer, to scenic locales in Asia and the Pacific. The 23-day Photo Album of India tour, limited to 10 participants, visits the Naguar Cattle Fair, the Keoladeo Bird Sanctuary, the Taj Mahal, and the cities of Delhi, Jaipur, Jodhpur, and Agra.

Specialties: Tribal groups, festivals, historic areas.

Faculty: Has included freelancer and instructor William Neill, who specializes in documenting natural and cultural aspects of third world countries; Jeffrey Aaronson, whose work has appeared in *Life*, *Time*, and *Geo*; and Tovya Wager.

Costs, Accommodations: Costs for the India tour land package, which includes first-class to moderate hotel lodging and some meals, is $3,489 (single supplement $462). A $300 deposit, which includes a nonrefundable $200 registration fee, must accompany application with balance due 90 days prior.

Location: Scenic locations in India.

Contact: Hima Singh, Manager, Asian Pacific Adventures, 826 S. Sierra Blvd., Los Angeles, CA 90036; (213) 935-3156, Fax (213) 935-2691.

BAJA EXPEDITIONS, INC. PHOTO WORKSHOPS
Baja California, Mexico/
May, August, November

Baja Expeditions, Inc., established in 1974 as an outfitter of natural history and adventure travel in Mexico, conducts two or three photo workshops annually for up to 18 photographers of all levels. Daily activities include whale watching, bird watching, beachcombing, or hiking. Group presentations, evening lectures, slide shows, and individual critiques are a part of the program and limited overnight processing is available.

Specialties: Nature and wildlife photography, emphasizing whales and birds.

Faculty: Ken Jacques has photographed more than 300 theatrical productions and his credits include *Time*, *Newsweek*, and the *Los Angeles Times*.

Costs: Include airfare, shared lodging aboard an 80-foot boat, and meals.

Contact: Baja Expeditions, Inc., 2625 Garnet Ave., San Diego, CA 92109; (800) 843-6967 or (619) 581-3311, Fax (619) 581-6542.

BALI PHOTOGRAPHERS WORKSHOP
Bali, Indonesia/June

Since 1989, Professor Edward Raskin of L.A. Mission College has conducted an annual 3-week photography workshop in Bali. Enrollment is limited to 35 participants of all levels and cost is $3,840.

Contact: Edward Raskin, Bali Photographers Workshop, L.A. Mission College, 13356 Eldridge Ave., Sylmar, CA 91342-3244; (818) 364-7700.

BIOLOGICAL JOURNEYS
Baja California and Galápagos Islands/
January, March, April

Established in 1979, Biological Journeys offers whale watching and natural history trips to areas known for their wildlife. The 12-day January and March Baja tours offer whale watching and other marine opportunities while the 18-day Galápagos April workshop offers the opportunity to photograph animals up close. Programs are limited to 22 participants with 2 instructors for Baja and 9 participants for Galápagos. Snorkeling and hiking are available.

Specialties: Wildlife.

Faculty: Tom Johnson, Ron LeValley, and George Lepp (Baja); and Ron Sanford (Galápagos).

Costs, Accommodations: Costs are $3,195 (Baja) and $4,495 (Galápagos), including meals, lodging, and transportation during the program. Participants live aboard cruise vessels. A $500 deposit must accompany reservation with balance due 90 days prior. Cancellations more than 60 days prior forfeit $100; refund thereafter only if space can be filled.

Location: Baja program participants move along the coast of Baja California from San Diego to La Paz. Galápagos programs are held in Quito, Ecuador, and the Galápagos Islands.

Contact: Ron LeValley, Biological Journeys, 1696 Ocean Dr., McKinleyville, CA 95521; (800) 548-7555, (707) 839-0178, Fax (707) 839-4656.

BODIE PHOTOGRAPHY WORKSHOPS
Bodie State Historic Park/
May-October

Begun in 1986, these 2- to 4-day workshops offer an opportunity to explore and photograph one of the last gold mining ghost towns in the West. Many of the interiors, generally not open to the public, are available to participants for daylight shooting and beyond normal park hours to allow photography of the exteriors during sunrise and sunset. Limited to 10 participants, workshops emphasize aspects of expressive photography and include discussions, critiques, and demonstrations of such topics as exposure and development techniques, selection of print and slide materials, and final presentations.

Specialties: Fine art color photography.

Faculty: Includes Clinton Smith, who is represented in galleries worldwide and has instructed for the Friends of Photography, Maine Photographic Workshop, and the New

School/Parsons; Bob Cumming, a Brooks Institute graduate and photography teacher at North Orange County Community College; Thomas Morse; Noella Ballenger; and Jalien Tulley.

Costs, Accommodations: Nonrefundable workshop fees range from $200 to $465. Motels are less than an hour drive from the park and camping is nearby.

Location: Bodie is 20 miles from Bridgeport and 26 miles from Lee Vining, just east of Yosemite National Park.

Contact: Mark Pupich, Park Ranger, Bodie State Historic Park, P.O. Box 515, Bridgeport, CA 93517; (619) 647-6445.

BROOKS INSTITUTE OF PHOTOGRAPHY
Santa Barbara/July

This 3-year college of professional photography (page 140), founded in 1945 by color photography pioneer Ernest H. Brooks, offers an annual 5-day summer workshop for photo educators at the high school and junior college level. Three graduate credit units are awarded. The Institute also sponsors a special 7-week noncredit audit program for photo educators.

Specialties: A variety of topics, from basic black & white to digital imaging.

Faculty: Full-time Brooks Institute instructors.

Costs, Accommodations: Average workshop tuition is $375. Credit card registrations are accepted. No on-campus housing is available; an accommodations list is provided upon request.

Location, Facilities: All workshops are held on the Institute's 2 Santa Barbara campuses, located in the foothills overlooking the city, ocean, and Santa Barbara Channel Islands (90 miles north of Los Angeles). Facilities include classrooms, studios, laboratories, library, and galleries for student and professional exhibits.

Contact: Brooks Institute of Photography, Admissions Dept., 801 Alston Rd., Santa Barbara, CA 93108; (805) 966-3888, ext. 217 or 218.

CALIFORNIA NATURAL WONDERS PHOTOGRAPHIC WORKSHOP SERIES
Locations in California/
March-May, September-November

Each year since 1985, Noella Ballenger and Jalien Tulley have taught botanically oriented courses at the California State and County Arboretum and conducted 3- to 4-day workshops in California and photo safaris to other locations. Programs are limited to 20 students with 2 instructors. Individual instruction emphasizes visual awareness and problem solving. Travel and nature photography, review of camera equipment, basic techniques, and composition are also covered. Travel programs have included a 3-day workshop to Bodie State Historical Park, Mono Lake, and Death Valley.

Specialties: Nature and travel photography.

Faculty: Noella Ballenger and Jalien Tulley have taught for the California State and County Arboretum, Los Angeles Museum of Natural History, and Grytten Photography Workshops. Their work has appeared in *Petersen's PhotoGraphic, Terra, Westways, ZooView,* and *Smithsonian Guide to Historic America.* Esmeralda Gibson, a full-time professional photographer, has 12 years of experience and has been published in the *Los Angeles Times.*

Costs, Accommodations: Workshops tuition is $175 to $300, due 30 days prior. Transportation, food, and lodging are additional. A $50 deposit is required, refundable if canceled 1 month prior. Refund is granted cancellations 2 weeks prior or if space can be filled.

Contact: Noella Ballenger, Noella Ballenger & Associates, P.O. Box 457, La Cañada, CA 91012; (818) 954-0933, Fax (818) 954-0910.

CAMERA-IMAGE WORKSHOPS
California/
February, March, May, November

Four workshops per year for intermediate and advanced photographers have been offered since 1984, each lasting 3 to 4 days with a maximum of 16 students. Emphasis is on landscape large-format photography and various printing processes. A typical day begins with a sunrise field shoot, followed by an instructional session. After lunch, there are critiques of prints, then a sunset field session, and finally informal evening gatherings.

Specialties: Landscape and large-format photography; platinum, palladium, and Ilfochrome printing.

Faculty: Craig Fucile and Jan Pietrzak teach in several California schools.

Costs, Accommodations: Tuition is $55 per day; a $75 deposit is required. Refund granted cancellations 7 days prior; deposit is forfeited thereafter. Nearby lodging and camping facilities are available from $35 to $75.

Location: California desert and coast and Sierra Nevada Mountains.

Contact: Camera-Image Workshops, P.O. Box 1501, Downey, CA 90240-0501.

CANON/OUTDOOR PHOTOGRAPHER SEMINARS
U.S. locations/Year-round

Canon and *Outdoor Photographer* magazine co-sponsor 5 to 7 one-day outdoor/nature photography seminars per month for scenic and wildlife photographers of all levels. Three programs are offered: George Lepp's Optimize the Possibilities covers slide and print films, multiple and projected flash for macro and wildlife subjects, and creative techniques for photographing flowers; DeWitt Jones' Art of Seeing focuses on creative and technical skills; and David Brownell's program covers outdoor exposure and lighting, balancing flash with natural light, creating simulated sunlight, capturing sports action, and the elements of balanced composition. Some programs feature an optional second day hands-on workshop, limited to 15 participants. Company representatives from Canon and other sponsors demonstrate the newest camera equipment and accessories.

Specialties: Outdoor and nature photography.

Faculty: George Lepp's cover credits include *Natural History, Science,* and *Outdoor Photographer*; DeWitt Jones credits include *National Geographic*; David Brownell's credits include *Ski, Outside, Sail,* and *National Geographic World.*

Costs: Registration for the 1-day program, which includes lunch, is $49 in advance, $65 at the door. Credit cards accepted.

Location: Many U.S. cities.

Contact: Canon/Outdoor Photographer Seminars, P.O. Box 6224, Los Osos, CA 93412; (805) 528-7385, Fax (805) 528-7387.

CENTER FOR PHOTOGRAPHIC ART
Carmel/Year-round

The Center for Photographic Art was established in 1988 to encourage an increased awareness and understanding of photography as a fine art form. The 10 to 20 one- to three-day workshops offered each year are intensive sessions that cover both technical and non-technical aspects of photography. Limited to 10 to 25 participants with one to four instructors, they explore a variety of art genres, ranging from traditional black & white imagery to the contemporary view.

Specialties: Fine art photography.

Costs, Accommodations: Workshops range from $50 to $475. Full payment must accompany application. Credit cards accepted. Full refund, less $35 fee, is granted written cancellations at least 3 weeks prior. Annual Center membership (not required for workshop participants) is $35. Members of The Center for Photographic Art receive an annual monograph, quarterly newsletters, announcements and invitations to openings, discounts on workshops, and eligibility for the annual Members Exhibit.

Location: The Center's exhibition space and central office is located in the Sunset Cultural Center, San Carlos and 9th St.

Contact: Center for Photographic Arts, P.O. Box 1100, Carmel, CA 93921; (408) 625-5181, Fax (408) 625-5199.

CENTER FOR WILDERNESS STUDIES
Palmdale/Year-round

Lee Bergthold conducts overnight wilderness photo trips and teaches photojournalism and photo marketing.

Contact: Lee Bergthold, Center for Wilderness Studies, 41331 20th St. W., Palmdale, CA 93551.

CHINA ADVOCATES
China/June-September

This private cultural organization, created to help Americans study in China, sponsors a variety of in-depth summer programs in photography, culture, archaeology, music, painting and sculpture, language, and medicine.

Specialties: Chinese culture.

Faculty: Professional photographers.

Costs, Accommodations: Fee includes tuition, airfare, double-occupancy dormitory room, meals, and weekend excursions. A deposit must accompany application with balance due 75 days prior to program.

Contact: China Advocates, 1635 Irving St., San Francisco, CA 94122; (800) 333-6474 or (415) 665-4505.

CLOSE-UP EXPEDITIONS
Locations worldwide/Year-round

Since 1979, Lyon Travel Services has sponsored Close-Up Expeditions for amateur photographers and camera club members who want to produce travelogues and competition qual-

ity images. Informal instruction emphasizes using equipment creatively, pre-visualizing the image, and capturing it on film. The 15 to 20 one- to three-week trips offered each year are limited to 7 to 10 participants.

Specialties: Travel and nature.

Faculty: Includes Nick Nicholson, Brenda Tharp, Tom Johnson, and Mary Mather.

Costs, Accommodations: The approximate cost of $150 to $200 per day includes meals, lodging, and ground transportation. A $300 deposit is required with balance due 60 days prior. Cancellations more than 90 days prior forfeit $100.

Location: Includes Grand Canyon, Yosemite, Death Valley, Everglades, Costa Rica, Greece, Turkey, Indonesia, and New Zealand.

Contact: Donald Lyon, Close-Up Expeditions, Lyon Travel Services, 1031 Ardmore Ave., Oakland, CA 94610; (800) 995-8482, (510) 465-8955, Fax (510) 465-1237.

THE DARKROOM
Sacramento/Year-round

Established in 1986, this photo lab and digital imaging center offers weekend workshops and on-going classes on beginning to advanced topics that include fundamentals of lighting, tabletop lighting, techniques of mounting and display, Ilfochrome printing from slides, and large format photography. About 16 to 20 programs are offered yearly, each limited to 12 to 15 students.

Specialties: Black & white and color photography, darkroom techniques, advanced topics.

Faculty: Includes Gene Kennedy, Ken Templeton, Randy Snook, Markus Pfitzner, and Jo Carol Mills.

Costs: Range from $75 to $195. Cancellations receive approximately 85% refund.

Location: The Darkroom facility in Sacramento.

Contact: Gene Kennedy, The Darkroom, 708 57th Street, Sacramento, CA 95819; (800) 676-9691, Fax (916) 454-4964.

ENGLISH COUNTRY PHOTOGRAPHIC WORKSHOP & TOUR
Dorchester, England/July and August

These workshops, begun in 1987 and limited to 7 participants of all levels, are offered twice a year and combine a guided photographic tour of the southwestern English countryside with hands-on instruction in various areas of technique.

Specialties: English countryside.

Faculty: Professional photographer and Brooks Institute graduate Gary Wagner specializes in landscape, travel, and portraiture.

Costs, Accommodations: The workshop fee includes transportation, lodging, and meals. A nonrefundable 50% deposit must accompany registration with balance due 4 weeks prior.

Location: Dorchester, in Dorset County, lies halfway between Dover and Lands End in the south of England.

Contact: Gary Wagner, 6171 Greenwood Dr., Paradise, CA 95969; (916) 877-3824.

FINDING & KEEPING CLIENTS
Atlanta, Chicago, Los Angeles, San Francisco, and other cities/ Year-round

Since 1985, creative services consultant Maria Piscopo has conducted 3-day seminars for photographers of all levels and others who want to increase the effectiveness of their marketing and selling. The monthly programs cover: finding clients, positioning in the marketplace with emphasis on "local" clients, realistic estimating and pricing, direct-mail campaigns, effective follow-up techniques, and successful advertising and publicity.

Specialties: Marketing and selling creative services.

Faculty: Author, teacher, and photo rep Maria Piscopo; art/photo rep Cindy Brenneman.

Costs: Range from $100 to $175 and include meals and instructional materials. No refunds within 3 days of program.

Location: Seminars are scheduled in major cities in the U.S. and Canada.

Contact: Maria Piscopo, Creative Services Consultants, 2038 Calvert, Costa Mesa, CA 92626-3520; (714) 556-8133, Fax (714) 556-0899.

FORUM TRAVEL INTERNATIONAL
Worldwide/Year-round

Established in 1965, this travel company offers more than fifty 1- to 2-week tours each year for photographers of all levels. Participant to instructor ratio is 12 to 1.

Specialties: Travel and wildlife.

Faculty: Experienced wildlife photographer Jim Nahmens.

Costs, Accommodations: Tour costs range from $100 to $350 per day. A $300 deposit is required with balance due 60 days prior to departure. Cancellations prior to that date receive a 50% deposit refund. Lodging varies and includes hotel, camping, and on-board.

Location: Destinations include Africa, Antarctica, Asia, Australia, Europe, South America, Alaska, and the Galápagos.

Contact: Jim Nahmens, Forum Travel International, 558 Nimitz Ave., Redwood City, CA 94061; (415) 365-3651 and (510) 671-2900, Fax (415) 365-3651 and (510) 671-2993.

FOUNDATION FOR FIELD RESEARCH
Worldwide locations/Year-round

Founded in 1982 to coordinate research expeditions that require volunteer assistance, this nonprofit organization meets the needs of scientists by finding individuals who are interested in contributing, both physically and financially, to research projects. Some expeditions require the taking of photographs for documentary purposes.

Specialties: Photo tagging, documentation.

Contact: Foundation for Field Research, (619) 450-3460, fax (619) 452-6708.

THE FRIENDS OF PHOTOGRAPHY WORKSHOP PROGRAM
San Francisco/June

Established in 1967, the nonprofit Friends of Photography (page 207) offers an Annual Members Workshop that focuses on aesthetic, technical, and historical concerns through a

variety of artist presentations, slide lectures, discussions, and portfolio reviews. The 2-day weekend program features field trips, gallery visits, and behind-the-scenes experiences of San Francisco's photo community. The organization also offers occasional classes and 1-day workshops that are open to both members and nonmembers.

Faculty: Well-known and emerging artists, including Jo Ann Callis, Morrie Camhi, Robert Dawson, Martha Madigan, Jo Whaley, and Friends Director Andy Grundberg.

Costs: The Annual Members Workshop cost is $180. Other programs range from $90 to $230. Membership dues begin at $35 per year.

Location: Ansel Adams Center for Photography in San Francisco and conference sites in the Bay area.

Contact: Julia Brashares, Workshop Coordinator, The Friends of Photography, Education Dept., 250 Fourth St., San Francisco, CA 94103; (415) 495-7000, Fax (415) 495-8517.

GALÁPAGOS TRAVEL
Ecuador and the Galápagos/
Year-round

Since 1990, Galápagos Travel has conducted 25 workshop-oriented photography/natural history yacht trips annually to the 13 Galápagos Islands. Each 14- to 18-day trip is limited to 16 participants with 2 instructors, who go ashore twice daily during optimal light (early morning and later afternoon) and attend evening presentations on the natural history of the region and photographic opportunities. Two daily snorkeling sessions are also included.

Specialties: Nature and wildlife.

Faculty: Barry Boyce, owner of Galápagos Travel, has a graduate degree in the biological sciences and is author of *A Traveler's Guide to the Galápagos Islands.* Tour leader is a wildlife photographer familiar with the Galápagos.

Costs, Accommodations: The land cost of $2,650 to $3,250 includes meals and lodging aboard a yacht and 3 nights and most meals in a first-class hotel in Ecuador ($150 single supplement). A $300 deposit must accompany application with balance due 75 days prior. Credit cards accepted. Written cancellations more than 90 days prior forfeit $50.

Location: Includes Pinnacle Rock on the island of Bartolome, the Fur Seal Grotto in James Bay, the South Plaza islets of the east coast of Santa Cruz Island, the islet of Rabida, and the Tortoise Rearing Center at the Charles Darwin Research Station.

Contact: Barry Boyce, Galápagos Travel, P.O. Box 1220, San Juan Bautista, CA 95045; (800) 969-9014, Fax (408) 623-2923.

GLOBAL PRESERVATION PROJECTS
Bodie and other California locations/
Year-round

Global Preservation Projects, established in 1989, leads photographic expeditions, limited to 12 participants and 2 instructors. Instruction covers new and advanced techniques with emphasis on historic and environmental perspectives.

Faculty: Bodie Workshop Series founder Thomas I. Morse, whose photographs were acquired by the Bibliothèque Nationale; and wildlife photographer B. "Moose" Peterson, nature columnist for *Popular Photography* and author of *Nikon System Handbook.*

Location: Bodie State Historic Park, east of Yosemite National Park.

Contact: Thomas I. Morse, Bodie Workshop Series, P.O. Box 30866, Santa Barbara, CA 93130; (805) 569-3731.

GOLDEN GATE SCHOOL OF PROFESSIONAL PHOTOGRAPHY
Belmont/June

Established in 1984 to provide continuing education for working and aspiring professional photographers, this 5-day summer school covers various aspects of professional photography. With a student-teacher ratio of 20 to 1, entry level courses include basic portraiture and wedding photography, and advanced courses cover such topics as environmental and studio portraiture, photographic art, commercial photography, and professional video. Teaching methods vary with each class and range from a hands-on approach, with students working under supervision in the studio and on location, to the master-camera format, in which the instructor demonstrates techniques and students observe.

Golden Gate School is a nonprofit committee of the Professional Photographers of the Greater Bay Area, which is affiliated with the PP of A. PP of A Merits are awarded to members who successfully complete a course.

Specialties: A wide range of professional photographic specialties, including studio and environmental portraiture, commercial photography, wedding photography, print enhancement, studio portrait background painting, and computer studio management.

Faculty: Includes Celeste Dobbins, Tim Kelly, Michael Libutti, Lori Rose, and LaMarr Williamson.

Costs, Accommodations: Tuition for PP of A members or other affiliated state association is $350, which includes a nonrefundable $75 registration fee. Refund, less fee, granted cancellations in writing more than 30 days prior. Credit card registrations accepted. The cost of on-campus dormitory room and meals in the student cafeteria is $350, double occupancy. Students are encouraged to live and dine on-campus.

Location, Facilities: The school uses the 90-acre campus of the College of Notre Dame in Belmont, near San Francisco International Airport. Once the estate of William Ralston, the original mansion and landscaped gardens offer photo opportunities and the 600-seat Memorial Chapel is used as a setting for wedding photography. Other facilities include swimming pool, tennis courts, and an exercise course.

Contact: James Inks, Golden Gate School of Professional Photography, P.O. Box 187, Fairfield, CA 94533; (707) 422-0319, Fax (707) 422-0973.

HARTNELL COLLEGE PHOTOGRAPHY WORKSHOPS
California locations/
Spring, Summer, Fall

Begun in 1987, Hartnell College offers 4 annual photographic workshops yearly limited to 30 beginning students. Typical courses, given locally, include Non-Silver Photography Workshop, which covers gum dichromate printing and cyanotypes; Portraiture Workshop, both in-studio and outdoors; and Color Photography Workshop, which concentrates on color enlargements. Two and 3-day combined workshops and camping trips are scheduled in Yosemite National Park, the San Diego Zoo, and the Redwood National Park.

Specialties: A variety of topics.

Faculty: Jerri Nemiro holds an MFA degree and California Community College teaching credentials.

Costs: Local workshops range in cost up to $25.

Contact: Hartnell College Photography Workshops, 156 Homestead Ave., Salinas, CA 93901; (408) 755-6700.

HEART OF NATURE PHOTOGRAPHY WORKSHOPS
Western U.S. and Canada/
Spring, Summer, Fall

Nature photographer Robert Frutos conducts 2 ½-day tours and workshops that emphasize personal vision and photographic awareness combined with the necessary technical skills. Approximately 12 programs are scheduled annually, each limited to 8 participants.

Specialties: Nature.

Faculty: Professional photographer Robert Frutos' credits include *Sierra, Brown Trout,* and *Argus.*

Costs: Cost of instruction is $125. Lodging and restaurant information is available.

Location: Northern California, Yosemite and Zion National Parks, Sierras, Mono Lake.

Contact: Robert Frutos, Heart of Nature Photography Workshops, 14618 Tyler Foote Rd., Nevada City, CA 95959; (916) 292-3839.

HIDDEN WORLDS
France and Bali/May-August

Begun in 1994, these nature and travel programs are conducted 4 times a year for 14 intermediate-level photographers. The 9- to 16-day programs typically schedule about an hour of informal teaching each day and students spend the remaining time in the field, often exploring on foot or by bicycle. Emphasis is on the optimal locations for sunrise and sunset shooting.

Specialties: Nature, wildlife, travel, and macro photography.

Faculty: Dr. John Cooke is former director of Oxford Scientific Films and a professor of zoology.

Costs, Accommodations: Costs range from $2,000 to $3,695, including hotel lodging and ground travel. A $500 deposit is required. Full refund, less $50 ($150), granted cancellations 60 days prior (within 60 days).

Location: France and Bali.

Contact: Dr. John Cooke, Hidden Worlds, 1774 Capistrano Ave., Berkeley, CA 94707; (510) 524-5900 or (510) 845-1934, Fax (510) 654-2614.

IDYLLWILD SCHOOL OF MUSIC AND THE ARTS
Idyllwild/July-August

Established in 1950 as a program of the nonprofit educational Idyllwild Arts Foundation, ISOMATA offers a 6-week annual Summer Program of workshops for young people and adults in dance, music, native arts, theatre, writing, and the visual arts. Five weeks of young people's photography workshops are offered, each consisting of field trips and shooting assignments, darkroom work, discussions, and critiques.

Costs, Accommodations: Cost of the youth workshops includes lab fee, dormitory housing, and board.

Location: The 205-acre school site is located at a 5,500-foot elevation in the San Jacinto Mountains, 2 ½ hours from Los Angeles and San Diego.

Contact: Idyllwild School of Music and the Arts, Box 38, Idyllwild, CA 92549; (909) 659-2171, Fax (909) 659-5463.

IN FOCUS WITH MICHELE BURGESS
Africa, Asia, and South America/
Year-round

Founded in 1987 by professional travel and wildlife photographer Michele Burgess, this company offers 4 photography tours annually, each limited to 20 photographers of any level. Tours are timed to visit photogenic sites during the best seasons for weather, and include individual, informal instruction as needed.

Specialties: Travel and wildlife photography.

Faculty: Tour escort Michele Burgess, a professional photojournalist for 20 years, has visited more than 80 countries, is a member of the Society of American Travel Writers, and has been published in *Travel & Leisure, Travel-Holiday, International Wildlife,* and *National Geographic Traveler.* She has lectured on travel and stock photography at the community college level.

Costs, Accommodations: Tour costs range from $3,000 to $5,000 and include double occupancy lodging, most meals, airfare, ground transportation, and sightseeing. A $300 deposit is required with balance due 65 days prior. Cancellation penalty ranges from $100 to 100% of trip cost.

Location: Includes Burma/Thailand, Indonesia, Kenya/Tanzania, Tunisia, Peru, Yemen/Jordan, and India.

Contact: In Focus with Michele Burgess, 20741 Catamaran Ln., Huntington Beach, CA 92646-5513; (714) 536-6104.

INTERNATIONAL PHOTOGRAPHY ADVENTURES
Virgin Islands/March

Since 1989, International Photography Adventures has conducted an annual 1-week sailing trip that features photographic consultation on the specific challenges of shooting in the islands, nautical photography, how to take better travel photos, and stock and editorial photography. Other activities include snorkeling, windsurfing, and fishing. Each trip is limited to to 10 participants of all levels.

Specialties: Island and travel photography.

Faculty: Professional photographer Jim Raycroft's clients include Sheraton Resorts, American Express, and Time. His magazine credits include *Yachting, Sail,* and *Cruising World.* Corporate, travel, and stock photographer Bobbi Lane is a photo educator at UCLA Extension. Her clients include AT&T, Blue Cross, Kodak, and Mattel Toys. Both have more than 15 years professional experience.

Costs, Accommodations: Cost is $1,575, which includes stateroom lodging, all meals and beverages, and water sports equipment.

Location: U.S. and British Virgin Islands.

Contact: Bobbi Lane, International Photography Adventures, 900 E. 1st St., #105, Los Angeles, CA 90012; (213) 626-7807 or (800) 542-5505, Fax (213) 626-2940.

IRIAN ADVENTURES
Irian Jaya, Indonesia/
March and August

Since 1991, this nature travel company has conducted 2- to 4-week tours that focus on the stone-age cultures and tropical rain forests of Irian Jaya. The 2 photography tours offered each year are limited to 10 participants and feature daily morning and afternoon photo sessions at a local village or bird site.

Specialties: Nature and traditional-culture photography.

Faculty: Includes wildlife photographer Arthur Morris, whose specialty is birds.

Costs, Accommodations: The $3,200 cost for 17 days includes lodging, most meals, and local transportation. Lodging, which at times may be basic, is usually in hotels and participants occasionally spend the night in traditional villages.

Location: Rain forests and islands of Irian Jaya, a territory of Indonesia.

Contact: Jerry Spencer, Director, or Liz Miller, General Manager, Irian Adventures, P.O. Box 210387, San Francisco, CA 94121; (800) 501-7700, Fax (415) 221-7614.

JAMES HENRY RIVER JOURNEYS
Alaska/June-August

Founded in 1973, James Henry River Journeys offers 10- to 12-day canoeing and hiking trips that feature photographic instruction and lectures on natural history and wilderness literature. Enrollment is limited to 10 to 20 participants who photograph wildlife, scenics, and flowering plants.

Specialties: Wildlife and nature, emphasizing Alaska's rivers .

Faculty: James Henry River Journeys director and tour leader James Katz has been an image-maker for more than 20 years and has led British Columbia-Alaskan trips since 1974.

Contact: James Henry River Journeys, Box 807, Bolinas, CA 94924; (800) 786-1830 or (415) 868-1836.

JOHN SEXTON PHOTOGRAPHY WORKSHOPS
California, Arizona, Utah, Yosemite
Valley, Wisconsin, Baja/Year-round

In 1990, master printmaker John Sexton established this workshop series for committed photographers who are actively working at improving craft, personal vision, and direction. The yearly schedule consists of 8 to 10 workshops, limited to 8 participants per instructor, with instruction in the techniques and aesthetics of making expressive images. Some involve darkroom work and others emphasize supervised work in the field. All workshops include directed outdoor photography sessions, portfolio review, informal discussions, and faculty presentations.

Specialties: Darkroom techniques; black & white landscape photography.

Faculty: Director John Sexton *(Quiet Light)* served as director of the Ansel Adams Workshops and was Technical and Photographic Assistant and consultant to Ansel Adams.

Other instructors are Morley Baer *(The Wilder Shore, Painted Ladies)*; Ruth Bernhard *(Collecting Light, The Eternal Body)*; Philip Hyde *(Drylands, Slickrock)*, and Ray McSavaney, whose work has been published in *Outdoor Photographer* and *View Camera* magazines.

Costs: Tuition ranges from $550 to $600 for a 5-day workshop. A $150 deposit (includes $50 nonrefundable registration fee) is required with application; balance is due 45 days prior. Accommodations are available at nearby motels and lodges.

Location: Darkroom sessions are conducted in John Sexton's studio/darkroom in Carmel Valley; field sessions are held on the Monterey Peninsula.

Contact: John Sexton Photography Workshops, 291 Los Agrinemsors, Carmel Valley, CA 93924; (408) 659-3130, Fax (408) 659-5509.

LEPP AND ASSOCIATES SEMINARS
Mono Lake/June

Outdoor/nature photographer George Lepp offers two 5-day June workshops, Mono Lake and the Eastern Sierra, which are limited to 9 photographers with 3 instructors. Instruction is tailored to each participant and covers landscape, wildflowers, macro, nesting birds, and small mammals. Mr. Lepp's 1-day seminar, Optimize the Possibilities, is presented by Canon and *Outdoor Photographer* magazine (page 13) for groups of 100 or more. Individual and group workshops are also available.

Specialties: Nature.

Faculty: George Lepp's cover credits include *Natural History, Science, Outdoor Photographer, Wilderness,* and *Arizona Highways.*

Costs, Accommodations: The 5-day workshop cost of $600 includes transportation during the program. Lodging is available in Lee Vining.

Location: Lake Mono, east of Yosemite National Park; California's central coast.

Contact: Lepp & Associates, Box 6240, Los Osos, CA 93412; (805) 528-7385.

LOS ANGELES PHOTOGRAPHY CENTERS WORKSHOPS
Los Angeles/Year-round

Established in 1960 and operated by the Cultural Affairs Department of the City of Los Angeles, these workshops cover a variety of topics, including photojournalism, black & white and color printing, portraiture, archival processes, the business of photography, hand-coloring, photo silkscreening, and framing, matting, and mounting techniques. Approximately 20 to 25 evening and half-day workshops, each with 6 to 25 participants, are offered each quarter. The Centers also offer exhibitions, classes, and lectures, as well as black & white and color rental darkrooms and studio facilities.

Faculty: Instructors include Dave Healey, Willie Middlebrook, Mort Loveman, Victoria Martin, Sam MacKenna, and Tony Martinez.

Location: The Los Angeles Center is located between Rampart and Alvarado; the San Pedro Center is located at the Angels Gate Cultural Center; the Encino Center is in an historic Mediterranean-style building.

Contact: Los Angeles Photography Center, 412 S. Park View St., Los Angeles, CA 90057; (213) 383-7342. Encino Photography Center, 16953 Ventura Blvd., Encino, CA 91316; (818) 784-7266.

MACRO TOURS PHOTO WORKSHOPS
Locations in the U.S./Year-round

Founded in 1983, Macro Tours offers more than thirty 1- to 10-day nature photography workshops and tours yearly throughout the western U.S and Alaska and fall programs on the East Coast. Enrollment is limited to 10 to 12 students, who spend most of each day in the field with on-location instruction. Formal sessions consist of slide shows, lectures, and pre-outing briefings. Students learn about the history and background of the area, composition and exposure, macro photography, and creative use of equipment. One-day color printing classes are conducted on a monthly basis.

Specialties: Nature photography.

Faculty: Founder/director Bert Banks, Gene Willott, Jennifer Erickson, and Spencer Westbrook.

Costs, Accommodations: Costs range from $45 to $1,995, which includes lodging, some meals, and ground transportation. One-day color printing class is $70.

Location: Includes Death Valley, Yosemite, and the wine country in California; the Santa Fe and Taos areas of New Mexico; Acadia National Park in Maine; and Olympic Peninsula in Washington.

Contact: Bert Banks, Director, Macro Tours Photo Workshops, P.O. Box 460041, San Francisco, CA 94146-0041; (800) 369-8430, (415) 826-1096.

MAKING A LIVING IN PHOTOGRAPHY
San Rafael/Spring and Fall

Since 1987, Jay Daniel has conducted seminars that focus on lighting skills necessary to earn a living as a professional photographer. Topics include basic studio lighting, advanced lighting techniques, location lighting, balancing strobe and available light, and creative new techniques.

Specialties: Studio and location lighting; business and technical aspects of photography.

Faculty: Jay Daniel has been working out of his Marin County studios for 14 years. His commercial clients include American Express, Mizuno Sports, Wordstar Software, and Playboy.

Location: Jay Daniel's studio at 816 W. Francisco Blvd. in San Rafael.

Contact: Jay Daniel Associates, P.O. Box 151232, San Rafael, CA 94915; (415) 459-1495.

MENDOCINO ART CENTER
Mendocino/Spring, Summer, Fall

Established in 1959 as an educational and resource center for the visual and performing arts, the nonprofit Mendocino Art Center offers programs primarily in theater production, ceramics, textile and fiber arts, and fine arts, including photography. Five-day summer and weekend fall and spring workshops are limited to 14 participants of all levels. A typical program consists of lectures, demonstrations, and daily field sessions.

Costs: Tuition ranges from $75 to $95 for a weekend, $150 to $250 for 5 days. Cancellations 3 weeks prior forfeit $20. Credit cards accepted. Art Center housing ranges from $125 to $225 per week and a list of nearby lodging is provided. Membership dues begin at $35 for an individual, $50 for a family and include a sub-

scription to *Arts and Entertainment* magazine.

Location: The Center is 150 miles north of San Francisco.

Contact: Mendocino Art Center, 45200 Little Lake St., P.O. Box 765, Mendocino, CA 95460; (707) 937-5818.

NATURE'S IMAGE PHOTOGRAPHIC EXPEDITIONS
Western U.S., East Africa, Costa Rica, Baja

Since 1980, Frank S. Balthis has conducted 1-day to 3-week workshops that combine instruction in photography and natural history and provide advice on getting work published. About 5 to 7 expeditions are offered annually, limited to 12 participants, who receive up to 12 hours of technical instruction daily. Pre-trip and post-trip slide presentations are arranged and personal critique is available.

Specialties: Outdoor photography.

Faculty: Frank Balthis' credits include publications of the National Geographic Society, Audubon Society, Oceanic Society, and Sierra Club.

Location: Destinations include Baja California, East Africa, Costa Rica, Yellowstone National Park, Alaska.

Contact: Frank S. Balthis, Nature's Image Photographic Expeditions, P.O. Box 255, Davenport, CA 95017; (408) 426-8205, Fax (408) 426-1623.

THE NUDE IN THE ENVIRONMENT WORKSHOP SERIES
Big Sur/May

Since 1983, Steve Anchell and Donna Conrad have conducted workshops on photographing the nude in the natural environment. Each of the 2 weekend workshops offered each May at Big Sur is limited to 12 participants of intermediate to advanced level. The program begins with a Friday evening discussion of the aesthetics of the human form in nature, its relationship to photography and art, and working with the model. Saturday and Sunday morning and afternoon field sessions include instruction in posing and working with the model, filtration in black & white and color, and camera techniques. The final session is spent critiquing participants' previous work. An optional Monday morning session is also offered.

Specialties: Fine art figure studies in the natural environment.

Faculty: Steve Anchell has been involved with photography for more than 20 years. He has conducted workshops for 6 universities, is a contributing editor for *Camera & Darkroom* magazine, and writes features for *View Camera* and *PhotoPro* magazines. Donna Conrad, a specialist in 35mm color travel and documentary photography, has worked with the nude since 1983.

Costs, Accommodations: The Big Sur workshop fee of $425 includes lunch on Saturday. A $200 deposit must accompany application with balance due 30 days prior. A list of local accommodations is provided upon registration. Refund, less $50, up to 30 days prior.

Contact: Steve Anchell, Director, 2067 18th Ave., San Francisco, CA 94116-1249; (415) 522-9702.

OCEANIC SOCIETY EXPEDITIONS
**Various sites in the U.S. and abroad/
July-August**

Oceanic Society Expeditions, a private nonprofit organization, is dedicated to environmental education through natural history expeditions to unique wildlife habitats. Typical expeditions include the Lake Baikal photographic ecotour featuring the Yshkanyi Islands, and fresh water seals; the wildlife, rainforest, and ruins of Peru's Manu National Park and Machu Picchu; the brown bears of Alaska; and Russia's Kamchatka Peninsula.

Specialties: Environmental photography.

Faculty: Nature photographer John Dillon and Boyd Norton, author-photographer of 9 books, whose credits include *National Geographic* and *Smithsonian*.

Costs, Accommodations: Costs range from $2,700 to $3,400, which includes lodging, most meals, ground transportation, and sometimes airfare. A $300 deposit must accompany application, an additional $400 is due 120 days prior, and the balance is due 60 days prior. Credit cards accepted. Cancellations 60 to 90 days prior forfeit deposit.

Contact: Oceanic Society Expeditions, Fort Mason Center, Bldg. E, San Francisco, CA 94123; (800) 326-7491 or (415) 441-1106, Fax (415) 474-3395.

OLIVER GAGLIANI PHOTOGRAPHIC PROCESS WORKSHOP
Virginia City, Nevada/June and July

Since 1970, Oliver Gagliani has conducted an annual 2-week total immersion Zone System workshop, limited to 15 students, designed to teach practical and exact methods of negative contrast control in fine black & white placed on large to medium formats. Lectures, demonstrations, darkroom work, and field sessions are scheduled daily with time for individual work.

Faculty: Professional photographer and printmaker Oliver Gagliani studied with Ansel Adams and Minor White at the California School of Fine Arts. He was awarded an NEA grant and has taught at the University of California and the Ansel Adams Yosemite Workshops.

Costs, Accommodations: Tuition includes a shared room in the Art Center and lab fee. A nonrefundable deposit must accompany enrollment. Students may reside outside the center at their own expense. An optional meal service is available.

Location, Facilities: Virginia City was once the center of the Comstock Lode, one of the world's leading gold and silver-mining regions. The workshops are held in St. Mary's Art Center, with three darkrooms, a lecture hall and living quarters.

Contact: Oliver Gagliani Workshops, 35 Yosemite Rd., San Raphael, CA 94903; (415) 472-4010.

ON ASSIGNMENT PHOTOGRAPHIC TOURS
A variety of worldwide locations

The 1- to 4-week On Assignment tours are designed for the traveling photographer who wishes to combine sightseeing with learning photo techniques based on the *National Geographic* style. The number of participants is limited to ensure a low student-instructor ratio and personal guidance is given throughout.

Specialties: Travel photography.

Faculty: Former *National Geographic* staff photographer Albert Moldvay is author of *The National Geographic Photographers' Field Guide.* Photo-journalist Erika Fabian has co-authored eight travel photo guides. They conduct Photographing the National Geographic Way workshops in conjunction with colleges and universities.

Costs, Accommodations: Tour costs, which include transportation, lodging, and some meals, range from $1,700 to $3,800, double occupancy (single supplement available). Full refund, less $75 fee, is granted written cancellations at least 45 days prior.

Location: Pacific Rim countries and Hawaii.

Contact: Erika Fabian or Albert Moldvay, Photographic Society International, 1380 Morningside Way, Venice, CA 90291; (310) 396-4307.

ON LOCATION PHOTOGRAPHY SEMINARS
Worldwide/Year-round

Since 1988, freelance photographer Brenda Tharp has offered photography workshops and tours, limited to 13 serious amateurs, that emphasize the creative aspects of photography and cover such topics as advanced composition and lighting, low-light photography, the photo essay, and photographic design. The 5- to 17-day programs run 6 or 7 times a year and are designed for participants who want to travel to unusual destinations and become acquainted with the inhabitants and their customs. The schedule consists of morning and afternoon field trips as well as presentations and critiques.

Specialties: Travel photography.

Faculty: Freelance photographer and writer Brenda Tharp has taught for 10 years. Her credits include *Sierra Club, Audubon, Travel-Holiday,* and *Travel & Leisure.*

Contact: On Location Seminars, Box 1653, Ross, CA 94957; (415) 927-4579.

THE PALO ALTO PHOTOGRAPHIC WORKSHOPS
Palo Alto/
March-May, September-November

Established by Douglas Peck and Stacy Geiken in 1989, these three 1-day workshops are offered once each fall and spring and limited to 10 students per instructor. Introduction to the View Camera has an equal mix of slide/lecture discussions, hands-on demonstrations, and field work emphasizing camera controls, the basic camera movements, and procedures for optimizing sharp focus; Introduction to Lighting covers professional techniques of studio and on-location lighting; Outdoor Photography features discussions and practice in wildlife, macro, landscape, and flash photography, as well as instruction on using light in the natural world. The Palo Alto Photographic Workshops are a certified California Private Postsecondary Educational Institution.

Specialties: Nature photography, lighting, and view camera.

Faculty: Freelancer Douglas Peck earned a degree in industrial photography at the Brooks Institute of Photography, where he subsequently served on the faculty for 5 years. He has been published in the Sierra Club Calendar and worked as technical advisor to Ernst Haas for the 1984 Olympic issue of *Life* magazine. Stacy Geiken received an MA in photography from the University of Michigan and has served on the faculty of Lansing Community College and the Brooks Institute of Photography. His credits include *Forbes, Runner's World,* and *Audio Magazine.*

Costs, Accommodations: Tuition ranges from $95 to $250. Full payment must accom-

pany registration. Participants receive a motel and restaurant list prior to arrival. Written cancellations more than 1 week prior forfeit $10.

Location: A newly expanded Palo Alto facility, 50 minutes from San Francisco.

Contact: Douglas Peck, Douglas Peck Photography, 991 Commercial St., Studio 1, Palo Alto, CA 94303; (415) 424-0105, Fax (415) 494-1127.

PHOTO ADVENTURES
San Francisco and other California locations/April-December

Established in 1986, Photo Adventures offers about a dozen spring and fall nature photography workshops, including 5 or 6 San Francisco workshops. Each 1- to 4-day program is limited to 12 photographers of all levels and emphasizes both creative and documentary photography, learning about the environment, and practical tips to improve techniques and sharpen visual skills.

Specialties: Nature, urban, and night photography.

Faculty: Freelancer and published photographer Jo-Ann Ordano, a photography instructor for the National Park Service at Marin Headlands Visitor Center, completed a photo survey of the Pepperwood Ranch Natural Preserve for the California Academy of Sciences, which exhibited her work.

Contact: Photo Adventures, P.O. Box 591291, San Francisco, CA 94159; (415) 221-3171.

PHOTO METRO DIGITAL WORKSHOPS
San Francisco/Year-round

Established in 1991, Photo Metro Digital Workshops offers 3-day courses featuring hands-on instruction in desktop publishing software, including Photoshop, Director, QuarkXPress, and Illustrator. Class size ranges from 8 to 10 beginner and advanced participants. Each student is provided a computer to work on during class.

Specialties: Desktop publishing software.

Faculty: The 6 instructors include Henry Brimmer, Peter Kesselman, Kyle Kosup, Therese Randall, and Barry Haynes.

Costs, Accommodations: Tuition of $400 must be paid in advance. Cancellations more than 1 week prior forfeit $50.

Contact: Henry Brimmer, Photo Metro Digital Workshops, 17 Tehama St., San Francisco, CA 94105; (415) 243-9917, Fax (415) 243-9919.

PHOTOCENTRAL/INFRARED WORKSHOPS
Locations in the Western U.S./Year-round

Established in 1983, this community-based facility offers 20 weekend workshops a year at locations in California and nearby states. Emphasis is on creative vision, and programs include sunrise and morning photo shoots and exercises, afternoon demonstrations, and evenings sharing photographs. Enrollment is limited to 18 participants, who range from advanced beginner to professional. Topics include infrared, night photography, Zone System, handcoloring, and self-promotion. Infrared, the most popular workshop, covers studio and technical issues as well as field applications.

Specialties: Infrared time lapse, Zone System, marketing, and other topics.

Faculty: Geir and Kate Jordahl earned MFA degrees in photography from Ohio University and have taught photography for 14 years. They are instructors at Chabot College and were artists-in-residence for Yosemite National Park in 1993.

Costs, Accommodations: Tuition ranges from $75 to $300; preregistration required. Cancellations more than 2 weeks prior receive a full refund. Accommodations and transportation are the responsibility of participants.

Location: Northern California and the West for travel workshops; San Francisco Bay area for technical workshops.

Contact: Geir and Kate Jordahl, PhotoCentral, 1099 "E" St., Hayward, CA 94541; (510) 278-7705 or (510) 881-6700, Fax (510) 881-6763.

POINT REYES FIELD SEMINARS
Point Reyes Station/Year-round

This self-supporting year-round program, sponsored by the Point Reyes National Seashore Association since 1976, offers courses in natural history, environmental education, and the arts, including about 20 one to five-day photography seminars annually. The programs are limited to 20 participants of all levels and combine lectures, critiques, and field photography with evenings devoted to slide presentations.

Specialties: Outdoor, wildlife, and nature photography.

Faculty: The 5 to 8 instructors each season include John Shaw, Pat O'Hara, John Fielder, Charles Krebs, and Robert Holmes.

Costs, Accommodations: Cost is $45 for one day; $200 for week-end, which includes dormitory-style lodging. Full payment must accompany registration. Refund is granted cancellations more than 16 working days prior.

Location: Point Reyes National Seashore is 50 miles north of San Francisco.

Contact: Point Reyes Field Seminars, Point Reyes National Seashore, Point Reyes, CA 94956; (415) 663-1200.

PROJECT OCEAN SEARCH
Islands worldwide/
July-September, November

Established in 1973, this intensive field study program is conducted by Jean-Michel Cousteau to promote appreciation and understanding of the ocean environment. Two to four 2-week programs are scheduled annually, each limited to 35 to 40 participants ages 16 and over. Lectures, films, nature walks, and workshops introduce participants to a variety of ecosystems; social activities provide insight into the islands' cultural aspects. Those interested in underwater exploration have access to sophisticated underwater photographic equipment, including the Nikonos V.

Specialties: Ecology, underwater photography.

Faculty: The three to four faculty members

Costs, Accommodations: Changes yearly, depending upon location. The 1995 cost of $5,200 includes lodging, meals, transportation, and all planned activities.

Location: Changes yearly. The 1995 locations are Fiji and the Cayman Islands.

Contact: Laura Sullivan, P.O.S. Registration Coordinator, Jean-Michel Cousteau Productions, 1933 Cliff Dr., Ste. #4, Santa Barbara, CA 93109; (805) 899-8899, Fax (805) 899-8898.

RAY MCSAVANEY PHOTOGRAPHIC WORKSHOPS
Los Angeles and the Southwest/ March-November

Established in 1991, these 2-to 7-day workshops are designed to help serious photographers of all levels use their equipment more effectively and advance their personal vision. Approximately 8 to 10 workshops are scheduled yearly, with 2- and 3-day darkroom sessions in Los Angeles limited to 6 participants and longer field sessions in scenic Southwest locations limited to 8 participants per instructor. Students should bring samples of previous work for critique.

Specialties: Darkroom techniques, urban and natural landscapes.

Faculty: Ray McSavaney has exhibited in the U.S. and Europe and served on the staffs of more than 100 workshops. His credits include West of Eden: *A History of the Art and Literature of Yosemite, California Scenic Magazine, View Camera, The Journal of Large Format Photography,* and *Outdoor Photographer.* Other instructors include Carol Brown, John Nichols, John Sexton, and Jack Waltman.

Costs: Tuition ranges from $125 to $625. A $125 to $150 deposit is required with balance due one month prior. Cancellations more than one month prior forfeit $50. Moderately-priced lodging is available nearby.

Location: Shorter workshops are held at Ray McSavaney's studio and urban Los Angeles sites; field workshops are held in Arizona, New Mexico, and Utah.

Contact: Ray McSavaney Photographic Workshops, 1984 N. Main St., #402, Los Angeles, CA 90031; (213) 225-1730.

REDWOOD EXPOSURE
Northern California/Year-round

Redwood Exposure offers day excursions and 2- to 7-day packages that explore the northernmost California redwoods and Pacific Coastal ecosystems. Enrollment is limited to 6 participants, who are accompanied by 2 natural scientists/outdoor photographers.

Costs, Accommodations: Day excursions are $195, which includes lunch; packages range from $395 for 2 days to $1,545 for 7 days, which includes oceanfront bed & breakfast double occupancy lodging, most breakfasts and lunches, and ground transportation. Advance reservation is required. Cancellations 14 days prior forfeit a 15% fee.

Contact: Rose & Jim Bond, Redwood Exposure, Box 525, Arcata, CA 95521; (800) 995-8688 or (707) 839-0216.

REDWOOD FIELD SEMINARS
Crescent City/May-September

Redwood National Park sponsors a series of 1- and 2-day summer outdoor field seminars, each limited to 18 to 24 participants, that cover a variety of subjects including photography, art, wildlife, plants, environment, and cultural history.

Specialties: Outdoor and nature photography.

Faculty: Includes Mark Higley, whose credits include *Sierra, Motorland, Birder's World,* and *Outdoor Life*; and Carrie E. Grant, a photography gallery director and experienced field photographer.

Location: Redwood National Park stretches along California's North Coast from north of Eureka to just south of the Oregon border. U.S. Highway 101 runs north and south through the park, providing a scenic drive along the coast. Park Headquarters is in Crescent City.

Contact: Seminar Coordinator, Redwood National Park, 1111 Second St., Crescent City, CA 95531; (707) 464-6101.

RON SANFORD
California, Alaska, Arizona,
Ireland, Baja

Travel and wildlife photographer Ron Sanford offers weekend photo workshops for advanced amateurs interested in marketing their work.

Specialties: Travel and wildlife photography.

Faculty: Ron Sanford has photographed throughout the world and his work has been published in the U.S., Europe, and Asia. Credits include *Gourmet, Outdoor Photographer, Popular Photography, Time, Natural History,* and National Geographic books.

Contact: Ron Sanford, Box 248, Gridley, CA 95948; (916) 846-4687.

SIERRA PHOTOGRAPHIC WORKSHOPS
Western U.S. and Maine/
Spring and Fall

Since 1981, Lewis Kemper and William Neill have conducted landscape workshops and wildlife tours that feature personalized photographic instruction. A half dozen 4- to 9-day programs are offered yearly, most limited to 16 participants and a student to instructor ratio of 8 to 1. Instruction covers depth of field, exposure, creative composition, filters, and the Zone System.

Specialties: Landscape and wildlife.

Faculty: Lewis Kemper holds a BA in fine art and founded the Sierra Photographic Workshops. He is a contributing editor to Outdoor Photographer, and his prints are in the permanent collection of The Baltimore Museum of Art. William Neill, a freelance photographer living in Yosemite National Park, is author of *Yosemite: The Promise of Wildness* and *Sense of Wonder.* His credits include *National Geographic, Outdoor Photographer,* and *The Outside Quarterly.*

Costs, Accommodations: Costs, including lodging, transportation, and some meals, range from $725 to $2,595. Deposits, registration deadlines, and refund policies vary.

Location: Includes Death Valley, Utah canyons, Acadia National Park in Maine, Kalispell in Montana (features trained wildlife models), Alaska, and Bosque del Apache in Albuquerque.

Contact: Sierra Photographic Workshops, PO Box 214096, Sacramento, CA 95821; (800) 925-2596 or (916) 974-7200, Fax (916) 974-7205.

SUMMIT PHOTOGRAPHIC WORKSHOPS
Western U.S. and Alaska/
February-November

Since 1990, Barbara Brundege has offered workshops and tours that visit a variety of natural locations. The 1-day to 3-week programs, limited to 15 participants, provide instruction and technical support through a combination of lectures and field demonstrations. Typical topics include composition, editing, night photography, the color Zone System, meter calibration, and business aspects.

Specialties: Landscape and wildlife photography.

Faculty: Barbara Brundege, whose credits include *National Geographic, Smithsonian, Outdoor Photographer,* and *The Atlantic.*

Costs, Accommodations: Costs range from $89 for a 1-day workshop to $2,995 for a 14-day Alaska trip and may include meals and lodging. Full payment is required to reserve space in workshops under $300. A $300 deposit is required for tours.

Location: Includes Yosemite, Zion, and Kenai Fjords National Parks, California's Tulelake Wildlife Refuge and Pt. Lobos State Preserve, and various totem pole parks in Alaska.

Contact: Barbara Brundege, Summit Photographic Workshops, P.O. Box 889, Groveland, CA 95321; (209) 962-4321, Fax (209) 962-4323.

TOP GUIDES
Asia and Europe/Year-round

Top Guides is a cooperative of professional guides who put together ecologically and culturally sensitive trips throughout the world. Focus on the World! is a series of about six 12- to 19-day tours per year that feature daily instruction and meetings with professional photographers in the countries visited. Each program is open to 5 to 16 participants.

Specialties: Travel and wildlife photography.

Faculty: ASMP member David Sanger, whose credits include *Escape, Sierra,* and *Sky,* and visual anthropologist Alison Wright, recipient of the Dorothea Lange Fellowship in Documentary Photography.

Costs, Accommodations: Land cost ranges from $3,490 to $4,990, which includes double occupancy lodging, most meals, and ground transportation. A $300 to $400 deposit is required with balance due 60 days prior.

Location: Itineraries include the Buddhist monasteries in Tibet and Nepal, Bolivia, Tuscany, China's Silk Road, the Himalayas, and Bhutan.

Contact: Top Guides, 1825 San Lorenzo Ave., Berkeley, CA 94707; (800) 867-6777 or (510) 527-9884, Fax (510) 527-9885.

UNIVERSITY OF CALIFORNIA EXTENSION — SANTA CRUZ
California, Southwestern U.S.,
Mexico, and other locations/
Year-round

Founded in 1973 and influenced by Ansel Adams and other prominent West Coast landscape photographers, the UC Extension Photography Workshops offer programs that increase artistic awareness and technical skills. More than forty 1-day to 1-week workshops

and two or three 2- to 3-week photo tours are scheduled annually, with some specifically for beginning, intermediate, or advanced photographers. Emphasis is on fine art photography and enrollment is limited to 15 to 25 students. Workshop format ranges from classroom sessions with lectures and critiques to field studies. In addition to such topics as computer imaging, portraiture, lighting, and resources for photographers, workshops for women, taught by leading women photographers and emphasizing women's vision, are also offered. Most workshops grant 1 to 3 quarter units of college credit.

Specialties: A variety of fine art photography and technical subjects.

Faculty: Approximately 40 accomplished photographers and educators, including Morley Baer, Martha Casanave, Henry Gilpin, Ted Orland, Stuart Scofield, and Cole Weston.

Costs, Accommodations: Workshop tuition ranges from approximately $140 to $395; typical tour fees include airfare, lodging, and some meals and begin at $1,900. Fees include optional academic credit. Full workshop payment must accompany registration and credit cards are accepted. Written cancellations received 10 working days prior forfeit $15. Tour payment and refund policies vary.

Location: California locations include Big Sur, Yosemite, Death Valley, and Mono Lake. Other locations include Santa Fe, Zion National Park, Oaxaca, and the Yucatan peninsula.

Contact: Photography Dept., University of California Extension, 740 Front St., Ste. 155, Santa Cruz, CA 95060; (408) 427-6620, Fax (408) 427-6608.

UNIVERSITY OF SOUTHERN CALIFORNIA ADVENTURE PHOTOGRAPHY
California and Southwestern U.S./
Year-round

Established in 1982, this program features about a dozen 2- to 6-day workshops a year in scenic California locales. Enrollment is limited to 8 photographers per instructor. Post-trip social and photo-sharing sessions are held at participants' homes.

Specialties: Nature and wildlife.

Faculty: Director Dave Wyman's credits include *Outdoor Photographer, Backpacker,* and *Outside.*

Costs, Accommodations: Two-day trips may include meals and lodging; 6-day trips to locations outside California include airfare from Los Angeles, lodging, and some meals.

Location: California destinations include Cuyamaca State Park, Yosemite, the Monterey Aquarium, Sequoia, and Mono Lake; other locations include Taos, Santa Fe, Mesa Verde, and Canyon de Chelly.

Contact: Dave Wyman, Adventure Photography, University of Southern California, Los Angeles, CA 90089-7791.

UNIVERSITY RESEARCH EXPEDITIONS PROGRAM
University of California-Berkeley
Worldwide locations/Year-round

Established in 1976, UREP's purpose is to bring the public and scientific community together and encourage greater communication and sharing of information and skills. Although the program is open to all, the 5 to 10 volunteers on each research team are selected on the basis of their suitability for the project. Wilderness experiences, observation skills,

and drawing, photography, and diving ability are helpful, as well as adaptability to other people and cultures. Approximately 30 expeditions are scheduled annually, inquiring into such areas as animal behavior, anthropology/sociology, archaeology, arts, botany/ecology, marine studies, and paleontology. College students may be able to receive academic credit through their own institution.

Specialties: Photo documentation.

Faculty: University of California scholars.

Costs, Accommodations: UREP volunteers participate in field and research expenses and the costs of planning and implementation. Expedition cost, which ranges from $750 to $1,800, includes meals and shared lodging, ground transportation, camping and field gear, and research equipment. Applicants must submit an application/questionnaire, accompanied by a $200 tax deductible contribution. Balance is due on acceptance. California teachers can apply for the Grants for Teachers Program, which covers a portion of the costs.

Contact: University Research Expeditions Program (UREP), Desk M13, University of California, Berkeley, CA 94720; (510) 642-6586, Fax (510) 642-6791.

VENTURA COLLEGE SUMMER PHOTOGRAPHY PROGRAM
England, France, and California/ Summer

Since 1988, Ventura College has offered an 8-week summer course, enrolling about 25 students and granting six units of credit, that includes 4 weeks of intensive camera work in the United Kingdom and France. Students register for either the 2-part basic class, Beginning Photography and Introduction to Color Photography, or the single class, Directed Studies, for those who have completed the 2-part series.

Specialties: Black & white and color photography.

Faculty: Tom Roe, a photography instructor at Ventura College for 20 years, earned a BA in photography from Brooks Institute of Photography.

Costs, Accommodations: The fee includes airfare, lodging, and some meals. Students may elect a credit or non-credit option.

Location: Ventura College is on California's southern coast, about an hour's drive north of Los Angeles.

Contact: Tom Roe, Ventura College, 4667 Telegraph Rd., Ventura, CA 93003; (805) 654-6468.

WEST COAST SCHOOL OF PROFESSIONAL PHOTOGRAPHY
Professional Photographers of California, Inc. Southern California/ February and July

Founded in 1956 to advance the art, science, and management of professional photography, the West Coast School sponsors 30 week-long sessions for aspiring to experienced professionals. Each course is limited to 15 to 25 students per instructor, meets 8 hours daily from Monday through Friday, and is classified as either basic, intermediate, or advanced. Typical workshop titles include The Emotion of Portraiture, Advanced Wedding Photography, and The Basics of Portraiture. A pre-session seminar on a specific topic is offered the Sunday prior to each session and other activities include evening talks, print critiques and an equipment sale.

Specialties: A variety of topics, including portrait, wedding, commercial, stock, darkroom, and retouching.

Faculty: All experienced, working professionals, has included portrait and wedding photographer Carlos Lozano, Sherman Hines, who has published 50 books; portrait artist Arnold Newman; Joyce Wilson, whose work is exhibited at the Photography Hall of Fame; and wedding photographers David Ziser and Monte Zucker.

Costs, Accommodations: Tuition for each course is $425 for PPC members, $490 for PPA members, and $525 for all others. A 50% deposit must accompany application with balance due 6 weeks prior. Cancellations more than 30 days prior forfeit $75. Motels are located nearby. Campus apartments are available for the San Diego session.

Location: The February session is held at the Brooks Institute of Photography, which occupies two campuses in the Santa Barbara area. The July session is held on the University of San Diego campus.

Contact: Allen Roedel, West Coast School of Professional Photography, Box 395, Imperial Beach, CA 91933; (800) 429-5839, (619) 429-5839, Fax (619) 429-1996.

WHOLE-LIFE PHOTOGRAPHY WORKSHOPS
California, New Hampshire, New Mexico/May and October

Since 1979, Steve Anchell and Ja Densmore have conducted workshops that focus on the development of the participant as a photographer, with emphasis on technique and self-expression. Three 5-day programs are scheduled annually, each limited to 16 participants, and consist of daily field travel and exercises and evening lectures and critiques.

Faculty: Steve Anchell and Ja Densmore.

Costs, Accommodations: Tuition of $745 includes lodging and all meals. A $200 deposit is required and is refundable, less $50, 30 days prior.

Location: October workshops are held in Etna, NH, and Taos, NM. May workshops are in Big Sur, CA.

Contact: Ja Densmore, Director, 0470 Stagecoach Lane, Carbondale, CO 81623; (303) 963-0685, Fax (303) 963-0685.

WILDERNESS TRAVEL PHOTOGRAPHY TOURS
Worldwide/Year-round

This tour company offers two to three 2- to 4-week programs per year that combine a tour of the region with a 3-day photo workshop consisting of lectures, field excursions, and critique. Emphasis is on scenic, portrait, and wildlife photography in the field. Enrollment is limited to 15 beginning photographers.

Specialties: Unusual scenic, cultural, and natural history locales.

Faculty: Galen Rowell and Frans Lanting.

Location: Includes Antarctica, Peru, Botswana, East Africa, and Nepal.

Contact: Ray Rodney, Special Projects Manager, Wilderness Travel Photography Tours, 801 Allston Way, San Anselmo, CA 94960; (510) 548-0420 or (800) 368-2794, Fax (510) 548-0347.

YOSEMITE FIELD SEMINARS
Yosemite National Park/
February-October

Established in 1974, the Yosemite Field Seminars offer a variety of outdoor classes and backpack trips to provide natural history instruction at the Park. More than seventy 1- to 4-day programs are offered each year in botany, geology, astronomy, birding, Indian studies, nature writing, art, photography, and teacher education. Some sessions are geared to an introductory level while others require experience. Enrollment ranges from 15 to 20 participants per 1 or 2 instructors, and participants should be in good health as all programs involve some hiking or backpacking. Photography courses include field instruction and evening lectures that cover technique, composition, film, filters, how to find and get close to animals, tracking, blinds, aesthetics, and the natural history of the region.

Specialties: Nature and wildlife.

Faculty: Includes Yosemite resident Annette Bottaro-Walklet; Brenda Tharp, whose credits include *National Geographic*; Howard Weamer, who has 30 years' experience photographing Yosemite; and Jeff Nixon, who has worked with the Ansel Adams Trust.

Costs, Accommodations: Seminars range from $50 to $200, including some meals. Tent campsites are free; cabins are $54, and rooms are $80. Full payment (credit cards accepted) must accompany registration; refunds, less $15 fee, are granted cancellations 28 days prior.

Contact: Penny Otwell, Yosemite Field Seminars, Yosemite Association, P.O. Box 230, El Portal, CA 95345; (209) 379-2321/2646, Fax (209) 379-2486.

YOSEMITE PHOTO TOUR AND WORKSHOP
Yosemite National Park/May

Since 1986, San Diego State University (SDSU) College of Extended Studies has coordinated 5-day workshops that emphasize topography and wildlife photography. Up to 30 participants spend 2 days traveling and 3 days in photo shoots and lectures. Basic and advanced techniques are taught on-site at Yosemite National Park.

Specialties: Topography and wildlife.

Faculty: Photographer Butch McGuffin is a professional freelance photographer associated with Cordoba Studios and Imagemaster.

Costs, Accommodations: Tuition of $474 includes coach transportation from San Diego, lodging, park fees, and tram ride. A $100 deposit is due in March and balance is due the end of April. No refunds thereafter. Lodging is in the Yosemite Lodge Cabins and at a motel at Mono Lake.

Contact: Patrick Lathrop, SDSU College of Extended Studies, 5250 Campanile Dr., San Diego, CA 92182-1919; (619) 594-5154, Fax (619) 594-7080.

COLORADO

ANDERSON RANCH ARTS CENTER
Snowmass Village/May-October

This multi-disciplinary visual arts center, established in 1966, offers 25 one and two-week intensive workshops (average 11 participants per instructor and 2 assistants); field expeditions to remote Rocky Mountain and Southwest locales; a 2-week program for youngsters;

and a residency program for emerging photographers. Most participants are serious amateurs or professionals. Workshops typically meet from Monday through Friday and include portfolio reviews, assignments, and demonstrations. Field expeditions explore wilderness areas, and the residency program for emerging artists features critiques, exhibition space, and interaction with noted photographers.

Specialties: A wide variety of topics, including black & white figure and landscape, portraiture, computer imaging, and alternative printing processes.

Faculty: Has included contemporary landscape photographers Mark Klett, Linda Connor, and John Sexton; commercial photographers Jay Maisel, Dick Durrance, and Sue Drinker; photojournalists Maggie Steber and Sam Abell; conceptual photographer David Levinthal; and MacArthur Fellowship recipient Richard Benson.

Costs, Accommodations: Workshop tuition is $325 to $475 per week plus lab fees of $30 to $100; fully- outfitted field expeditions range from about $900 to $3,970. A $250 deposit and nonrefundable $30 registration fee must accompany application with balance due 45 days prior. Credit cards are accepted. Refund, less $30 fee and $50 cancellation fee, is granted cancellations more than 30 days prior. On-campus shared housing with meals is $275 per week. A $100 housing deposit is required, with balance due 45 days prior. Tuition grants of $300 are awarded to selected aspiring photographers. Residency applications should be received by May 1. Application deadline for summer apprenticeships is March 15.

Location, Facilities: The Ranch, a mixture of historic log cabins and barns and modern studio facilities, is in the mountain resort of Snowmass Village, 10 miles west of Aspen and 160 miles west of Denver. Field expedition sites include the San Juan River in Southeast Utah and Arizona canyon lands.

Contact: James Baker, Photography Program Director, Anderson Ranch Arts Center, Box 5598, Snowmass Village, CO 81615; (303) 923-3181, Fax (303) 923-3871.

BLACKHAWK MOUNTAIN SCHOOL OF ART
Estes Park/June-July

Established in 1963, this nonprofit school's summer program provides the opportunity to work with the faculty of artists-in-residence who are prominent professionals in drawing, painting, printmaking, sculpture, and photography. The 2-week photography program is limited to 12 participants.

Faculty: Joseph Jachna, winner of Guggenheim and NEA awards.

Costs: Tuition is $350 per week, room and board are $54 per day.

Location: In the Colorado Rockies, 90 minutes from Denver.

Contact: Blackhawk Mountain School of Art, Box 5324, Estes Park, CO 80517; (800) 477-2292.

BRANSON REYNOLDS PHOTOGRAPHIC WORKSHOPS
Southwest U.S./Spring and Fall

Begun in 1992 and limited to 8 participants, Branson Reynolds offers a dozen 5-day workshops yearly that are devoted to photography of traditional native models in a Southwest setting. Typical programs include the Native American Model Workshop, which is held in the ancestral home of the Pueblo, Navajo, and Ute people and features model released photo sessions that include potters, weavers, dancers, and children on horseback.

Specialties: Figure and landscape photography.

Faculty: Professional photographer Branson Reynolds, whose credits include Backpacker, Outside Nature, Outdoor & Travel Photography, and The New York Times.

Costs, Accommodations: Tuition is $750. A $200 deposit is required, with balance due/refund granted 1 month prior. Lodging, which is additional, is arranged by the workshop.

Location: The Four Corners region.

Contact: Branson Reynolds Photographic Workshops, P.O. Box 3471, Durango, CO 81302; (303) 247-5274.

BRECKENRIDGE PHOTOGRAPHY WORKSHOPS
Colorado Mountain College
Breckenridge/June, July, and August

Colorado Mountain College offers about a half-dozen 3- to 5-day summer photography workshops, each meeting 4 to 8 hours daily and limited to 10 to 15 beginning to experienced photographers. Topics include black & white, large format environmental photography, commercial photography, wildlife, and photojournalism.

Specialties: A variety of topics.

Faculty: Has included freelance commercial photographer Todd Powell, whose clients are *Natural History* and *Ski;* W. Perry Conway, whose credits include *Audubon* and *Backpacker;* and *National Geographic* freelance photographer David Hiser.

Costs: Tuition is determined by residency and course credit value.

Location: The college is 85 miles west of Denver, off Interstate 70.

Contact: Colorado Mountain College, Box 2208, Breckenridge, CO 80424; (303) 453-6757.

FOCUS ADVENTURES
Steamboat Springs/July-September

Since 1992, Karen Schulman has offered 2- to 4-day workshops that emphasize personal growth and self-discovery through photography. Typical programs are Hand-Painting Black & White Photographs, Photography and the Art of Seeing, and Fall Foliage. The 3 to 5 workshops per year, each limited to 5 to 10 students, include classroom instruction, critiques, field trips, and daily E-6 film processing.

Specialties: Personal growth through photography, hand-coloring.

Faculty: Karen Schulman is co-author of *Steamboat* Visions and has conducted workshops since 1983.

Costs: Tuition ranges from $175 to $350. A $100 deposit is required and full payment is due 30 days prior. Refund, less $50, is granted cancellations 30 days prior.

Location: Steamboat Springs is a year-round mountain resort with natural hot springs.

Contact: Karen Schulman, Owner, Focus Adventures, Box 771640, Steamboat Springs, CO 80477; (303) 879-2244 (phone/fax).

FOUR SEASONS NATURE PHOTOGRAPHY, INC.
Locations in the U.S., Canada, and
Africa/Year-round

Four Seasons Nature Photography offers approximately 22 nature and wildlife tours annually, each limited to 5 photographers per instructor. Classroom instruction is provided during mid-day and evening and field work is scheduled to take advantage of the best light and during periods of peak wildlife activity. Participants are invited to bring slides and prints for critique.

Specialties: Nature and wildlife.

Faculty: Daniel Poleschook, Jr., has been published in *Nature Photographer* and served as president of the Colorado Nature and Mile High Wildlife Camera Clubs. Joseph K. Lange, APSA, has been published in *Nature Photographer* and served as president of the Colorado Council of Camera Clubs and director of the Rocky Mountain Chapter of the PSA.

Costs, Accommodations: Fees, which include shared lodging, continental breakfast, and local transportation are $1,045 to $1,995 for 1-week workshops in the U.S. and Canada, $3,995 for 2 weeks in Southern Africa. A $200 to $300 deposit reserves a space and balance is due 60 to 120 days prior. Cancellation penalty ranges from $50 to total deposit.

Location: National Parks.

Contact: Four Seasons Nature Photography, Inc., 2292 Shiprock Rd., Grand Junction, CO 81503; (800) 207-4686 or (303) 244-8855.

GALLERY 412 WORKSHOPS
Varied locations/Year-round

These 3- to 10-day workshops, first offered in 1988 and open to 8 to 12 intermediate level participants, feature daily field trips, classes, review sessions, and same-day processing. Shoots are scheduled for early and late light, and mid day is devoted to programs or travel. Instruction covers camera handling, exposure, depth of field, composition, lenses, light, close-ups, exhibiting, and marketing.

Specialties: Landscape and nature photography.

Faculty: Steve Traudt has exhibited in the U.S. and 12 other countries and his photographs are in more than 300 private collections. Robert Hitchman specializes in photo travel.

Costs, Accommodations: Fees range from $500 to $3,000 and usually include motel lodging, some meals, and some airfare. A $250 to $500 deposit is required and cancellations more than 60 days prior forfeit $100.

Location: Includes Costa Rica, Galapagos, Tahiti, Arizona's Slot Canyons, Colorado, Utah, and Mexico (Monarch Butterflies).

Contact: Steve Traudt, Gallery 412, 412 Main St., Grand Junction, CO 81501; (303) 245-6700, fax (303) 245-6767.

JUDD COONEY'S OUTDOOR PHOTOGRAPHY WORKSHOPS
Colorado, New Mexico,
South Dakota, Texas/Year-round

Judd Cooney conducts personalized wildlife photography workshops for 2 to 4 participants of any level. Days are spent in the field, where the emphasis is on techniques for finding and

photographing free-roaming wild birds and animals. Evenings are reserved for discussions, slide presentations, and review of published images. Sessions in instructor's home city, Pagosa Springs, include darkroom processing and critique of each day's work.

Specialties: Wildlife photography.

Faculty: Judd Cooney's credits include magazine covers, calendars, greeting cards, and advertisements. He has a degree in wildlife management from South Dakota State College and worked for the Alaska Department of Fish & Game and the Colorado Division of Wildlife.

Costs, Accommodations: Cost per day includes meals, lodging, and all planned activities. Lodging is in motels, private ranches, camping, or the Cooney home in Pagosa Springs. A 50% deposit is required to secure a date.

Location: Pagosa Springs, in southwestern Colorado, and areas of wildlife activity in New Mexico, South Dakota, Texas, and other parts of Colorado.

Contact: Judd Cooney, J.C. Photo Enterprises, Box 808, Pagosa Springs, CO 81147; (303) 264-5612.

KELLY PLACE
Cortez/Spring and Fall

Founded by George and Sue Kelly in 1965, Kelly Place, a living history and archaeological education facility in southwestern Colorado, offers 6-day portrait photography workshops, each limited to 24 participants. Hands-on workshops in landscape gardening and horticulture, native weaving, draft horse harness and hitching, and Southwest archaeology are also offered.

Specialties: Portrait photography.

Faculty: Professional photographers.

Location: Kelly Place, a 100-acre re-creation of a 19th-century pioneer's farm in the Red Rocks Desert, is in southwestern Colorado. Within the property is McElmo Canyon, the site of at least five Indian communities dating back 1,000 years or more.

Contact: Kelly Place, 14663 County Road G, Cortez, CO 81321; (303) 565-3125.

LATIGO RANCH
Kremmling/July and September

This resort ranch offers photography workshops each year, 1 during peak wildflower season (July), the other during the annual fall cattle round-up (September), when wranglers gather hundreds of head of cattle from mountain pastures and drive them down to winter pastures. Each workshop is limited to 12 students (1 instructor to 6 students) of all levels, who should bring slides for critique. Topics include previsualizing, landscapes, portraiture, the photo essay, and close-up and action photos. A typical day begins with an early morning shoot followed by discussion tailored to participants' interests. Shooting is again scheduled in the late afternoon and evenings are devoted to slide presentations and informal talks. Overnight E-6 processing is available.

Specialties: Wildflower and cattle round-up photography.

Faculty: Dave and Deborah Crough, who produce multi-image documentaries and lead workshops; commercial photographer Sonny Rains, whose clients have included Bell

Telephone and Mary Kay Cosmetics.

Costs, Accommodations: Cost of $1,365 for the wildflower workshop, $1,145 for the cattle round-up workshop, includes meals, lodging, recreational facilities, and programmed activities (horseback riding and instruction, overnight pack trip, dances). A 25% deposit must accompany enrollment. Cancellations more than 45 days prior forfeit $50; deposit is forfeited thereafter unless space can be filled. Accommodations are in modern log cabins.

Location, Facilities: Latigo is at 9,000 feet in the Colorado Rockies, surrounded by Arapaho and Routt National Forests. It's approximately 40 miles southeast of Steamboat Springs and northwest of Denver. Other ranch activities include horseback riding (each person is paired with a horse for the stay), fishing, hiking, square dancing, and gymkhana.

Contact: Photography Workshops, Latigo Ranch, P.O. Box 237, Kremmling, CO 80459; (800) 227-9655 or (303) 724-9008.

NANPA FORUM
Site changes yearly/January *(see also page 209)*

Since 1995, the North American Nature Photography Association has sponsored an annual 2- to 3-day conference that features presentations, panel discussions, audience participation, and a trade show geared to the needs of the nature photographer.

Specialties: Nature.

Faculty: Speakers have included Galen Rowell, Art Wolfe, DeWitt Jones, and Frans Lanting, all of whom have won awards and have several magazine and book credits.

Costs: Early registration is approximately $250 ($200 for NANPA members).

Contact: NANPA Forum, 10200 W. 44th Ave., Ste. 304, Wheat Ridge, CO 80033; (303) 422-8527, Fax (303) 422-8894.

NATURAL HABITAT ADVENTURES
Magdalen Islands, Churchill/
February-March, October-November

Each year, Steve Morello leads eighteen 5- to 9-day wildlife workshops that offer close-up encounters with polar bears (October and November) and seals (February and March). Enrollment is limited to 20 participants for polar bear watches and 37 for seal watches. The schedule consists of early morning trips to visit the animals followed by discussion sessions and review of slides.

Specialties: wildlife.

Faculty: Steve Morello's credits include *National Geographic, USA Today,* and the *New York Times.*

Costs, Accommodations: Tuition, which includes hotel lodging, ranges from $1,695 to $3,095.

Location: Seal watches are held at Magdalen Islands, Canada. Polar bear watches are held in Churchill, Manitoba, Canada.

Contact: Ben Bressler, Natural Habitat Adventures, 2945 Center Green Ct. S., Ste. H, Boulder, CO 80301; (800) 543-8917 or (303) 449-3711, Fax (303) 449-3712.

NATURAL IMAGE EXPEDITIONS
Locations in the U.S./
January-October

More than a dozen 3- to 5-day nature and wildlife photo tours are offered each year to a variety of natural sites. Each trip includes instruction and critique sessions. Typical titles include Orcas of the Pacific Northwest, Mountain Goats & Bighorn Sheep, Utah Desert by Houseboat, Wildflowers of the Rockies, and Maui Photo Adventure.

Specialties: Wildlife and nature photography.

Costs, Accommodations: Range from $495 to $1550, including lodging and local transportation.

Location: Includes Maui, Utah's Arches National Park, Washington's Olympic National Park, Colorado's Rocky Mountain National Park, Washington's San Juan Island, and Wyoming's Grand Teton National Park.

Contact: Natural Image Expeditions, 13785 W. 68th Dr., Arvada, CO 80004; (800) 259-8771, (303) 420-7893.

THE NATURE PLACE
Florissant/July

Offered since 1992, this annual 6-day wildflower and landscape photography program is limited to 10 students who learn composition, methodology, manual camera work, and skills in finding, protecting, and photographing wild flowers. Participants must have a working knowledge of their equipment and should bring a 35 mm camera with a macro-capable lens, tripod, and film. Typically, students shoot in the morning from sunrise until 11 am and reconvene in the evening for a critique of their processed film.

Specialties: Wildflower and landscape photography.

Faculty: John D. Smithers served as the photographer and film producer for the National Wildflower Research Center and has conducted more than 70 photo and video workshops.

Costs, Accommodations: The $790 cost includes shared cabin lodging, meals, ground transportation, and film processing. Single cabin cost is $1,125. A $100 deposit is required; refund granted cancellations 3 weeks prior.

Location: Florissant and nearby locations.

Contact: The Nature Place, Colorado Outdoor Education Center, Florissant, CO 80816; (719) 748-3475.

NIKON SCHOOL OF UNDERWATER PHOTOGRAPHY
Key Largo and locations in the
Caribbean/March-October

WaterHouse Photo Tours, a travel company specializing in scuba diving destinations and underwater photography, is exclusive agent for the Nikon School of Underwater Photography, sponsored by Nikon, Inc. for Nikonos System photographers. Approximately 10 one-week programs are offered per year, including the Nikon School, the advanced Nikon School, and the Nikonos Shootout photo contest. Nikon School programs combine classroom and underwater photo instruction covering lenses, close-up, macro, wide angle, composition, working with models, and multiple strobe technique. The daily schedule gen-

erally includes 2 to 3 hours of instruction and a 2-tank dive excursion. WaterHouse also organizes the Stephen Frink MFT Photo Tours, non-instructional programs that travel to underwater locations.

Specialties: Underwater photography.

Faculty: Includes Marty Snyderman, Rick Frehsee, Scott Frier, Stephen Finck, and Frank Fennell.

Costs, Accommodations: Tuition is $250 for the basic Nikon School and $500 for advanced. A variety of lodging and meal plans are available. A $250 deposit is required within 10 days of booking with balance due 60 days prior.

Location: Includes Bonaire, Cayman Brac, Cayman Aggressor, and Key Largo.

Contact: Maria DiPasqua, WaterHouse Photographic Tours, 3004 Arapahoe Ave., Boulder, CO 80303; (800) 272-9122 or (303) 440-7189, Fax (303) 443-4485.

PHOTOGRAPHY AT THE SUMMIT
THE STEAMBOAT WORKSHOPS
Steamboat Springs/Summer

This retrospective, conference, and workshop, an annual event since 1985, is designed for 50 working professionals and serious students of photography who are selected on the basis of slide submission. The 5-day workshop is devoted to researching and photographing a local picture story or essay. Mornings are reserved for private sessions with faculty advisors, afternoons are spent photographing the story, and evening sessions include presentations by faculty and critiques of the day's work.

Specialties: Photo-essay, photojournalism.

Faculty: Photographers who are currently or have previously been affiliated with *National Geographic* magazine.

Costs, Accommodations: The conference fee includes breakfast, lunch, and reception. Application must be accompanied by a deposit and at least 5 examples of work. Balance is due upon acceptance. Credit cards accepted.

Location: Steamboat Springs, a popular ski resort in the 6,900-foot-high Yampa Valley, is 157 miles northwest of Denver.

Contact: Photo Workshop, Steamboat Ski & Resort Corporation, 2305 Mt. Werner Circle, Steamboat Springs, CO 80487; (303) 879-6111 ext. 472, Fax (303) 879-7844.

ROBERT WINSLOW PHOTO TOURS, INC.
Montana and Canada/
February, June, July

Since 1988, Robert Winslow has conducted workshops devoted to photographing wild animals in natural settings. Wildlife Model Workshops, a 3-day workshop offered in February and June, is limited to 6 intermediate photographers who photograph mountain lions, bears, bobcats, lynx, foxes, wolves, and otter in natural settings under controlled conditions. Photographing Birds of Prey, a 1- or 2-day workshop, features bald and golden eagle, peregrine and saker falcon, harris and swainson's hawk, and a variety of owl species. Enrollment is limited to 6 the first day, 3 the second. The daily schedule for both programs includes morning and afternoon photographing and evening slide presentations.

Specialties: Wild animals in controlled settings.

Faculty: Robert Winslow has an MS in biology and has been a full-time professional nature photographer for almost 20 years. His credits include *Discover, Field & Stream,* and *Travel & Leisure.*

Costs, Accommodations: Cost is $1,325 ($350 per day) for Wildlife Models (Birds of Prey), which includes lodging, breakfasts, and lunches. A $500 (40%) deposit is required and is refundable 30 days prior, less $100 fee.

Location: Bozeman, MT, a 2-hour drive from Yellowstone National Park; and Lethbridge, Alberta, between Glacier/Waterton and Banff National Parks.

Contact: Robert Winslow, Director, Robert Winslow Photo Tours, Inc., Box 334, Durango, CO 81302; (970) 259-4143 (phone/fax).

ROCKY MOUNTAIN NATURE ASSOCIATION
Rocky Mountain National Park/February-September

Established in 1962, the Rocky Mountain Nature Association offers a half-dozen 1-day to 1-week workshops yearly in the natural environs of Rocky Mountain National Park. Enrollment is limited to 8 to 20 participants and typical titles include Alpine Nature Photography, Wildflower Photography, Exploring the Natural World, Learning to See With a Camera, and Autumn Nature Photography. At least 1 day is devoted to sunrise-to-sunset photography; other days typically run from 8 am to 6 pm.

Specialties: Nature photography.

Faculty: Includes Wendy Shattil, a professional photographer for 18 years; and Bob Rozinski, a professional for 7 years and photography teacher for 12 years. They are grand prize recipients of *BBC Wildlife's* Wildlife Photographer of the Year competition and have been published in *National Wildlife, Audubon, Natural History,* and *Outdoor Photographer.* Other instructors include Willard and Kathy Clay, Perry Conway, James Frank, and David Halpern.

Costs, Accommodations: Tuition ranges from $50 for a 1-day workshop to $180 for 1 week. Lodging is in free campgrounds or local motels.

Location: Rocky Mountain National Park.

Contact: Kris Marske, Seminar Coordinator, Rocky Mountain Nature Association, Rocky Mountain National Park, Estes Park, CO 80517; (303) 586-1258, Fax (303) 586-1310 RMNP Dispatch.

TOM STACK & ASSOCIATES PHOTO MARKETING SEMINAR
Colorado Springs

This nature photo agency offers an annual 1-day photo marketing seminar, How to Shoot What Sells and Sell What You Shoot. The program covers photo submissions; creating a file system; selecting the most competitive film, lenses, and cameras; pricing guidelines and copyright protection; and the use of computers and copy machines.

Specialties: Photo marketing.

Faculty: Tom Stack, a photo agent with 20 years of experience, represents several hundred photographers worldwide. His clients include The National Geographic Society, Time-Life Books, and Hallmark Cards.

Costs: Seminar fee must accompany application.

Location: Tom Stack's Colorado Springs office.

Contact: Tom Stack & Associates, 3645 Jeannine Dr., Suite 212, Colorado Springs, CO 80917; (719) 570-1000, Fax (719) 570-7290.

WELDON LEE WILDLIFE PHOTO TOURS
Colorado, Nebraska, East Africa/
Year-round

Since 1989, Weldon Lee has conducted workshops and tours that feature the photography of species in the wild or trained wildlife models. Most programs consist of field work throughout the day with emphasis on close-up opportunities. About 15 to 20 programs are scheduled yearly, mostly 1- and 2-day sessions, and a 2-week East African safari. Enrollment is limited to 12 participants of all levels.

Specialties: Wildlife photography.

Faculty: Weldon Lee has conducted workshops for 7 years. His wildlife images have been published in magazines and he is author of Watchable Birds of the Rockies and the forthcoming Photographing Rocky Mountain Wildlife.

Costs, Accommodations: Costs range from $220 to $4,895, which includes lodging and box lunches in the field. A 50% deposit is required for workshops, with balance due 30 days prior. Refund granted cancellations more than 30 days prior.

Location: Colorado, Nebraska, and East Africa.

Contact: Weldon Lee Wildlife Images, P.O. Box 487, Allenspark, CO 80510; (303) 747-2074 (phone/fax).

CONNECTICUT

BLOCK ISLAND PHOTOGRAPHY WORKSHOPS
New England and other
U.S. locations

Since 1984, professional photographers Steve Sherman and Jack Holowitz have offered 2- to 5-day workshops for serious hobbyists and professionals who want to create top quality black & white prints. The programs, limited to 12 students, emphasize creative expression and cover new techniques of exposure and development. The Block Island Workshops emphasize the Zone System and contrast controls. Daily schedule consists of an early morning field session and afternoon class or a morning class with an afternoon lighting session. Other programs may include a portrait workshop and photo trips to Death Valley and the Arizona canyons. The weekend Silver Printing Workshop, for the serious photographer with a working knowledge of the black & white print process, consists of photography and darkroom instruction on the Zone System, advanced printing techniques, and processing to archival standards.

Specialties: Black & white photography and printing.

Faculty: Jack Holowitz, a professional photographer for more than 25 years and owner of Holowitz Photography in Springfield, has been published in *Popular Photography* and other magazines. Printmaker Steve Sherman is represented in galleries and his work was featured in Agfa's national ad campaign.

Costs, Accommodations: Fee, which includes local transportation, is $475 for the Death Valley Workshop, $245 for the Block Island Workshop, $295 (including meals) for the Silver Printing Workshop. A 50% deposit must accompany application with balance due 30 days prior. Full refund more than 30 days prior; no refunds thereafter unless space can be filled. Sponsor arranges for lodging.

Location: Block Island, located on Rhode Island's eastern coast, offers a varied landscape of cliffs and surf, rolling hills, and a harbor village with many examples of 19th-century architecture. The Silver Print workshop is held at Jack Holowitz's home in Springfield.

Contact: Jack Holowitz, 114 Bellevue Ave., Springfield, MA 01108; (413) 739-3480 or Steve Sherman, 319 Pheasant Dr., Rocky Hill, CT 06067; (203) 563-9156.

CREATIVE ARTS WORKSHOP
New Haven/Year-round except August

Founded in 1960 to provide education in the visual arts, the nonprofit CAW offers 3- and 6-hour workshops and on-going classes. A variety of subjects are taught, including photography, drawing, painting, sculpture, design, book arts, printmaking, pottery, fiber, jewelry, and media arts. One-day workshops, taught by faculty members or visiting artists, are open to students of all levels and include lighting, portraiture, and advanced black & white.

Specialties: Various topics.

Faculty: Professional photographers/teachers who exhibit their work regularly, including Virginia Blaisdel, Terry Dagradi, Karen Klugman, Joan Fitzsimmons, and Harold Shapiro.

Costs: Three-hour workshops typically cost $30. Payment must accompany registration; refund granted cancellations for medical reasons only.

Location: CAW, in New Haven's Arts District, is situated in its own 3-story building devoted exclusively to studio space and a gallery. New Haven, home of Yale University, is near beaches and New York City.

Contact: Harold R. Shapiro, Head, Photography Dept., Creative Arts Workshop, 80 Audubon St., New Haven, CT 06510; (203) 562-4927.

MARK WARNER NATURE PHOTOGRAPHY WORKSHOPS
Connecticut and Rhode Island/
April-October

Since 1979, Mark Warner has taught nature and wildlife photography workshops that stress individual attention and getting the most out of simple equipment. From 4 to 6 day-long workshops are offered annually, with a limit of 12 students each, and most are conducted outdoors, usually focusing on areas of biological or ecological importance.

Specialties: Nature and wildlife.

Faculty: Photographer and writer Mark Warner's credits include *Audubon, Natural History, International Wildlife,* and *Best Places to Photograph North American Wildlife.*

Costs: Range from $20 to $25.

Location: Connecticut state parks, private lands, and other locations.

Contact: Mark Warner, Box 142, Ledyard, CT 06339; (203) 376-6115.

NEW ENGLAND SCHOOL OF PHOTOGRAPHIC ARTS
New Milford/Year-round

Established in 1986, NESPA offers 30 to 40 introductory to advanced courses and workshops yearly, most with a student to teacher ratio of 6 to 1. Weekly courses are held in the evenings, workshops are scheduled on weekends, and summer programs meet daily. Workshop topics include the Zone System, panoramic photography, Polaroid image transfer, digital imaging, infrared, silver printing, lighting, and hand coloring. Field trips and travel workshops are offered from time to time.

Specialties: A variety of beginning to advanced topics.

Faculty: The 6-member staff and 15- to 20-member visiting faculty includes Andrea Braun-Byrne, Tillman Crane, Georgia Sheron, Alison Shaw, and Joseph Meehan.

Costs, Accommodations: Ranges from $25 for a lecture to $200 for a weekend workshop. Local bed & breakfasts range from $50 to $85 per night.

Location: Northwestern Connecticut, 90 minutes from New York City.

Contact: Laura Buckbee, Director, New England School of Photographic Arts, P.O. Box 1509, 22 Bennitt St., New Milford, CT 06776; (203) 355-LENS (phone/fax).

PHOTOLIGHT WORKSHOPS
Connecticut/Year-round

Since 1992, Rick Sereque has conducted 1-day workshops that are limited to 8 participants of all levels. Approximately 20 programs are scheduled yearly on a variety of technical, commercial, and fine art subjects.

Faculty: Rick Sereque and guest instructors, all of whom have had work published.

Costs, Accommodations: Range from $49 to $149. Lodging is available at local inns, hotels, and bed & breakfasts.

Location: Scenic locales in Connecticut.

Contact: Rick Sereque, Director, Photolight Workshops, 28 Silva Terr., Oxford, CT 06478-1816; (203) 888-1259, Fax (203) 881-2700.

VISCOMM
San Francisco and New York City/
June and November

First held in 1990, this weekend event is scheduled twice yearly for the advanced/professional. The program consists of 2-hour to 3-day seminars that cover such topics as lighting, digital imaging, stock advertising, self-promotion, and documentary, fashion, portrait, and travel photography.

Specialties: A variety of commercial photography topics.

Faculty: Approximately 50 instructors.

Costs: About $55 per 2-hour seminar; pro shoots are $70.

Location: Moscone Center in San Francisco and Jacob Javits Center in New York City.

Contact: Andrea Cassello, Director of Conference Program, Viscomm, c/o CMC, 200 Connecticut Ave., Norwalk, CT 06856-4990; (800) 243-3238, Fax (203) 831-8446.

BIKE WEEK WORKSHOP
Daytona Beach/March

Since 1978, Daytona Beach Community College has offered 5-day photography workshops during the annual gathering of Harley-Davidson riders known internationally as Bike Week. The programs, which are geared to photography students, professionals, and advanced amateurs, feature instruction in shooting techniques, critiques, and class discussions. Workshop topics include color, black & white, and portraiture.

Specialties: Harley-Davidson bikers.

Faculty: Has included Magnum photographer Constantine Manos, portrait photographer Philippe Vermés, Mary Ellen Mark, Eddie Adams, Burk Uzzle, and Bruce Davidson.

Costs, Accommodations: Tuition is $300. Registrants select 1 workshop. A list of local lodging is provided.

Location: Daytona Beach, on Florida's east coast.

Contact: Southeast Museum of Photography/Bike Week Workshop, P.O. Box 2811, Daytona Beach, FL 32120-2811; (904) 254-4475, Fax (904) 254-4487.

BILL THOMAS TOUCH OF SUCCESS SEMINARS
U.S. and worldwide/Year-round

Since 1978, photojournalist Bill Thomas has taught students the professional skills necessary to publish their work. Weekend seminars include 2 half-days of lecture on composition, lighting, equipment, film, marketing, and business management and 2 half-days of shooting in the field. The longer workshops and safaris, limited to 15 students, offer photographic training and sessions on building rapport with wildlife. Some film is developed for group critique.

Specialties: Nature and wildlife photojournalism.

Faculty: A professional photojournalist for 30 years, Bill Thomas' credits include national and regional publications and he is author of more than 20 books, including How to Make $50,000 a Year as a Nature Photojournalist. He received the Geographic Society Award in 1976.

Costs, Accommodations: Weekend workshops are $195 to $375, including lodging and box lunches; 1-week workshops begin at $895, including transportation, meals, and lodging; adventure safaris range to $4,995, including airfare, meals, and lodging. Deposit ($50 for weekend, $150 for 1-week, $750 for safaris) must accompany registration with balance due 30 days (60 days for safaris) prior. Cancellations more than 30 (60) days prior forfeit $50 ($75 for safaris); no refunds thereafter.

Location: Weekend workshops: Smoky Mountains, Florida Eagle Country, and Cataract Valley in Indiana; 1-week workshops: Arizona, Utah, Everglades, Suwanee River, Okefenokee Swamp, San Juan Islands and Olympic Rainforest, Maine Seminar of the Sea, Nova Scotia; adventure safaris: southeast Alaska, East Africa, Amazon, Galápagos.

Contact: Bill Thomas, P.O. Box 194, Lowell, FL 32663; (904) 867-0463.

BIRDS AS ART INSTRUCTIONAL PHOTO-TOURS & SEMINARS
Locations in the U.S. and Canada/
Year-round

Since 1992, Arthur Morris has offered approximately 20 programs a year that emphasize the improvement of bird and nature photography skills. The day-long seminars and 2- to 7-day tours, limited to 8 participants, cover artistic design, technical aspects, pro tips, and the ethical approach to wildlife. Typically, participants are up before dawn and shoot until late morning and again from mid-afternoon until sundown; slide presentations and classroom work are scheduled in the afternoons or evenings.

Specialties: Bird and nature photography.

Faculty: Arthur Morris is author of *Bird Photography Basics*, and his credits include *National Geographic, Natural History, Nature Photographer, Birder's World, Bird Watcher's Digest,* and *Wildbird.*

Costs, Accommodations: Seminar cost is approximately $55; photo tours range from $80 a day, including lunch, to $125 to $200 a day, which includes meals, lodging, and transportation. Accommodations are usually first class motels or bed & breakfasts.

Location: Includes Fort Myers, Florida; Cape May, New Jersey; Albuquerque, New Mexico; Churchill, Manitoba; and Pt. Pelee National Park, Ontario.

Contact: Arthur Morris, Birds as Art Instructional Photo-Tours & Seminars, 1455 Whitewood Dr., Deltona, FL 32725; (407) 574-3350, Fax (407) 574-5584.

BOB GRYTTEN, INC.
Florida, North Carolina, Montana/
November-April

Established in 1988, freelance photographer Bob Grytten offers eight 1- to 5-day nature workshops that include field shoots, classroom instruction, and individual critique. Emphasis is on recognizing subjects in nature as light presents them, and instruction covers composition, ethics of wildlife photography, exposure, focusing, cameras, lenses, filters, films, blinds and other accessories, and marketing. Maximum class size is 12 intermediate-level participants.

Specialties: Nature.

Faculty: Bob Grytten's credits include *Sailing, Southern Boating,* and *Florida Naturalist.*

Costs, Accommodations: Tuition is $75 per day. Rustic lodging is about $50 per day. A $50 refundable deposit is required. Credit cards accepted.

Location: Florida, North Carolina, Montana.

Contact: Bob Grytten, Inc., P.O. Box 8792, St. Petersburg, FL 33738; (813) 397-3013, Fax (813) 398-2945.

CREALDE SCHOOL OF VISUAL ART
Winter Park and other Florida locations/
Year-round

Founded in 1975, this nonprofit art organization offers courses and workshops in photography, sculpture, ceramics, painting, drawing, and related arts. One-and-a-half-day courses for beginners are scheduled each quinmester and young people's and parent/child 1-day

workshops are also offered. Lecture and slide workshops are limited to 15 students, dark-room workshops and photographic field trips are limited to 10.

Specialties: A variety of topics.

Faculty: Photography Department Head Peter Schreyer, a freelance photographer specializing in landscape and documentary photos, has exhibited internationally. Other faculty includes Linda Carpenter, Anna Tomczak, and Rick Lang.

Costs, Accommodations: Workshop tuition, which is due 3 days prior, ranges from $60 to $125 including materials. Cancellations at least 3 days prior receive full refund less $15. Membership in Crealde School of Visual Art begins at $25 for an individual, $50 for a family.

Location: Winter Park, just north of Orlando. Facilities include a class darkroom with black & white enlarging stations, black & white and color darkrooms, a film processing and print finishing area, and a library.

Contact: Crealde School of Visual Art, 600 St. Andrews Blvd., Winter Park, FL 32792; (407) 671-1886.

EVERGLADES PHOTO SAFARI
Everglades National Park/October-April

Since 1989, commercial photographer Vic Ramos has conducted photo tours through the tidal flats, bays, rivers, and islands of the Everglades. Each tour is limited to 4 photographers, who are transported on an 18-foot boat that has been custom built for photographing and observing birds and other wildlife.

Specialties: Nature and wildlife.

Faculty: Vic Ramos is a graduate of the Art Institute of Ft. Lauderdale, has been a professional photographer for more than 10 years, and has lived in South Florida for more than 30 years.

Location: South Florida, from Flamingo to Chocoluskee.

Contact: Vic Ramos, Everglades Photo Safari, 8390 S.W. 132nd St., Miami, FL 33156; (305) 255-3111.

FLORIDA GULF COAST PHOTOGRAPHIC CONFERENCE
Sarasota/March

This annual weekend seminar, first offered in 1995, features small group discussions, presentations, and field trips in a tropical locale.

Faculty: More than a dozen photographic artists, imaging experts, and journalists, including Michelle and Tom Grimm, Dale Sanders, Clyde Butcher, Carol Perry, and Luke Melton.

Costs: Two-day passes are $115.

Location: Marie Selby Botanical Gardens in Sarasota, Florida.

Contact: John Hynal, Norton Camera & Video, 2069 Siesta Dr., Sarasota, FL 34239; (813) 366-1478.

GLAMOUR PHOTO SHOOT
Florida and Nevada/Year-round

Since 1980, glamour and celebrity photographer Wayne F. Collins has conducted 2-day weekend glamour and figure photography workshops for beginner to advanced amateurs.

Each of the 4 workshops offered during the year is limited to 15 participants, who have the opportunity to photograph several professional models in a variety of settings. Instruction covers outdoor and indoor lighting, posing techniques, and using props.

Specialties: Glamour photography.

Faculty: Glamour and celebrity photographer Wayne F. Collins has photographed such personalities as Miss U.S.A., Bob Hope, and the Rolling Stones and has produced work for Made in the USA and Playboy.

Costs: Workshop fee is $300 to $325. Full payment must accompany registration; no refunds, however, course credit is granted.

Location, Facilities: The Tampa Bay area on Florida's Gulf Coast and locations in Las Vegas.

Contact: WFC Enterprises, Box 5054, Largo, FL 34649; (813) 581-5906 (phone/fax).

HORSE PHOTOGRAPHY SEMINAR
Citra/April

Since 1980, Harold Campton has offered annual 3-day seminars limited to 25 intermediate-level photographers who wish to pursue a part- or full-time career photographing show horses. Instruction covers techniques for photographing show horses at halter and in performance, correct lighting for indoor and on-location shots, use of professional camera equipment, how to book shows and farm jobs, and how much to charge.

Specialties: Horse photography.

Faculty: Harold Campton, photographer.

Costs: Tuition is $375.

Location: Central Florida, approximately 12 miles north of Ocala.

Contact: Harold Campton Photography, 13939 N. Hwy. 441, Citra, FL 32113; (904) 629-6359.

MACRO/NATURE PHOTOGRAPHY
Englewood/Year-round

Since 1989, Bob Sisson has conducted one-on-one nature photography workshops that emphasize close-up and macro work. The program is customized to the needs of the student and topics may include: the philosophy and ethics of nature photography, exposure, lighting, visualization, photojournalism, macro photography, aquarium photography, basic photomicrography, or special projects.

Specialties: Nature and macro photography.

Faculty: A former staff photographer/writer for *National Geographic Magazine,* Bob Sisson contributed photographs for 87 published stories and was the first staff photographer to be sponsored by National Geographic in a one-man show. He was awarded the Canadian Natural Science Award and his work has been exhibited by the Brooks Institute of Photography, Nikon House, and the Metropolitan Museum of Art in New York City.

Costs, Accommodations: Tuition is $175 per day or $800 for a 5-day session. Motels are located within a 15-minute drive. A nonrefundable $25 deposit must accompany application.

Location: Englewood is situated on Florida's Gulf Coast, between Fort Myers and Sarasota.

Contact: Bob Sisson, Macro/Nature Photography, P.O. Box 1649, Englewood, FL 34295; (813) 475-0757, Fax (813) 474-5001.

NATURAL HISTORY PHOTO TOURS
Belize, Costa Rica, Ecuador & the Galápagos/Year-round

Since 1974, Holbrook Travel has offered natural history vacations to locations in Mexico, South America, and South Africa. Approximately four 1- to 2-week photo tours are scheduled annually, each limited to 15 participants. Daytime activities include touring and field work; workshops are held in the evenings

Specialties: Nature and wildlife.

Faculty: Includes Whit Bronaugh, whose credits include National Geographic, Audubon, and Natural History, and nature photographer Tom Ulrich.

Costs, Accommodations: Land cost ranges from $120 to $175 per day, depending upon location, and includes meals, hotel lodging, and ground transportation. Single supplement available.

Contact: Sandy Schmidt, Group Sales, Holbrook Travel, Inc., 3540 N.W. 13th St., Gainesville, FL 32609; (800) 451-7111, Fax (904) 371-3710.

NATURE IMAGES, INC.
Various U.S. locations/ January, May, July, September

Since 1987, writer-photographer Helen Longest-Slaughter has conducted nature and wildlife photography workshops that emphasize natural light photography and ethical behavior in the wild. Four workshops are scheduled yearly, each limited to 6 to 8 beginner/intermediate photographers. Students receive instruction in the field from sunrise to sunset, attend lectures and programs, and have their work critiqued.

Specialties: Nature and wildlife photography.

Faculty: Helen Longest-Slaughter, a photographer for 33 years and professional for 10, is photo editor of *Nature Photographer* magazine, and teaches photography seminars for Loxahatchee National Wildlife Refuge and the Nature Conservancy. Her work has been published in magazines, textbooks, encyclopedias, and by educational and poster/card companies.

Costs, Accommodations: Costs range from $295 for the 4-day Everglades trip to $2,200 for the Costa Rica tour, which includes meals and lodging. A 15% deposit must accompany registration with balance due 75 days prior. No refunds within 120 days unless space can be filled.

Location: Yellowstone National Park, Everglades National Park, Little St. Simons Island, and Costa Rica.

Contact: Helen Longest-Slaughter, Nature Images, Inc., P.O. Box 2037, West Palm Beach, FL 33402; (407) 586-7332, Fax (407) 586-9521.

PALM BEACH PHOTOGRAPHIC WORKSHOPS
Boca Raton and locations worldwide Year-round

Established in 1986, this nonprofit educational program offers more than a hundred 1-day to 1-week workshops yearly for photographers of all levels, with each workshop geared specifically for beginners, advanced amateurs, or professionals. Each workshop is limited to

15 students and instruction consists of lectures, field work, studio and/or darkroom activity. College credit is available. The range of topics includes equipment and technique, fine arts, commercial subjects, photojournalism, digital imaging, and nature photography. One-day seminars that cover a variety of subjects are scheduled throughout the year and an evening lecture series is held each week. One- to 2-week travel workshops are also available.

Specialties: A variety of topics.

Faculty: The resident faculty members are Directors Fatima and Art NeJame, Dr. Tom McCartney, and Gene Arant. Visiting faculty includes travel and stock photography expert George Schaub; *Time* magazine picture editor Arnold Drapkin; portrait photographer Arnold Newman; Ernst Wildi, author of *The Hasselblad Manual*; Irene Sacilotto; Bobbi Lane; and John Shaw.

Costs, Accommodations: Tuition ranges from $35 to $1,495. A $25 application fee (covers any number of workshops in a year) plus 50% tuition deposit must accompany application with balance due 30 days prior. Cancellations more than 30 days prior receive a full refund, less $50 and application fee. One-day seminars range from $35 to $150.

Location: Boca Raton, on Florida's Southeast coast. Travel workshops visit Russia, Costa Rica, Canadian Rockies, Africa, Israel, Galápagos, and German wine country.

Contact: Palm Beach Photographic Workshops, 2310 E. Silver Palm Rd., Boca Raton, FL 33432; (407) 391-7557.

PETER SCHREYER PHOTOGRAPHIC TOURS
U.S. and Europe

Since 1986, Peter Schreyer has conducted 2-day to 2-week photography tours that are usually limited to 15 photographers of all levels and may include scenic train rides, accommodations at historic inns, mountain or desert hikes, gallery and museum visits, and critique sessions.

Specialties: Nature, documentary, and landscape photography.

Faculty: Peter Schreyer, head of the Photography Department of the Crealde School of Visual Art, is a freelance photographer specializing in landscape and documentary. He has exhibited internationally and is a repeat grant recipient.

Contact: Peter Schreyer Photographic Tours, P.O. Box 533, Winter Park, FL 32790; (407) 671-1886.

VERO BEACH PHOTOGRAPHY WORKSHOPS
Vero Beach/Year-round

Established in 1994 and offered 17 times throughout the year, these 1- to 4-day workshops cover such topics as camera capabilities, photojournalism, landscape, nude and fashion, fine art, portrait, sports, and travel photography. Each workshop is limited to 12 participants and typically consists of a morning field trip followed by slide critiques and classroom lectures on composition, lighting, and creativity.

Specialties: A variety of topics.

Faculty: Professional photographer Dan Burns, photojournalist Bob Ruff, fine art photographer Chuck Harris, *Nature Photographer* editor Helen Longest-Slaughter, and *Shutterbug* editor Bob Shell.

Costs, Accommodations: Cost ranges from $65 to $250, excluding lab fees. A $25

deposit is required; refund granted cancellations more than 30 days prior.

Location: An oceanside site in Vero Beach.

Contact: Denis McCarthy, Director, Center for Photography of the Americas, Inc., 3206 Cardinal Dr., Vero Beach, FL 32963; (407) 231-8848, Fax (407) 231-8840.

VERONICA CASS ACADEMY OF PHOTOGRAPHIC ARTS
Hudson/January-October

This school, incorporated in 1975, offers a series of 8 week-long courses in print and negative retouching, enhancing, and restoring, for students pursuing a career in the photographic arts. All students enter at the same level regardless of prior experience and candidates should possess some concept of artistic principles and understand the relationship between retouching and the photographic industry. Each 35-hour course combines hands-on experience with class instruction and the use of the Video Retouching System. Course titles are: Color Negative Retouching, Print Retouching and Enhancement, Black & White Restoration, Photographic Airbrush, Color Restoration, Transparency Retouching, Photo Oil Painting, and The Finishing Touch.

Specialties: Photographic retouching arts.

Faculty: Veronica Cass, a member of the Professional Photographers of America, Inc., received the Photographic Craftsman Degree in 1974.

Costs, Accommodations: Each workshop is $395. Application must include Student Enrollment Agreement and $100 deposit, refundable within 3 business days. Balance is due at registration; cancellations 10 working days prior receive $80. The school provides assistance in locating lodging; on-premises apartments are available.

Location: Hudson, a small town on U.S. Highway 19 along Florida's Gulf Coast, is 45 miles northwest of Tampa and 90 miles west of Orlando.

Contact: Veronica Cass Academy of Photographic Arts, 7506 New Jersey Ave., P.O. Box 5519, Hudson, FL 34674; (800) 472-9336 or (813) 862-5327, Fax (813) 862-3567.

GEORGIA

DENIS REGGIE WORKSHOPS
Atlanta/Year-round

Denis Reggie conducts monthly 3-day wedding photography workshops for beginning to experienced photographers. Instruction covers lighting and photojournalistic shooting techniques in 35mm and medium formats; business topics of pricing, selling, marketing, computers; and operating procedures.

Specialties: Wedding photography.

Faculty: Wedding photographer Denis Reggie is recommended by *Town and Country* and *Harper's Bazaar*. His client list includes singers James Taylor and Mariah Carey, and actors James Garner and Arnold Schwarzenegger.

Costs, Accommodations: Tuition is $595 ($495 for a second person). A $195 deposit is required; $75 is nonrefundable; balance is due at workshop. Credit cards accepted. A variety of hotel options are available.

Location: Atlanta's Occidental Grand Building.

Contact: Denis Reggie Workshops, 75 Fourteenth St., Atlanta, GA 30309; (404) 873-8080 or (800) 379-1999, Fax (404) 873-8088.

GEORGIA SCHOOL OF PROFESSIONAL PHOTOGRAPHY
Clarkesville/Spring

This nonprofit school, operated by the Georgia PPA, sponsors an annual 5-day workshop for photographers of all levels. Approximately 8 classes are offered during the week, covering such topics as weddings and portraits, negative retouching, background painting, digital imaging/photoshop, studio management, and marketing and sales.

Specialties: A variety of topics.

Faulty: Has included Stephen Rudd, Lamarr Williamson, Terry Harris, Eddie Tapp, David Newman, Jane Ziser, and Robert Stevenson.

Costs, Accommodations: Tuition, which includes lunch, is $395 and a $150 deposit is required. Full refund, less $50, granted cancellations in writing more than 90 days prior; thereafter cancellation fee varies from $100 to $150. Special hotel rates are usually available to registrants.

Location: The campus of North Georgia Tech.

Contact: Georgia School, c/o Enoch Hicks, Director, Georgia School of Professional Photography, 1720 Williams Cir., Cumming, GA 30131; (800) 805-5510, (404) 844-7329, Fax (404) 887-2329.

WINONA
Atlanta/Year-round

This wholly owned not-for-profit subsidiary of Professional Photographers of America, Inc., founded in 1922, offers more than 120 intensive 2- to 5-day studio and electronic imaging courses each year for practicing professionals or those pursuing a photographic career. Popular courses are offered several times during the year and the school schedule is structured so that individuals may enroll in a series of sequential courses over a 2- to 3-week period. Sessions meet for 8 hours each day and number of participants varies. Typical courses include Portrait I & II, Glamour/Boudoir, Color Matching Systems, View Camera Techniques, Imaging in Government, Studio Operations for the 90's, Advanced Multimedia, Digital Photographic Retouching, Adobe Photoshop 3.0, Internet and the Other On-line Services, and Desktop Design.

Specialties: Studio and electronic imaging topics for the professional and aspiring professional.

Faculty: The more than 130 faculty members include established professionals who hold the degree of Master of Photography, Photographic Craftsman, Photographic Specialist, or Fellow-American Society of Photographers.

Costs, Accommodations: Tuition for studio (electronic imaging) courses ranges from $240 to $439 ($390 to $1,083) for PP of A members, $440 to $661 ($650 to $1,472) for non-members. A $30 lab fee is charged for each course.

Contact: Erin Metcalf, Administrator, Winona, 57 Forsyth St. N.W., Ste. 1500, Atlanta, GA 30303; (800) 742-7468 out of state or (404) 522-3030.

IDAHO

NATURAL PHOTOGRAPHY
Yellowstone and the Tetons/
June-September

Established in 1990, Natural Photography offers 1-week photography programs that emphasize hands-on field work with a variety of photo opportunities. Enrollment is limited to 5 students.

Specialties: Nature photography.

Faculty: Douglas Bobb has 15 years experience as an outdoor photographer, has taught at the College of Southern Idaho, and has won awards from the Professional Photographers of Idaho and the Idaho Governors Convention on Travel & Tourism.

Costs, Accommodations: The $1,200 cost includes meals, lodging, and local transportation. A $300 deposit is required, with balance due 30 days prior; no refunds thereafter. Accommodations are double-occupancy cabins set on 14 acres at the foot of Yellowstone and the Tetons.

Location: Yellowstone ecosystem, including the Tetons.

Contact: Douglas and Jill Bobb, Natural Photography, 418 Knottingham Dr., Twin Falls, ID 83301; (800) 574-2839, Fax (208) 733-2839.

SUN VALLEY CENTER FOR THE ARTS AND HUMANITIES
Sun Valley/May-August

Established in 1972, this nonprofit institution sponsors a variety of programs for all ages and levels, including 1 or 2 river expeditions that feature photography or painting instruction.

Contact: Sun Valley Center for the Arts and Humanities, P.O. Box 656, Sun Valley, ID 83353; (208) 726-9491.

ILLINOIS

ABERCROMBIE & KENT INTERNATIONAL, INC.
Africa and Antarctica/Year-round

Established in 1962, this tour company offers two to four 1- to 3-week trips yearly that are accompanied by a professional photographer. Each trip is limited to 10 to 18 participants of all levels and features hands-on field instruction and daily lectures.

Specialties: Wildlife, landscape.

Faculty: Includes George Lepp and David Keith Jones.

Costs, Accommodations: Land costs range from $3,000 to $12,000, which includes meals and lodging. A $500 deposit is required.

Location: Focus on Antarctica, an 18-day cruise of the Falklands and South Georgia Islands; Focus on Safari, a 15-day photo safari in Kenya.

Contact: Special Interest Group Dept., Abercrombie & Kent, 1520 Kensington Rd., Oak Brook, IL 60521; (800) 323-7308 or (708) 954-2944, Fax (708) 954-3324.

AMBIENT LIGHT WORKSHOPS
**U.S . locations/January-June,
September-October**

Established in 1990 by John J. Mariana and Joe Falout as the Latent Image Workshops, these 1-day and 1-week field programs provide instruction in metering, composition, black & white and color film, and the Zone System. Fifteen to 20 workshops are scheduled yearly, each limited to 15 participants.

Specialties: Composition, exposures, lenses, films, and filters.

Faculty: John J. Mariana has won awards for his black & white and color prints and exhibits in 4 galleries. Joe Falout uses the Zone System and works with black & white prints, color slides, and Cibachrome printing. Other instructors include Don Moritz, Gordon Bowie, and Ron Anthony, who each have over 25 years of experience.

Costs: Costs range from $950 to $1,500 for 1-week programs and include lodging and ground transportation. One-day workshops range from $45 to $85. A 30% deposit is required, with balance due 45 days prior.

Location: The Southwest, Rockies, West Coast, and New England.

Contact: John J. Mariana, 5 Tartan Ridge Rd., Burr Ridge, IL 60521; (708) 325-5464.

ART KETCHUM PHOTO WORKSHOPS
**Various locations in the U.S./
April and September**

Since 1994, Art Ketchum has conducted 12 to 15 programs a year for advanced photographers interested in lighting and posing techniques using live models. Two-day workshops, each limited to 20, cover such topics as fill-flash, boudoir, rim, high key, portrait, and Rembrandt lighting, as well as new posing ideas. Professional backgrounds and props are available and participants shoot both in-studio and on-location. A makeup artist is also available to provide instruction and assistance. Five-hour seminars concentrate on posing and lighting and include information on building business and the use of 4-color printing to attract clients. An optional workshop, offered the following afternoon and available only to seminar registrants, provides hands-on experience and an opportunity to build a portfolio.

Specialties: Lighting and posing techniques for commercial photography.

Faculty: Art Ketchum is author of *Profitable Model Photography* and has written for *Shutterbug, Studio Photography, Rangefinder,* and *Professional Photographer.* Makeup artist Shannon Smith teaches glamour, boudoir, and high fashion makeup.

Costs, Accommodations: Tuition is $259 for 2-day program; $59 early registration for seminar, and $95 for hands-on workshop.

Location: Workshops are held in Taos, NM. and Woodstock, VT. Seminar sites include Newark, Hartford, Philadelphia, and Washington, DC,

Contact: Art Ketchum Studios, 2818 W. Barry Ave., Chicago, IL 60618; (312) 478-9217 (phone/fax).

IMAGE·A·NATION, UNLTD.
**Locations in the Midwest and West/
Year-round**

Established in 1988 and scheduled 4 to 6 times a year, these 3- to 7-day workshops are limit-

ed to 10 intermediate students who are interested in shooting landscapes and nudes in landscapes. A typical day includes a 2-hour lecture and critique and 4 hours of work on location.

Specialties: Human figure in the landscape.

Faculty: Lucien Clergue, John Mariana, and Don Moritz.

Costs: Ranges from $75 to $150 per day, which includes model fees. A deposit is required and refund offered 30 days prior.

Location: Locations from the Midwest to the West.

Contact: Don Moritz, Image·a·Nation, Unltd., P.O. Box 305, Clarendon Hills, IL 60514; (708) 789-0087 (phone/fax).

LAKE FOREST COLLEGE HOLOGRAPHY WORKSHOPS
Lake Forest/July

Since 1971, Lake Forest College has sponsored an annual 2-part series of holography workshops, including an introductory-level hands-on course for beginners and an advanced lecture course for the experienced student. Both workshops run from Monday through Friday. The introductory course covers the various forms of holograms and the basic principles, techniques, and equipment for their production. The advanced course covers color control, computer-generated stereograms, embossing, fiber optics, hot stamping, marketing, materials and processing, and also includes visits to Chicago-area holography labs.

Specialties: Holography.

Faculty: Dr. Tung Hon Jeong, Professor of Physics; and research associate Ed Wesly.

Location, Facilities: The campus is 30 miles north of Chicago, within walking distance of Lake Michigan. Bus service is available to O'Hare Airport.

Contact: Holography Workshops, Lake Forest College, 555 N. Sheridan Rd., Lake Forest, IL 60045-2399; (708) 234-3100.

INDIANA

CHARLENE FARIS WRITING/ PHOTOGRAPHY SEMINAR FOR BEGINNERS
Large U.S. cities/Year-round

Writer-photographer Charlene Faris teaches 2-day seminars for 4 to 25 beginning writers and photographers. Instruction covers the query letter, syndication, recycling, idea development, working with editors and art directors, and specialty markets. Each student receives a market analysis and is taught how to get articles and photos published. Instruction is provided on cruises.

Specialties: Travel writing and photography, marketing.

Faculty: Charlene Faris' credits include *The Christian Science Monitor, Saturday Evening Post, Grit,* and *Los Angeles Times Syndicate.*

Costs: The fee is $140. A $75 deposit is required with balance due 10 days prior. Because half the program is devoted to writing and half to photography, students interested in only one segment can pay half the fee for one day.

Location: Includes Los Angeles, Chicago, Detroit, Dallas, Phoenix, Indianapolis, and Madison.

Contact: Charlene Faris, 9524 Guilford Drive, Apt. A, Indianapolis, IN 46240; (317) 848-2634.

KANSAS

V.J.'S EXOTIC SAFARIS
Locations worldwide/Year-round

Established in 1979, professional photographer V.J. Sherring offers fifteen 12- to 40-day photo tours per year for beginning and intermediate photographers. Maximum number of participants ranges from 8 to 15, with a student to instructor ratio of 7 to 1. Instruction covers composition, creativity, film, filters, macro, and basic techniques for photographing wildlife, people, festivals, and night scenes. Photo excursions are scheduled early mornings and late evenings.

Specialties: Travel, including wildlife, people, and festivals.

Faculty: V.J. Sherring has 15 years of commercial, wedding, and wildlife photography experience.

Costs, Accommodations: Cost ranges from $2,500 to $9,500, depending on destination, and includes deluxe or first class hotel lodging. A $500 deposit is required. Customized group tours are available.

Location: Asia, Africa, Spain, Galápagos, Chile, Argentina, Amazon.

Contact: V.J. Sherring, V.J.'s Exotic Safaris, 320 Stevens St., #4, Winfield, KS 67156; (800) 392-9678 or (316) 221-4085, Fax (316) 221-4085.

KENTUCKY

MOUNTAIN PEOPLES WORKSHOP
Western Kentucky University
Kentucky/October

Offered since 1977, this annual 4-day workshop is designed to enhance the participants' skills in the professional areas of photojournalism. The program, which concentrates on the picture story as a medium, brings together a group of students and outside professionals in a small Kentucky town where portable darkroom and facilities are set up. The participants, most of whom are already working at a newspaper, are given story leads and spend their entire time on this project. Each instructor works with approximately five students and both general and individual critique methods are employed.

Specialties: Photojournalism.

Faculty: Core faculty are Dave Labelle, C. Thomas Hardin, Jack Corn, and workshop director Mike Morse. Visiting faculty, which varies each year, has included Bill Luster, Don Rutledge, Michael Heyman, Stormi Greener, Dan Dry, Richard Dirk, Richard Ferro, Jay Dickman, and Larry Nighswander.

Costs: The $325 tuition fee must accompany registration.

Location: A different small south-central Kentucky town each year.

Contact: Mike Morse, Major Chairman for Photojournalism, Western Kentucky University, Bowling Green, KY 42101; (502) 745-6292, Fax (502) 745-6207

LOUISIANA

CACTUS CLYDE PRODUCTIONS
Louisiana and Arizona/
April, May, August, October

Since 1975, wildlife photographer, writer, and naturalist C.C. Lockwood has conducted workshops that are devoted to wildlife and other natural history subjects. Groups are limited to 15 beginning and intermediate photographers. A 1-day workshop, scheduled once during spring and fall, features an evening lecture, a canoe trip into the Atchafalaya Basin, and a follow-up critique session. An 8-day workshop in the Grand Canyon includes rafting and hiking.

Specialties: Wildlife and nature.

Faculty: C.C. Lockwood has published 4 books including *Atchafalaya, America's Largest River Basin Swamp, Discovering Louisiana,* and *The Yucatan Peninsula.* His work has appeared in more than 100 books and magazines, including *Natural History,* and he received the Ansel Adams Award for conservation photography in 1978.

Contact: C.C. Lockwood, Cactus Clyde Productions, P.O. Box 14876, Baton Rouge, LA 70898; (504) 387-3704.

MAINE

ISLAND PHOTOGRAPHIC WORKSHOPS
Maine and Puerto Rico

Since 1983, professional photographer Joan Brown has directed workshops that emphasize learning new techniques and refining personal style while exploring the more than 3,000 islands off the coast of Maine in late summer and fall and the Island of Vieques (Puerto Rico) during the winter. Workshops are limited to 10 participants of all levels and consist of daily island and coastal trips and evening presentations.

Specialties: Outdoor island photography.

Faculty: Includes workshop leader Joan Brown who is experienced in network television, national publishing, and commercial and fine art photography.

Contact: Island Photographic Workshops, 109 Bayview St., Camden, ME 04843; (207) 236-9087

THE MAINE PHOTOGRAPHIC WORKSHOPS
Rockport and overseas locations/
February-December

Established in 1973 by magazine photographer and writer David H. Lyman, this private educational institution is devoted to the serious study of photography as an art, career, and personal pursuit. More than one hundred 1- and 2-week intensive workshops are held annually in Rockport, each limited to 10 to 15 participants. The daily schedule includes lectures, critiques, demonstrations, and field and studio assignments. Evenings are reserved for slide shows and lab work. From June to October, six 1- to 2-week programs are offered for intermediate to advanced students in Mexico, France, Italy, Bali, and Alaska. Two-week Young Photographers Workshops are offered in the summer for youngsters, ages 13 to 19, who have some experience.

The Workshops also offers a 2-year Associate Degree program (page 159) and the

International Film & TV Workshops, more than 100 workshops and courses in film, television, and video production and master workshops for professional writers.

Specialties: A variety of subjects for serious photographers of all levels.

Faculty: The more than 100 faculty members include Mary Ellen Mark, George Tice, Arnold Newman, Eugene Richards, and Joyce Tenneson.

Costs, Accommodations: Two-week tuition ranges from $400 to $800. Room and board ranges from $350 to $680 per week. A $300 deposit (plus portfolio, if required) must accompany application with balance due 2 weeks prior to workshop. Costs for 2-week overseas sessions are $2,400-$2,500, including room and board. A $300 deposit is required.

Location, Facilities: The seacoast village of Rockport, 65 miles from Portland. Facilities include library, theater, media center, research center, darkrooms, color labs, offices, studios, and classrooms. Other locations are Oaxaca, Mexico; Arles, France; Tuscany, Italy; Bali; and Alaska.

Contact: David Lyman, The Maine Photographic Workshops, 2 Central St., Rockport, ME 04856; (207) 236-8581, Fax (207) 236-2558.

RAFIKI SAFARIS
East Africa/
January-March, June-October

Established in 1982 by professional photographers Chris and Jim McLarty, who have lived and worked in East Africa, these three-week photo safaris are planned to maximize shooting opportunities. The pace is leisurely and groups are limited to 12 participants: photographers of all levels and their non-photographing companions. Photographic instruction is given on both an individual basis and during informal classes and discussions also cover the wildlife, ecology, history, and culture of the areas visited.

Specialty: East African landscape and wildlife.

Faculty: Chris and Jim McLarty have taught through the Maine and Island Photographic Workshops and have been published in *The New York Times, Insights, Down East Magazine, Harrowsmith,* and Time-Life Books. They spent nine months traveling in Africa in 1984 while photographing the National Outdoor Leadership School's Kenya program.

Location: The trip features visits to Kenya's less-frequented parks and game reserves, several stops at private game sanctuaries, and stays at the Soysambu/Lake Elmenteita Wildlife Sanctuary and in the Maasai Mara Game Reserve.

Contact: Chris and Jim McLarty, Rafiki Safaris, 45 Rawson Ave., Camden, ME 04843; (207) 236-4244, Fax (207) 236-6253.

WOODEN BOAT SCHOOL
Brooklin/September

Each summer, WoodenBoat School schedules more than 40 boatbuilding, woodworking, and related craft courses, including marine photography. Limited to 10 students, this 1-week session emphasizes obtaining good boat pictures both on the water and in the shop. Overnight film processing is provided. The school also offers a 4-month program of Sunday evening to Friday afternoon courses in seamanship, boatbuilding, woodworking, and related crafts.

Specialties: Boatbuilding and related crafts, including marine photography.

1-foo

22T 15 41

store

3 d w

Faculty: The more than 30-member faculty of experienced, working, boatbuilding professionals, headed by

Rich Hilsinger, includes well-known wooden boat photographer Benjamin Mendlowitz.

Costs, Accommodations: Tuition is approximately $450 per week plus film and developing costs. Room and board is $295 per week and campsites are $65; campers can have board for $100. A 50% deposit must accompany application, with balance due on first day of class. Refund of deposit, less $100 fee, is granted cancellations more than 30 days prior. Accommodations are double rooms with shared bath.

Location: Approximately 250 miles from Boston by car and 150 miles by boat. Airline service is available to Bangor and arrangements for pick-up can be made with the school.

Contact: WoodenBoat School, P.O. Box 78, Naskeag Rd., Brooklin, ME 04616-0078; (207) 359-4651, Fax (207) 359-8920.

MARYLAND

THE HAND COLORING WORKSHOP
Bethesda/May-July

Offered since 1991, these 2-day summer workshops are limited to 5 students per instructor and teach the basic and advanced techniques of hand coloring of photographs.

Specialties: Hand coloring of photographs.

Costs, Accommodations: Tuition is $250 for the 2-day workshop.

Location: Bethesda is 12 miles from the Washington, D.C. metro area.

Contact: M. Paul Alexander, The Hand Coloring Workshop, 9112 Kittery Ln., Bethesda, MD 20817; (301) 469-6383 (phone/fax).

LATENT IMAGE WORKSHOP
Washington, DC.

Established in 1974 by professional and fine art photographer Lowell Anson Kenyon, LIW offers a 10-month program, career counseling, and classes for serious students. Alternative classes are formed when 6 or more students express an interest in a specific topic. The format may be hands-on, lecture/slide presentation, demonstration, gallery talk, and/or field session.

Specialties: Fine art photography, advanced darkroom techniques, exhibition planning and execution.

Faculty: A teacher, writer, and freelancer since 1955, Lowell Anson Kenyon was a staff photographer with the Smithsonian Institution and Chief of the Office of Photography at the National Museum of American Art and National Portrait Gallery.

Contact: The Latent Image Workshop, 5613 Johnson Ave., West Bethesda, MD, 20817-3503; (301) 897-0083.

OSPREY PHOTO WORKSHOPS AND TOURS
U.S. and abroad/Year-round

Since 1979, Irene Hinke Sacilotto has conducted 1-day to 3-week nature photography workshops and tours to areas known for wildlife and scenic beauty. Field programs combine lectures and slide shows with outdoor practice and tours include individual instruction. Approximately 15 programs, limited to 15 students each, are offered each year.

Specialties: Wildlife, close up, landscape, and basic outdoor photography.

Faculty: Freelance photographer Irene Hinke Sacilotto has led photo workshops for Johns Hopkins University, the Miami, Baltimore, and Atlanta zoos, and the National Park Service. Her credits include *National Wildlife, Natural History,* and *Outdoor Photographer* as well as calendars, books, and posters of the National Geographic Society.

Costs, Accommodations: Vary by location and length of class. Tuition from $250 includes park fees, room (double occupancy), some ground transportation, and some meals. Lodging is in motels and bed and breakfasts near the day's site. A full refund is granted cancellations 91 days prior for weekend programs; 121 days for 3 day or more programs; no refund less than 45 days prior.

Location: U.S. locations include the Rio Grande Valley, the West Virginia mountains, and Montana. International trips visit Africa, South America, Canada, and the Falklands.

Contact: Irene Hinke Sacilotto, Osprey Photo Workshops and Tours, 2719 Berwick Ave., Baltimore, MD 21234-7616; (410) 426-5071.

APPALACHIAN MOUNTAIN CLUB
**Locations in New Hampshire,
and New York/
June and August-January**

Since 1977, Appalachian Mountain Club has offered a series of seminars for the serious photographer who wants to concentrate on specific aspects of natural light photography in water, landscape, and forest settings. About a dozen 1- to 3-day seminars, each limited to 10 to 15 students, are offered each year. Topics include wildlife, foliage, water light, mountains, and nature.

Established in 1876 to promote the wise use and preservation of our natural resources, the 50,000-member AMC is active in conservation, education, research, and back-country management throughout the Northeast.

Specialties: Nature, wildlife, seasons.

Faculty: Includes natural history photographer John Green, landscape photographer Philip H. Evans, Rod Sutton, Tom Tyning, and Kent Johnson.

Costs, Accommodations: Costs range from $50 to $350. Additional tuition is charged for college credit. Full course fee must accompany application for all 1- and 2-day workshops; otherwise a $100 deposit is required. Full refund for cancellations 30 days prior. Rustic cabin lodging and home-cooked meals are often included.

Location, Facilities: Pinkham Notch Visitor Center, located in the White Mountain National Forest, is 8 miles north of Jackson. Nearby scenic attractions include Tuckerman Ravine and the Alpine Gardens. Facilities include darkroom, common living room, library, rathskeller, conference rooms, and a trading post. Several photography workshops are offered at AMC's Bascom Lodge on top of Mt. Greylock in Massachusetts' Berkshires and at Valley View Lodge, in New York's Catskill Mountains.

Contact: Appalachian Mountain Club, P.O. Box 298, Gorham, NH 03581; (603) 466-2721, Fax (603) 466-2720.

ART NEW ENGLAND SUMMER WORKSHOPS
Bennington/July and August

Since 1983, Art New England Summer Workshops has offered a 3-week summer program consisting of approximately 20 one-week workshops in photography, painting, drawing, sculpture, printmaking, clay, and independent study. Classes are limited to intermediate and advanced adult students, who meet daily and are encouraged to pursue personal goals and develop new skills. A typical workshop, Photography, emphasizes personal style of seeing and camera work and features mornings devoted to viewing and discussing slides of photographers from specific areas or genres, and afternoon shooting sessions based on the guidelines from the morning's work. Independent Study enables artists who have work in progress to explore and develop their project further in private studio space and receive individual and group critiques each day. Evenings are reserved for lectures and slide presentations by instructors, chamber music concerts, and social activities.

Specialties: Photography, drawing and painting, sculpture, jewelry, clay, printmaking.

Faculty: Instructors, all accomplished artists and craftspeople, have included Peter Laytin,

head of the photography program at Fitchburg State College; Jane Tuckerman, associate professor at The Art Institute of Boston; and Judith Natal, who teaches art at Nazareth College.

Costs, Accommodations: Resident tuition is $785, which includes double occupancy dormitory room and board ($75 extra for single occupancy); nonresident tuition is $475, which includes lunches only. An additional $50 materials/model fee is required for some courses. Two graduate or undergraduate credits at $100/$140 per course are available for all courses. Slides are requested of those applying for independent study. A $250 nonrefundable deposit must accompany application with balance due by June 1. Cancellations before June 1 receive a full refund minus deposit; cancellations between June 1 and July 30 receive a 50% refund less deposit.

Location, Facilities: The 550-acre Bennington College campus in the Green Mountains. Facilities include fully equipped studios and darkroom. Tanglewood, Saratoga, Marlboro, Jacob's Pillow, Williamstown, and the Clark Art Museum are nearby.

Contact: Art New England Summer Workshops, 425 Washington St., Brighton, MA 02135; (617) 232-1604.

DISTANT HORIZONS PHOTOGRAPHIC WORKSHOPS

Travel photographer Brian Vikander leads two 2- to 3-week photo tours per year to locations in Europe and Asia. Enrollment is limited to 20 and seminars and field instruction are provided throughout.

Specialties: Travel.

Faculty: Brian Vikander's credits include *National Geographic, Travel & Leisure,* and *Bon Appétit.*

Costs, Accommodations: Cost ranges from $4,100 to $5,400 which includes airfare, hotel lodging, and some meals. A $200 deposit is required with balance due 60 days prior. Cancellation penalty ranges from $150 (more than 5 weeks prior) to 90% of cost (14 days prior).

Location: Includes Indochina, Syria and Jordan, Indonesia, and Tibet.

Contact: Distant Horizons, 619 Tremont St., Boston, MA 02118; (800) 333-1240.

EARTHWATCH
Worldwide/Year-round

This nonprofit institution, dedicated to increasing the public understanding of science and expanding the knowledge of earth and its inhabitants, sponsors scholarly field research by finding paying volunteers to help scientists on research expeditions around the world. Since its founding in 1971, more than 28,000 volunteers have assisted in more than 700 projects in 36 states and 85 countries. Each year, several expeditions require volunteers with photographic interests or skills who photograph subjects for documentation and research purposes.

Specialties: Photo documentation.

Faculty: Research scholars.

Contact: Earthwatch, 680 Mt. Auburn St., Box 403-P, Watertown, MA 02272; (617) 926-8200.

ECO VOYAGER
Venezuela/Year-round

The Eco Voyager tour company emphasizes awareness of South American ecosystems and how to conserve them. Two 11-day nature and wildlife photo tours are scheduled per month, each traveling different routes and limited to 10 photographers of all levels. The program is informal but structured, and participants have unlimited access to the instructor. Discussions cover equipment and accessories, advanced exposure methods, films, filters, and composition. Panorama cameras, light meters, tripods, and other accessories are provided.

Specialties: Nature and wildlife of Venezuela.

Faculty: Bruce Hilliard and Bob Dickson each have 15 years of teaching experience at the New England School of Photography.

Costs, Accommodations: Cost for either trip is $3,495, which includes round-trip airfare from New York or Miami, double occupancy lodging, meals, and transportation in Venezuela; single supplement and add-on fares available. Refund for cancellation 45 days prior, minus a $100 fee. In cities, lodging is in 5-star hotels; in national parks, deluxe lodges.

Location: One tour itinerary includes Gran Sabana and Canaima; the other includes the high Andes and Llanos. Optional extensions are available to Los Roques National Park or Choroni.

Contact: Bernardo X. Carrillo, Program Director, Eco Voyager, P.O. Box 35495, Boston, MA 02135-0005; (800) 326-7088, Fax (617) 562-0177.

HORIZONS: THE NEW ENGLAND CRAFT PROGRAM
Sunderland, Massachusetts and Tuscany, Italy/April-october

Established in 1983 as a year-round craft school, Horizons offers arts programs encompassing eight studios: drawing and color, ceramics, weaving, surface design, wood sculpture and furniture design, metalsmithing and jewelry construction, glass blowing, and photography. Three to six-day intensives for adults, limited to 8 students, cover such topics as Cyanotypes and Polaroid Transfers. The emphasis is on creativity, as well as composition, subject, darkroom techniques, printing, principles of film exposure, camera operations, and special effects. Workshop time is formally scheduled approximately 7 hours a day and studios are open 24 hours daily. A summer intensive art program for high school students allows participants to enroll in either of two 3-week sessions or the full 6 weeks. Each studio is limited to 8 students, who enroll in two studios and spend mornings in one and afternoons in the other. High school credit is available. One-week international workshops in photography and culinary arts are held in Tuscany during the October wine harvest.

Specialties: Visual and technical elements of photography.

Faculty: Founder and Director Jane Sinauer is a graduate of Smith College. Workshops are led by noted photographers, assisted by graduate students or those embarking on a career.

Costs, Accommodations: Cost, which includes room and board, is $335 for the adult intensives, $1,765 per 3-week session for the high school program, and $1,345 for the Tuscany program.

Location: Horizons is located in the five-college community of Amherst/Northampton, 2 hours from Boston and an hour from Hartford.

Contact: Horizons, 108 N. Main St., Sunderland, MA 01375; (413) 665-0300, Fax (413) 665-4141.

MASSACHUSETTS AUDUBON SOCIETY NATURE PHOTOGRAPHY
South Wellfleet/Year-round

Since 1985, the Wellfleet Bay Wildlife Sanctuary has sponsored the Cape Cod Natural History Field School's 1-week courses in writing, art, and photography for adults interested in learning more about the Cape Cod coast. The nature photography course, limited to 12 participants, emphasizes outdoor experiences and the use of natural light. Daily lectures cover fundamentals, exposure, composition, depth of field, and techniques for photographing natural history subjects. Other activities include critiques and slide presentations. Massachusetts Audubon Society, the largest conservation group in New England, is open to all who value preservation of the environment.

Specialties: Nature.

Faculty: Includes John Green, a naturalist, nature photographer, and co-founder of Naturethics, which sponsors photography and nature programs.

Costs, Accommodations: Fees are $350 to $400 for members and $380 to $430 for nonmembers. Cancellations more than 30 days prior forfeit $50. A $50 nonrefundable deposit is required, with balance due 30 days prior. Accommodations are $135.

Location: Overlooking Nauset Marsh in the Cape Cod National Seashore.

Contact: Chris Brothers, Education Coordinator, Massachusetts Audubon Society, Wellfleet Bay Wildlife Sanctuary, P.O. Box 236, South Wellfleet, MA 02663; (508) 349-2615, Fax (508) 349-2632.

NANTUCKET ISLAND SCHOOL OF DESIGN & THE ARTS
Nantucket/Year-round

Established in 1973, this nonprofit art institution offers 1- and 4-day institutes, 1-week workshops, courses for adults and children, a 7-week interdisciplinary/environmental graduate and undergraduate program through affiliation with the Massachusetts College of Art, and a year-round artists' interdisciplinary residency program. Workshops and institutes cover such subjects as photography, painting, drawing, tapestry, clay, fabric dyeing, and writing. Other activities include a weekly critique and discussion seminar, cultural arts lecture, and multi-discipline studio session.

The NISDA Residency Program provides artists in all fields with the opportunity to work undisturbed at their own pace. Most residencies are 2, 4, 6, or 8 months with 1-week to 1-month residencies dependent on space availability.

Specialties: Fine arts, fiber arts, clay, photography.

Faculty: Includes NISDA co-founders Kathy Kelm and Anthony Thompson, and photographers Larry Cronin, Evergon, and Judith H. Steinhauser.

Location: Nantucket is accessible by air or ferry from Cape Cod.

Contact: NISDA, Box 958, Nantucket, MA 02554; (508) 228-9248.

NATUREGRAPHS
New England/May-September

Since 1984, Naturegraphs has offered 3-day New England Classics workshops that empha-

size the discovery and development of individual creativity. The 4 workshops scheduled yearly are limited to 5 students and include morning and afternoon field shoots, lectures, and critiques.

Specialties: The New England landscape and historic landmarks.

Faculty: Budd Titlow, a freelance photographer and instructor for 20 years, has been published in a variety of magazines, books and calendars.

Costs, Accommodations: The $695 cost includes meals and lodging in inns and bed & breakfasts. A 25% nonrefundable deposit is required.

Location: Nantucket, Maine's Monhegan Island, Grafton in Vermont, Rhode Island's Block Island, and other locations in New England.

Contact: Budd Titlow, Naturegraphs, 49 Oak Hill Road, Southborough, MA 01745; (508) 460-5106.

NATURETHICS PHOTOGRAPHIC WORKSHOPS
Eastern U.S. and Canada

Founded in 1982 to promote awareness and respect for the environment, Naturethics sponsors tours and other natural history activities, including 2- to 10-day photography workshops. The daily program, which consists of indoor slide sessions and outdoor field trips, provides introductions to each locale and covers depth-of-field, exposure calculations under low light, and interpreting natural light. Customized workshops can be arranged.

Specialties: Ethical natural history photography.

Faculty: John Green, a conservationist and freelance interpretive naturalist, has photographed natural subjects in the U.S. and Canada. Herpetologist Tom Tyning, a naturalist for the Massachusetts Audubon Society, has photographed natural subjects in the U.S., Canada, Mexico, and Africa.

Location: Local workshops are held in various areas of western Massachusetts. Trips are scheduled to Newfoundland, Florida, southeast Arizona, and other areas in eastern Canada and the U.S.

Contact: Naturethics, Box 961, Amherst, MA 01004; (413) 256-8739.

MICHIGAN

BOB MITCHELL PHOTO TOURS
Austria and Prague/June

Bob Mitchell conducts photographic travel workshops each summer. Participants can meet after breakfast each day for informal discussion and may request instruction as needed at other times.

Specialties: Travel photography.

Faculty: Bob Mitchell is author of A Guide to Travel Photography and is a regular contributor to Darkroom & Creative Camera Techniques.

Contact: Bob Mitchell Photo Tours, 707 Myrtle Ave., St. Joseph, MI 49085; (616) 983-5893.

CHINA PHOTO WORKSHOP TOURS
China/April and September

Since 1981, photographer and China specialist D. E. Cox has conducted annual tours of the major cities, rivers, and mountains of China. Open to 10 to 12 photographers of all levels, as

well as spouses and friends, the 2- to 3-week program includes informal photographic instruction and features opportunities to meet and photograph with members of the Chinese Photographers Association (CPA) in Beijing and other cities. As time permits, methods and techniques of photojournalism, travel photography, and location portraiture are discussed.

Specialties: Photographing the cities, rivers, and mountains of China.

Faculty: Dennis Cox has photographed on five continents and made more than a dozen China trips. His photos of China have been published in several countries and in the international photo annual, the Minolta Mirror. He has photographed on assignment for *Forbes, U.S. News & World Report, Historic Preservation,* and *Midwest Living* and contributed to *Chinese Photography.* Tour Guide Christopher Liu is a veteran photographer and writer based in Beijing.

Costs, Accommodations: Tour price ranges from $2,800 to $4,000 and includes airfare, ground transportation, meals in China, and hotel lodging. A $400 deposit is required with balance due 60 days prior. Cancellations more than 60 days prior forfeit $100, no refunds thereafter.

Location: Itineraries include the major cities of Beijing and Shanghai. Location shooting takes place along the Yangtze, Li, and Yellow Rivers; in such mountains as Huangshan, Taishan, and Gmei; and such scenic areas as Yunnan and Tibet.

Contact: China Photo Workshop Tours, 22111 Cleveland #211, Dearborn, MI 48124-3461; (313) 561-1842, (800) 315-4462.

GERLACH NATURE PHOTOGRAPHY
Locations in the U.S.,
Kenya, Antarctica, Galapagos/
January-May, September

Professional nature photographers John and Barbara Gerlach conduct about a dozen 1-day workshops and 3 or 4 two-week tours yearly. Seminars, limited to 125 intermediate photographers with 2 instructors, cover equipment, metering, lighting, close-ups, and composition, among other subjects. Tours, limited to 10 to 16 participants, travel to countries with unique wildlife. Morning and late afternoon field trips are geared to maximize time spent in photographing animals.

Specialties: Nature photography.

Faculty: John Gerlach's credits include *National Wildlife, Natural History, Ranger Rick, Sierra,* Time-Life Books, and National Geographic Books. He is also an associate editor of *Nature Photographer* magazine. Barbara Gerlach's photos have appeared in Sierra Club calendars, *International Wildlife,* and wall calendars produced by Audubon.

Costs, Accommodations: One-day seminars are $65; refund, less $5 fee, for cancellations more than 48 hours prior. Tours range from $4,500 to $6,000, which includes airfare, meals, and lodging.

Location: Seminars are held in cities throughout the country. Tour destinations include Samburu, Great Rift Valley, and Masai Mara in Kenya; Elephant Island, Bleaker Island, and South Scotia Sea in Antarctica; and Galapagos Islands.

Contact: Bill Jasko, Gerlach Nature Photography, P.O. Box 259, Chatham, MI 49816; (906) 439-5991, Fax (906) 439-5144.

HOWARD BOND WORKSHOPS
Ann Arbor, Denver, and other locations/March-December

Since 1975, Howard Bond has offered indoor and field workshops for intermediate and advanced black & white photographers. Up to eighteen 1- to 5-day workshops are offered annually, with 9 to 15 students participating. The programs emphasize craft and aesthetics and include individual assistance, print critiques, and discussion sessions.

Specialties: Indoor and outdoor black & white photography.

Faculty: Photographer and magazine article writer Howard Bond has exhibited in galleries and museums and is the author of 2 books. Dick Dokas is a self-taught fine art photographer.

Costs, Accommodations: One-day workshops are $45; 2-day, $145; 3-day, $195; 5-day, $240. Lodging is available at nearby motels, cottages, or campsites.

Location: Ann Arbor, Denver, Lake Superior Provincial Park, and Great Sand Dunes National Monument.

Contact: Howard Bond, Howard Bond Workshops, 1095 Harold Circle, Ann Arbor, MI 48103; (313) 665-6597.

LEELANAU ENRICHMENT PROGRAMS
Glen Arbor/Summer

Established in 1982, The Leelanau Center for Education sponsors an art workshop, a writers' conference, and an outdoor classroom series of natural history workshops, which include 1-week nature photography programs, each limited to 20 participants.

Specialties: Nature photography.

Faculty: Has included Larry West, John Gerlach, and Rod Planck.

Location: The Center is located on 83 acres of forest within Sleeping Bear Dunes National Lakeshore, 30 miles west of Traverse City.

Contact: Leelanau Enrichment Programs, One Old Homestead Rd., Glen Arbor, MI 49636; (616) 334-3072.

MIDWEST PHOTOGRAPHIC WORKSHOPS / MPW INTERNATIONAL
Western Michigan, Belize, Guatamala/Year- round

Since 1980, this company has offered courses and 1 or 2 weekend workshops a month at locations in the metropolitan Detroit area, summer weekend workshops in western Michigan, and yearly tours to Belize and Guatemala. Enrollment is limited to 12 to 14 participants per instructor. Weekend workshop titles include Artistic Nude Figure in the Environment, Boudoir, Black & White Fashion, and Nude Centerfold. Topics covered during the travel workshops include photojournalism, close-up, animal, architecture, portrait, and landscape.

Specialties: Nude, figure, portrait, landscape, close-up, travel.

Faculty: Alan Lowy, a commercial photographer for more than 25 years, conducts model shoots and has been published in magazines and trade journals. CJ Elfont's credits include *Sierra, Travel & Leisure, Caribbean Travel & Life, Michigan Traveler,* and a book, *Roar of*

Thunder, Whisper of Wind.. Bryce Denison, BFA, lectures for Ilford and Westcott and is a photographer for the Detroit Fire Dept.

Costs, Accommodations: One and two-day workshops range from $45 to $225; the travel workshop fee, which includes round-trip airfare from Houston, ground transportation, meals, and shared lodging, is $2,100. A $500 deposit is required and balance is due 30 days prior to departure.

Location: Metropolitan Detroit area and Western Michigan's sand dune region; Western Belize and Guatemala's Peten region.

Contact: MPW International, 28830 W. 8 Mile Rd., Farmington Hills, MI 48336; Fax (810) 471-7299.

ROD PLANCK PHOTOGRAPHY
Hiawatha National Forest/
May, June, August

Since 1994, nature photographer Rod Planck has offered four 1-week *How to Photograph Nature* workshops per year for up to 12 photographers of all levels. Instruction covers close-up, landscape, and wildlife photography, combining daily classroom discussions with early morning and afternoon-evening in-the-field application of techniques. Workshops are timed to take advantage of seasonal color and activity.

Specialties: Hiawatha National Forest ecosystems.

Faculty: Rod Planck has 19 years of photographic experience. His credits include *Audubon, Sierra, National Wildlife,* and *Natural History.* Marlene Planck has been a field assistant for 19 years and has marketed photographic images for 10. Her articles have been published in *Birder's World* magazine.

Costs, Accommodations: Cost is $500, which includes lunch on all-day field trip. Lodging is $39 per night, single occupancy. A $200 deposit is required with balance due 60 days prior to workshop. Cancellations thereafter receive refund only if space can be filled.

Location: Hiawatha National Forest features beech and maple forest glades, bogs, coastal marshes, and interdunal wetlands. Spring sessions are held at St. Ignace; summer sessions are held at Trout Lake.

Contact: Marlene Planck, Manager, Rod Planck Photography, P.O. Box 106, Metamora, MI 48455; (517) 727-3260 (phone/fax) or (810) 678-2141.

SWMCCC SUMMER WEEKEND OF PHOTOGRAPHY
Holland, Michigan/July

Begun in 1974 and limited to the first 700 registrants, this annual weekend program consists of lectures, workshops, special seminars, model and on-location shoots, a trade show, and various social events. Typical topics covered include studio lighting for portraiture, nature closeups, color printing, audio visual basics, model posing techniques, night photography, and studio lighting. The Southwestern Michigan Council of Camera Clubs , a group of 30 camera clubs in southern Michigan and northern Indiana, is dedicated to promoting photographic skills and methods.

Specialties: A variety of topics.

Faculty: Includes Monte Zucker, Andre Cabuche, C. M. Elfont, Rudy Keller, Joe Littleton, and Evelyn R. Zeek.

Costs, Accommodations: Early registration is $68. Additional fees for special sessions range from $15 to $40 and field trips are $10 to $15. Tuition refund, less $5 to $15, granted cancellations. Dormitory-style lodging is $35 to $83 and a meal plan is available.

Location: Hope College in Holland, a small city noted for its Dutch heritage and annual spring tulip festival.

Contact: Sylvia Schlender, SWMCCC Summer Weekend of Photography, 380 Montezuma Rd., Benton Harbor, MI 49022; (616) 925-8238.

UNIVERSITY OF MICHIGAN SCHOOL OF ART
Ann Arbor/July-August

Since 1974, the University of Michigan has conducted a summer workshop program for undergraduate and graduate students, art teachers, and serious part-time visual artists. Three 2-week sessions run consecutively from early July to mid-August, each consisting of 5 workshops on topics that include a range of photography subjects as well as drawing, painting, papermaking, fiber arts, and computer graphics. Enrollment is limited to 20 participants.

Specialties: Various topics.

Faculty: Instructors, who are noted photographers and artists, have included Judy Eliyas, Ken Baird, Doug Hagley, Erika Leppmann, and Kathe Kowalski.

Location: The School of Art on the University campus, in Ann Arbor.

Contact: University of Michigan School of Art, 2000 Bonisteel Blvd., Ann Arbor, MI 48109; (313) 764-0397, Fax (313) 936-0469.

MINNESOTA

MIDWEST MEDIA ARTISTS ACCESS CENTER
St. Paul/Year-round

The MMAAC offers about a dozen 1- and 2-day workshops annually, usually on weekends. Up to 10 beginner and intermediate-level photographers participate in sessions that cover such topics as large-format photography, hand-tinting of black & white photos, darkroom processes, and photographing artwork for slides.

Faculty: Rebecca Dallinger, Stevie Rexroth, and Nancy Shelp.

Costs: $25 to $50 per workshop.

Contact: Carrie Bennett, Publicity Director, Midwest Media Artists Access Center (MMAAC), 2388 University Ave., St. Paul, MN 55114; (612) 644-1912.

NATIONAL AUDUBON SOCIETY ECOLOGY AND PHOTOGRAPHY TOURS
U.S. and abroad/
Spring, Fall, Winter

The National Audubon Society offers a variety of programs, including 6- to 8-day nature and wildlife photography workshops.

Specialties: Nature and wildlife.

Costs: Range from $1,250 to $1,375.

Location: Typical destinations include Yellowstone, Yosemite/Sequoia, and Churchill Polar Bears

Contact: National Audubon Society Ecology and Photography Tours, P.O. Box 530, Sandstone, MN 55072; (612) 245-2648, fax (612) 245-5272.

PHOTOGRAPHIC COLOR ARTISTRY, INC.
Apple Valley/
March-May, September

Since 1982, Gladys Teig has offered 2- to 3-day workshops in basic to advanced photographic arts finishing for working photographers, artists, receptionists, and lab personnel. Instruction covers techniques in hand coloring and print enhancement. Approximately a half-dozen workshops are scheduled yearly and enrollment is limited to 6 students.

Specialties: Photographic retouching.

Faculty: Gladys Teig was awarded the PPA Craftsman Photographer degree and the Minnesota PPA Accredited Color Artist and Accredited Photographer awards.

Costs, Accommodations: Fee, which includes supplies, is $115 a day (or $215 for 2 days). Students bring their own airbrush or retouch machines. A 25% deposit is required 3 weeks prior to workshop with balance due on first day of class. Former students who want practice may enroll for 1 day for $50. A full refund is granted those who cancel at least 10 days prior to class. Motels are located nearby and airport pickup is available.

Location: Gladys Teig's photographic studio and art lab, a half mile from downtown Apple Valley, a Minneapolis/St. Paul southern suburb.

Contact: Gladys Teig, President, Photographic Color Artistry, Inc., 193 Garden View Dr., Apple Valley, MN 55124; (612) 431-6711.

ST. CLOUD STATE UNIVERSITY IMAGING EDUCATORS' WORKSHOP
St. Cloud/June

Since 1974, St. Cloud State University has conducted an annual 2-week workshop program for teachers who are involved or want to become involved in teaching a photography class. Typical days consist of 2 cycles of lecture and lab work. Topics include the current aspects of exposure, processing, and printing, both in color and black & white. College credit is available.

Specialties: Darkroom procedures, safety, environmental concerns, and darkroom techniques for black & white and color.

Faculty: Professors Wayne Braith and John Gammell teach photography/photographic engineering in the Department of Technology at SCSU.

Costs, Accommodations: Tuition is $300 and supplies are about $50. Dormitory lodging is $10 per day.

Location: The University is in central Minnesota, about 70 miles northwest of Minneapolis/St. Paul.

Contact: Wayne Braith, Assoc. Prof., 216 Headley Hall, St. Cloud State University, 720 Fourth Ave. South, St. Cloud, MN 56301-4498; (612) 255-2107, Fax (612) 654-5122.

SPLIT ROCK ARTS PROGRAM
Duluth/Summer

Sponsored by the University of Minnesota, Split Rock is a summer series of 50 six-day intensive residential workshops in the visual and literary arts and the nature and application

of creativity. Workshops begin on Sunday evening and end the following Saturday at noon and are limited to 16 participants, most of whom have some photography background. Workshops require approximately 60 hours of preparation, including assignments, prior to arrival. Each day's activities features a variety of approaches to visual narrative and image sequencing, shooting and feedback, and one-on-one with the instructor.

Specialties: Nature, documentary, and portrait photography and other topics.

Faculty: Robert Capa Gold Medal recipient Harry Mattison, who was assistant to Richard Avedon.

Costs, Accommodations: Tuition is $350 and must accompany reservation. Credit cards accepted. Full refund, less $25 fee, is granted cancellations more than four weeks prior; penalties for withdrawal thereafter. Moderate priced on-campus housing is available.

Location, Facilities: Split Rock is held at the University of Minnesota's Duluth campus, overlooking the city, Lake Superior, and the St. Louis River. Campus facilities include a pool, tennis courts, tracks, the Tweed Museum of Art, and the Minnesota Repertory Theatre. Duluth, 150 miles north of the Twin Cities, offers such activities as sports, sailing, and trout fishing.

Contact: Vivien Oja, Registrar, Split Rock Arts Program, 306 Wesbrook Hall, 77 Pleasant St. SE., University of Minnesota, Minneapolis, MN 55455; (612) 624-6800, Fax (612) 624-5891.

SUPERIOR/GUNFLINT PHOTOGRAPHY WORKSHOPS
Northeastern Minnesota/
February and September

Since 1988, Minneapolis-based magazine photographer Layne Kennedy has conducted 5-day workshops that combine guided wilderness exploration with the art of photography. Two workshops are scheduled yearly, each limited to 8 serious fine art or editorial photographers, who should be in good physical condition. Instruction is geared toward shooting successful magazine images using primarily 35mm equipment; overnight film processing is available mid-week. Discussions cover marketing to publications.

Specialties: Wilderness areas.

Faculty: Magazine photographer Layne Kennedy's credits include *Smithsonian, Sports Illustrated, Newsweek, Audubon, Forbes, German Geo, Life,* and National Geographic publications.

Costs, Accommodations: Workshop fee ranges from $650 to $750 and includes lodging. A $100 deposit is required with balance due at workshop. Cancellations more than 30 days prior forfeit $15; thereafter deposit is forfeited if space is not filled.

Location: Northeastern Minnesota out of Grand Marais on the North Shore of Lake Superior, 110 miles north of Duluth. The winter session involves treks along the frozen shores of Lake Superior and a day-long dogsled trip inside the Boundary Waters Canoe Area; the summer/fall session entails canoeing along the border country of Minnesota and Canada and the Granite River system.

Contact: Superior/Gunflint Photography Workshops, P.O. Box 19286, Minneapolis, MN 55419; Fax (612) 825-3075.

MISSISSIPPI

INTERNATIONAL WILDLIFE ADVENTURES
Worldwide/Year-round

This travel operator offers more than 20 five-day to two-week nature photography tours a year to

regions noted for their wildlife activity. Enrollment is limited to 8 to 16 participants, depending on trip.

Specialties: Nature and wildlife, including monarch butterflies, harp seals, whooping cranes, seabirds, musk oxen, polar bears, and wildlife models.

Faculty: Includes Kathy Bushue, Bradford Glass, Randy Green, Darrell Gulin, Dr. Dan Guravich, Mike lacey, and George Lepp.

Costs, Accommodations: Costs range from $1,250 to $11,500, which includes lodging.

Location: Includes Alaska, Montana, New Mexico, Texas, the Galapagos, Canada, Mexico, South America, Russia, and Antarctica.

Contact: International Wildlife Adventures, Box 891, Greenville, MS 38702-0891; (601) 335-2444, Fax (601) 332-9528.

MISSOURI

MISSOURI PHOTO WORKSHOP
University of Missouri-Columbia
Small-town America/October

This annual 5-day documentary photojournalism workshop, first offered in 1949 and now limited to 50 participants selected by a panel of photojournalists and educators, concentrates on creating a photo story that documents life in small-town America, stressing research and the strength and believability of the unposed photograph. The 5-day program consists of story approval sessions, private meetings with faculty, daily work on the project, and evening discussions. The final group show presents the best of the week's stories. One hundred of these create an exhibit for the community the following spring. The workshop concludes with an award session.

Specialties: Photojournalism.

Faculty: Includes workshop founder Vi Edom and co-directors, University of Missouri-Columbia faculty members Bill Kuykendall and Duane Dailey. Past faculty has included Sam Abell and Wilbur Garrett of *National Geographic,* Alan Berner of the *Seattle Times,* Howard Chapnick of the Black Star Agency, William E. Eppridge of Time, Inc., Carolyn Lee of *The New York Times;* and Sandra Eisert of the *San Jose Mercury News.*

Costs, Accommodations: Workshop tuition is $385. At least 2 1/2 months prior, applicants must submit application, full tuition, a portfolio of 20 photographs, a statement of why they wish to attend, and a letter of recommendation. Check is returned to those not accepted. No refunds are granted within 3 weeks of Workshop. Housing information is sent upon acceptance.

Location: A different Missouri town each year.

Contact: Missouri Photo Workshop, School of Journalism, University of Missouri, 9th & Elm Sts., 27 Neff Annex, Columbia, MO 65201; (314) 882-4442, Fax (314) 884-4999.

PHOTOGRAPHY WORKSHOPS WITH LEE AND ED MASON
St. Louis/Year-round

Since 1969, Edward and Lee Mason have offered nature photography workshops that are designed for a mix of beginning and experienced photographers who have access to a single lens reflex camera. One, two, and five-session workshops, limited to 20 participants, are held in the St. Louis area. Instruction covers photographic seeing, exposure, depth of field, shutter speeds, composition, lighting, filters, films, lenses, accessories, special techniques, and equipment care.

Specialties: Nature and close-up photography.

Faculty: Edward and Lee Mason have conducted workshops for the Audubon Society, the St. Louis Zoo, the Missouri Botanical Garden, Shaw Arboretum, Missouri University, and continuing education programs. Local credits include the *St. Louis Post-Dispatch, Kansas City Star*, and *Missouri Life.*

Location: St. Louis Zoo, Missouri Botanical Garden, Shaw Arboretum, University of Missouri, Missouri state parks.

Contact: Edward and Lee Mason, Nature Photography Workshops, 8410 Madeline Dr., St. Louis, MO 63114; (314) 427-6311.

WASHINGTON UNIVERSITY PHOTOGRAPHY WORKSHOP
Florence, Italy/Summer

Since 1990, Washington University's School of Fine Arts has conducted a 1-month black & white photography workshop that focuses on the people living in urban and rural areas of Northern Italy. Classes meet 4 days a week and are limited to 20 participants. Field work is emphasized and students are encouraged to generate a body of work during field trips accompanied by faculty. Other activities include art-historian led walking Gothic and Renaissance tours of Florence, day trips to nearby sites, and overnight trips to other cities. College credit is available through Washington University.

Specialties: Black & white photography of the people of Italy.

Faculty: Stan Strembecki, Chair, Department of Photography, School of Fine Arts, Washington University.

Costs: Tuition is $1,250.

Contact: Stan Strembecki, School of Fine Arts, Washington University, 1 Brookings Dr., St. Louis, MO 63130; (314) 935-8406, Fax (314) 935-8412.

MONTANA

ALLAMAN'S MONTANA PHOTOGRAPHIC ADVENTURES
Montana/Year-round

Established in 1975, this company offers 25 five-day programs per year. Enrollment is limited to 4 participants and emphasis is on wildlife photography.

Faculty: Ken C. Allaman and Moose Peterson.

Costs, Accommodations: Cost ranges from $800 to $1,500, which includes meals, cabin lodging, and ground transportation. A one-third deposit is required; refund, less $100, granted cancellations 60 days prior.

Location: Western Montana National Forest, Western Montana wilderness areas, and southwestern Montana ghost towns.

Contact: Ken C. Allaman, Allaman's Montana Photographic Adventures, 185 Red Dog Trail, Darby, MT 59829; (406) 821-3763.

THE GLACIER INSTITUTE
Glacier National Park/June-August

This nonprofit corporation, established in 1984, sponsors 3 to 5 field-level photography

courses per year in the Glacier National Park ecosystem. The 2- to 4-day programs include Advanced Photography, Nature Photography, and Wildlife Photography. The daily schedule consists of 1 to 2 hours of classroom work and 6 to 8 hours in the field. Enrollment is limited to 15 participants.

Specialties: Wildlife, nature, and advanced photography.

Faculty: Includes Diane Ensign, James Mepham, and John Hooton.

Costs, Accommodations: Course fees, payable with application, range from $130 to $175 and include transportation and entrance fees. A 75% refund is granted cancellations 30 days prior. Lodging in primitive cabins with hot showers and communal kitchen is $13 per night.

Location, Facilities: Glacier National Park, located on the Canadian border in northwestern Montana, offers a variety of wildlife and diverse glaciated landscapes ranging from alpine cirques to broad forested valleys.

Contact: The Glacier Institute, P.O. Box 7457, Kalispell, MT 59904; (406) 756-3911, Fax (406) 756-3815.

ROCKY MOUNTAIN SCHOOL OF PHOTOGRAPHY
Locations in the U.S. and abroad/ *(see also page 167)*
Year-round

Established in 1989, this school offers approximately 30 weekend to 2-week workshops per year in a variety of locations and a 10-week Summer Intensive career program in Montana. Workshop enrollment is limited to provide opportunities for one-on-one assistance in the field. The program includes lectures, discussions, critique of student work, and daily field shoots.

Specialties: Include fine art, nature, documentary, travel, macro, darkroom, and portraiture.

Faculty: The 17-member faculty includes RMSP president Neil Chaput de Saintonge, Bruce Barnbaum, Jim Bones, Galen Rowell, and Alison Shaw.

Costs, Accommodations: Workshop tuition ranges from $250 to $3,195 (lodging and travel sometimes included). Lodging varies from rustic to deluxe. Deposit must accompany registration and full refund, less $25 fee, is granted cancellations 60 days prior. Credit cards accepted; discounts granted early registrants.

Location: Montana, Vermont, Alaska, Colorado, Utah, New Mexico, Martha's Vineyard, Texas, Georgia, and New Zealand.

Contact: Jeanne Chaput de Saintonge, RMSP, P.O. Box 7697, Missoula, MT 59807; (406) 543-0171 or (800) 394-7677, Fax (406) 543-0171.

WILDERNESS PHOTOGRAPHY EXPEDITIONS
Yellowstone National Park/
January, February, June, September

Founded in 1986, Wilderness Photography Expeditions offers a dozen 6-day nature workshops that are designed to help individuals see and photograph the natural wildlands and wildlife of the Greater Yellowstone Ecosystem. Groups are limited to 8, who photograph from sunrise to sunset. Field instruction is supplemented by evening slide shows and lectures and one-on-one assistance is provided with exposure problems and composition. Private itineraries for groups can be customized to such interests as bird watching, rare flowers, geology, archaeology, hot springs, geysers, or waterfalls.

Specialties: Nature and wildlife photography.

Faculty: Tom Murphy has been published in *The New York Times Magazine* (cover), *Audubon, National Geographic World*, and *Outdoor Photographer*. A full-time professional photographer, he has lived in the Yellowstone area since 1978.

Costs, Accommodations: Cost is $1,495, which includes transportation, meals, and lodging (bed & breakfasts, motels, and park lodges). A $300 deposit must accompany reservation with balance due 30 days prior. Written cancellations more than 30 days prior forfeit $100.

Location: Yellowstone National Park.

Contact: Tom and Bonnie Murphy, Wilderness Photography Expeditions, 402 S. 5th St., Livingston, MT 59047; (800) 521-7230, (406) 222-2302, Fax (406) 222-2480

NEBRASKA

DESTINATION HIMALAYA
India/Year-round

Since 1989, Destination Himalaya has conducted 2-week photo-cultural and adventure tours to the Indian Subcontinent. Four different itineraries are offered, each limited to 6 to 14 beginner to intermediate photographers, who are accompanied by 1 or 2 professionals.

Specialties: Travel and nature photography.

Faculty: Includes William Neill, Lewis Kemper, Shankar Barua, Brenda Tharp, and Connie Bickman.

Costs, Accommodations: Land cost ranges from $2,475 to $3,270, based on a group of 4 to 12 participants.

Location: Itineraries include Ladakh in Northern India, Rajasthan in Western India, and Arunachael Pradesh.

Contact: Destination Himalaya, 521 N. 52 St., Omaha NE, 68132; (800) MY-INDIA or (402) 556-0303, Fax (402) 556-0220.

NEW JERSEY

EDWARD BARRY PHOTOGRAPHIC SERVICES
**Massachusetts, New Jersey,
Pennsylvania, Vermont, Cape May/
May, June, October**

Established in 1988 to meet the needs of amateur travel photographers interested in skill development, contest work, and/or marketing their images, this company conducts five to seven 2- and 4-day workshops a year that emphasize development of a personal style and group identity. Exposure, lighting, filter/film combinations, composition, and pre-visualization are covered in the field, during frequent individual and group critique sessions, and at briefings. Enrollment in each workshop is limited to 8 intermediate photographers (or 16 for 2 instructors), who should bring 20 slides for critique.

Specialties: Travel.

Faculty: Director Edward Barry, a professional educator and self-taught photographer, has taught more than 1,000 adults at the Jointure for Community Adult Education in Bound Brook, New Jersey, and Waterloo Foundation for the Arts in Stanhope. Head of the instructional program for a New Jersey high school, he is a frequent competitor, judge for the New

Jersey Federation of Camera Clubs, and produces images for Schellmark, Inc. Gene Sellers is a published photojournalist.

Costs, Accommodations: Workshop cost, which includes double occupancy motel lodging and follow-up critique, is $150 for Pennsylvania and New Jersey, $455 for Vermont, and $450 for Massachusetts (includes whale watch and money-back guarantee). A 50% deposit is required with balance due two weeks prior; full refund is granted cancellations at least one week prior. Single supplement is available.

Location: Southeastern Pennsylvania's Amish region; Woodstock and Bradford; Cape Ann Lighthouse, 45 minutes northeast of Boston; and Cape May, New Jersey.

Contact: Edward Barry Photographic Services, 203 Beekman Ln., Neshanic Stn., NJ 08853; (908) 359-0288.

HASSELBLAD UNIVERSITY ON LOCATION
Cities throughout the U.S./
Year-round

Since 1994, Victor Hasselblad, Inc., has sponsored 1-day seminars that cover a variety of topics, including lighting, composition, nature and wildlife, and commercial photography. Programs change every 3 or 4 months and each program is presented in 7 cities and attended by 150 to 200 photographers of all levels. Hasselblad products are on display.

Faculty: The 3 or 4 speakers at each program include electronic imaging manager Rudy Guttosch, Hasselblad's Technical Director Ernest Wildi, and lighting specialist Tony L. Corbell.

Costs: Tuition is $60 in advance, $85 on-site, $35 for students. The first 40 enrollees at each seminar receive a free camera cleaning.

Location: Major cities throughout the U.S.

Contact: Tony Corbell, Victor Hasselblad, Inc., 10 Madison Rd., Fairfield, NJ 07004; (201) 227-7320.

LE'IMAGE GLAMOUR WORKSHOP
Nutley/Year-round

Begun in 1985, these monthly 4-hour Sunday sessions emphasize posing and lighting techniques using professional models. Each program is limited to 15 to 20 participants of all levels, with 5 students per instructor.

Specialties: Boudoir, figure, glamour.

Faculty: Michael Cotellessa, a professional photographer with 20 years experience.

Location: A private 5-acre estate in central New Jersey.

Contact: Le'Image Photography, 259 Prospect St., Nutley, NJ 07110-2267; (201) 661-3320.

LEONARD RUE ENTERPRISES
U.S. locations/Year-round

Leonard Lee Rue III and Len Rue, Jr., conduct one-day seminars on nature and wildlife photography under the sponsorship of various organizations. The program covers 7 subjects: equipment, exposure, macro, landscape and scenic, reptiles and amphibians, and birds and mammals. More than 600 slides are shown to demonstrate techniques.

Specialties: Nature and wildlife.

Faculty: Leonard Lee Rue III has sold to more than 1,500 different companies and publica-

tions in 42 countries and his photographs appear in more than 50 magazines each month. Len Rue, Jr., holds a degree in Professional Photography from Rochester Institute of Technology and manages the business. His work has appeared in several hundred publications.

Location: Various U.S. locations.

Contact: Leonard Rue Enterprises, 138 Millbrook Rd., Blairstown, NJ 07825; (908) 362-6616, Fax (908) 362-5808.

NATURE ONE PHOTOGRAPHY AND WILDLIFE ADVENTURES
Worldwide/Year-round

Established in 1987, this nature photography trip operator offers 25 three- to ten-day trips per year for photographers of all levels. Enrollment is limited to 12 participants and 2 instructors. Some programs feature visits to game ranches and farms where a variety of wildlife models can be photographed up close.

Specialties: Nature and wildlife.

Faculty: Includes Director John Finley, who has specialized in nature, up close wildlife, and travel photography for over 15 years; Branson Reynolds, a specialist in Native American photography and author of *Among the Aspens;* Gary Stanley, who has been published in national magazines, including *Outdoor Photographer;* photographic biologist and environmental writer William Hartley; Marc Levey, author of 7 photo books; and Jim Roetzel, a contributing photographic writer and editor for *Outdoor and Travel Photography.*

Costs, Accommodations: Costs range from $150 for a weekend to $3,895 for 2 weeks in New Zealand, which includes meals and lodging. Most trips in the U.S. do not include meals and lodging.

Location: Includes national parks and preserves in Colorado, Wyoming, Montana, Florida, British Columbia, Newfoundland, and New Zealand.

Contact: John Finley, Nature One Photography and Wildlife Adventures, P.O. Box 531, Haddonfield, NJ 08033; (800) 659-9718 or (609) 427-9223, Fax (609) 427-9139.

PETERS VALLEY CRAFT CENTER
Layton/June-August

Established in 1970 as a nonprofit craft education center, Peters Valley maintains an educational facility in cooperation with the National Parks Service to provide instruction in the production, marketing, and appreciation of handcrafts. The summer programs include lectures and demonstrations in the various disciplines, public exhibitions, an annual craft fair, and twelve 3- to 5-day photographic workshops. Topics include basic photography, the Cyanotype process, photographing works of art, the color landscape, pinhole photography, composition, and multiple image print.

The year-round resident program offers accomplished professionals the opportunity to manage a studio and plan programs while earning a living at their craft. Summer assistantships are also available to serious students who want to pursue individual studies and projects.

Specialties: A variety of topics for beginning to advanced photographers.

Faculty: Has included William Abranowicz, Audrey Bernstein, Jill Enfield, John Humble, Elizabeth Kenneday, Joanne Kirwin, Ward V. Roe, Stephen Schneiderman, Norman Seider, Harvey Stein, Brian Lav, and David Wells.

Costs, Accommodations: Tuition ranges from $175 (3 days) to $275 (5 days) plus lab fee. A nonrefundable $15 enrollment fee must accompany application. Cancellations at least three weeks prior forfeit $15; no refunds thereafter. Shared lodging in a local historic house including meal plan is available for a limited number of students. Alternate housing information is offered and meals may be purchased separately by day students. Annual Peters Valley membership begins at $25 regular, $40 couple.

Location: Peters Valley is located in the Delaware Water Gap National Recreation Area in the Kittatinny Mountains bordering the Delaware River in northwest New Jersey, 70 miles from Newark airport.

Contact: Peters Valley Craft Center, 19 Kuhn Rd., Layton, NJ 07851; (201) 948-5200, Fax (201) 948-0011.

THE PROFESSIONAL VIEW CAMERA WORKSHOP
Edison/January-October

Since 1983, Sinar Bron has sponsored 5-day workshops, each limited to 8 professionals, that cover photographic principles and the practical techniques of large format equipment. The 6 workshops that are offered yearly begin with classroom sessions that cover such subjects as optical theory, depth of field, exposure control, and film plane metering. The class is then divided into 3-member teams that work on typical advertising assignments. Students apply previously learned principles to create optimum solutions and become comfortable handling the view camera and such accessories as the digital shutter and film plane meters. Lighting management problems and techniques are discussed by a commercial photographer.

Specialties: Professional photography using the large format view camera.

Costs, Accommodations: Tuition, which includes lunches and one group dinner, is $550 without hotel, $880 with. A $100 deposit must accompany application with full payment due 4 weeks prior. Full refund 30 days prior.

Location: Edison can be reached from New York City via the New Jersey Transit train to Iselin Metro Park Station.

Contact: Workshop Coordinator, Sinar Bron, Inc., 17 Progress St., Edison, NJ 08820-1102; (908) 754-5800.

SAYLOR'S SAFARIS
U.S., Canada, and Europe

Since 1982, Sam Saylor has conducted photo tours for serious amateurs, most of whom belong to New York City camera clubs. The 3 to 5 trips scheduled each year are timed to provide the best seasonal photo opportunities and local color. Instruction consists of hands-on tips rather than formal lectures and covers composition, filtration, lenses, and lighting.

Specialties: Travel and outdoor photography.

Faculty: Sam Saylor, winner of the 1986 Mallas Award, conducts programs for camera clubs in the New York-New Jersey area. He has sold work to Eastman Kodak, the Empire State Building Corp., and New York magazine.

Costs, Accommodations: Costs range from $75 to $1,700 and include local transportation and lodging.

Contact: Sam Saylor, 27 Dunn Pl., Dumont, NJ 07628; (201) 384-7635.

NEW MEXICO ARTISTS' ASSOCIATION
Santa Fe/Year-round

Since 1987, this organization has offered individualized 5-day workshops that are taught in Santa Fe artists' studios. Arrangements are made for one to three artist students of all levels, matching their requirements and level of skill with a suitable artist/teacher. Mornings are spent in the studio or darkroom and afternoons are devoted to field work.

Specialties: Include photography, painting, sculpture, printmaking, woodworking, Indian silversmithing, ceramics, pastel, Indian pottery.

Faculty: Association artists, approximately 30 professionals who exhibit in Santa Fe galleries, include photographers Warren Hanford, J.B. Smith, and Ed LaBoue.

Costs, Accommodations: Tuition for five days is $775. A $375 deposit is due 3 weeks prior to instruction with balance due on arrival. No refund is granted cancellations except for a documented emergency.

Location: Santa Fe offers a wide range of cultural activities and has more than 130 galleries and five major museums.

Contact: Winona Garmhausen, Ph.D., Director, New Mexico Artists' Association, 2801 Rodeo Rd., Ste. 239B, Santa Fe, NM 87505; (505) 982-5639, Fax (505) 473-4718.

THE PLUM TREE SCHOOL
Pilar/May-October

This bed and breakfast hostel sponsors a summer fine arts program that includes 5-day workshops in photography, painting, papermaking, ceramics, sculpture, and printmaking, each limited to 12 participants. Titles include Photography: The Inner Landscape, devoted to creating a personal essay; and Landscape Photography, focusing on man's alteration of the landscape.

Specialties: Various topics.

Faculty: Has included David Barbero, Katherine Ferwerda, Bill Gersh, Douglas Kent Hall, Joan Myers, Bob Saltzman, Sam Scott, and Ray Tomasso.

Costs, Accommodations: Tuition averages $275 for five days. A 50% deposit must accompany application with balance due on arrival. Hostel facilities consist of private rooms for couples and families, a women's and men's dorm, kitchen, and get-together area.

Location: Pilar, a centuries-old village along the banks of the Rio Grande, is 50 miles north of Santa Fe.

Contact: The Plum Tree School, Box 1A, State Rd. 68, Pilar, NM 87531; (505) 758-4765.

SANTA FE WORKSHOPS
Santa Fe/June-September

Established in 1990, the Santa Fe Workshops offer professionals and serious amateurs a choice of more than 60 week-long summer workshops on a variety of topics, including portraiture, photojournalism, corporate/advertising, landscape, and studio photography. Enrollment is limited to 18 participants, who work from dawn until midnight in sessions designed to increase knowledge of the craft of photography as well as expand aesthetics and vision.

Specialties: A variety of topics.

Faculty: The 45-member faculty includes professional photographers Joyce Tenneson, Christopher Springmann, Greg Gorman, Sheila Metzner, and Sam Abell, whose credits include *National Geographic.*

Costs, Accommodations: Tuition ranges from $595 to $695. Dormitory housing ranges from $290 to $350; double and single rooms available. A $300 deposit is required.

Location, Facilities: The Workshop Center in Santa Fe, in the foothills of the Sangre de Cristo Mountains. Facilities include meeting spaces, library, studio, gallery, dining, and housing.

Contact: Santa Fe Workshops, P.O. Box 9916, Santa Fe, NM 87504; (505) 983-1400, Fax (505) 989-8604.

TAOS INSTITUTE OF ARTS
Taos/June-October

Established in 1989, this multi-disciplinary school offers approximately sixty 1-week summer courses in photography, painting, sculpture, clay, textiles, jewelry, and writing as well as a weekend interdisciplinary field excursion that emphasizes sharing perspectives with artists from other fields. Eight hours per day are spent with the instructor and feedback is provided at least twice a week. Maximum course enrollment is 12, and most sessions are open to both beginning and experienced students.

Specialties: A variety of topics.

Faculty: Sixty-member faculty includes prominent New Mexico photographers and teachers, such as Douglas Kent Hall, author and photographer for *Frontier Spirit* and other works about the west; landscape photographer Bill Davis, whose work is in the book *If Mountains Die;* Cynthia Johnson-Bianchetta, who has been director of the Western Photographic Gallery and assistant director of the Museum of Photographic Arts; and Chuck Heningson, who teaches platinum printing and has had 15 one-man shows.

Costs, Accommodations: Tuition is approximately $300 to $450 per week plus materials. A $100 deposit plus $20 registration fee is required with balance due 30 days prior to course. Cancellations more than 1 month prior forfeit $50; no refunds thereafter. An accommodations list is provided. College credit from the University of New Mexico and New Mexico Highlands University is available for some courses for an additional fee and some partial scholarships are awarded northern New Mexico residents with economic need.

Location: On the western slope of the Sangre de Cristo mountains of northern New Mexico.

Contact: Ursula Beck, Executive Director, Taos Institute of Arts, P.O. Box 2469, Taos, NM 87571; (505) 758-2793 or (505) 751-0735, Fax (505) 751-0735.

TAOS PHOTO HUNT
Taos/July-September

The Taos Indian Ranch, established in 1969, sponsors two 5-day summer trips that utilize traditional Indian hunting techniques to search for deer, elk, bighorn sheep, black bears, and mountain lions. The 6 participants hike and ride horses 10 to 30 miles daily, spending about 10 hours in the saddle.

Specialties: Wildlife of the Sangre de Cristo range.

Faculty: Two or three Native American guides.

Costs, Accommodations: Cost is $2,500, which includes meals and lodging in lean-tos. Reservations should be made 6 months in advance.

Location: Northern New Mexico. Pick-up is in Albuquerque.

Contact: Taos Indian Ranch, Box 3019, Taos, NM 87571-3019; (505) 758-3212 or (800) 659-3210.

TRAVEL PHOTOGRAPHY WORKSHOPS AND TOURS WITH LISL DENNIS
Santa Fe and locations abroad/ April-November

Since 1980, Lisl Dennis has taught travel photography workshops that are designed to develop personal style and increase creative confidence. One-week workshops are held in Santa Fe in July, September, and October; 2- to 3-week tours visit destinations outside the U.S. Enrollment in all programs is limited to 18. The workshop schedule consists of daily classroom instruction, three photo critiques, and a photo day trip to Taos. Topics include landscapes, people, travel adventure experiences, composing travel graphics, developing self assignments, handling color, overcoming unfavorable conditions, stock photography, and going pro. The tours feature on-location demonstrations and evening discussions.

Specialties: Travel photography.

Faculty: Lisl Dennis is author of *The Essential Image, Travel Photography: Developing a Personal Style,* and *Shooting Portraits on Location.* She is travel photography columnist for *Outdoor Photographer.*

Costs, Accommodations: Workshop fee of $1,125 includes double occupancy ($325 single supplement) lodging at the Inn on the Alameda, Taos trip, breakfasts, and farewell dinner. Nonparticipating guest fee is $645 and $350 deposit is required. Full refund is granted cancellations at least 30 days prior; cancellations from 15 to 30 days prior forfeit deposit.

Location: Workshops are held in Santa Fe and Taos. Tour destinations include Morocco, Provence, and India.

Contact: Travel Photography Workshop in Santa Fe, Box 2847, Santa Fe, NM 87504-2847; (505) 982-4979.

NEW YORK

CENTER FOR NATURE PHOTOGRAPHY
U.S. and Europe/Summer

Established in 1984 by writers/photographers Allen Rokach and Anne Millman, the Center for Nature Photography offers 1-week workshops for 15 participants of all levels.

Specialties: Nature photography.

Faculty: Instructor Allen Rokach has served for 14 years as staff photographer at the New York Botanical Garden and is author of Focus on Flowers: Discovering and Photographing Beauty in Gardens and Wild Places. Teaching experience includes The American Museum of Natural History, The New School, and Japan Photo Show.

Contact: Center for Nature Photography, P.O. Box 118, Riverdale, NY 10471; (914) 968-7163.

CHAUTAUQUA INSTITUTION
Chautauqua/July and August

This educational institution offers a diverse curriculum of more than 200 continuing education courses for adults and young people during its annual 9-week summer program. Photography courses, which meet from Monday through Friday and are limited to 10 students, cover such subjects as black & white basics, camera-less photography, nature and landscape, architecture, and the use of light.

Costs, Accommodations: Approximate nonrefundable tuition ranges from $45 to $70 per week (15 hours). Students are encouraged to pre-register. An accommodations directory is available.

Location: The cultural environs of Chautauqua Institution, a lakeside community in the southwest corner of New York State.

Contact: Chautauqua Institution, Schools Office, Box 1098, Chautauqua, NY 14722; (716) 357-6233/6234.

CREATIVE ADVENTURES
Locations worldwide/Year-round

Since 1991, photographer Richie Suraci has offered 1-day to 1-month workshops for all levels. Costs, topics, and locations vary.

Contact: Richie Suraci, Fine Art Productions, 67 Maple St., Newburgh, NY 12550; (914) 561-5866.

THE EDDIE ADAMS WORKSHOP
New York/October

First held in 1988, this annual 4-day photojournalism workshop brings together 100 young photojournalists - students or professionals with 2 years or less experience in the field - who are selected based upon portfolio. Students are divided into 10 teams, each led by a photographer, editor, and researcher, and each with a different assignment to cover. The daily schedule includes shooting, editing, speeches, panels, and one-on-one time with editors.

Specialties: Photojournalism.

Faculty: Noted photographers and editors from such publications as *Life, National Geographic, Newsweek,* and *Time.*

Costs, Accommodations: The workshop is tuition-free. Cost of room and board is $200. Applicants are required to submit application, personal statement, recommendation and portfolio. Application deadline is mid-May.

Location: Eddie Adams' farm in Jeffersonville, NY, about 2 1/2 hours from New York City.

Contact: The Eddie Adams Workshop, P.O. Box 4182, Grand Central Stn., New York, NY 10163-4182; (212) 880-1613.

FIRST LIGHT PHOTOGRAPHIC SAFARIS
U.S., Africa, Australia/Year-round

Since 1990, this photo tour operator has conducted workshops and tours that range from half-day programs to 20-day trips. Eight programs are offered per year, with 2 instructors and a maximum of 15 participants.

Specialties: Nature and travel photography.

Faculty: Bill Rudock, Master Photographer with P.P. of A.

Costs, Accommodations: Costs range from $69 to $5,800 (including airfare) for the Africa tour. Accommodations vary and include lodges and tent camping. A 20% deposit is required.

Location: Fire Island, Long Island, U. S. National Parks, Africa, Australia.

Contact: Bill Rudock, President, First Light Photography, P.O. Box 246, Sayville, NY 11782; (516) 563-0500.

THE IMAGE EXPERIENCE PHOTO WORKSHOPS
Northeastern U.S. and Canada/
Year-round

Established in 1986 by professional photographer Peter Finger, The Image Experience offers 6 to 12 weekend to week-long workshops annually. Enrollment is limited to 15 participants and emphasizes seeing photographically, composing effectively, and capturing personal vision as it relates to the landscape. Instruction, self-assignments, and exercises are provided specific to individual needs and each day offers 10 hours of scheduled activities. Overnight processing is available at most locations and participants are encouraged to bring samples of their work for critique. Slide shows and group critiques are also a part of the program.

Specialties: Nature, landscape.

Faculty: Peter Finger has more than 20 years of experience as a professional photographer and has taught for more than 15 years. His credits include *Outdoor Photographer, Outdoor & Travel Photography, Outside,* and *Vermont Life.*

Costs, Accommodations: Costs range from $99 for a weekend to $1,500 for a week. Some programs are tuition only and some are all-inclusive.

Location: The Catskill Mountains, Vermont, Maine, New Hampshire, the Berkshires, and Prince Edward Island.

Contact: Peter Finger, Peter Finger Photography, 55 Bobwhite Dr., Glenmont, NY 12077; (518) 432-9913, Fax (518) 439-1159.

INDIAN RIVER PHOTO WORKSHOPS
New York/May and September

Since 1981, nature photographers Steve Diehl and Vici Zaremba have conducted 5-day workshops in the western Adirondacks for intermediate to professional photographers. Enrollment is limited to 16 participants , who should be in good physical condition and able to hike with gear for several miles. Daily sessions consist of field trips, lectures, one-on-one demonstrations, and critiques. Instruction covers equipment, lenses, film, technique, plant identification, field ethics, freelancing, and working with publishers. Participants should bring samples of their work for critique and audiotaped critiques of workshop photos are mailed to participants.

Specialty: Nature.

Faculty: Stephen Diehl is assistant professor of photography at Rochester Institute of Technology, where he teaches nature photography, color photo design, and color printing theory. Freelance commercial photographer Vici Zaremba has a BFA. in photography from RIT's School of Photographic Arts and Sciences. They have conducted programs for New

York State Council on the Arts and their credits include *Outdoor and Travel Photography,* *Nature Conservancy,* and *Outdoor Photographer.*

Costs, Accommodations: The program fee includes tuition, taped critique, and lunches.

Location: Central New York's Finger Lakes Region.

Contact: Indian River Photo Workshops, P.O. Box 7, Antwerp, NY 13608; (315) 659-8544.

INTERNATIONAL CENTER OF PHOTOGRAPHY
New York/Year-round

Established in 1974 as New York City's museum of photography, the ICP offers approximately 20 to 25 workshops each quarter, as well as courses, lectures, seminars, and certificate and degree programs (page 171) for photographers, artists, editors, and others interested in photography. The Center is accredited by the American Association of Museums and holds an Absolute Charter from the Regents of the University of the State of New York. The 1- to 5-day workshops, limited to 12 to 25 participants, meet from 6 to 12 hours daily and offer intensive instruction in techniques and special topics. Workshops for beginning photographers include Intensive Introduction to Photography, Electronic Flash, and Hand-Coloring. Advanced workshops require a portfolio review or successful completion of 1 or more of the ICP's courses, which meet 3 hours weekly for 10 weeks. Topics include magazine photojournalism, large format, alternative printing processes, and the nude. Summer workshops cover such subjects as portraiture, fashion, computer graphics, the photo essay, and the fine print.

Specialties: A variety of topics.

Faculty: Instructors are ICP staff members and established professionals, including Guggenheim Fellowship recipients Emmet Gowin, Judy Dater, and Keith Smith; author and electronic flash specialist Lester Lefkowitz; 1984 Photographer of the Year Peter B. Kaplan; and award-winning photographers Charles Harbutt and Nan Goldin.

Costs: Workshop tuition ranges from $155 to $325; registration fee is usually $20 and studio or materials fee ranges from $10 to $60. ICP members receive tuition discounts. Credit cards accepted. Advanced workshop applicants who have not completed prerequisite courses must schedule a portfolio review prior to enrollment. Tuition refund, less a withdrawal fee, is granted those who submit written cancellations at least 10 business days prior.

Location, Facilities: Bordering Central Park on Manhattan's Upper East Side, the ICP houses galleries, archives, black & white darkroom and color facilities, library, screening room, and bookstore.

Contact: International Center of Photography, 1130 Fifth Ave., New York, NY 10128; (212) 860-1776.

IRELAND PHOTO AND CULTURAL EXCURSIONS
Ireland/May-September

Since 1975, Ron Rosenstock has conducted 2-week guided field trips in the west of Ireland. Enrollment is limited to 11 participants who are interested in photography and the culture and geography of Ireland. Daily activities consist of work in the field photographing seascapes, landscapes, old monasteries, monuments, and people. Instruction covers the Zone System, camera operation, filters, and discovering a personal vision. Participants also have the opportunity to meet Irish people and attend music sessions at local pubs as well as other cultural events.

Specialties: Travel and nature, with focus on Ireland.

Faculty: Ron Rosenstock, who specializes in large format nature photography, studied with Minor White and Paul Caponigro and has been teaching photography since 1967. He has been on the faculty of Clark University in Worcester, MA. for 25 years.

Costs, Accommodations: Land cost, which includes local transportation, breakfasts, suppers, and lodging at Ron Rosentock's house in Ireland, is $2,195 double occupancy ($350 single supplement). A $400 deposit is required, with refund, less $100 fee, granted cancellations up to 121 days prior.

Location: Hillcrest House, the workshop base, is located midway between Westport and Newport. The group travels south to Connemara and north to Achil Island, working at 2 or 3 locations daily.

Contact: Ireland Photo and Cultural Excursions, Voyagers International, P.O. Box 915, Ithaca, NY 14851; (800) 633-0299, Fax (6070257-3699.

JOHN HART STUDIO
New York/Year-round

Since 1984, John Hart has conducted 3-hour workshops that cover the techniques of portrait lighting. The workshops are limited to 3 intermediate photographers who usually meet in the late afternoon or evening.

Specialties: Lighting techniques and portraiture.

Faculty: John Hart is author of *50 Portrait Lighting Techniques, Lighting for Action,* and *Professional Headshots.*

Costs: The fee is $300 per 3-hour session. A $100 deposit is required, with the balance due the day of the workshop.

Location: Various New York City locations, including Riverside Park and Central Park.

Contact: John Hart Studio, 344 W. 72nd St., New York, NY 10023; (212) 873-6585.

NANCY BROWN PHOTOGRAPHIC WORKSHOPS
New York City/August-October

Since 1986, Nancy Brown has offered workshops for the serious photographer interested in beauty, fashion, and stock photography. One-week sessions are held once a month and limited to 15 participants. The commercially oriented program demonstrates different types of lighting techniques for studio and location situations and emphasizes learning to work with models, assistants, hair and make-up artists, stylists, and props. Students, who should have some knowledge of studio strobes, actively participate in shooting sessions, both in the studio and outside.

Specialties: Beauty, illustration, and stock photography.

Faculty: Former New York model Nancy Brown runs a beauty and fashion photography studio and is author of *Photographing People for Advertising* and *Photographing People for Stock.* Professional photographic assistants also work with the class.

Costs, Accommodations: The $1,000 workshop fee includes daily breakfast and lunch in the studio. A deposit of $450 must accompany application with balance due at workshop.

Location: The workshop is held in Nancy Brown's studio in New York City's photo district.

The class also goes on location around the city.

Contact: Nancy Brown, 6 West 20th St., New York, NY 10011; (212) 924-9105/9106.

NELSON BURACK PHOTOGRAPHY TOURS
U.S. and abroad

Since 1985, Nelson Burack has conducted tours that are limited to 16 photographers of all levels. Instruction is informal, with the emphasis on scenics and people. Participants are taught how to see photographically, and the appropriate use of black & white and color film.

Specialties: Travel photography.

Faculty: Nelson Burack has traveled and photographed in 41 countries and presents his slide programs at schools, libraries, and camera clubs. He has taken workshops and been influenced by George Tice, Arthur Leipzig, and Henry Shull.

Location: Includes Kenya and Tanzania, and Chile.

Contact: Nelson Burack, 55 Juneau Rd., Woodbury, NY 11797; (516) 496-8200.

NEVERSINK PHOTO WORKSHOP
Woodbourne/August

Since 1988, professional photographers Lou Jawitz and Ed Bohon have offered these Catskill Mountains summer week-end workshops to intermediate photographers who want to improve their technique and heighten their visual awareness. Each workshop begins with a Friday evening portfolio review and critique of the 8 participants' previous work and concludes Sunday afternoon. In addition to supervised field shooting, discussions cover the principles of pictorial photography, creative use of color, the effects of weather and time of day, film and equipment selection, stock photography, and marketing. Emphasis is on color, but students may work in black & white if they wish.

Specialties: Scenic and nature color photography.

Faculty: Lou Jawitz has been a professional photographer for more than 20 years and markets his work through The Image Bank. He has exhibited at Nikon House and other New York galleries and been featured in *Popular Photography*. Ed Bohon, a professional photographer for more than 12 years, has had articles on photographic technique published in *Modern Photography, Popular Photography, Studio Photography,* and *Outdoor & Travel Photography*.

Costs, Accommodations: Fee, which includes lunches, is $175. A 50% deposit must accompany application. Written cancellations at least 2 weeks prior receive full refund, less $25 fee. Accommodations at local inns and bed & breakfasts begin at $50 per night.

Location: The workshop is conducted out of Mr. Jawitz's restored 19th century barn, situated on the bank of the Neversink River, a popular trout stream. Photo opportunities include mountains, streams, waterfalls, covered bridges, farms, and meadows. Woodbourne is a 2-hour drive northwest of New York City, in the heart of the Catskill resort area.

Contact: Lou Jawitz, 13 E. 17th St., New York, NY 10003; (212) 929-0008 or (914) 434-0575, Fax (212) 929-2689.

THE NIKON SCHOOL
21 U.S. cities/September-June

Established in 1992, the Nikon School offers 50 one-day seminars a year for amateur to advanced amateur photographers. Attendance averages 200 participants, who can enroll in

either a Saturday or Sunday session in each city. The program combines audio-visual methods with lectures and covers lens selection, exposure, composition, lighting and flash, close-ups, nature and travel, films and filters, and tricks of the trade.

Specialties: 35 mm photography.

Faculty: Includes Sam Garcia and Bill Durrence, who have trained top photographers and NASA astronauts.

Costs: Tuition is $80, which includes lunch and the Nikon School handbook. A $15 fee is charged cancellations 5 days prior.

Location: Major cities in California, Colorado, Florida, Georgia, Illinois, Massachusetts, Missouri, New York, Ohio, Oregon, Pennsylvania, Texas, Washington, and Washington, DC.

Contact: The Nikon School, 1300 Walt Whitman Rd., Melville, NY 11747; (516) 547-8666, Fax (516) 547-0309.

NORTHLIGHT PHOTOGRAPHIC WORKSHOPS
U.S. locations/February-October

Established in 1995 by nature and travel photographer Brent McCullough, NorthLight offers 8 to 10 weekend to 10-day workshops and several 1-day seminars per year. Enrollment ranges from 6 to 20 serious amateurs and professionals, depending on location. Each workshop features group and individual instruction and critique, slow pace with maximum time in the field, marketing consultation, and evening discussions. A survey of published images of each location is available on site.

Specialties: Landscape, wildlife, and travel photography.

Faculty: Brent D. McCullough's 16 years of teaching experience include Fairleigh Dickinson University's Human Development program, Mohonk Mountain House, and the Montclair Art Museum. An ICP scholarship and New Jersey Council for the Arts fellowship recipient, his credits include *Outdoor Photographer,* Time-Life books, Sierra Club calendars, and Audubon nature calendars.

Costs, Accommodations: One-day seminars are $65; workshops range from $250 for a weekend to $1,675 for 10 days, which includes lodging, some meals, and ground transportation. Deposit ranges from $100 to $300, of which all but $100 is refundable for cancellations 91 days prior.

Location: Includes Baja, the Arizona desert, Bryce and Zion National Parks, Cape May, Mount Rainier, Yellowstone, the Maine coast, and the Oregon coast.

Contact: NorthLight Photo Workshops, 362 Bullville Rd., Montgomery, NY 12549; (800) 714-1375.

P.P.S.N.Y. PHOTO WORKSHOP
Geneva/August

Since 1968, the Professional Photographers' Society of New York has conducted an annual Monday-through-Friday series of specialized workshops for professional photographers in various aspects of portrait and commercial photography. Topics vary each year, depending on faculty, and may include portraiture, weddings, and print re-touching.

Specialties: Portrait and commercial photography.

Faculty: Has included Harold Bovee, Joe Arnone, Don Blair, Stephen Rudd, and Tom McDonald.

Costs, Accommodations: Tuition is $475, which includes meals and dormitory lodging. A $100 deposit is required. Refund granted cancellations prior to start of program.

Location: The Hobart/William Smith Colleges in Geneva, New York.

Contact: Lois Miller, Director, P.P.S.N.Y., 121 Genesee St., Avon, NY 14414; (716) 226-8351.

PARSONS SCHOOL OF DESIGN
New York City and Paris/
June and July

Parsons School and the New School for Social Research co-sponsor 2 annual summer photography programs: 4 weeks of study in Paris and a 5-week program in New York City, each with a student teacher ratio of 20 to 1. The Paris course is devoted to photographing neighborhoods, lectures on collections, the history of French photography, and professional practices. The New York program uses the city's landmarks, streets, and residents as photographic resources. The workshop emphasizes the development of work through lectures, discussions, field trips, specialized workshops, darkroom instruction, and assignments.

Specialties: Fine arts, documentary, and commercial photography.

Faculty: Has included Mimi Wlodarczyk, a graduate of Parsons and the New York University Graduate Film School who has exhibited internationally, and Terry Yank, an MFA graduate of Bard College who has been artist-in-residence for the North Carolina Council for the Arts.

Costs, Accommodations: Cost for Paris study, including airfare from New York, breakfasts, hotel lodging, and 6 undergraduate credits is approximately $4,200. The New York program is approximately $2,000 and includes residence-hall accommodation. A $350 deposit is required.

Contact: Office of Admissions, Parsons School of Design, 66 Fifth Ave., New York, NY 10011; (800) 252-0852, (212) 229-8910, Fax (212) 229-8975.

PHOTO ADVENTURE TOURS
Worldwide/March-December

Since 1986, this company has offered 5 to 10 tours each year for photographers of all levels. The 1- to 27-day programs are accompanied by local guides and a qualified photographer who is available to assist participants.

Specialties: Travel photography.

Costs, Accommodations: Costs, including meals, lodging, and local transportation, range from approximately $385 for the 3-day Albuquerque Balloon Fiesta to $3,700 for 3 weeks in India. A $200 to $400 deposit secures registration with balance due 60 days prior.

Location: Albuquerque, New York, Navajoland, Iceland, India, China, Nepal, South Africa, and Russia.

Contact: Richard Libbey, Mgr., Photo Adventure Tours, 2035 Park St., Atlantic Beach, NY 11509-1236; (516) 371-0067 or (800) 821-1221, Fax (516) 371-1352.

SAGAMORE INSTITUTE — PHOTOGRAPHING NATURE
Raquette Lake/February,
May, September

This historic resort, built by William West Durant in 1897, is run by Sagamore Institute, a

nonprofit organization dedicated to preserving history and the environment, professional growth, and arts and crafts. Sagamore offers programs on fishing, storytelling, llama trekking, arts and crafts, and 3-day photography weekends. Photographing the Upper Hudson, scheduled in the spring and fall, is a trip by wooden boat to shoot inaccessible portions of the river corridor and includes guidance in composition and exposure. Photographing Winter combines field work, discussion, and critique and covers such topics as composition, equipment, and camera care in winter weather. Enrollment is limited to 10 students.

Specialties: Nature.

Faculty: Gary Randorf is a photographer and naturalist specializing in the Adirondack region. His credits include *Adirondack Life, Audubon,* and *Travel & Leisure.*

Costs, Accommodations: The $445 (Hudson trip) and $220 (Winter trip) fees include double occupancy lodging and meals. A $100 deposit is required and refund, less $50, is granted cancellations more than 15 days prior.

Location: Sagamore is near Raquette Lake in the central Adirondack mountains, 2 1/2 hours north of Albany and 3 hours south of Canada.

Contact: Sagamore, P.O. Box 146, Raquette Lake, NY 13436; (315) 354-5311, Fax (315) 354-5851.

SCHOOL OF VISUAL ARTS
New York/June, August

The School of Visual Arts offers a Bachelor of Fine Arts and graduate degrees in photography (page 174) as well as 3- to 5-day summer workshops. Topics include Ansel Adams' Zone System, Basic Studio Photography, The Professional Photographer's Assistant, Travel and Location Photography, Polaroid Process, Photography to Painting, The Nude, and Hands-on Lighting.

Specialties: A variety of topics including lighting, photographic illustration, planning a photography exhibit, and the Polaroid process.

Faculty: Seven-member faculty includes Ed Meyers, a commercial photographer and writer and former executive editor of *Popular Photography;* Bill Newman, a professional photographer's assistant; Susan McCartney, who studied with Richard Avedon and Melvin Sokolsky; Bernard Lawrence, who studied with Richard Avedon and has been published in *Harper's Bazaar, Glamour,* and *Seventeen;* and John Reuter, with credits in *Aperture, American Photographer,* and *Popular Photography.*

Costs: Tuition ranges from $290 to $390 plus a nonrefundable $20 registration fee. Credit cards accepted. Written withdrawals prior to first session receive full refund.

Location: The School of Visual Arts is on Manhattan's East Side.

Contact: Joseph Cipri, School of Visual Arts, Office of Continuing Education, 209 E. 23rd St., New York, NY 10010; (212) 592-2055, Fax (212) 592-2060.

SOUTHAMPTON MASTER PHOTOGRAPHY WORKSHOP
Southampton/July and August

Established in 1985, Long Island University's Southampton Master Photography Workshop consists of approximately a dozen week-long workshops and weekend conferences. Each workshop is limited to 15 intermediate to advanced photographers, who are encouraged to develop their own creative and technical skills.

Specialties: A variety of art, technical, and professional topics.

Faculty: Has included Renate Pfleiderer, winner of two 1993 Boli awards; Robert Giard, who specializes in portrait, landscape, and nude; Cheryl Machal Dorskind, a specialist in hand-painted photography who has been published in the *New York Times* and *Country Living;* Diane Vahradian, co-director of the Southampton workshops; and Lynton Gardiner, formerly a staff photographer for the Metropolitan Museum of Art.

Costs, Accommodations: Five-day workshop tuition is $365 per undergraduate credit, $382 per graduate credit; lab fee is $50; registration fee is $15. Dormitory lodging and meals are available on a first-come, first-served basis for $78 to $125 per week. Full refunds, less $25 deposit, for cancellations prior to workshop.

Location: Long Island University's Southampton Campus, in the Hampton ocean resort and art community.

Contact: Carla Caglioti, Summer Director, Summer Programs, Southampton College, Long Island University, 239 Montauk Hwy., Southampton, NY 11968-4198; (516) 287-8349 or (516) 287-8427, Fax (516) 283-4081.

STUDIO CAMNITZER SUMMER PRINTMAKING PROGRAM
Valdottavo/June-August

Since 1975, Studio Camnitzer has offered graphics arts courses that are designed to assist the participant in maximizing expression through exploration or invention of appropriate techniques. The two 5-week summer sessions are each limited to 10 artists and students, selected on the basis of motivation and commitment, who work with 1 faculty member and 2 assistants. Workshop activities, which are based on individual tutorials, include such printmaking techniques as photography, intaglio, relief techniques, and mixed-media techniques. The first session concentrates on aesthetic problem-solving and photo-etching techniques, including color separation; the second session stresses multi-plate color etching and registration, non-acid techniques, and photo-etching. Seven hours of instruction are offered weekdays (4 hours on Wednesday), and the studio is available as an open, informal workshop all day Sunday.

Specialty: Printmaking.

Faculty: Studio director Luis Camnitzer is Professor of Art, SUNY-Old Westbury, and an Honorary Member of the Academy of Florence. His work is represented in such collections as New York's Museum of Modern Art, Metropolitan Museum, and Public Library, and the Bibliothèque Nationale in Paris. He is assisted by Carlos Capelan, artist resident in Sweden. The Studio is known for its work and textbook on 4-color separation photo-etching.

Costs, Accommodations: Tuition, including 4 lunches and general supplies, is $2,000 for each session. Applications, which must include artistic background and proposed project, 10 slides of work, 2 character references, and a $200 deposit, are accepted until March 25. Cancellations prior to April 25 receive full refund; deposit is forfeited thereafter; tuition is forfeited after May 10. Dormitory housing is $530 per week double occupancy, $720 single.

Location, Facilities: The Studio, originally an 18th century farmhouse, includes intaglio, relief, and photographic facilities. It's in the Tuscan village of Valdottavo, 1 hour from Florence.

Contact: Luis Camnitzer, Studio Camnitzer, 124 Susquehanna Ave., Great Neck, NY 11021; (516) 466-6975, Fax (516) 487-8244.

TISCH SCHOOL OF THE ARTS-NYU
New York/Summer

New York University's Tisch School of the Arts offers a limited enrollment summer program of of applied production courses and professional seminars for serious students and professionals. Courses cover color printing, studio and large format photography, documentary and photo essay, electronic imaging, and non-silver and historical processes.

Location: Greenwich Village.

Contact: American Photography Institute, Tisch School of the Arts, New York University, 721 Broadway, 8th Fl., New York, NY 10003; (212) 998-1930.

VISUAL STUDIES WORKSHOP SUMMER INSTITUTE
Rochester,/Summer

Founded in 1969 as a learning center for photography, visual books, video, and independent film, the nonprofit Visual Studies Workshop provides services that range from education, exhibition, and publishing programs to facilities for the production of artworks and resources for scholarly research. Educational programs include an M.F.A. Program in Visual Studies through SUNY Buffalo and SUNY College at Brockport, year-round evening and weekend courses, and a summer institute, which sponsors about 2 dozen 1- and 2-week workshops and seminars, each limited to 12 participants of all levels.

An Artists-in-Residence program, started in 1983, provides month-long residencies and an honorarium. Applications are reviewed in April. VSW also publishes *AFTERIMAGE,* a monthly journal of photography, independent film, video, and artists' books.

Faculty: Has included freelance magazine photographer Charles Harbutt, whose credits include *Life, Paris Match,* and *Epoca;* landscape photographer Mark Klett, who published *Traces of Eden: Travels in the Desert Southwest;* VSW founder and director Nathan Lyons, who is the author and editor of many books; and Judy Natal, who has been awarded several grants.

Location, Facilities: VSW is located in Rochester's Museum District within walking distance of galleries and museums. The workshop facilities include galleries, research center, bookstore, and darkrooms.

Contact: Visual Studies Workshop, 31 Prince Street, Rochester, NY 14607; (716) 442-8676.

VOYAGERS INTERNATIONAL
Worldwide/Year-round

Since 1983, Voyagers International has sponsored overseas photographic workshops that emphasize the art of seeing as well as camera technique. Trips range from 10 days to 3 weeks and are usually limited to 8 to 12 participants. Instruction is informal with opportunities for individual tutoring and evening discussion groups.

Specialties: Nature and travel photography.

Faculty: Trips are led by experienced, working photographers including Walt Anderson, Craig and Nadine Blacklock, Alan Briere, Kevin Bubriski, Katherine Feng, John and Barbara Gerlach, Weldon Lee, Joe and Mary Ann McDonald, Boyd Norton, David Robbins, Ron Rosenstock, and Robert Winslow.

Costs, Accommodations: Cost, including round-trip airfare, most meals, and shared

lodging, ranges from about $2,000 for 10 days to $5,500 for 3 weeks. A partially refundable $400 deposit must accompany enrollment, with balance due 60 days prior.

Location: Includes East Africa, the Galápagos, India, Indonesia/Malaysia, Ireland, Nepal, New Zealand, Southern Africa, Tahiti, Tuscany, and Venezuela.

Contact: Voyagers International, Dept. GPW, P.O. Box 915, Ithaca, NY 14851; (607) 257-3091 or (800) 633-0299.

WOMEN'S STUDIO WORKSHOP
Rosendale/Spring, Summer, Fall

This multi-disciplinary nonprofit arts organization, dedicated to contemporary arts education, offers 5-day summer workshops and weekend spring and fall workshops. Topics include basic black & white photography, photo printmaking, and non-silver processes. Enrollment is limited to 6 participants.

Faculty: Tana Kellner, MFA-RIT; Jill Gusso, MFA-RIT; Marilyn Sware, author of *The New Photography;* and Bea Nettles, chair of the photography program at the University of Illinois.

Costs, Accommodations: Weekend workshop is $120; 5-day workshops are $310 each ($290 for members). A $50 deposit is required. Cancellations more than 1 month prior receive full refund; deposit is forfeited thereafter. Lodging is available nearby. Membership in the Women's Studio Workshop begins at $25 for an individual ($35 family).

Location: In the Binnewater Arts Center near Rosendale, a village in the foothills of the Catskills, 90 minutes north of New York City.

Contact: Women's Studio Workshop, P.O. Box 489, Rosendale, NY 12472; (914) 658-9133.

WOODSTOCK PHOTOGRAPHY AND TRAVEL WORKSHOPS
Woodstock and other locations/
May-October

Founded in 1977, the nonprofit Center for Photography at Woodstock started its workshop program in 1979 and began offering travel workshops in 1992. About twenty 1- and 2-day weekend workshops are scheduled during the summer and three or four 4- to 17-day travel workshops are offered in spring and fall. Enrollment is usually limited to 15 participants and trips are accompanied by 2 instructors. The emphasis is on creativity and each program usually includes group interaction, hands-on work, and individual portfolio review. A Saturday evening lecture, which runs parallel to the workshop, is open to the public.

Specialties: A variety of topics, including photojournalism, digital imaging, stock photography, portraiture, black & white printing, the nude, magazine photography, landscape, fashion and figure, Polaroid, platinum/palladium printing, and exhibiting.

Faculty: Has included Marie Cosindas, Cole Weston, Eikoh Hosoe, Maggie Steber, Wendy Ewald, Arnold Newman, Sally Mann, Lilo Raymond, Lucien Clergue, William Albert Allard, and Craig Stevens.

Costs: Cost ranges from $75 to $325 for workshops at the Center and up to $2,700 for travel workshops. Full tuition is required for workshops at the Center, 50% deposit for travel workshops. Credit cards accepted. Cancellations 3 weeks prior forfeit $40. Discounts are available to Center members and those who enroll in more than 1 workshop. Each year 3 interns are selected who work from July through September for tuition remission and experience. Personal interviews are held in March and April.

Location: Most weekend workshops are held at the Center in Woodstock, an art colony on the edge of the Hudson River Valley along the base of the great eastern escarpment of the Catskill Mountains. Some programs are in New York City. Travel workshop destinations have included Santa Fe, Italy, Ireland, France, and Mexico.

Contact: The Center for Photography at Woodstock, 59 Tinker St., Woodstock, NY 12498; (914) 679-9957, Fax (914) 679-6337.

ZEN MOUNTAIN MONASTERY
Mt. Tremper/Summer

Zen Mountain Monastery, the main house of the Mountains and Rivers Order of Zen Buddhist temples in the U.S. and abroad, offers week-long summer workshops in mindful photography, an approach to photography as a spiritual practice that enhances the art of seeing and develops perception of the original, unconditioned eye. The program is designed for workers in the visual arts, particularly photographers interested in the exploration of the self in self-expression. The practice of mindful photography is introduced through meditation, creative audience feed-back sessions, and work on visual koans. Zen Mountain Monastery also offers a year-round art practice program.

Specialties: Photography within the Zen Buddhist context.

Faculty: Sensei John Daido Loori, Vice-Abbot of Zen Mountain Monastery, has given lectures and workshops on Zen photography for more than 18 years. He studied with Minor White and has been widely exhibited and published in the Zen Writing series, *Aperture,* and the Time-Life Photography series.

Costs, Accommodations: Cost is $325 per week and includes room, board, and training in Zen Buddhism. Location: The Monastery is on a 200-acre nature sanctuary in the foothills of the Catskill Mountains near Kingston, 120 miles north of New York City and 80 miles south of Albany.

Contact: Zen Mountain Monastery, S. Plank Rd., Box 197, Mt. Tremper, NY 12457; (914) 688-2228, Fax (914) 688-2415.

NORTH CAROLINA

THE JOHN C. CAMPBELL FOLK SCHOOL
Brasstown/Year-round

Founded in 1925, John C. Campbell Folk School is the nation's oldest and largest craft school, offering more than 350 intensive weekend and 5-day craft workshops and music and dance programs throughout the year. Disciplines include fiber, jewelry, blacksmithing,

woodworking, watercolor, clay, enameling, and photography. Workshop enrollment is limited to 10 to 12 adult students of all levels. The 1-week photography programs consist of such introductory and specialty workshops as Understanding Your Camera, Color Photography, Your Landscape or Mine, Start Your Own Darkroom, and Hand Coloring Black & White Photographs. Other activities include slide shows, morning campus walks and song programs, videos, picnics, campus tours with historical lectures, crafts demonstrations, and music and dance.

Specialties: Basic photographic and darkroom techniques.

Faculty: The 10-member photography faculty includes Mary Jo Brezny, Glenn Barnett, and Ruth Harris.

Costs, Accommodations: Tuition, lab fee, room, and all meals are approximately $225 per week plus materials and supplies. Room and board is available.

Location, Facilities: The 365-acre campus, a national historic site, is in a mountain setting, seven miles east of Murphy, NC, 2 1/2 hours from Knoxville, Chattanooga, and Asheville, and 100 miles north of Atlanta. The school is within 50 miles of the Cherokee Indian reservation and Joyce Kilmer National Forest. Facilities include guest houses, studios, open-air pavilions, and a log cabin museum.

Contact: Ruth Truett, Instruction Manager, John C. Campbell Folk School, Rte. 1, Box 14A, Brasstown, NC 28902; (800) 365-5724 or (704) 837-2775, Fax (704) 837-8637.

NATURE'S PERSPECTIVE
Townsend, Tennessee/Spring

Since 1988, Tim Black and William Lea have taught weekend workshops on the fundamentals of nature and wildlife photography, emphasizing 35mm format and the use of natural light. The program, which is limited to 10 beginners per instructor, includes field work and lectures on techniques, equipment, composition, exposure, use of blinds, filing systems, and locations.

Specialties: Nature and wildlife.

Faculty: Tim Black's work has appeared in *Outdoor America, Nature Conservancy,* and Sierra Club Calendars; William S. Lea's work has been published in *American Forests, Field & Stream,* and *Outdoor Canada.*

Location: Townsend, near Great Smoky Mountains National Park.

Contact: Nature's Perspective, 205 Wayah Rd., Franklin, NC 28734; (704) 369-6044.

PENLAND SCHOOL
Penland/March-November

Founded in 1929, this multi-discipline craft school offers 1- and 2-week summer workshops and 8-week concentrations in fall and spring. One photography workshop, open to individuals of all levels, is scheduled during each session. The programs, which reflect the instructor's area of expertise, emphasize process, manipulating imagery or altering surfaces, and are designed to encourage the student to exercise creativity and explore new ideas and techniques. Recent workshop topics have included black & white, non-silver, mixed-media, and photo-print processes.

Faculty: Has included Alida Fish, Bea Nettles, Jay Phyfer, Evon Streetman, Jayne Wexler, Wallace Wilson, and Jeffrey Wolin.

Costs, Accommodations: Tuition is $450 for a 2-week workshop. A nonrefundable $25 fee must accompany registration. College credit is available through East Tennessee State University for an extra charge. A limited number of work-study scholarships are available each session based on need. Assistantships are available to applicants who are equivalent to graduate level students with a full knowledge of a working studio.

Location, Facilities: The photography studio is housed in the newest building on campus. Penland's 470 acres and 47 buildings are located 50 miles northeast of Asheville Airport .

Contact: Dana Moore, Asst. Director, Penland School, Penland Rd., Penland, NC 28765; (704) 765-2359, fax (704) 765-7389.

OHIO

BIXEMINARS PHOTOGRAPHY SEMINAR
Ohio and Pennsylvania/
February, June, October

This weekend seminar, limited to 20 beginners through advanced amateurs, provides 26 hours of instruction in composition, lighting, cityscapes, outdoor portraits, floral close-ups, and special effects. An early bird session for beginners covers f-stops, film and shutter speeds, guide numbers, and other camera basics.

Specialties: Outdoor photography and other topics.

Faculty: Photojournalist Richard C. "Bix" Bixler, holds highest awards of Ohio News Photographers Association, Greater Canton Writers' Guild, and Canton Advertising Club.

Costs: Tuition is approximately $175 for registrations two weeks prior, $200 thereafter; former students may receive discount. Full refund for cancellations more than ten days prior; 50% thereafter.

Location: Sites in eastern and central Ohio, western Pennsylvania, and West Virginia.

Contact: Bixeminars, 919 Clinton Ave. SW, Canton, OH 44706-5196; (216) 455-0135.

EXUMA WORKSHOPS
Exuma, Bahamas/January, June

Established in 1993, Exuma Workshops offer four 1-week programs per year in the Bahamas for 12 participants. The schedule includes daily photo sessions and discussions designed to aid creative growth and help participants solve technical problems. The Art of Travel Photography covers principles and aesthetics of good photography, logistics, equipment, and how to get assignments. The Glamour Workshop features experienced photographic models and scenery.

Specialties: Travel and glamour, including landscape, underwater, and photojournalism.

Faculty: Includes Harvey Lloyd, an aerial, location, landscape, and fine-art photographer and winner of a 1990 National Art Directors Club gold medal in advertising and silver medal in photography; Bill Suttle; and Bob Shell, a photographer and author who is editor of *Shutterbug* and technical advisor for *Photopro,* and has written three professional camera system manuals.

Costs, Accommodations: Cost, which includes lodging, is $995 for glamour photography and $895 for travel photography. A $100 nonrefundable deposit is required. Full refund for cancellation at least 30 days prior; 50% refund for cancellation 20-30 days prior. Lodging includes a pool and beach.

Location: Georgetown, Exuma, Bahamas.

Contact: Barry J. Benjamin, Benjamin Publishing Co., 1862 Akron-Peninsula Rd., Akron, OH 44313; (216) 928-3674 or (800) 466-1464, Fax (216) 928-9124.

MCNUTT FARM II OUTDOORSMAN LODGE
Blue Rock/Spring, Fall, Winter

Since 1974, Patty McNutt has taught outdoor-wildlife photography seminars that stress livestock and animal images. Programs, limited to 4 students per instructor, meet 6 hours daily and include review of work and one-on-one instruction. Camcorder and 35-mm techniques are taught in various settings.

Specialties: Outdoor photography emphasizing livestock and animals.

Faculty: Outdoor writer-photographer Patty L McNutt owns and operates the farm/lodge with her husband.

Costs, Accommodations: The fee of $140 per day includes lodging. A 50% deposit secures a reservation. No refunds.

Location, Facilities: The modern, rustic lodge is in southeastern Ohio hill country near Zanesville and Blue Rock State Forest. Recreational activities include trail rides, archery, riflery, fishing, swimming, canoeing, and hiking. Facilities are available for those who wish to bring horses.

Contact: Patty L. McNutt, McNutt Farm II Outdoorsman Lodge, 6120 Cutler Lake Rd., Blue Rock, OH 43720; (614) 674-4555.

NATURE'S LIGHT
U.S./Year-round

Since 1993, Nature's Light has offered 14 to 16 nature and outdoor photography field workshops and tours per year. The 2-day weekend workshops, limited to 25 students of all levels, and 7-day tours, limited to 12, are held in wilderness areas throughout the U.S. and allow each participant to work side by side with the instructor. Workshops begin with a Friday evening slide presentation on the technical and aesthetic aspects of photography; Saturday and Sunday are spent in the field. A 2-day extension is limited to 12 participants. Tours are designed to maximize photo opportunities and a typical day is spent in the field from sunrise until sunset. All tours require some hiking though most are short and easy.

Specialties: Nature and landscape photography.

Faculty: Adam Jones has been published in *Wildbird*, *Birder's World*, and *Peterson's Photographic* and in calendars and notecards for Audubon, the Sierra Club and the National Parks & Conservation Associations. William Manning's credits include *Outdoor Photographer* and *Travelogue*, as well as Sierra Club and Photographers Forum calendars.

Costs, Accommodations: Tours range from $775 to $1,150, including double occupancy lodging; single supplement available. A $200 deposit is required with balance due 60 days prior. Full refund granted cancellations 91 days prior. Workshop cost, tuition only, is generally $150; the 2-day extension is $125. A 50% refundable deposit is required, with balance due 30 days prior; no refunds thereafter.

Location: Includes Arches National Park in Utah, Grand Tetons and Yellowstone National Parks in Wyoming, Great Smoky Mountains National Park in Tennessee, Big Bend National Park in Texas, and Everglades National Park in Florida.

Contact: William Manning, Nature's Light, 7805 Lake Ave., Cincinnati, OH 45236; (513) 793-2346.

OHIO INSTITUTE OF PHOTOGRAPHY AND TECHNOLOGY
Dayton/Summer

Established in 1971, OIPT offers Diploma and Associate Degree programs in photography (page 177) as well as a summer workshop program.

Faculty: OIPT staff members, whose backgrounds range from 5 years of work experience to masters' degrees.

Location: Three miles south of downtown Dayton.

Contact: Ohio Institute of Photography and Technology, 2029 Edgefield Rd., Dayton, OH 45439; (513) 294-6155 or (800) 932-9698, Fax (513) 294-2259.

OKLAHOMA

DAVID HALPERN PHOTOGRAPHY WORKSHOPS
Western U.S./May-September

First offered in 1991, these weekend and 1- week workshops emphasize hands-on teaching and the fulfillment of student goals. The programs, limited to 20 students with 2 instructors, cover such topics as general landscape and nature photography, large format photography, and the art of seeing. About a half-dozen programs are scheduled annually, some with institutional sponsors. Each May, a nature photography workshop is conducted at Quartz Mountain State Park.

Faculty: David Halpern and 2 part-time assistants. All are practicing professionals with publication and exhibition credits and institutional teaching experience.

Location: Includes Colorado's San Juan Mountains, the Rocky Mountain National Park, and Quartz Mountain State Park in Oklahoma.

Contact: David Halpern Photography Workshops, 7420 E. 70th St., Tulsa, OK 74133-7719; (918) 252-4973, Fax (918) 252-5710.

OKLAHOMA ARTS INSTITUTE
Quartz Mountain State Park/ October

Established in 1976 as a nonprofit institution dedicated to providing summer workshops for artistically gifted children, the Oklahoma Arts Institute began offering October weekend workshops for adult photographers and artists in 1983. The 4-day workshop is led by a noted expert and limited to 20 professionals and serious amateurs who desire an intensive class and study environment in which to develop their skills. Six hours of classes are scheduled daily, including studio work, field trips, and darkroom experience and evenings are devoted to faculty presentations. Other weekend activities include chamber music concerts, nature hikes, panel discussions, and lectures by visiting artists.

Specialties: Landscape, fine art, photojournalism, darkroom technique.

Faculty: Has included photographers Paul Caponigro, Ralph Gibson, Sally Mann, Arnold Newman, and John Sexton.

Costs, Accommodations: Each workshop is $450, including shared lodging and meals.

A $125 deposit is required. Refund is granted cancellations at least 14 days prior. Accommodations are provided in lodge rooms or cabins.

Location, Facilities: Quartz Mountain State Park is in the Great Plains country of southwestern Oklahoma, 20 miles north of Altus. Facilities include new studio pavilions, gallery library, amphitheatre, and darkroom.

Contact: Linda DeBerry, Asst. Program Director, Oklahoma Arts Institute, P.O. Box 18154, Oklahoma City, OK 73154; (405) 842-0890, Fax (405) 848-4538.

OREGON

DUCKWORTH FORENSIC PHOTOGRAPHY

John Duckworth has taught evidence photography courses for professionals and aspiring professionals since 1975. His 30-hour seminar on the science of evidence photography is offered by invitation (based on student questionnaire) and covers such subjects as crime scene, traffic fatality, assault, autopsy, latent print, surveillance, arson, physical evidence, and court preparation. All classes are certified by the Board of Police Standards and Training and the Fire Standards and Accreditation Board for Oregon law enforcement and fire personnel. Programs are also available to agencies and groups.

Specialties: Forensic photography.

Faculty: John Duckworth, author of Forensic Photography, was head of the Oregon State Police evidence photography lab. He has developed the curriculum, taught forensic photography at colleges and agencies, and currently serves as a consultant to law enforcement and corporate clients.

Costs, Accommodations: Tuition and expenses vary depending on class content, size, and location.

Location: Group programs can be held anywhere in the U.S.

Contact: John E. Duckworth, 2495 Maple Ave, NE., Salem, OR 97303; (503) 364-9570.

FOLKWAYS INSTITUTE
Locations abroad

Folkways Institute, a private U.S.-based international education organization, develops and coordinates overseas study programs, seminars, and educational tours that emphasize cross-cultural learning experiences and education in natural and cultural history. Photo workshop topics have included people and landscape, composition and aesthetics, and wildlife and nature. Each group is limited to 8 to 15 participants.

Specialties: Travel, landscape, nature, wildlife, aesthetics, people.

Faculty: Each trip is conducted by a program leader whose background is suited to the region and focus of the trip. Faculty has included photographer/writer/teacher Ken Wanderer, who has published articles and photographs and taught journalism, history, photography, and mountaineering; and freelancer and community college photography instructor Robert Stahl.

Location: Has included Nepal, India, Bhutan, and Kenya.

Costs, Accommodations: Costs vary depending on program.

Contact: Folkways Institute, 14600 SE Aldridge Rd., Portland, OR 97236-6518; (800) 225-4666 or (503) 658-6600, Fax (503) 658-8672.

HAYSTACK PROGRAM IN THE ARTS AND SCIENCES
Cannon Beach/Summer

Established in 1968 by Portland State University, this summer-long educational program offers courses in visual arts, writing, and music, as well as special readings, concerts, and art shows. Classes meet weekdays and the student-teacher ratio is 15 or 20:1. Each week culminates in readings, exhibitions, and performances by students and faculty. Informal activities include evening gatherings, cookouts, discussion sessions, concerts, and readings. Photography workshops cover such topics as portrait and outdoor photography and consist of lectures, slide presentations, discussions, demonstrations, and studio and/or field work. Basic knowledge of camera and photography is helpful.

Specialties: Outdoor photography and other topics.

Faculty: Has included John Barna, MA, director of PSU's photography program, who taught at San Francisco State College and established the Silver Gallery for student exhibitions in Portland; and Tony Capone, a local portrait photographer and lecturer in the PSU program.

Location: On Oregon's scenic North Coast, Cannon Beach is served by Highways 26 and 101 and is 80 miles west of Portland.

Contact: Haystack Program in the Art and Sciences, Portland State University, P.O. Box 751, Portland, OR 97207; (800) 547-8887, ext. 4081 or (503) 725-4081.

OREGON SCHOOL OF ARTS AND CRAFTS
Portland /Year-round

Established in 1906, this accredited 4-year college offers workshops in book arts, ceramics, drawing, fibers, metal, wood, and photography. Some programs are open to all levels while specialized topics are geared to those with intermediate to advanced skills. Three-day photography workshop topics include landscape photography of the Oregon coast and creative imagery. Enrollment is limited to 15 participants per instructor.

Specialties: A variety of topics.

Faculty: Includes Harrison Branch, Rick McKee Hock, and Rosamond Wolff Purcell.

Location, Facilities: The 7-acre campus, built in 1979, consists of 9 buildings with studios, library, and galleries. Portland's city center is 10 minutes away.

Contact: Valorie Hadley, Admissions Counselor, Oregon School of Arts and Crafts, 8245 SW. Barnes Rd., Portland, OR 97225; (503) 297-5544; Fax (503) 297-9651.

SITKA CENTER FOR ART AND ECOLOGY
Otis/Summer

Founded in 1970 as a learning center for art, music and the ecology of the central Oregon coast, the Sitka Center for Art and Ecology offers more than 30 summer workshops and seminars in painting, fibers, book arts, music, ecology, and ceramics, including two or three weekend workshops in photography. Enrollment is limited to 10 to 20 participants of all levels.

Specialties: A variety of topics.

Faculty: Has included Douglas Frank, whose platinum prints are in the San Francisco Museum of Art and Bibliothèque Nationale; and fine art photographer Deborah DeWitt.

Location: Otis, on Oregon's central coast.

Contact: Randall Koch, Exec. Director, Sitka Center for Art & Ecology, P.O. Box 65, Otis, OR 97368; (503) 994-5485.

UNIVERSITY OF OREGON PHOTOGRAPHY WORKSHOP
Malheur Field Station/June

Since 1985, the University of Oregon has offered an annual 1-week outdoor photography workshop at the Malheur Field Station in eastern Oregon's high desert country. The program provides field experience in diverse locales, supplemented by lectures, critique, and darkroom demonstrations. Student to instructor ratio is 8:1 with one assistant.

Specialties: Outdoor and nature.

Faculty: Workshop director Terri Warpinski has taught at the University of Oregon since 1984.

Location, Facilities: Participants visit ghost towns, Diamond Crater, the Alvord Desert and hotsprings, a 3,000-foot lava tube cave with subterranean lake, and Steens Mountains.

Contact: Prof. Terri Warpinski, Dept. of Fine Arts, University of Oregon, Eugene, OR 97403; (503) 686-3610.

PENNSYLVANIA

AARDWOLF WORKSHOPS
California and the Bahamas/
March, May, June, August

Begun in 1985, the Aardwolf Group offers sailing trips to the Bahamas and houseboat excursions on Lake Mead and Lake Powell. Three 7-day trips are scheduled yearly, each limited to 12 to 16 participants of all levels. Emphasis is on video production principles and basic still photographic techniques. The Bahamas trip is held aboard a 65-foot motor-sailor that affords access to remote islands and reefs.

Specialties: Video production, basic still techniques.

Faculty: Dr. Thomas Reed has done video and photographic work for BBC, *National Audubon,* and *National Geographic.*

Costs, Accommodations: Cost of $695 includes food and basic sailboat or luxury houseboat lodging.

Contact: Dr. Thomas Reed, TOR Studio, c/o Aardwolf Group, 321 Dean St., West Chester, PA 19382; (610) 436-6844 (phone/fax).

JOE MCDONALD WILDLIFE PHOTOGRAPHY
U.S. and abroad/Year-round

Since 1985, Joe McDonald has conducted workshops and safaris for photographers who have a basic camera knowledge. The schedule includes approximately a dozen weekend (general nature, electronic flash, snakes, birds, regional subjects) and 1-week (wildlife and scenery of specific locations) workshops, each limited to 12 participants, and 3 or 4 photo safaris or tours, each limited to 6 to 18 participants. Workshops provide a maximum amount of shooting time in the field, usually from before dawn to dusk, with evening slide lectures devoted to subject matter, exposure, composition, lens selection, macro, flash, and camera handling. Photo tours and

safaris include a pre-safari workshop day which covers exposure, composition, lenses, and special subjects.

Specialties: Nature and wildlife.

Faculty: Professional wildlife photographer Joe McDonald's credits include *Audubon, Natural History, Outdoor Photographer, Smithsonian, Sports Afield,* and *Time;* and Audubon, Sierra, and Nikon calendars. He is author of 3 books on wildlife photography, including *A Practical Guide to Photographing American Wildlife.* His wife Mary Ann, also a professional photographer and author, co-leads the programs.

Costs, Accommodations: Workshop fees, including food and lodging, are $400 for a weekend. Photo tour fees, which include most meals and lodging, range from $775 to $2,500. A $200 deposit is required. Full refund is granted cancellations at least 60 days prior.

Location: Includes Pennsylvania, Florida, Montana, Wyoming, Arizona, Utah, Kenya, Argentina, the Galápagos, and Costa Rica.

Contact: Joe McDonald, McDonald Wildlife Photography, RR 2, Box 1095, McClure, PA 17841-9340; (717) 543-6423 (phone/fax).

MICHAEL A. SMITH/PAULA CHAMLEE WORKSHOPS
Grand Canyon/Year-round

Photographers Michael Smith and Paula Chamlee offer workshops and an apprenticeship program for 8 intermediate and advanced photographers. The emphasis is on photographic seeing and personal vision.

Faculty: Michael A. Smith and Paula Chamlee, whose photographs have appeared in major museums and recent books.

Costs, Accommodations: Ranges to $3,000 for the Grand Canyon workshop, which includes meals and camping accommodations. A deposit is required.

Location: Colorado River in the Grand Canyon and other locations.

Contact: Michael A. Smith, P.O. Box 400, Ottsville, PA 18942; (610) 847-2005, Fax (610) 847-2373.

POCONO ENVIRONMENTAL EDUCATION CENTER
Dingmans Ferry/
January, April-July, October

Since 1975, this nonprofit organization has sponsored teacher workshops, birding weekends, creative arts workshops, Elderhostels, educational family vacations, and a variety of environmentally focused programs. Three-day photography workshops, limited to 24 students with 2 instructors, feature sunrise photo shoots, afternoon field trips, evening presentations, and critiques. Topics include basic techniques, macro lenses and flash, telephoto, environmental photography, and seasonal colors.

Specialties: Nature and wildlife; using photography in the classroom.

Faculty: Published photographer and educator Timothy White; macro specialist Marilyn Takesh, who has been published in *New Jersey Outdoors* magazine; bird photographer Arthur Morris; Dan Hendey, whose credits include the *Washington Post;* Frank Knight, who has been published in *NYS Conservationist, New Jersey Outdoors,* and *Natural History.*

Costs, Accommodations: Cost ranges from $105 to $120, which includes meals and lodging. A $25 nonrefundable deposit is required. Participants are housed in single-room, heated cabins with modern plumbing and electricity.

Location, Facilities: The field center is in the Delaware Water Gap, 2 hours from New York City and 3 hours from Philadelphia. It consists of 38 acres of residential facilities and 200,000 acres of public lands. Facilities include an indoor pool, arts and crafts center, darkroom, dance floor, library, bookstore, and computer lab.

Contact: Tom Shimalla, Asst. Director, Pocono Environmental Education Center, RR 2, Box 1010, Dingmans Ferry, PA 18328; (717) 828-2319, Fax (717) 828-9695.

TOUCHSTONE CENTER FOR CRAFTS
Farmington/June-August

Opened in 1972 as a summer arts center in a mountain retreat setting, Touchstone offers a series of intensive weekend and 1-week workshops in ceramics, fibers, drawing and painting, metals, wood and basketry, and glass and photography. Approximately 3 photo workshops are offered during the 9-week summer session, each stressing lecture, demonstration, and hands-on experience. Typical titles include Darkroom Photography, Nature Photography, and In Your Own Image (a woman's photography class). Special events include faculty exhibits and lectures, and a Thursday evening performance. Touchstone is operated by the Pioneer Crafts Council, a nonprofit organization founded in 1972 to promote traditional regional crafts.

Specialties: A variety of creative art topics.

Faculty: Has included photographers Carlie Collier and Dennis Childers.

Costs, Accommodations: Tuition ranges from $130 to $225, plus materials. A $50 deposit per class must accompany application with balance due 3 weeks prior. Cancellations 4 weeks prior forfeit $25. Students are housed in rustic cabins with electricity and modern bath house. A $20 deposit for lodging is also required.

Contact: Julie K. Greene, Executive Director, Touchstone Center for Crafts, RD1, Box 60, Farmington, PA 15437; (412) 329-1370.

ULTIMATE IMPRESSION WORKSHOPS
Lawton/Year-round

Since 1983 Bob Deasy has conducted 1- and 2-day workshops on topics that include film and exposure, black & white, psychology and philosophy of photography, basic and advanced darkroom techniques, still life/product photography, perspective and composition, photographing people, and shooting in the outdoors. Programs are limited to 4 participants and can be customized to the student's interests and schedule.

Specialties: A variety of topics.

Faculty: Bob Deasy is a commercial photographer who has taught for 11 years.

Costs: Rate of $125 per day includes lodging at Woodbourne Farms, a 180-year-old bed & breakfast. Workshop only is $75 per day.

Location: The Endless Mountains of Pennsylvania, 45 minutes from Scranton.

Contact: Bob Deasy, Ultimate Impression Workshops, P.O. Box 22, Lawton, PA 18828-0022; (717) 934-2105 (phone/fax).

ARROWMONT SCHOOL OF ARTS AND CRAFTS
Gatlinburg/Summer

Arrowmont, a visual arts complex for adults of all abilities, offers 1- and 2-week photography workshops as part of its summer arts and crafts program and during Elderhostel in the fall. Slide lectures, concerts, exhibitions, and demonstrations are part of the school's ongoing program. Students can audit their courses or receive graduate/undergraduate credit, two semester credits per week, from the University of Tennessee Department of Art.

Location, Facilities: The Gatlinburg campus, situated on 70 acres of wooded hillside in eastern Tennessee, is three miles from the entrance to the Great Smoky Mountains National Park and 45 miles from Knoxville McGhee Tyson Airport. Facilities include cottage-type housing, studios, supply store, resource center, a permanent art collection, and an exhibition gallery.

Contact: Arrowmont School of Arts and Crafts, P.O. Box 567, Gatlinburg, TN 37738; (615) 436-5860.

CORY NATURE PHOTOGRAPHY WORKSHOPS
**U.S. locations/February, April,
July, October, November**

Since 1985, Tom Cory has conducted 1- to 6-day nature and landscape photography workshops that emphasize field work, supplemented by slide shows, lectures, and demonstrations. The 10 workshops offered annually are each limited to 10 to 14 participants Special attention is given to composition, creative exposure, and macro photography.

Specialties: Nature.

Faculty: Clinical psychologist Thomas L. Cory, Ph.D., a professional landscape and nature photographer for 30 years, has studied with John Shaw, Freeman Patterson, and Cole Weston. Pat Cory has 15 years of photography experience and 4 years in video. Harold Stinnette has 8 years of photography experience.

Costs, Accommodations: Costs range from $60 to $1,285. A $50 to $200 deposit is required and full refund granted cancellations more than 30 days prior.

Location: Include Tennessee's Smoky Mountains and Chattanooga; California's High Sierra Mountains; Washington's Olympic National Park; and Michigan's Upper Peninsula.

Contact: Tom or Pat Cory, Cory Photography, 1629 Rustic Homes Ln., Signal Mtn., TN 37377; (615) 886-1004 or (800) 495-6190.

GREAT AMERICAN PHOTOGRAPHY WEEKEND
U.S./Year-round

Established in 1993, GAPW offers more than 20 weekend to 1-week nature photography programs each year. Weekend sessions, limited to 200 participants, feature slide lectures, shooting in the field, informal discussions, and awards for the best photos in several categories. Top winners are published in Outdoor Photographer. The Extended Option 4-day program, limited to 60, begins on Thursday and includes 3 small-group field trips, slide critique, and individual instruction. Limited enrollment 1-week programs include a marketing workshop and a summer session in the Smokies.

Specialties: Nature photography, marketing.

Faculty: Speakers include Pat O'Hara, Rod Planck, Bryan Peterson, Galen Rowell, John Shaw, and Art Wolfe; resident faculty includes Mike Ellison, Bill Fortney, and David Akoubian.

Costs, Accommodations: Weekend events are $155 and Extended Option is $195 additional; the marketing seminar is $395 and the 1-week summer session is $595. Lodging and meals are not included; however, hotel information is supplied upon registration. Full payment by check or credit card required with registration. Refund, less $10 fee, granted cancellations 48 hours prior.

Locations: Include Sanibel Island; Anza Borrego State Park; Cape May; The Grand Tetons; Monument Valley; Grandfather Mountain; and Yosemite, Great Smoky Mountains, Olympic, Arches, Acadia, and Yellowstone National Parks.

Contact: Barb Ellison, Great American Photography Weekend, 5942 Westmere Dr., Knoxville, TN 37909-1056; (615) 539-1667, Fax (615) 539-1348.

WILDERNESS WILDLIFE WEEK OF NATURE
Pigeon Forge/January

This annual week-long program, offered since 1992, consists of workshops, walks, slide presentations, and lectures on a variety of nature and wildlife topics, including several devoted to photography. Typical titles include Wildflowers, How to Photograph Tennessee Waterfalls, Landscape Photography With a View Camera, General Nature Photography, Practical Application of Photo Equipment, and Photo Contest Overview.

Specialties: Nature photography

Faculty: Includes professional nature photographer Kendall Chiles, retired advertising photographer Jerry Drown, John May of 50 Minute Photo, professional landscape photographer Jim Thurston, and fine art photographer Chuck Randles.

Costs: All programs are free.

Location: Heartlander Country Resort, at the foot of Great Smoky Mountains National Park.

Contact: Bob Easton, Special Events Coordinator, City of Pigeon Forge, Department of Tourism, Office of Special Events, P.O. Box 1350, Pigeon Forge, TN 37868-1350; (615) 429-7350, Fax (615) 429-7355.

TEXAS

HILL COUNTRY ARTS FOUNDATION
Ingram/July

Established in 1959, The Hill Country Arts Foundation offers a variety of summer arts workshops including intermediate and advanced weekend programs in photography. A typical workshop, Platinum/Palladium Printing, covers negative and paper selection, hand-coating of the sensitizer, the effects of light sources and chemistry, and the impact of digital imaging. Enrollment is limited to 6 students per instructor.

Specialties: A variety of topics.

Faculty: Dan Burkholder, a graduate of Brooks Institute, teaches photography at University of Texas-San Antonio.

Costs, Accommodations: Tuition is $225 plus $70 materials fee; a $50 deposit must accompany registration. Partial refund is granted cancellations more than 4 weeks prior; no refunds thereafter. Partial scholarships are available. A housing list is provided.

Location, Facilities: HCAF is situated on the banks of the Johnson Creek at its

confluence with the Guadalupe River, 65 miles northwest of San Antonio. Facilities include a photo lab, art gallery and studios.

Contact: Registrar, Hill Country Arts Foundation, Duncan-McAshan Visual Arts Center, P.O. Box 1169, Ingram, TX 78025; (800) 318-4223, (210) 367-5120.

JIM BONES' PHOTO-NATURALIST WORKSHOPS
Southwestern U.S. rivers

Nature photographer Jim Bones conducts photo-naturalist floating workshops that emphasize the natural environment of the river and its surroundings. Each workshop is limited to 8 participants of all levels, who have the opportunity to photograph landscapes, portraits, still life, wildlife, and whitewater action, as well as learn about the geological, biological, and archaeological resources of the area.

Specialties: Nature photography with emphasis on Southwest rivers.

Faculty: Chief Instructor Jim Bones has operated photographic workshops for more than 10 years, served as apprentice to Eliot Porter, published 5 photo-anthologies on natural subjects, and had photos published in *Audubon, Texas Highways,* and *New Mexico.*

Location: Includes Salt River, the Mariscal Canyon and Rio Chama.

Contact: Far Flung Adventures, P.O. Box 31, Terlingua, TX 79852; (800) 359-4138 or (915) 371-2489.

JOHN JEFFERSON PHOTO SAFARI WORKSHOPS
Texas and Colorado/
March, May, September-October

Since 1978, John Jefferson has offered weekend workshops, limited to 15 participants, that emphasize photography of Southwest nature and wildlife. The 5 to 7 workshops scheduled annually consist of about 18 hours of instruction and field work. A typical schedule consists of a sunrise and morning light shoot, followed by classroom work during mid-day, a return to the field from late afternoon to dusk, and an evening seminar. Topics include basics, composition, equipment, camera handling, film selection, and at least 1 session devoted to outdoor portraiture, John Jefferson's specialty. Workshops are held at the 42,000-acre Y.O. Ranch, where students have the opportunity to photograph 10,000 head of native and exotic game; the Aransas National Wildlife Refuge, home of whooping cranes, shore birds, and alligators; and the Moncrief Mountain Ranch for fall colors in the Rockies.

Specialties: Wildlife and nature photography; outdoor portraiture.

Faculty: John Jefferson, a professional photographer for 25 years, was formerly director of *Texas Parks & Wildlife.*

Costs, Accommodations: Workshops include lodging and ranch-style meals and range from $450 to $535. A 50% deposit must accompany registration with balance due 2 weeks prior. Full refund, less $25 fee, is granted cancellations more than 72 hours prior. Accommodations depend on location and include rustic cabins, mountain lodges, and resort motels.

Location: Y.O. Ranch is in Texas Hill Country, west of Kerrville; the Arkansas National Wildlife Refuge is located on the Texas coast; Moncrief Mountain Ranch is in southwest Colorado.

Contact: John Jefferson, 10433 Firethorn Ln., Austin, TX 78750; (512) 219-1199.

SOUTHWEST CRAFT CENTER
San Antonio/Year-round

Incorporated in 1965 to provide visual arts and crafts education to adults and children of all levels, this nonprofit organization offers year-round courses and a visiting artists program of workshops, demonstrations, and slide lectures in the disciplines of photography, ceramics, fibers, metals, painting, surface design, and papermaking. Four to six photography workshops are offered each year, with enrollment limited to 12 to 15 students. Typical titles include Polaroid Transfers, Portfolio Concepts in Platinum/Palladium, and Hand Coloring and Image Manipulation.

Faculty: Each year, 24 nationally recognized artists conduct programs at SWCC. Photographers have included Marion Brown, Dennis Darling, Michael Kenna, and Arnold Newman.

Costs, Accommodations: Tuition ranges from $125 to $225; lab fees vary. A nonrefundable 50% tuition deposit must accompany application. Senior citizens receive a 10% discount and scholarships are available. Hotel lodging is available within walking distance.

Location, Facilities: Downtown San Antonio, on the grounds of the old historic Ursuline Academy and Convent, overlooking the San Antonio River. Facilities include an exhibition gallery, a visitor/hospitality center, a luncheon restaurant, and a sales gallery.

Contact: Southwest Craft Center, 300 Augusta, San Antonio, TX 78205; (210) 224-1848, Fax (210) 224-9337.

SPECIAL EFFECTS WORKSHOP
San Marcos/January-November

Since 1987, professional photographer Jim Wilson has conducted monthly workshops that are limited to 12 participants of all levels. Each 3-day program is devoted to special effects techniques with background projection and consists of lectures, demonstrations, and hands-on experience.

Cost: Tuition of $325 is payable in advance and includes lunches, workbook, and video tapes. A money-back guarantee is offered.

Contact: Jim Wilson, E.P.S. Photographic, P.O. Drawer 1745, San Marcos, TX 78667; (800) 647-3777, Fax (512) 353-0611.

TANGRAM PHOTOGRAPHIC WORKSHOPS
Texas and New Mexico/
February, June, October

Since 1986, Richard Fenker and Marianne Fittipaldi have taught photographic workshops for 10 to 14 students of all levels. Approximately 4 programs are offered each year, mostly field oriented with shooting during the day and critiques in the evenings. Instruction is individualized and schedules are arranged to maximize lighting opportunities.

Specialties: Nature, architecture, infrared.

Faculty: Richard Fenker, a professor of psychology and photographer with 20 years' experience, specializes in black & white and infrared and is author of *Where Rainbows Wait For Rain;* Marianne Fittipaldi has been a commercial photographer in the Ft. Worth area for 15 years.

Contact: Tangram Workshops, P.O. Box 2249, Granbury, TX 76048; (817) 573-2699.

Since 1981, Joe Englander has offered outdoor photography workshops at scenic locations in the Southwest. About fifteen 2- to 10-day workshops are scheduled yearly, each limited to 10 participants. Emphasis is on the how-to's and grammar of photography, and personal and professional expression. Sunrise-to-sunset field sessions are followed by evening classroom instruction.

Specialties: Darkroom techniques, nature and landscape.

Faculty: Joe Englander's photographs are in the collections of Yale University, Carnegie Institute of Art, Tucson Museum of Art, and the Denver Art Museum. He is a contributing editor for *Camera and Darkroom* and has a Ph.D. in aesthetics.

Costs, Accommodations: Tuition ranges from $275 to $3,000. A 50% deposit is required and full refund granted cancellations 60 days prior. Motels cost about $50 per night.

Location: Field workshop locations include California, Texas, Arizona, Utah, Washington, Oregon, New Mexico, Wyoming, Montana, and Alberta, Canada.

Contact: Joe Englander, President, Workshops in the West, P.O. Box 1261, Manchaca, TX 78652; (512) 295-3348.

UTAH

BRIGHAM YOUNG UNIVERSITY
Provo/July

Brigham Young University sponsors 5-day summer Design Workshops in graphics, illustration, and photography. Designed for high school students and teachers, the programs cover design concepts and new research and techniques.

Specialties: Design.

Faculty: Includes Wallace Barrus and John Telford.

Costs, Accommodations: Cost is $265 with lodging, $165 without.

Location: Brigham Young University campus.

Contact: Margie Green, Conference Planner, Brigham Young University, 147 Harman Bldg., Provo, UT 84602; (801) 378-2536.

GRAND CANYON PHOTOGRAPHY WORKSHOP
Grand Canyon/May

Since 1984, Rich Pogue has conducted photography river trips under the sponsorship of Colorado River & Trail Expeditions, which has been in operation since 1971. Each trip is limited to 11 participants, who travel on the Colorado River aboard motorized pontoon rafts that are outfitted for visual artists and their equipment. Participants are provided with a list of possible topics and interviewed prior to the expedition to determine their interests. The most popular topics are covered in formal workshop sessions while informal instruction, assistance, and advice is available on an individual, basis.

Specialties: Grand Canyon.

Faculty: Freelance outdoor photographer Rich Pogue has led workshops for Intermountain Society of Artists and the Photographic Society of America.

Contact: Colorado River & Trail Expeditions, Inc., P.O. Box 7575, 5058 South 300 West, Salt Lake City, UT 84107; (801) 261-1789.

PHOTOGRAPHY WORKSHOPS ON LAKE POWELL
Lake Powell/May-July

Lake Powell Tours, Inc., outfitters of adventure vacations for more than 20 years, offers weekend photographic workshops for groups of six to twelve.

Specialties: Anasazi Indian ruins.

Faculty: Local photography instructors.

Location: Lake Powell, a 200-mile lake located within Glen Canyon National Recreation Area in northern Arizona and southern Utah.

Contact: Lake Powell Tours, Inc., P.O. Box 40, St. George, UT 84770; (801) 673-1733.

VERMONT

JMC EYE PHOTO
Atlanta, Park City, Mt. Snow, Chicago/
May, July, September, November

Since 1978, this ophthalmic imaging and photographic training firm has offered short courses for technicians and others who are involved in photographing the eye. The 4-day workshops, limited to 64 participants, include lectures, photo labs, and work evaluation sessions.

Specialties: Biomedical photography of the external and internal eye.

Faculty: The 6- to 12-member national faculty includes JMC Eye Photo owner and course director J. Michael Coppinger, CRA; and CRA's Kirby Miller, Paul Montague, James Gilman, and Dennis Thayer.

Costs: Tuition is $600 for 4 days and includes film and workbook. Hotel or condo lodging is available for $60 to $100 per night. Full payment is required and is refundable, less $150, for cancellations at least 2 weeks prior.

Contact: Michael Coppinger, Course Director, JMC Eye Photo, Rte. 1, Box 21A, Shaftsbury, VT 05262; (802) 442-2907, Fax (802) 442-3725.

VIRGINIA

BOB SHELL PHOTO WORKSHOPS
Locations in the U.S. and
worldwide/Year-round

Since 1982, Bob Shell has offered glamour and nude workshops for intermediate photographers. Approximately a half dozen 2-day to 1-week workshops are scheduled yearly, each limited to 10 to 20 students. Emphasis is on lighting, posing, exposure, and subtle details.

Specialties: Studio and on-location glamour and nude photography.

Faculty: Bob Shell is the editor of *Shutterbug*, publisher of PIC, and author of 12 photography books.

Costs, Accommodations: Costs range from $350 to $2,000. Lodging is sometimes included. A $50 deposit is required.

Location: U.S. sites include Florida, Virginia, New York, New Jersey, Nevada, and California. International sites include England, Germany, Russia, Bahamas, Japan, and Malaysia.

Contact: Bob Shell Photo Workshops, P.O. Box 650, Blacksburg, VA 24063; (703) 639-4393, Fax (703) 633-1710.

OUTER BANKS WORKSHOP
North Carolina/May

Since 1978, Virginia Intermont College has offered an annual 1-week workshop limited to 12 students of all levels. Instruction covers camera techniques, view camera, and processing of black and white and color.

Specialties: Nature.

Faculty: Rotates each year and includes Jay Phyfer, John Scarlata, and Joe Champagne, who have MFA degrees.

Location: Hatteras, a small fishing village on the Outer Banks region of the North Carolina coast.

Contact: Joe Champagne, Photo Dept., Virginia Intermont College, Bristol, VA 24201; (703) 669-6101.

WASHINGTON

CENTER FOR INNER FOCUS
Pacific Northwest and
other locations/Year-round

Established in 1992, this educational organization offers programs that emphasize the development of creative vision and the art of visual expression, using Zen techniques. Four to six programs are offered yearly, including 3- to 6-day workshops and retreats, limited to 10 to 14 participants. Workshops consist of guided experiences, slide lectures, review of work, and field shoots. Typical titles are Awakening the Photographer Within, a weekend devoted to enhancing awareness and creative expression; and The Art of Mindfulness and Photography, an intensive 5-day retreat that explores new ways of seeing and includes lectures on aesthetics and visual design.

Specialties: Creative vision and self-expression.

Faculty: Photographer, teacher, and psychotherapist Jane Kennedy studied with Freeman Patterson and John Daido Loori. Photojournalist and commercial photographer Larry Bullis has contributed to *Petersen's Photographic* and *Pinhole Journal.*

Costs, Accommodations: Costs range from $325 to $650, which may include lodging and some meals. A $150 deposit is required with balance due 6 weeks prior. Refund, less $50, granted cancellations 6 weeks prior.

Location: Bryce and Zion National Parks and other Pacific Northwest and Southwest locations.

Contact: Jane Kennedy, Center for Inner Focus, 2802 E. Madison, Box 123, Seattle WA 98112; (206) 720-1907.

CHINA SPAN
China and the Far East/Year-round

Chinese painter, poet, and professional photographer Keren Su conducts 3-week trips for up to 12 participants to China, Vietnam, Tibet, Nepal, and Bangkok.

Costs: Range from $4,300 to $4,700, including international airfare.

Contact: Keren Su, China Span, 1429 173rd Ave., NE, Bellevue, WA 98008; (206) 747-5549 (phone/fax).

COUPEVILLE ARTS CENTER PHOTO FOCUS
Washington/March-June, October

Founded in 1988, this nonprofit organization dedicated to promoting the arts and crafts offers a variety of 2- to 4-day intensive workshops for intermediate and advanced photographers. Enrollment is limited to 20 participants, who should bring samples of their work for critique. The daily schedule includes early morning and late evening field work, critiques, print and slide viewing, and review of overnight processing.

Specialties: Black & white, landscape, photojournalism, portrait, personal growth, and creative writing for photographers.

Faculty: Includes Bruce Barnbaum, Gary Braasch, Judy Dater, Cherie Hiser, John Shaw.

Costs, Accommodations: Cost ranges from $200 to $300, depending on number of days. A $100 deposit must accompany registration, with balance due 4 weeks prior. Cancellations more than 4 weeks prior forfeit $35; deposit is forfeited thereafter. Credit cards accepted. Camping, motels, and bed & breakfasts are near the workshop. Seattle Pacific University post-graduate credit is available.

Location: Coupeville is on Whidbey Island, 90 minutes from Seattle and accessible by ferry from the south and west, by bridge from the north. Photogenic areas include Mt. Baker and the Olympic Peninsula.

Contact: Judy Lynn, Director, Coupeville Arts Center, P.O. Box 171, Coupeville, WA 98239; (206) 678-3396; Fax (206) 678-7420.

GREG MCGONAGILL PHOTOGRAPHY WORKSHOPS
Pacific Northwest/Year-round

Offered since 1991, these 1- to 3-day workshops travel to coastline, rain forest, mountain, and desert settings to photograph the nude in natural environments. Three to four workshops are offered yearly, with a limit of 12 intermediate photographers. Some hiking is involved.

Specialties: Photography of the nude in nature.

Faculty: Professional photographer Greg McGonagill.

Location: Natural regions of the Pacific Northwest.

Contact: Greg McGonagill Photography Workshops, P.O. Box 1297, Milton, WA 98354; (206) 661-0979.

JOSEPH VAN OS PHOTO SAFARIS & WORKSHOPS
Locations worldwide/Year-round

Founded in 1985 by ornithologist, biology teacher, and photographer Joseph Van Os, this photography/nature tour organization offers approximately fifty 1-day to 3-week safaris and workshops per year. Enrollment ranges from 6 to 32 participants with an average of 12 students per instructor. Safaris are timed to visit photogenic locales during peak wildflower and wildlife activity and include informal instruction as needed. Workshops are usually based at a single site, to optimize time for indoor slide lectures and field instruction. Specific areas can be personalized and itineraries are flexible, to meet the needs of the group.

Specialties: Nature and wildlife photography.

Faculty: Joseph Van Os is founder of New England Whale Watch in Massachusetts and has been published in *Outdoor Photographer, Natural History, Audubon,* and *Sierra.* Other tour leaders include naturalist David Middleton, author of *Ancient Forests: A Celebration of North America's Old Growth Wilderness;* nature photographer John Shaw, author of *The Nature Photographer's Complete Guide to Professional Field Techniques;* Rod Planck, whose credits include *Audubon, Sierra,* and *Backpacker;* and James Martin, who has written and photographed for *Smithsonian, Outdoor Photographer,* and *Sports Illustrated.*

Costs, Accommodations: Costs range from $245 to $6,495. Workshops include instruction only; safaris include double occupancy lodging, meals, ground transportation, and entrance fees. Accommodations vary from hotels to lodges to tented camps. A $300 to $400 deposit is required. Cancellation penalty ranges from $100 to $200 (90 days prior) to 85% of cost (20 days prior).

Location: Includes South Florida, Yellowstone, Arizona, Alaska, Canadian Rockies, Mexico, Venezuela, Africa, and Antarctica.

Contact: Joseph Van Os Photo Safaris, Inc., P.O. Box 655, Vashon Island, WA 98070; (206) 463-5383, Fax (206) 463-5484.

LINDA MOORE PHOTO TOURS
Northwestern U.S. and Canada/
Year-round

Since 1985, freelance nature photographer and naturalist Linda Moore has led photo tours that emphasize field work and include daily lectures and critique. Approximately 10 to 15 programs are scheduled yearly, including 1- to 5-day workshops, 3- to 12-day tours, and 1- to 3-day customized programs.

Specialties: Outdoor and nature.

Faculty: Linda J. Moore, studied with Pat O'Hara, Art Wolfe, Freeman Patterson, and Robert Stahl, and is contributing editor for *Photo Traveler* and *PhotoMedia.* Her credits include *Natural History, Forbes, Sierra,* and *Pacific Discovery.* One or 2 other photographers lead or assist.

Costs, Accommodations: Workshops tuition ranges from $40 to $75 per day; tours average $100 to $200 per day, all-inclusive. A 25% deposit is required and cancellations 6 weeks prior forfeit $75.

Location: Scenic locales in Washington, Oregon, Idaho, Alaska, and Canada.

Contact: Linda J. Moore, 11221 9th Place W., Ste. 4, Everett, WA 98204; (206) 347-7650 (phone/fax).

NORTH CASCADES INSTITUTE (NCI)
Washington/Year-round

This private, nonprofit educational organization, dedicated to increasing understanding and appreciation of the natural, historical, and cultural landscapes of the Pacific Northwest, provides wilderness and environmental education through more than 70 adult field seminars, 10 weeks of Elderhostel, and 5 weeks of children's summer camp. Approximately a half-dozen 1- to 3-day photo workshops are scheduled yearly at scenic locales, each limited to 12 participants.

Specialties: Nature.

Faculty: Includes Ernest Jones, Linda Moore, Tom Boyden, and Alan Marcowitz.

Costs, Accommodations: Workshop cost, which includes lodging, is $95 (credit cards accepted). Full payment must accompany registration, and phone cancellations 30 days prior receive full refund less $25 processing fee. Refunds granted cancellations less than 30 days prior if space can be filled. Participants are lodged in rustic cabins with bunks and shared baths. Group facilities include a fully equipped kitchen and meeting room.

Location: Ranges from the North Cascade Mountains to the San Juan Islands, and from the Methow Valley to the Columbia River Basin.

Contact: Ruthy Porter, North Cascades Institute, 2501 State Route 20, Sedro-Woolley, WA 98284-9394; (206) 856-5700, ext. 366, Fax (206) 856-1934.

OLYMPIC FIELD SEMINARS
Olympic National Park/Summer

Established in 1987, the nonprofit Olympic Park Institute educational organization offers outdoor photography seminars that focus on the resources of Olympic National Park. Two to four programs are offered annually, each limited to 12 students with basic camera knowledge. All are field experiences supplemented by lecture. The Institute is located in and works cooperatively with the Olympic National Park and offers annual Friends membership to contributors interested in supporting the programs.

Specialties: Outdoor and nature.

Faculty: Has included Natalie Forbes, author of *Reaching Home-Pacific Salmon-Pacific People;* and Ross Hamilton, a photographer of the Olympic Peninsula for the past 20 years.

Costs, Accommodations: Costs range from $75 to $200 and payment should accompany application. A 5% to 8% discount is available to Friends. Friends tax-deductible annual membership dues begin at $25 for an individual and $35 for a family. Full refund, less $35 fee, is granted cancellations received at least 30 days prior; no refunds thereafter. Shared lodging is available in utilitarian cabins, 4 rooms to a cabin.

Location: Olympic National Park, a complete ecosystem encompassing 938,000 acres, contains the largest temperate rain forest in the western hemisphere, 60 glaciers, 80 kilometers of roadless ocean coastline, and the largest mixed coniferous forest in the U.S.

Contact: Anna Manildi, Program Director, Olympic Park Institute, 111 Barnes Point Rd., Port Angeles, WA 98363; (800) 775-3720) or (360) 928-3720, Fax (360) 928-3046.

PHOTOGRAPHIC ARTS WORKSHOPS
U.S. and abroad/Year-round

Since 1975, Bruce Barnbaum has conducted photographic art workshops that include directed outdoor photography sessions, portfolio review, lectures, hands-on darkroom work, and demonstrations. More than a dozen 5- to 8-day workshops are offered annually, each limited to 8 or 9 serious photographers per instructor. Emphasis is on photography as personal expression through the understanding of light, use of Ansel Adams Zone System, and fine printing in color and black & white. Workshop titles include Four-Wheel Drive Canyon Country Photography, Arizona-Utah View Camera Workshop, and Complete Photographic Process, which includes 2 days of darkroom work.

Specialties: Nature and landscape photography, darkroom techniques, natural lighting.

Faculty: Bruce Barnbaum's work is represented by 20 galleries and is in private and museum collections. He is Sierra Club recipient of the Ansel Adams Award for Photography and Conservation and his published work includes *Visual Symphony* and *The Art of Photography: An Approach to Personal Expression.* Other instructors include Huntington Witherill, Jay Dusard, Stu Levy, and Robert Glenn Ketchum.

Costs: Tuition is $200 for the darkroom workshops, $500 to $600 for other workshops. A $100 nonrefundable deposit must accompany reservation with balance due a month prior to workshop. Refund of balance is granted cancellations 2 weeks prior or if space can be filled.

Location: Includes Washington, California, Montana, Olympic Peninsula, Utah, Arizona, Georgia, Canada, Mexico, and France.

Contact: Bruce Barnbaum, Photographic Arts Workshops, P.O. Box 1791, Granite Falls, WA 98252; (206) 691-4105 (phone/fax).

PHOTOGRAPHIC CENTER SCHOOL
Seattle/Year-round

Established in 1982, this teaching facility and gallery offers on-going classes, 1- and 2-day workshops for photographers of all levels, and a certificate program in fine art or commercial photography (page 186). Approximately 60 introductory and 35 advanced classes and workshops are scheduled each year, with enrollment ranging from 4 to 12 participants. Saturday workshop topics include Portable Flash, Cibachrome Masking, Pinhole Photography, Polaroid Transfer, Photo Essay, Hand Coloring, Creative Self Promotion, and Matting and Framing.

Specialties: A variety of topics, taught in a studio and darkroom setting.

Faculty: Includes Stephanie Frideres, David Johnson, Rachel Olsson, Mel Curtis, and Claire Garoutte.

Costs, Accommodations: Tuition ranges from $40 for 1-day workshop to $450 for a 4-credit course, payable in full with registration. Cancellations more than 5 days after payment forfeit $20. Credit cards accepted.

Location: The Greenlake space contains classrooms, studio, and black & white facilities. Color classes are taught at the downtown location, which has dry to dry color processing, a gallery, and rental darkrooms.

Contact: Peggy Jacobson, Director of Education, Photographic Center School, 2617 Fifth Ave., Seattle, WA 98121; (206) 441-7030.

WILDERNESS/TRINITY ALPS WORKSHOPS
Worldwide/Year-round

Founded in 1976, these 1- to 2-week nature photography workshops are designed to help individuals of all levels learn how to see and how to develop the technical mastery to capture their visions on film. Mornings are devoted to field work and one-on-one instruction; afternoons are free for individual work and critiques; and evenings are reserved for slide viewings and discussions. Workshops are geared to the serious amateur and the aspiring professional.

Specialties: Nature photography.

Contact: Charles Krebs, 4439 - 189th Pl., SE, Issaquah, WA 98027; (206) 644-0077, Fax (206) 747-7251.

ZEGRAHM EXPEDITIONS, INC.
Worldwide/Year-round *(see display ad page 117)*

Zegrahm Expeditions offers adventure travel to exotic destinations with several departures geared to the photographic traveler. The 10-day to 4-week photo expeditions are accompanied by a professional photographer who provides instruction.

Specialties: Outdoor and travel photography.

Costs, Accommodations: Cruise and land costs range from $1,575 to $16,900, including lodging, meals, and planned excursions.

Contact: Zegrahm Expeditions, Inc., 1414 Dexter Ave. N., #327, Seattle, WA 98109; (800) 628-8747.

WEST VIRGINIA

MEXICO PHOTOGRAPHY WORKSHOPS
Nochixtlán, Oaxaca and Xico,
Veracruz/Year-round

Since 1990, photographer/anthropologist John Warner has conducted hands-on workshops that offer 5 to 7 participants of all levels the opportunity to live in a small Mexican town and photograph its people, landscape, architecture and archaeological ruins, as well as nearby jungle, mountain, desert, and alpine environments. Three to four 8-day workshops are scheduled yearly.

Faculty: Fine art photographer John Warner, owner of Otter Creek Photography, holds a BA in Anthropology from Penn State and has done ethnographic research and archaeological excavation in Mexico. He has photographed the Nochixtlán and the Xico areas for more than 25 years and his work has appeared in books, magazines, and exhibits.

Costs, Accommodations: Cost of $1,300 ($1,105 for non-photographers) includes round-trip ground transportation from Veracruz or Oaxaca cities, all meals, double occupancy lodging (single supplement $50), mid-week film processing, and all planned activities. A $300 deposit is required with balance due 60 days prior. Credit cards accepted. Cancellation penalty ranges from $100 (more than 60 days prior) to 75% to 100% (less than 30 days prior).

Location: Xico, situated in the foothills of the Eastern Sierra Madre Mountains, is 30 minutes from Xalapa, the capitol of the State of Veracruz. The Oaxaca workshops are split between Oaxaca City and the highland Mixtec region.

Contact: John Warner, Otter Creek Photography, Hendricks, WV 26271; (304) 478-3586.

STONE CELLAR DARKROOM
Buckhannon/Year-round

Since 1989 Jim Stansbury has conducted 2 or 3 Your World in Color weekend photography workshops a year and a week-long summer workshop. Enrollment is limited to 5 students of all levels. The general workshop covers basic to intermediate photography and includes field work with emphasis on technique. The color darkroom workshop consists of field work as well as darkroom processing and printing. A typical weekend begins with a Friday evening slide lecture and student critique, followed by a Saturday field trip and darkroom work.

Specialties: Color technique and darkroom skills.

Faculty: Lecturer and photographer Jim Stansbury has taught color darkroom for 12 years, including college-level workshops and lectures, and has had more than 30 one-man exhibits, including Gateway Arch in St. Louis.

Costs, Accommodations: Weekend workshops are $75; week-long summer workshop, including darkroom materials, is $350. Full payment must accompany registration; refund granted cancellations more than 1 week prior, 50% refund thereafter. Local motel and bed & breakfast accommodations are available.

Location: Buckhannon in the hills of West Virginia.

Contact: Jim Stansbury, Director, Stone Cellar Darkroom, 51 Hickory Flat Rd., P.O. Box 253, Buckhannon, WV 26201; (304) 472-1669.

TWIN FALLS NATURE WORKSHOPS
Mullens/May and September

Since 1986, Twin Falls Resort State Park has sponsored a spring and fall weekend workshop conducted by well-known nature photographers. Instruction covers nature photography, including lens selection, close-up work, bird and animal photography, equipment care, and marketing.

Specialties: Nature.

Faculty: Has included John Gerlach, Irene Hinke Sacilotto, Bill Thomas, and Larry West.

Costs, Accommodations: Cost includes lunches and modern lodge or cottage accommodations. Full payment is required with registration; cancellations more than 2 weeks prior receive a full refund. Credit cards accepted.

Location: Twin Falls Resort State Park, in the hills of southern West Virginia, has waterfalls, wildlife, wildflowers, and an 1840's pioneer farm.

Contact: A. Scott Durham, Twin Falls Nature Workshops, Rte. 97, P.O. Box 1023, Mullens, WV 25882; (800) 225-5982 or (304) 294-4000.

WISCONSIN

THE CLEARING
Ellison Bay/May-October

The Clearing offers 1-week courses for all levels in the arts, nature, ecology, writing, and the humanities. Photography courses cover a variety of general topics and include lectures, field sessions, and evaluations.

Faculty: University professors and practicing professionals.

Costs, Accommodations: Cost includes shared dormitory room and most meals. A deposit is required 1 month prior.

Location: Wisconsin's Door County woods, on Green Bay.

Contact: The Clearing, Box 65, Ellison Bay, WI 54210; (414) 854-4088.

HIGH SPEED PHOTOGRAPHY AND PHOTONICS
Milwaukee/October

Since 1975, the University of Wisconsin's Center for Continuing Engineering Education has conducted this seminar/workshop for approximately 80 scientists, engineers, and industrial photographers. The program is an introduction to the principles, techniques, and uses of high speed imagery as applied to motion analysis problems. State-of-the-art cameras and ancillary equipment are covered with emphasis on high-speed motion picture and video camera techniques for the acquisition of scientific and engineering data.

Specialties: Photonics and photo-instrumentation.

Costs, Accommodations: The course fee includes program materials, lunches, and one scheduled dinner. Local hotel/motel information is provided.

Location: South Hall at the University's Civic Center campus, in downtown Milwaukee.

Contact: Center for Continuing Engineering Education, University of Wisconsin-Milwaukee, 929 N. Sixth St., Milwaukee, WI 53203; (800) 222-3623, (800) 222-4643 (Wisconsin) or (414) 227-3100.

PHOTOSOURCE INTERNATIONAL
U.S./Year-round

Since 1978, Rohn Engh has presented week-end How to Make Sales seminars limited to 15 participants. Designed for the individual who wants to market a stock file of 1,000 or more photographs, this 3-hour course is offered about 4 times a year and covers such topics as finding markets, copyright, model releases, lost photos, stock photo agencies, and dealing with buyers. An optional critique of students' slides and photos is offered prior to some seminars.

Specialties: Marketing of stock photographs.

Faculty: Rohn Engh has authored the guidebook, *Sell & Re-Sell Your Photographs*, now in its fifth edition.

Costs: The fee ranges from $99 to $195.

Location: Includes Baltimore, Minneapolis, Los Angeles, and San Diego.

Contact: Rohn Engh, PhotoSource International, Pine Lake Farm, Osceola, WI 54020-5602; (715) 248-3800 or (800) 624-0266 (card orders), Fax (715) 248-7394.

SCHOOL OF THE ARTS AT RHINELANDER
Rhinelander/July

Sponsored by the University of Wisconsin since 1963, this annual 5-day school offers a variety of courses in writing, visual and folk arts, and theatre. Photography courses cover a range of general topics, with emphasis on nature and field work. Special events include lectures, art exhibits, and an arts festival. CEUs and DPI equivalency-clock hours are granted if requested.

Specialties: Nature.

Faculty: Has included freelance nature photographer Jim Young, whose credits include *Audubon, National Wildlife,* and *Natural History;* UW-Madison faculty member Shiela Reaves, author of *Pathways to Prosperity;* award-winning free lance photographer Ralph Russo; and Tom Capp, the stringer-photographer for *The New York Times* in Wisconsin.

Location: James Williams Jr. High School in Rhinelander, in northern Wisconsin.

Contact: University of Wisconsin-Madison, School of the Arts at Rhinelander, 727SA Lowell Hall, 610 Langdon St., Madison, WI 53703; (608) 263-3494.

WYOMING

JACKSON HOLE PHOTOGRAPHIC EXPEDITIONS
Yellowstone and Grand Teton
National Parks/Year-round

Landscape photographer, educator, and naturalist D.J. Bassett offers 1-day field workshops and custom expeditions to national parks and scenic regions of the West. Instruction covers composition, exposure, film, camera and metering techniques, visual perception, and developing a personal methodology for precision and repeatability.

Contact: D.J. Bassett, Jackson Hole Photographic Expeditions, Box 7395, Jackson Hole, WY 83001; (307) 733-5733.

SNAKE RIVER INSTITUTE
New Mexico and Utah/
June to September

The Snake River Institute was founded in 1988 to offer workshops and seminars that explore connections between the arts and the natural world. Two or three 5-day photographic workshops are scheduled yearly, limited to 15 participants. Subjects include landscape, wildlife, and abstract nature.

Specialties: Western landscape and nature.

Faculty: Has included Jim Bones, whose credits include *Audubon* and *Texas Monthly;* Ed Riddell; Jon Stuart, photographer and owner of Mountain Camera; and John Telford, professor of photography and design at Brigham Young University.

Costs, Accommodations: Cost ranges from $800 to $1,200 and includes lodging, some meals, developing, and ground transportation.

Location: Workshops are held in Abiquin, NM, and Bryce and Zion National Parks, UT.

Contact: Samantha Strawbridge, Director of Adult Programs, Snake River Institute, P.O. Box 128, Wilson, WY 83014; (307) 733-2214, Fax (307) 739-1710.

THE YELLOWSTONE INSTITUTE
Yellowstone National Park/
January, July, September

Founded in 1976 as part of the Yellowstone Association, the Yellowstone Institute offers 4 to 6 workshops a year, each limited to 12 participants. The 4- and 5-day workshops emphasize field shooting in wilderness areas of the park.

Faculty: Includes Sandy Nyerk, a naturalist who has credits in calendars, books, and journals; Pete Houdeshel, a commercial pilot who has produced work for *New Worlds* and *Aloha,* Hallmark cards, and hotel chains; and Linda Joseph.

Costs, Accommodations: Tuition, which does not include meals or lodging, is approximately $45 per day. Accommodations include campgrounds and cabins in the park and motels outside the park. Refund is granted cancellations up to 45 days prior. Membership in the nonprofit Yellowstone Association, which begins at $25 yearly, offers course discounts.

Location: Various locations in the park with the majority at the Buffalo Ranch, a Park Service facility in the Lamar Valley.

Contact: Don Nelson, Institute Director, Yellowstone Institute, P.O. Box 232, Yellowstone National Park, WY 82190; (307) 344-2294 (phone/fax).

AUSTRALIA

COUNCIL OF ADULT EDUCATION
Australia and worldwide/Year-round

This educational organization offers more than 100 on-going classes, short courses, workshops, and travel programs on a wide range of topics, including photography, fine art, crafts, performing arts, recreation, food and wine, personal development, family history, writing, languages, literature, and natural history. Typical titles include About Color Film, Careers in Photography, Flash Photography, Handcoloring Photographs, Introduction to Darkroom Work, Landscape Photography Workshop, Photography for Travellers, Understanding the Zone System, Buying a Camera, and Wedding Photography.

Faculty: Includes photographers, authors, scholars, naturalists, historians, and other experts.

Costs, Accommodations: Costs, which include transportation, lodging, and meals, range from about A$200 to A$2,300 for programs within Australia, A$2,500 to A$7,600 for overseas tours. Credit cards accepted.

Location: Programs in Australia, which range from 1 to 9 days, include national parks, maritime locations, and historic and literary sites. Overseas destinations have included Egypt, northern India, New Zealand, and U.S. national parks.

Contact: Council of Adult Education, 256 Flinders St., Melbourne 3000, Victoria, Australia; (61) 3 652 0611, Fax (61) 3 654 6759.

LIGHT OF AUSTRALIA
Sydney/April

This annual 4-day workshop features lectures by internationally known photographers, small group discussions, workshops in which the lecturers demonstrate their methods, and a concluding panel discussion and question/answer session.

Faculty: Has included Jean-Marie Bottequin, Don Emmerich, Robert Farber, Greg Heisler, Art Kane, Hans Carl Koch, Jay Maisel, Cal Newby, Arnold Newman, Gene Nocon, Harry Przekop, and Gaston Wicky.

Location: Darling Harbour Convention Centre on Sydney Harbour, serviced by monorail and within walking distance of City Centre.

Contact: Baltronics, 99 Union St., N. Sydney, NSW 2060, Australia; (61) 2 959 5200, Fax (61) 2 922 7877.

AUSTRIA

INTERNATIONAL SUMMER ACADEMY OF FINE ARTS
Salzburg/July-August

Founded in 1953 by Oskar Kokoschka and Friedrich Welz, this annual program consists of 20 to 22 five-week classes in such subjects as photography, painting, drawing, etching, wood engraving, sculpture, architecture, jewelry design, stage-set design, graphic arts, experimental art, and video. Approximately 400 to 600 students enroll each summer and classes are limited to 25 students who are selected on the basis of curriculum vitae and artistic training.

Specialties: Photography, fine arts, graphic arts, and jewelry design.

Faculty: Has included such internationally recognized photographers as Katharina Sieverding, Dieter Appelt, Heinz Cibulka, Verena von Gagern, Tamarra Kaida, Friedl Kubelka-Bondy, Erich Lessing, and Michael Schmidt.

Costs, Accommodations: Tuition is AS8,100 and an additional AS1,500 enrollment fee is due on acceptance. Lodging in student homes is available from AS220 to AS350 per day and private accommodations range from AS180 to AS400.

Location: Hohensalzburg Fortress, a medieval castle in the historical center of town.

Contact: International Summer Academy of Fine Arts, Kaigasse 2, P.O.B. 18, A-5010 Salzburg, Austria; (43) 662 842113/843727, Fax (43) 662 849638.

CANADA

ARTSPERIENCE SUMMER SCHOOL OF THE ARTS
North Bay, Ontario/July and August

Since 1978, Canadore College has sponsored an annual program of more than seventy 1- and 2-week workshops in photography, painting, computer graphics, animation, glassblowing, quiltmaking, ceramics, papermaking, video, writing, cooking, dance, and music. Enrollment is limited to 12 to 15 students. Typical topics include nature, black & white, and advanced landscape. Evening activities include performances, exhibits, lectures, and discussions.

Specialties: Photography, fine arts, book arts, quilting, ceramics, glass.

Faculty: Has included professional photographers David W. Lewis, Michael de Moree, Arnold Zageris, and Ed Eng.

Location: The 700-acre campus is situated on a wooded escarpment overlooking Lake Nipissing and the city of North Bay.

Contact: Artsperience, Canadore College, 100 College Dr., P.O. Box 5001, North Bay, ON, P1B 8K9, Canada; (800) 461-7340 (in Canada), (705) 495-2862 (in Ontario and Quebec), or (705) 474-7600, ext. 384.

ECOSUMMER EXPEDITIONS
Worldwide/Year-round

Since 1976, this adventure travel has conducted expeditions that focus on sea kayaking, trekking, canoeing, rafting, sailing, dogsledding, and photography. More than twenty 6- to 12-day photo tours and workshops are offered yearly, limited to 6 to 12 participants. Instruction includes composition, night sky photography, light painting, and interpretive photography.

Specialties: Nature.

Faculty: Professional photographer Paul Lazarski, whose credits include *Photo Life;* photographer and teacher Robert Stahl; and Sharron Milstein.

Location: Includes the Desert Southwest, the Pacific Northwest, and the Midwest.

Contact: Ecosummer Expeditions, 1516 Duranleau St., Vancouver, BC, V6H 3S4, Canada; (800) 465-8884 (Canada), (800) 688-8605 (US), (604) 669-7741, Fax (604) 669-3244.

FEDERATION OF ONTARIO NATURALISTS
Port Elgin/Year-round

The Federation of Ontario Naturalists membership trip program provides opportunities for novice and veteran naturalists to learn more about the environment. The program offers more than 150 day and weekend nature trips year-round, several of which are devoted to outdoor and nature photography.

Specialties: Natural history and wildlife.

Faculty: All trips are conducted by volunteer photographers/naturalists who are members of FON.

Costs, Accommodations: Day trips range from C$25 to C$165; a deposit is required with balance due 30 days prior. Refunds, less C$25, are granted written cancellations at least 4 weeks prior. FON annual membership dues range from C$25 to C$38.

Contact: FON Membership Trips, 355 Lesmill Rd., Don Mills, ON, M3B 2W8, Canada; (416) 444-8419, Fax (416) 444-9866.

GARRY BLACK PHOTOGRAPHY WORKSHOPS
Grand Manan Island,
New Brunswick/Summer

Since 1984, nature photographer Garry Black has conducted photo workshops and safaris that are limited to 12 photographers of all levels. A 6-day workshop on Grand Manan Island, scheduled twice each summer, features early morning and late afternoon/early evening field shoots and instructional programs that cover technical skills, improving photographic vision, evaluation, and critique.

Specialties: Nature and wildlife.

Faculty: Garry Black teaches color photography workshops in the Ottawa area and his work has been used by Canadian Airlines, Coca-Cola, Honeywell, and United Airlines.

Costs, Accommodations: The 6-day workshop fee of C$1,025 (reduced rate for nonparticipant guest) includes lodging and meals at the Shorecrest Lodge. A C$200 deposit secures a space with balance due 45 days prior. Cancellations more than 45 days prior forfeit $25, thereafter deposit is forfeited unless space can be filled.

Location: Grand Manan, the largest of the Bay of Fundy Isles, is 35 km. from mainland New Brunswick.

Contact: Garry Black Photography, 1083 St. Emmanuel Terr., Gloucester, ON, KIC 2J6, Canada; (613) 824-9295.

HALIBURTON SCHOOL OF FINE ARTS
Haliburton/July-August

The Haliburton School of Fine Arts, founded in 1968 as a branch of Sir Sandford Fleming College, offers weekend and 5-day summer workshops for adults and children in a variety of art and craft topics, including photography. Programs cover a variety of general topics.

Faculty: Has included documentary photographer John Dowding, whose credits include *Ontario Craft, Heddle Magazine,* and *Interior Design Choice;* and Jill Glessing, BFA, whose work has been featured in *Exile and Fireweed.*

Costs, Accommodations: Five-day courses are approximately C$128 plus material fee, weekend courses are C$67. Full fee must accompany registration and refund is granted written cancellation 2 weeks prior. A list of local bed & breakfasts is provided.

Location: Sir Sandford Fleming College in Haliburton Highlands, southern Ontario.

Contact: Haliburton School of Fine Arts, P.O. Box 839, Haliburton, ON, K0M 1S0, Canada; (705) 457-1680, Fax (705) 457-2255.

THE NEW BRUNSWICK COLLEGE OF CRAFT AND DESIGN
Fredericton, New Brunswick/
September-April

Established in 1938 by the New Brunswick Government to provide skills and work for young people in small communities, this school offers more than a dozen weekend workshops yearly. Enrollment is limited to 15 participants with a foundation in the subject.

Location: Centrally located on the banks of the Saint John River.

Contact: New Brunswick College of Craft and Design, Box 6000, Fredericton, NB, E3B 5H1, Canada; (506) 453-2305, Fax (506) 457-7352.

PATTERSON/MOWRY PHOTO WORKSHOPS
Workshops recommence in 1996.

Contact: Patterson/Mowry Photo Workshops, R.R. 2, Clifton Royal, NB, E0G 1N0, Canada; (506) 763-2271.

PHOTO-CANOE TRIPS
Quetico Provincial Park/
May-September

Since 1988, John Stradiotto and Martha Morris have conducted weekly 5-day wilderness canoe and photo trips, limited to 7 participants. Instruction covers basic 35mm camera and canoe-tripping skills with at least 3 hours devoted to photography. Orientation, demonstrations, review of work, and short assignments with supervision are included in the program. Family groups are welcome.

Specialties: Nature.

Faculty: John Stradiotto has an MA in Geography and diverse wilderness experience. Martha Morris has a B.Ed., is qualified to teach environmental sciences, and has taught at a variety of outdoor centers. Both have photographed film shorts for CBC Television and prepared a guide to Canada's national and provincial parks, *The Road to Canada's Wilds.*

Costs, Accommodations: The C$500 fee includes meals, lodging (tents or cabins), and ground transportation. Students and seniors groups receive a 10% discount. A C$50 deposit must accompany reservation with balance due 30 days prior. Full refund is granted cancellations at least 21 days prior; deposit is forfeited thereafter.

Location: Quetico Provincial Park is a wilderness park with more than 1,500 kilometers of canoe routes in its 4,662-square-km. expanse. Natural phenomena include Precambrian rocks, bogs, and such wildlife as beavers, mink, otters, bears, moose, and more than 90 species of birds.

Contact: John Stradiotto/Martha Morris, Quetico Discovery Tours, P.O. Box 593, 18 Birch Rd., Atikokan, ON, P0T 1C0, Canada; (807) 597-2621.

RED DEER COLLEGE - SERIES SUMMER PROGRAM
Red Deer, Alberta/July

Since 1982, this annual residential summer school in the visual arts has offered 5 consecutive weeks of about a dozen 5-day courses. A variety of beginning, intermediate, and advanced programs are available, including 2 photography courses. Typical titles include Developing Your Own Photos Without a Darkroom, and Gum Bichromate Printing: an Alternative Printing Process. Enrollment is limited to 15. Additional activities include weekly visual presentations and a student exhibition.

Faculty: The more than 40 experienced instructors from Canada, U.S., and other countries, has included photographers Bernard Bloom and Candace Makowich.

Costs, Accommodations: Tuition for most courses is C$225. Lodging is C$98 per week. Meals are available in the college cafeteria.

Location, Facilities: Red Deer is in a rolling parkland area between Edmonton and Calgary. The campus has studios for photography, sculpture, glassblowing, ceramics, painting, and printmaking.

Contact: Anne Brodie, Visual Arts Coordinator, Red Deer College, Box 5005, Red Deer, AB, T4N 5H5, Canada; (403) 342-3130, Fax (403) 340-8940.

SEA KAYAKING PHOTOGRAPHIC TOUR
Jasper and Banff National Parks/
Summer

Since 1983, nature photographer Ken Pugh has conducted more than 20 workshops in the Canadian Rockies, Alaska, and the Yukon. One or two 5-day workshops are scheduled during July and August, each limited to 15 participants of all levels. Instruction covers metering, wide angle lens, close-up and macro flash techniques, creative composition, selective focusing, and getting close to wildlife.

Specialties: Nature and wildlife of the Canadian Rockies.

Costs, Accommodations: Tuition is C$360. Meals and lodging are additional. The C$50 deposit is refundable for cancellations before May 1.

Contact: Ken Pugh, 45964 Ivy Ave., Sardis, BC, V2R 2C5, Canada; (604) 858-0544 (eves. and weekends).

SPINDRIFT PHOTOGRAPHICS
Victoria, British Columbia/
Year-round

Since 1983, Sharron Milstein has conducted a variety of photographic education programs in the Pacific Northwest. More than a dozen programs are scheduled yearly, including field schools, which emphasize field instruction and include classroom sessions and slide presentations; workshops, which are similar to field schools but feature on-site processing and daily one-on-one evaluations; tours, in which instruction is offered as needed; seminars, which are single session presentations; and courses, which emphasize classroom instruction.

Specialties: Nature of the Pacific Northwest.

Faculty: Sharron Milstein has conducted workshops with Paul Lazarski, Courtney Milne, and Freeman Patterson. She teaches photography at Camosun College and her work was published in *City Guide, Victoria.*

Contact: Sharron Milstein, Box 8141, Victoria, BC, V8W 3R8, Canada; (604) 361-6393.

VALLEY VENTURES PHOTO
Ontario/July-September

Established in 1993, Valley Ventures conducts 3- and 6-day workshops that are limited to 8 participants. The daily schedule includes field shoots, discussions, and critiques of processed film.

Specialties: Nature and landscape.

Costs, Accommodations: The 3-day (6-day) program is $450 ($800), which includes lodging, meals, and local transportation. A 30% deposit is required, half of which is refundable 2 weeks prior. Accommodations are in a cedar log lodge on a private island.

Location: Algonquin Park and Cedar Lake.

Contact: Don Smith, Valley Ventures, Box 1115, RR #1, Deep River, ON K0J 1P0, Canada; (613) 584-2577, Fax (613) 584-9016.

VANCOUVER TOTEM PHOTOGRAPHY
Stanley Park, Vancouver/
July and August

Since 1969, Dan Propp has taught adult education courses that concentrate on scenic and close up totem photography. Workshops, limited to 7 participants, provide practical instruction using Stanley Park's collection of totems as the major learning tools. The emphasis is on creativity.

Specialties: Scenic and close up totem photography.

Faculty: Dan Propp has written and photographed for publications and produces scenic postcards.

Contact: Dan Propp, 10430 Hollybank Dr., Richmond, BC, V7E 4S5, Canada; (604) 277-6570.

WHISTLER PHOTOGRAPHY WORKSHOPS
Whistler/Spring and Summer

The Whistler Centre for Business and the Arts, an educational institute dedicated to providing innovative learning experiences, offers 5 landscape and nature photography workshops per year. Each 3- to 5-day workshop is limited to 15 participants and consists of one-on-one

instruction, critique, and slide/lecture sessions followed by practice. Most programs include a trip up Blackcomb or Whistler Mountain and some feature a helicopter journey to remote mountain lakes and trails.

Faculty: Includes photographer Bryan Peterson, author of *Learning to See Creatively* and *Understanding Exposure;* and DeWitt Jones, photography columnist and contributor to *National Geographic.*

Costs, Accommodations: Tuition begins at C$350. Credit cards accepted. A nonrefundable C$75 deposit is required and cancellations 2 weeks prior receive a 50% refund. A variety of accommodations are available at the resort.

Location: The Whistler resort and ski community is 90 miles north of Vancouver in the Coastal Mountains.

Contact: Whistler Centre for Business & the Arts, Box 1172, Whistler, BC, VON 1BO, Canada; (604) 932-8310, Fax (604) 932-4461.

CZECH REPUBLIC

PAVEL MÁRA PHOTOGRAPHY WORKSHOPS
Prague and Dobesice/Year-round

Since 1991, Pavel Mára has conducted fine art workshops for photographers of all levels. The 4- to 8-day Prague workshops, scheduled monthly from September to June, are limited to 6 participants. Students can work on still life, portrait, nude, commercial, or mixed media. The 8-day Dobesice summer workshop, limited to 8 participants, is conducted in the Mára family farmstead and in the field. Students can work on such assignments as still life, portrait, nude, or architecture. Photographs from all workshops may be displayed once a year in a collective exhibition in a Prague gallery.

Specialties: Fine art photography.

Faculty: Pavel Mára is a prominent Czech professional photographer. Guests may include noted Czech theorists and artists.

Contact: Ivona Brynová, Pavel Mára Photography Workshops, Eledrova 728, 181 00 Prague 8, Czech Republic; (42) 2 782 03 92, Fax (42) 2 220 560.

ENGLAND

ACORN ACTIVITIES
Herefordshire/July

Established in 1989, this activity holiday provider offers a 2-day course on landscape, portrait, and dramatic action photography in a fully-equipped studio and darkroom and on location. On-site processing and use of the newest equipment are available. Enrollment is limited to 12 beginning to intermediate photographers.

Costs, Accommodations: Tuition is £100. Accommodations, including breakfast, range from farmhouses and cottages at £20 per night to prestigious hotels at £95 per night. A £20 deposit is required with balance due/refund granted 60 days prior.

Location: Herefordshire, near the Welsh border, 120 miles (a 3-hour train ride) west of London.

Contact: Charles Cordle, Acorn Activities, P.O. Box 120, Hereford, HR4 8YB, England; (44) 1-432-830083, Fax (44) 1-432-830110.

THE EARNLEY CONCOURSE
Chichester, Sussex/Year-round

This residential center for courses and conferences, established in 1975 by the Earnley Trust, Ltd. educational charity, offers 2- to 6-day workshops on a variety of general photography subjects.

Location, Facilities: The center is in a rural setting in West Sussex, 6 miles south of Chichester. Facilities include lecture rooms, arts & crafts studios, conference hall, computer room, heated pool, squash court, and snooker table.

Contact: The Earnley Concourse, Earnley, Chichester, Sussex, PO20 7JL, England; (44) 243 670392, Fax (44) 243 670832.

EAST KENT FIELD CENTRE
Kent/Year-round

Founded in 1986, this field center offers weekend programs devoted to photography, painting and drawing, and musical performances as well as approximately 40 special interest programs a year, consisting of structured study courses and country walks that focus on local natural history. Enrollment is limited to 6 to 15 participants. Evening activities include concerts, theater, and local events.

Location: Beaconhill Cottage, a 200-year-old converted country house, is located south and east of Canterbury.

Contact: East Kent Field Centre, Beaconhill Cottage, Great Mongeham, Deal, Kent CT14 0HW, England; (44) 304 372809.

FIELD STUDIES COUNCIL
Great Britain/Year-round

Established more than 40 years ago, the educational charity Field Studies Council offers more than 25 photography courses annually at 9 residential Field Centres in Great Britain. Most courses are one week, running from Friday to Friday. All courses are open to anyone over the age of 16 and most are suited to beginners, with a few geared to a more advanced level.

Location: Field Centres in England are Flatford Mill, Colchester, Essex; Juniper Hall, Dorking, Surrey; Malham Tarn, Settle, North Yorkshire; Nettlecombe Court (Leonard Wills Centre), Taunton, Somerset; Preston Montford, Montford Bridge, Shrewsbury; Slapton Ley , Slapton, Kingsbridge, Devon, England. Locations in Wales include Dale Fort, Haverfordwest, Dyfed; Orielton, Pembroke, Dyfed; and Rhyd-y-creuau (The Drapers' Centre), Betws-y-coed, Gwynedd.

Contact: Field Studies Council, Preston Montford, Montford Bridge, Shrewsbury, SY4 1HW, England; (44) 743 850647.

HF HOLIDAYS LIMITED
Great Britain/
March, May, September-October

Established more than 75 years ago, the nonprofit HF offers a wide variety of special interest 3- to 7-day holidays that include landscape photography as well as natural history, birdwatching, literature, British heritage, garden visits, music weeks, dancing, sports, bridge, and arts and crafts. Photography programs, which are limited to 15 participants, focus on the local scenery and consist of daily outdoor field shoots with emphasis on technique. Evenings are reserved for discussion, study, and critiques.

Specialties: Landscape.

Faculty: Instructors and professionals in their fields.

Costs, Accommodations: Cost, which includes double occupancy lodging and full board, begins at £144 for 3 nights. Deposit ranges from £25 (up to 4 nights) to £45 (7 nights). Participants usually stay in HF-owned country houses with lounges, game rooms, and, in some cases, tennis courts and heated swimming pools.

Location: Nineteen locations in Great Britain, including Arran and Loch Leven in the Scottish Highlands, Conwy in North Wales, Derwentwater in the Lake District, Sedbergh and Scarborough in Yorkshire, and Dovedale in the Peak District.

Contact: Reservations Dept., HF Holidays Ltd., Imperial House, Edgware Rd., London NW9 5AL, England; Administration (44) 181 905 9556, Reservations (44) 181 905 9558, Fax (44) 181 205 0506.

INTERNATIONAL ACADEMIC PROJECTS SUMMER SCHOOLS
London/June-July

International Academic Projects, an educational charity that provides and training in the areas of conservation, archaeology and museum studies, runs courses at the Institute of Archaeology of the University of London and other locations. The Summer Schools, established in 1984, offer more than 40 intensive 5-day courses annually, several of which are devoted to the application of photography to these fields. Enrollment is limited to 10 participants, who receive up to 7 hours of instruction daily. Visits to London museums to photograph art objects are also included. Photographic Workshop, designed for participants who are familiar with the basics, covers photographic techniques appropriate to archaeology and conservation, including large format camera, infrared and u-v lighting, and other techniques.

Specialties: Photography applied to conservation, archaeology, museum studies.

Faculty: Includes Institute of Archaeology faculty members Peter Dorrell and Stuart Laidlaw.

Costs, Accommodations: Tuition is $495, which includes materials and equipment. Full payment must accompany registration. Bed & breakfast accommodation is $230 per week.

Contact: James Black, Coordinator, International Academic Projects, c/o Inst. of Archaeology, 31-34 Gordon Square, London WC1H OPY, England; (44) 171 387 9651, Fax (44) 171 388 0283.

KNUSTON HALL
Wellingborough, Northamptonshire/
Year-round

Established in 1951 as an adult residential college, Knuston Hall offers more than eighty 1-day to 1-week courses on a variety of topics, including photography, literature, history, and arts and crafts.

Contact: The Principal, Knuston Hall, Irchester, Wellingborough, Northamptonshire, NN9 7EU, England; (44) 933 312104.

LOSEHILL HALL
Castleton, Derbyshire/Year-round

Opened by Princess Anne in 1972 and designed as a meeting place for all those interested in countryside conservation, this residential study center offers more than fifty 2-day to 1-

week courses a year on a variety of topics, including photography, art, nature study, and conservation. Enrollment ranges from 8 to 25 participants. Faculty: Park rangers and specialists, all with college degrees.

Location: Losehill Hall, a modernized Victorian mansion situated on 25 acres of gardens and woodlands, is midway between Manchester and Sheffield.

Contact: Losehill Hall, Peak National Park Study Centre, Castleton, Derbyshire, S30 2WB, England; (44) 433 620373.

TAUNTON SUMMER SCHOOL
Taunton/July

Established in 1980, Taunton Summer School offers 2 week-long summer photography techniques programs for 10 photographers who have mastered the basics and wish to improve their skill and visual imagination. Practical, hands-on work is emphasized and a range of techniques and equipment, including close-up and studio flash, are covered.

Faculty: Illustrative and technical photographer Julian Comrie.

Costs, Accommodations: Non-resident tuition is £55; resident tuition ranges from £210 to £335, which includes meals and lodging. A £20 (non-resident) or £50 (resident) deposit is required. Refund granted cancellations prior to May 31.

Location: Somerset, the West Country of England.

Contact: Diana Atkinson, Taunton Summer School, Taunton, Somerset TA2 6AD, England; (44) 1823 349243, Fax 01823 349201.

WENSUM LODGE
Norwich, Norfolk/Year-round

Founded in 1965, this residential adult education center offers more than 40 weekend courses in photography, art, crafts, writing, local history, and archaeology.

Location: Norwich is a 2-hour train ride from London with direct airline connections to Heathrow Airport.

Contact: Wensum Lodge, King Street, Norwich, NR1 1QW, England; (44) 603 666021/2.

WEST DEAN COLLEGE
Chichester, West Sussex/
Year-round except February

Established in 1971, West Dean College offers approximately fifteen 2-, 5-, and 7-day courses yearly in photography and videography. Topics range from beginning to advanced and include seasonal landscapes, auto camera, photojournalism, portrait, and black & white printing. Enrollment is limited to 6 or 12 students per instructor.

Faculty: Includes Howard Coles, Robin Dance, Nicholas Sinclair, Terry Ladlow, and David Roberts.

Costs, Accommodations: Fees, including room and board, are £139 for weekend workshops, £334 for 5 days, and £449 for 7 days. Lodging is in single- and twin-bedded rooms, some with private baths.

Location: West Dean College, located on the 6,000-acre West Dean Estate in southeastern England, is 5 miles north of Chichester and 1 hour from Heathrow and Gatwick Airports.

Contact: Heather Way, Public Relations, West Dean College, West Dean, Chichester, West Sussex, PO18 0QZ, England; (44) 1243-811301, Fax (44) 1243-811343.

WESTHAM HOUSE COLLEGE
Barford, Warwick/April-December

Established in 1947 as an independent educational trust and registered charity, this short term adult residential college offers more than 70 day, weekend, and 1-week courses on photography, literature, arts and crafts, and health and nutrition.

Location: A half hour train ride from Birmingham and two hours from the London Paddington station.

Contact: Jean Long, Westham House College, Barford, Warwick, CV35 8DP, England; (44) 926 624206.

FRANCE

FRENCH FOTO TOURS
Provence/Year-round

Established in 1994, this photo tour operator offers about 25 one-week workshops and day tours yearly. Enrollment is limited to 5 participants, who are encouraged to see the world around them and create photographs that communicate with the viewer. The schedule consists of morning review sessions, instruction, discussions, and excursions to various sites in Provence.

Specialties: The Provence region.

Faculty: Photographer Cynthia Foster, who has worked in the photo department of *National Geographic;* French magazine travel photographer Pierre Mariey; and Norman Sagansky, photographer for *The Economist.*

Costs, Accommodations: The week-long workshop is $1,700, which includes 3-star hotel lodging in Aix, breakfasts and lunches, farewell dinner, 12 rolls of film with processing, and ground transportation. Day tours are $95. A 50% deposit is required, with balance due 60 days prior. Cancellation fee is $200.

Location: Includes the Luberon Valley, Aix, Arles, Avignon, and Marseille.

Contact: Cynthia Foster, French Foto Tours, 70 Bd. Marcel Parraud, St. Cannat, 13760, France; (33) 42 50 66 69, Fax (33) 42 50 62 46.

GREECE

THE AEGEAN CENTER FOR THE FINE ARTS
Greece and Italy/April-December

Founded in 1965, the Aegean Center for the Fine Arts offers courses in photography, printmaking, sculpture, painting and drawing, creative writing, history of the arts, and Greek literature. The spring photography program in Paros, Greece, is 13 weeks; the summer program in Paros is 2 to 4 weeks; and the fall program in Italy and Paros is 14 weeks. Course enrollment is limited to 20 students per 5 instructors, and self-motivation is emphasized. All levels of photographic instruction are offered. The introductory level covers camera basics, film selection, exposure control, and darkroom procedures. Technique is stressed as a means of developing a personal vision. Advanced students,

accepted on the basis of work samples, carry out individualized studies of technique, materials, and color theory.

Specialties: Introductory to advanced photographic technique with emphasis on individual work.

Faculty: Four-member faculty includes Director John A. Pack, who taught at Laney College and the University of New Mexico. He studied with Mary Ellen Mark, Ansel Adams, and Jerry Uelsmann and his work is in the Smithsonian Collection.

Costs, Accommodations: The Greece 13-week spring course fee of $6,000 includes room and studio. The Italy-Greece session tuition is $7,500, including room, board, travel in Italy, and room and lab fees in Greece. Both programs require a nonrefundable application fee. Summer tuition is $500 per week, plus room, board, and transportation. Housing cost is about $450 per week. Lodging in Paros is at the Aegean Village apartments, a 5-minute walk from the Center. An 80% refund is granted cancellations at least 60 days prior; 50% between 30 and 60 days prior; no refund thereafter. Tuition grants and scholarships are available.

Location, Facilities: The Center is in a neoclassical 16th-century townhouse in the village of Parikia. The main port town of Paros, one of the Cycladic Islands in the Aegean Sea, is approximately 100 miles from Athens. Facilities include a darkroom and studio space. The Italy portion of the Italy-Greece Sessions is in a 16th-century villa in the Tuscan countryside above Pistoia, 20 miles west of Florence.

Contact: Johnny Pack, Director, Aegean Center for the Fine Arts, Paros 844 00 Cyclades, Greece; (30) 28423287 (phone/fax).

IRELAND

EN-VISION PHOTOGRAPHIC WORKSHOPS
County Mayo/
March, April, November

Established in 1989, the 2- and 6-day Voyage of Visual Discovery workshops for photographers of all levels emphasize enhancement of the visual senses. Each program is limited to 12 participants per 2 instructors and daily sessions include lectures, assignments, field trips, and review of the previous day's processed images. Participants are encouraged to bring at least 10 slides for the first day's evaluation.

Specialties: Nature, abstracts, city and rural scenes.

Faculty: Canadian photographer Keith Ledbury and British photographer Tim Durham.

Costs, Accommodations: Costs, which include double occupancy lodging and meals, are IR£108 per weekend and IR£574 per week. Payment in full required for weekends; an IR£200 deposit for week-long programs with balance due 60 days prior. Cancellation penalty ranges from IR£75 to 75% of cost up to 15 days prior; no refunds thereafter.

Location: Rosturk Woods Guest House, a County Mayo home with views of the Clew Bay islands.

Contact: Louisa Stoney, En-Vision Photo, Rosturk Woods, Rosturk, Mulranny, Co. Mayo, Ireland; (353)98-36264 (phone/fax).

ITALY

CLICK UP SCHOOL OF FASHION PHOTOGRAPHY
Florence, Italy/
Year-round, except August

Established in 1990, this fashion photography school offers basic and professional 3-month courses that emphasize technique and the aesthetic study of the image. Each course is scheduled 3 times yearly (January, April, September) and limited to 6 students, who attend classes 2 mornings a week. Topics include portrait, beauty, still life, fashion, lingerie, and glamour. Each topic is covered in slide lectures and practiced by the students through projects and assignments. The final day is devoted to review, selection of work for portfolios, and marketing discussions.

Specialties: Studio photography, including fashion, still life, portrait, and advertising.

Faculty: Art Director/Founder Leonardo Maniscalchi's images have appeared in *Vogue Italia, Marie Claire, Elle, Harper's Bazaar, Playboy, Cosmopolitan,* and *Panorama,* and he has worked on advertising campaigns for Fendi, Valentino, Armani, Yves Saint Laurent, Dior, Versace, and Pierre Cardin. He is assisted by Francesco Donadio and Franco Fiesoli. The staff includes make-up artists, hairdressers, art buyers, stylists, and professional models.

Costs, Accommodations: Tuition is approximately $1,200. Foreign students can receive a grant of approximately $600. A 30% refundable deposit is required.

Contact: Leonardo Maniscalchi, Click Up School, Via San Francesco di Paola 15, Florence 50124, Italy; (39) 55 2298548, Fax (39) 55 2298430.

SCOTLAND

INVERSNAID PHOTOGRAPHY CENTRE
Inversnaid/April-October

Established in 1987, this photography centre conducts 20 to 25 three- to five-day workshops yearly on subjects that include landscape and wildlife photography, studio work, and black & white and color printing. Days are devoted to field trips, with evenings spent processing film, in critique sessions, and at tutor's work shows. Enrollment is limited to 14 participants, who can choose from beginning to advanced sessions. Masterclass workshops, conducted by guest professionals, offer practical advice and demonstrations.

Specialties: Landscape, wildlife, studio, and darkroom.

Faculty: The 2-member full-time faculty includes Andre Goulancourt, a professional photographer with a degree from the Manchester College of Art and Design. Guest tutors include landscape photographer Fay Godwin, fine-art photographer John Blakemore, color landscape specialist Charlie Waite, and nature photographer Laurie Campbell.

Costs, Accommodations: Tuition ranges from £246 to £670 and includes all use of facilities and full room and board. A £70 nonrefundable deposit is required. Inversnaid Lodge is an 18th-century restored hunting lodge surrounded by a 50-acre nature reserve.

Location: The lodge is located in Inversnaid by Aberfoyle, Stirlingshire, near Loch Lomond.

Contact: Andre Goulancourt or Linda Middleton, Inversnaid Photography Centre, Inversnaid Lodge, Inversnaid by Aberfoyle, Stirlingshire, FK8 3TU, Scotland, UK; (44) 1-877-386254.

MODERN LIGHTS AG WORKSHOPS
Europe, Australia, Far East

Modern Lights AG, the European manufacturers of Balcar flashlighting equipment and accessories since 1960, organizes a half dozen 2- to 4-day photography workshops each year. Designed for accomplished amateurs and professionals, the programs concentrate on wedding, portrait, fashion, and beauty photography. The daily schedule includes demonstrations, lectures, and open forums and evenings are reserved for presentations by schools and associations.

Contact: Modern Lights AG, Lättichstrasse 8a, 6340 Baar, Switzerland; (41) 42 31 08 55, Fax (41) 42 31 34 66.

WALES

SNOWDONIA CENTRE OF PHOTOGRAPHY
Talysarn/Year-round

Established in 1972, this residential photography school offers more than 20 different 1- to 4-day workshop modules, each limited to 4 students. Novice modules cover fundamentals, outdoor techniques, and basic darkroom practices; intermediate modules cover print finishing, framing and exhibiting prints, color transparency techniques, architecture, night photography, and monochrome printing; advanced modules cover the school's Zone VIII exposure system, large format photography, advanced exhibition techniques, and advanced film processing. Private instruction is available. The Zone VIII Photographic Society, started in 1977, offers a free advisory service, newsletters, and workshop discounts.

Specialties: A variety of beginning to advanced topics, with emphasis on monochrome fine print techniques and the Zone VIII exposure system for all formats.

Faculty: Brian S. L. Allen, founder.

Costs, Accommodations: Cost is £65 per day, which includes local transportation, chemistry, and printing paper. Half-board lodging on-site is £20.50 per night, which includes use of darkrooms. A 20% deposit is required. Credit cards accepted.

Location: In the Snowdonia National Park area, 7 miles from Caernarfon.

Contact: Brian S.L. Allen, Snowdonia Centre of Photography, Glanrafon House, Talysarn, Gwynedd, LL54 6AB, Wales, UK; (44) 1286-881545 (phone/fax).

2

Schools

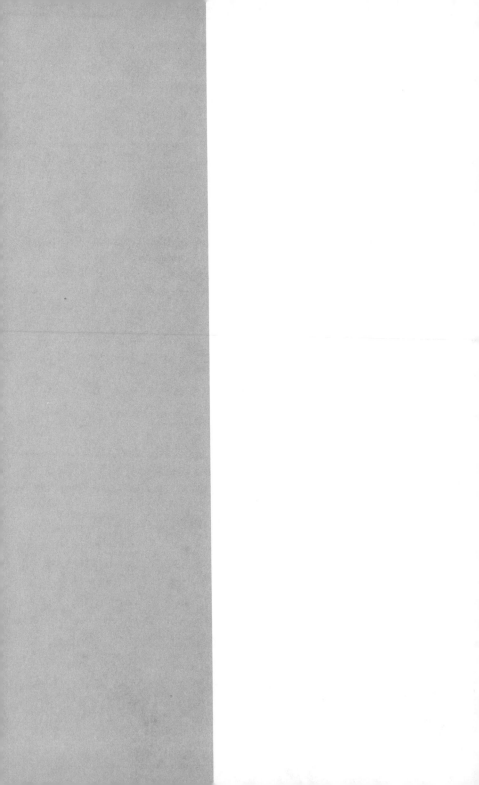

CAREER PROGRAMS OFFERED BY TRADE SCHOOLS, COLLEGES, AND UNIVERSITIES IN UNIVERSITIES

The following institutions offer programs that concentrate on fine art and commercial photography and photojournalism. Each institution was mailed or faxed a questionnaire requesting the following information about their photography programs.

Name of Institution
City/Months of operation
Description of institution (trade school, 2-yr college, university)
Photography degrees, certificates, or diplomas awarded (see Key to Abbreviations, below)
Year photography program was established
Accreditation (see Key to Abbreviations, below)
School calendar (quarter, semester, trimester)
Curriculum: core (includes general education courses) or photography only
Admission dates
Total number of students enrolled as photography majors
Number of photography majors enrolling each admission period
Percentage of photography majors accepted
Student to instructor ratio in photography classes
Percentage of graduates that become employed in the photography field
Percentage of graduates that pursue further education
Percentage of increase/decrease in photography program enrollment
Photography courses offered
Number of hours or credits of photography courses required for graduation
Emphasis of photography program
Other photography-related courses and activities
School-related employment opportunities, ie., internships, assistantships, work-study programs
Number of full- and part-time photography faculty members and their qualifications
Tuition and other expenses
Location of institution
Contact for photography programs (including address, telephone, fax number)

Key to Abbreviations

Degrees

AA - Associate of Arts	BA - Bachelor of Arts
AAS - Associate of Applied Science	BFA - Bachelor of Fine Arts
AFA - Associate of Fine Arts	MA - Master of Arts
MFA - Master of Fine Arts	AS - Associate of Science
AST - Associate of Specialized Technology	MS - Master of Science

Key to Abbreviations

Accrediting Organizations
ACCSCT - Accrediting Commission of Career Schools & Colleges of Technology
ACE - American Council on Education
ACEJMC - American Council on Education in Journalism & Mass Communication
MSA - Middle States Association of Colleges & Schools NASAD - National Association of
Schools of Art & Design
NCA - North Central Association of Colleges & Schools
NEASC - New England Association of Schools & Colleges
SACS - Southern Association of Colleges & Schools
WASC - Western Association of Schools & Colleges

ALABAMA

CALHOUN STATE COMMUNITY COLLEGE

Div. of Fine Arts, Hwy. 31 N., Decatur, AL 35609-2216; (205) 353-3102, Fax (205) 350-1379.

COMMUNITY COLLEGE OF THE AIR FORCE

Photography Dept., 130 West Maxwell Blvd., Maxwell Air Force Base, AL 36112;
(205) 953-5008, Fax (205) 953-5231.

UNIVERSITY OF ALABAMA

P.O. Box 870270, Tuscaloosa, AL 35487; (205) 348-1889, Fax (205) 348-9642.

UNIVERSITY OF MONTEVALLO

Art Dept., Station 6400, Montevallo, AL 35115; (205) 665-6400, Fax (205) 665-6387.

UNIVERSITY OF NORTH ALABAMA

Art Dept., Box 5006, Florence, AL 35632-0001; (205) 760-4384, Fax (205) 760-4329.

ARIZONA

NORTHLAND PIONEER COLLEGE
Holbrook/August-May

This 2-yr college awards an AAS degree in photography. Program started 1975. Accredited
by NCA. Calendar: semester. Curriculum: core. Admission dates: Aug and Jan. Total enroll-
ment: 20; 4-5 enrollees each admission period; 100% of applicants accepted; 12
students/instructor; 5%-10% of graduates obtain employment in field; 5% pursue further
education. Enrollment is increasing by 5%.

Courses: Beginning, Intermediate and Advanced Photography, Color I & II, Portfolio, View
Camera, Photo History, Stock Photography. 28 hrs of photography-related courses required
for graduation. Emphasis: commercial and fine art. Related courses & activities: Western

Exposure Workshop. School-related employment opportunities: co-op with local newspapers and studios.

Faculty: 1 full time, 3 part time. Qualifications: MFA, 20 yrs field experience, 15 yrs stock work.

Costs: Tuition is $22/cr hr. Other expenses: books.

Location: 140 miles from Flagstaff (northeastern AZ).

Contact: Dale Schicketanz, Instructor, Northland Pioneer, Photography, P.O. Box 610, Holbrook, AZ 86025; (602) 537-2976.

PHOENIX COLLEGE

1202 W. Thomas Rd., Phoenix, AZ 85013; (602) 264-2492, Fax (602) 285-7700.

SCOTTSDALE COMMUNITY COLLEGE
Scottsdale/August-May

This 2-yr college awards a 4-semester AA degree in photography. Program started 1972. Accredited by NCA. Calendar: semester. Curriculum: core. Admission dates: year-round. Total enrollment: 10; 100% of applicants accepted; 24 students/instructor; 1% of graduates obtain employment in field; 10%-15% pursue further education. Enrollment is increasing by 10%.

Courses: B&W, Commercial, 4/5 View, Color, Portrait. Emphasis: general. Related courses & activities: art courses. School-related employment opportunities: work-study.

Faculty: 2 full time, 5 part time. Qualifications: MA or MFA.

Costs: Tuition is $32/cr hr. Other expenses: $15/sem lab fee.

Location: 10 miles from Phoenix.

Contact: Bill Martin, Scottsdale Community College, Art/Photography Dept., 9000 E. Chaparral Rd., Scottsdale, AZ 85250; (602) 423-6334/6100, Fax (602) 423-6200.

CALIFORNIA

ACADEMY OF ART COLLEGE

79 New Montgomery St., San Francisco, CA 94105; (415) 274-2258, Fax (415) 771-3165.

ALLAN HANCOCK COLLEGE

Fine Arts Dept., 800 South College Dr., Santa Maria, CA 93454; (805) 922-6966, Fax (805) 922-7905.

ANTELOPE VALLEY COLLEGE

3041 West Ave. K, Lancaster, CA 93536; (805) 943-3241, Fax (805) 943-5573.

ART CENTER COLLEGE OF DESIGN

Photography Dept., 1700 Lida St., Pasadena, CA 91103; (818) 396-2200.

ART INSTITUTE OF SOUTHERN CALIFORNIA

2222 Laguna Canyon Rd., Laguna Beach, CA 92651; (714) 497-3309, Fax (714) 497-4399.

BAKERSFIELD COLLEGE

1801 Panorama Dr., Bakersfield, CA 93305; (805) 395-4241.

BROOKS INSTITUTE
Santa Barbara/Year-round *(see also page 12)*
This university awards a 3-year BA degree, 3-trimester MS degree, & Diploma (7 weeks shorter than degree program for those with a prior bachelor's degree) in photography. Program started 1945. Accredited by ACICS. Calendar: trimester. Curriculum: core. Admission dates: Jan, Mar, Apr, July, Sept, Nov. To be admitted, applicant must have at least 1 semester of college study with a minimum of 9 credits. Total enrollment: 450; 175 enrollees each admission period; 50% of applicants accepted; 20 students/instructor; 93% of graduates obtain employment in field; 6% pursue further education. Enrollment is level.

Courses: 7 undergraduate majors are offered: Color Technology, Commercial, Illustration/Advertising, Industrial/Scientific, Media, Motion Picture/Video, Portraiture. Graduate studies focus on still photography. 96 sem cr of photography-related courses required for graduation. Emphasis: photography, motion picture/video. Related courses & activities: 18 hrs/wk in lab/studio work, special projects & assignments simulate on-the-job situations. School-related employment opportunities: many internships to upper division.

Faculty: 18 full time, 21 part time, guest lecturers. Qualifications: 5 yrs as working pro, 10 yrs experience, degree.Costs: Tuition is $2,150/7-wk session. Other expenses: $25 undergraduate/diploma & $50 graduate application fee, $100 registration fee, $600/7-wk session supplies fee. Lodging ranges from $400-$650/mo.

Location: The 2 campuses for still photography overlook the city, ocean, and Santa Barbara Channel Islands, 90 miles from Los Angeles.

Contact: Inge Kautzmann, Brooks Institute, Photography and Filmmaking, 801 Alston Rd., Santa Barbara, CA 93108; (805) 966-3888, Fax (805) 564-1475.

BUTTE COLLEGE

3536 Butte Campus Dr., Oroville, CA 95965; (916) 895-2237, Fax (916) 895-2346.

CALIFORNIA COLLEGE OF ARTS AND CRAFTS

5212 Broadway at College Ave., Oakland, CA 94618; (415) 653-8118, Fax (510) 655-3541.

CALIFORNIA INSTITUTE OF THE ARTS

24700 McBean Pkwy., Valencia, CA 91355; (805) 255-1050, Fax (805) 259-5871.

CALIFORNIA STATE UNIVERSITY

Photo/Art Dept., Hayward, CA 94542;(415) 881-3111.

CALIFORNIA STATE UNIVERSITY

Art Dept., 800 N. State College Blvd., Fullerton, CA 92634; (714) 773-3471, Fax (714) 773-3005.

CALIFORNIA STATE UNIVERSITY

Journalism Dept., 6000 J St., Sacramento,CA 95819;(916) 278-6166.

CALIFORNIA STATE UNIVERSITY
San Bernardino/September-June

This university awards a 4-yr BA degree in Art. Program started 1978. Accredited by NASAD. Calendar: quarter. Curriculum: core. Admission dates: Fall, Winter, Spring. Total enrollment: 25; 12 enrollees each admission period; 100% of applicants accepted; 18 students/instructor; 80% of graduates obtain employment in field; 50% pursue further education. Enrollment is increasing by 20%.

Courses: Beginning-Advanced Photo-Visual Concepts, Photo-Illustration & Design, New Genres. 40 units of photography-related courses required for graduation. Emphasis: fine art. School-related employment opportunities: internship at California Museum of Photography.

Faculty: 1 full time, 4 part time. Qualifications: MFA & nationally exhibited.

Costs: Tuition is $659/qtr in-state, $2,400/qtr out-of-state. Other expenses: $25/course lab fee.

Location: 60 miles from Los Angeles.

Contact: Sant Khalsa, California State University, Art Dept., 5500 University Pkwy., San Bernardino, CA 92407; (909) 880-5802, Fax (909) 880-5903.

CERRITO COMMUNITY COLLEGE

Photography Dept., 11110 E. Alondra Blvd., Norwalk, CA 90650; (213) 860-2451.

CHABOT COLLEGE
Hayward/August-May

This 2-yr college awards a certificate & 2-yr AA degree in photography. Program started 1975. Accredited by WASC. Calendar: semester. Curriculum: core. Admission dates: open. Total enrollment: 225; 20 enrollees each admission period; 100% of applicants accepted; 24 students/instructor. Enrollment is level.

Courses: B&W, Color, Studio Lighting, Workshop, Digital Imaging. 27 of photography-related courses required for graduation. Emphasis: . Related courses & activities: Art/Design, Mass Communications, Commercial Art. School-related employment opportunities: calls from employers provide employment opportunities.

Faculty: 2 full time, 6 part time. Qualifications: MA, commercial photography experience.

Costs: Tuition is $13/cr hr in-state, $110 out-of-state.

Location: 20 miles from San Francisco & San Jose (northern CA).

Contact: Gene Groppetti or Dan Leonardi, Chabot College, Photo/Humanities, 25555 Hesperian Blvd., Hayward, CA 94545; (510) 786-6838.

CHAFFEY COLLEGE

5885 Haven Ave., Rancho Cucamonga, CA 91701; (909) 941-2393.

CITRUS COLLEGE

1000 West Foothill Blvd., Glendora, CA 91740; (818) 914-8862.

CITY COLLEGE OF SAN FRANCISCO
San Francisco/Year-round

This 2-yr college awards a 2-yr AS degree & Award of Photo Achievement. Program started 1947. Accredited by WASC. Calendar: semester. Curriculum: core. Admission dates: Aug, Jan. Total enrollment: 300; 50 enrollees each admission period; 100% of applicants accepted; 15 students/instructor; 50% of graduates obtain employment in field; 50% pursue further education. Enrollment is increasing by 3%.

Courses: Beginning, Intermediate, Color, Studio, Printing, Digital Imaging. 18 or 43 hours of photography-related courses required for graduation. Related courses & activities: history of photo. School-related employment opportunities: internships.

Faculty: 3 full time, 14 part time. Qualifications: MFA, 5 yrs experience.

Costs: Tuition is $50/cr hr. Other expenses: $25 health fee.

Contact: Janice Giarrocco, City College of San Francisco, Photo Dept., 50 Phelan Ave., San Francisco, CA 94131; (415) 586-5013, Fax (415) 239-3992.

COLLEGE OF THE REDWOODS

7351 Thompins Hill Rd., Eureka, CA 95501; (707) 445-6842, Fax (707) 445-6990.

COLUMBIA COLLEGE

11600 Columbia College Drive, Columbia, CA 95310; (209) 533-5222, Fax (209) 533-5104.

COSUMNES RIVER COLLEGE
Sacramento/August-May

This 2-yr college awards a certificate & 2-yr AA degree in photography. Program started 1957. Accredited by WASC. Calendar: semester. Admission dates: Aug, Jan. Total enrollment: 250; 50 enrollees each admission period; 100% of applicants accepted; 15 students/instructor; 44% of graduates obtain employment in field; 75% pursue further education. Enrollment is increasing by 20%-30%.

Courses: numerous. Related courses & activities: Digital Imaging. School-related employment opportunities: internships, assistantships, job board.

Faculty: 2 full time, 3 part time. Qualifications: MA, BFA, AA.

Costs: Tuition is $31. Other expenses: film, paper.

Contact: Jim West, Cosumnes River College, Photography Dept., 8401 Center Park Way, Sacramento, CA 95823; (916) 688-7346, Fax (916) 688-7349.

CYPRESS COLLEGE

Photography/Voc-Tech Div.,9200 Valley View St., Cypress, CA 92804;(714) 826-2220, Fax (714) 527-8238.

DE ANZA COLLEGE

21250 Stevens Creek Blvd., Cupertino, CA 95014; (408) 864-8804.

EL CAMINO COLLEGE
Torrance/September-July

This 2-yr college awards a certificate & 2-yr AA & AS degrees in photography. Calendar: semester. Curriculum: photography. 100% of applicants accepted; 24 students/instructor; 50% pursue further education. Enrollment is increasing.

Courses: Beginning 35mm, View Camera, Beginning-Advanced B&W, Portraiture, Special Processes and Color. Emphasis: general. Related courses & activities: TV/Media, Graphics Design, Computer Graphics, Studio Art and Art History Classics.

Faculty: 1 full time, 5 part time. Qualifications: Master's degree, professional and fine art background.

Costs: Tuition is $13/cr hr. Other expenses: film, paper.

Location: 3 miles from Los Angeles.

Contact: Art Department, El Camino College, Fine Art Division, 16007 Crenshaw Blvd., Torrance, CA 90506; (310) 532-3670.

FOOTHILL COLLEGE

12345 Elmonte Rd., Los Altos Hills, CA 94022; (415) 949-7318.

FRESNO CITY COLLEGE

1101 East University, Fresno, CA 93741; (209) 442-8240, Fax (209) 485-3367.

GLENDALE COMMUNITY COLLEGE

1500 N. Verdugo Rd., Glendale, CA 91208; (818) 240-1000, Fax (818) 549-9436.

GROSSMONT COLLEGE
El Cajon/Year-round

This 2-yr college awards a 2-yr AA degree in photography. Program started 1964. Accredited by state. Calendar: semester. Curriculum: core. Admission dates: Aug, Jan. Total enrollment:

50; 30 enrollees each admission period; 100% of applicants accepted; 25 students/instructor; 28% pursue further education. Enrollment is increasing by 5%.

Courses: Basic Photography, Studio, Zone Systems, Large Format, Color Neg, Cibachrome, Digital. 33 units/major of photography-related courses required for graduation. Emphasis: fine art, problem solving approach. Related courses & activities: workshops, lectures. School-related employment opportunities: varied.

Faculty: 2 full time, 5 part time. Qualifications: MFA, practicing artists.

Costs: Tuition is $13/cr hr. Other expenses: materials fee.

Location: 10 miles from San Diego.

Contact: David Wing, Professor, Grossmont College, Art/Photo Dept., El Cajon, CA 92020; (619) 465-1700, Fax (619) 461-3396.

HUMBOLDT STATE UNIVERSITY

Art Dept., Arcata, CA 95521; (707) 826-3624, Fax (707) 826-5550.

LANEY COLLEGE

900 Fallon Ave., Oakland, CA 94607; (510) 464-3281.

LASSEN COLLEGE

P.O. Box 3000, Susanville, CA 96130; (916) 257-6181, Fax (916) 257-8964.

LONG BEACH CITY COLLEGE

4901 East Carson St., Long Beach, CA 90808; (213) 599-8036.

LOS ANGELES PIERCE COLLEGE

6201 Winnetka Rd., Woodland Hills, CA 91371; (818) 719-6481, Fax (818) 710-9844.

LOS ANGELES TRADE-TECHNICAL COLLEGE

400 W. Washington Blvd., Los Angeles, CA 90015; (213) 744-9471.

LOS ANGELES VALLEY COLLEGE

Journalism/Photography Dept., 5800 Fulton Ave., Van Nuys, CA 91401-4096; (818) 781-1200.

MERCED COMMUNITY COLLEGE
Merced/August-September

This 2-yr college awards a 2-yr AA degree in photography. Program started 1974. Accredited by WASC. Calendar: semester. Curriculum: core. Admission dates: Fall, June. Total enrollment: 20; 5 enrollees each admission period; 100% of applicants accepted; 18

students/instructor; 50% of graduates obtain employment in field; 50% pursue further education. Enrollment is decreasing by 8%.

Courses: Beginning, Intermediate, Color, View Camera, Studio, Expression, Independent Study. 24 units of photography-related courses required for graduation.

Faculty: 1 full time, 1 part time. Qualifications: BA with professional experience.

Costs: Tuition is $13/cr hr. Other expenses: $10 health fee, $20 parking.

Location: 55 miles from Fresno.

Contact: Alan C.Beymer, Merced Community College, Arts Division, Photo Dept., 3600 M St., Merced, CA 95348-2898; (209) 384-6000, Fax (209) 384-6339.

MODESTO JUNIOR COLLEGE

Art Dept., 435 College Ave., Modesto, CA 95350; (209) 523-1014, Fax (209) 575-6342.

MONTEREY PENINSULA COLLEGE

980 Freemont St., Monterey, CA 93940; (408) 646-4200, Fax (408) 645-1353.

MOORPARK COLLEGE

7075 Campus Rd., Moorpark, CA 93021; (805) 378-1442, Fax (805) 378-1499.

MT. SAN ANTONIO COLLEGE

Photographics Dept.,1100 N. Grand Ave., Walnut, CA 91789; (714) 594-7661, Fax (714) 594-7661.

MT. SAN JACINTO COLLEGE
San Jacinto/August-May

This 2-yr college awards a certificate & 2-yr AS degree in photography. Program started 1963. Accredited by state. Calendar: semester. Curriculum: core. Admission dates: Aug, Jan. Total enrollment: 50; 25 enrollees each admission period; 100% of applicants accepted; 15 students/instructor; 10% of graduates obtain employment in field; 70% pursue further education. Enrollment is level.

Courses: Beginning, Advanced, Commercial, Color and Portrait. 60 sem hrs of photography-related courses required for graduation. Emphasis: career in photography. Related courses & activities: art.

Faculty: 1 full time. Qualifications: BA degree in photography, studio owner.

Costs: Tuition is $13/cr hr. Other expenses: $30 parking & ID.

Location: 35 miles from Riverside.

Contact: Roger Adams, Instructor, Mt. San Jacinto College, Photography, 1499 N. State St., San Jacinto, CA 92583; (909) 654-8011.

NAPA VALLEY COLLEGE

2277 Napa Vallejo Hwy., Napa, CA 94558; (707) 253-3238.

ORANGE COAST COLLEGE

Photography Dept., 2701 Fairview Rd., Costa Mesa, CA 92672; (714) 432-5520, Fax (714) 492-5913.

OTIS ART INSTITUTE OF PARSONS SCHOOL OF DESIGN

Photography Dept., 2401 Wilshire Blvd., Los Angeles, CA 90057; (213) 251-0525.

PALOMAR COLLEGE
San Marcos/Year-round

This 2-yr college awards a certificate & 2-yr AA degree in photography. Program started 1953. Accredited by CCLC, AACIC. Calendar: semester. Curriculum: photography/core. Admission dates: Jan, Aug. Total enrollment: 60; 15 enrollees each admission period; 100% of applicants accepted; 18 students/instructor; 30% of graduates obtain employment in field; 50% pursue further education. Enrollment is increasing by 10%.

Courses: Beginning-Advanced, Commercial, Portrait, Color Printing/Slides, Lab Technique, Digital Imaging, Creative, History. 30 hours of photography-related courses required for graduation. Emphasis: art/commercial. Related courses & activities: national parks field trips. School-related employment opportunities: internships.

Faculty: 3 full time, 6 part time. Qualifications: MA, MFA.

Costs: Tuition is $15/cr hr. Other expenses: $30 + $10-$30 lab fee.

Location: 35 miles from San Diego.

Contact: Will Gullette, Assoc. Professor, Palomar College, Communications Dept., 1140 W. Mission Rd., San Marcos, CA 92069; (619) 744-1150, Fax (619) 744-8123.

PASADENA CITY COLLEGE

Art/Photo Dept., 1520 E. Colorado Blvd., Pasadena, CA 91106; (818) 585-7238, Fax (818) 585-7912.

PORTERVILLE COLLEGE

Photography Dept., 100 E. College Ave., Porterville, CA 93257; (209) 781-3130, Fax (209) 784-4779.

RIVERSIDE COMMUNITY COLLEGE

4800 Magnolia Lane, Riverside, CA 92506; (909) 684-3980.

SADDLEBACK COLLEGE

28000 Marguerite Pkwy., Mission Viejo, CA 92692; (714) 582-4747, Fax (714) 347-0580.

SAN BERNARDINO VALLEY COLLEGE

701 S. Mt. Vernon Ave., San Bernardino, CA 92410; (714) 888-6511, Fax (909) 381-9332.

SAN DIEGO CITY COLLEGE

1313 - 12th Ave., San Diego, CA 92101; (619) 230-2567, Fax (619) 230-2063.

SAN FRANCISCO ART INSTITUTE
San Francisco/Year-round

This 4-yr college awards a BFA degree in photography. Program started 1946. Accredited by WASC, NASAD. Calendar: semester. Curriculum: core. Admission dates: Sept, Jan. Total enrollment: 130; 50+ enrollees each admission period; 75% of applicants accepted; 18 students/instructor; 90% pursue further education.

Courses: Beginning Photography, Strategies of Presentation, Large Format, Color, Extended Media. 36 sem hrs of photography-related courses required for graduation.

Faculty: 5 full time, 7 part time. Qualifications: MFA.

Costs: Tuition is $14,500/yr.

Contact: Tim Robison, VP Enrollment, San Francisco Art Institute, Admissions Dept., 800 Chestnut St., San Francisco, CA 94133; (415) 749-4500, Fax (415) 749-4590.

SAN JOAQUIN DELTA COLLEGE
Stockton/Year-round

This 2-yr college awards an AA degree in photography. Program started 1960. Calendar: semester. Curriculum: core. Admission dates: Aug, Jan. Total enrollment: 50; 15 students/instructor.

Courses: Beginning-Advanced B&W, Beginning-Advanced Color, Non-Silver. Emphasis: fine art. Other courses: print shop.

Faculty: 1 full time, 2 part time.

Costs: Tuition is $10/cr hr.

Location: 40 miles from Sacramento, 70 miles from San Francisco.

Contact: Greg Goodman, San Joaquin Delta College, Art Dept., 5151 Pacific Ave., Stockton, CA 95207; (209) 474-5532.

SAN JOSE STATE UNIVERSITY
San Jose/Year-round

This university awards 4-yr BFA & BA degrees & a 2-yr MFA degree in photography. Program started 1984. Accredited by WASC, NASAD. Calendar: semester. Curriculum: core. Admission dates: Aug, Feb. Total enrollment: 200+; 5-30+ enrollees each admission period; 16 (4 grad) students/instructor; 30% pursue further education. Enrollment is level.

Courses: B&W, Color, Digital, Product, Lighting, History. 51-60 hrs of photography-related courses required for graduation. Emphasis: critical theory, product, digital. Related courses & activities: computers in fine art, graphic design, illustration. School-related employment opportunities: internships, graduate teaching assistantships.

Faculty: 4 full time, 6 to 8 part time. Qualifications: MA, MFA.

Costs: Tuition is $876/sem, +$246 out-of-state. Other expenses: materials, some courses $25 lab fee.

Contact: Brian Taylor, Photo Coordinator, San Jose State University, School of Art & Design, 1 Washington Sq., San Jose, CA 95118; (408) 924-4320, Fax (408) 924-4326.

SANTA MONICA COLLEGE

1900 Pico Blvd., Santa Monica, CA 90405; (310) 452-9230, Fax (310) 452-9386.

SIERRA COLLEGE

5000 Rocklin Rd., Rocklin, CA 95677; (916) 781-0525, Fax (916) 781-0455.

SOLANO COLLEGE
Suisin/Year-round

This 2-yr college awards a certificate & 2-yr AS degree in photography. Program started 1973. Calendar: semester. Curriculum: core. Admission dates: Aug, Dec, May. Total enrollment: 22; 10 enrollees each admission period; 100% of applicants accepted; 20 students/instructor; 75% of graduates obtain employment in field; 5% pursue further education. Enrollment is level.

Courses: Studio, Design, Photojournalism, Large Format. Emphasis: ad illustration, commercial, portrait, photojournalism, industrial, landscape. Related courses & activities: 4 sections color, 3 sections portfolio, special projects, creative techniques. School-related employment opportunities: externships, assistantships.

Faculty: 1 full time, 4 part time. Qualifications: BA, MA, professional experience.

Costs: Tuition is $12-$50/unit. Other expenses: materials $200-$300/sem.

Location: 12 miles from Vallejo (northern CA).

Contact: Bruce Blondin, Solano College, Photography Dept., 4000 Suisun Valley Rd., Suisun, CA 94585; (707) 864-7000.

SOUTHWESTERN COLLEGE
Chula Vista/August-June

This 2-yr college awards an AA degree in photography. Program started 1962. Calendar: semester. Curriculum: core. Admission dates: Aug, Jan. Total enrollment: 25-30; 25-30 enrollees each admission period; 100% of applicants accepted; 20 students/instructor; 5% of graduates obtain employment in field; 8% pursue further education. Enrollment is level.

Courses: Beginning-Advanced B&W, Beginning-Advanced Color, Portfolio Presentation. 180 hrs of photography-related courses required for graduation. Emphasis: fine art. Related courses & activities: digital imaging. School-related employment opportunities: lab assistants.

Faculty: 3 full time, 4 part time. Qualifications: MA.

Costs: Tuition is $13/cr hr. Other expenses: supplies, books.

Location: 12 miles from San Diego.

Contact: Ron Lawson, Instructor, Southwestern College, Arts/Humanities, 900 Otay Lakes Rd., Chula Vista, CA 91910; (619) 421-6700.

VENTURA COLLEGE

4667 Telegraph Rd., Ventura, CA 93003; (805) 654-6455, Fax (805) 654-6466.

WEST VALLEY COLLEGE
Saratoga/Year-round

This 2-yr college awards a certificate & 2-yr AAS degree in photography. Program started 1971. Calendar: semester. Admission dates: Aug, Jan, June. Total enrollment: 100; 25 enrollees each admission period; 25 students/instructor; 30% of graduates obtain employment in field; 70% pursue further education. Enrollment is level.

Courses: B&W, Color, Digital, Studio. 25 units of photography-related courses required for graduation. Emphasis: photo technology or digital. Related courses & activities: Graphics, Desktop Publishing, Multi-media. School-related employment opportunities: photo internship.

Faculty: 2 full time, 4 part time.

Costs: Tuition is $13/cr hr. Other expenses: supplies.

Location: 10 miles from San Jose.

Contact: Michael Leary, West Valley College, Photography, 14000 Fruitvale Ave., Saratoga, CA 95070; (408) 741-2050.

YUBA COLLEGE
Marysville/Year-round

This 2-yr college awards a certificate and 2-yr AA & AS degrees in photography. Program started 1978. Calendar: semester. Curriculum: photography. Total enrollment: 25; 10 enrollees each admission period; 100% of applicants accepted; 22 students/instructor; 90% of graduates obtain employment in field; 75% pursue further education. Enrollment is level.

Courses: Basic B&W & Color, Documentary, Studio. 18 sem hrs of photography-related courses required for graduation. Emphasis: general. Related courses & activities: mass communication (film, TV). School-related employment opportunities: internships at local newspaper, college media production.

Faculty: 1 full time, 2 part time. Qualifications: graduate degree, working artists.Costs: Tuition is $13/cr hr.

Location: 40 miles from Sacramento.

Contact: Richard Murai, Yuba College, Art, 2088 N. Beale Rd., Marysville, CA 95901; (916) 741-6891.

COLORADO

COLORADO INSTITUTE OF ART

200 East 9th Ave., Denver, CO 80203; (800) 525-6556.

COLORADO MOUNTAIN COLLEGE
Glenwood Springs/August-May

This 2-yr college awards an AAS degree in photography. Program started 1969. Accredited by NCA. Calendar: semester. Curriculum: core. Admission dates: fall, spring. Total enrollment: 55; 35-40 enrollees each admission period; 100% of applicants accepted; 17 students/instructor; 66% of graduates obtain employment in field; <10% pursue further education. Enrollment is level.

Courses: B&W, Color, Zone System, Field Trips, Commercial, Portraiture, Portfolio, Large Format, History. 46 hrs of photography-related courses required for graduation. Emphasis: commercial. Related courses & activities: field workshops in national parks. School-related employment opportunities: financial aid, work-study.

Faculty: 2 full time, 3 part time. Qualifications: degrees, experience.

Costs: Tuition is $60/cr hr in-state, $185 out-of-state. Other expenses: supplies, lab fees.

Location: 40 miles from Aspen.

Contact: James Elliott, Professor, Colorado Mountain College, Photography Dept., 3000 County Rd. 114, Glenwood Springs, CO 81601; (303) 945-7481, Fax (303) 945-1227.

COMMUNITY COLLEGE OF DENVER
Denver/Year-round

This 2-yr college awards AA & AAS degrees in photography. Program started 1974. Accredited by NCA, state. Calendar: semester. Curriculum: core. Admission dates: Jan, May, Aug. Total enrollment: 90; 20 enrollees each admission period; 90% of applicants accepted; 20 students/instructor; 65% of graduates obtain employment in field; 35% pursue further education. Enrollment is increasing by 10%.

Courses: Fundamentals and Intermediate B&W and Color, Studio Lighting, Landscape, Portrait and Fine Printing. 33 hrs of photography-related courses required for graduation. Emphasis: integration of craft and art. Related courses & activities: computer graphics, digital imaging. School-related employment opportunities: studios and labs in Denver area.

Faculty: 2 full time, 1 part time.

Costs: Tuition is $50/cr hr. Other expenses: $25 + materials.

Contact: Professor Ray Whiting, Community College of Denver, Photography, Auraria Campus, Box 173363, Denver, CO 80217-3363; (303) 556-2484.

CONNECTICUT

HARTFORD ART SCHOOL

University of Hartford, 200 Bloomfield Ave., West Hartford, CT 06117; (203) 243-4393.

UNIVERSITY OF BRIDGEPORT

Art Dept-Bernhard, , Bridgeport, CT 06601; (203) 576-4418.

UNIVERSITY OF CONNECTICUT
Storrs/Year-round

This university awards BFA & MFA degrees in photography. Program started 1974. Accredited by NASAD. Calendar: semester. Curriculum: core. Admission dates: rolling. Total enrollment: 20; 20 enrollees each admission period; 70% of applicants accepted; 15 students/instructor. Enrollment is level.

Courses: B&W, Color, Alternate Processes. 18 hrs of photography-related courses required for graduation. Emphasis: fine art. School-related employment opportunities: internships.

Faculty: 2 full time, 2 part time. Qualifications: MFA.

Costs: Tuition is $1,912/sem. Location: 25 miles from Hartford.

Contact: David C. Kelly, University of Connecticut, Art Dept., U-99, Storrs, CT 06269-1099; (203) 486-3930, Fax (203) 486-3869.

DISTRICT OF COLUMBIA

CORCORAN SCHOOL OF ART

Photography Dept., 17th St. & New York Ave., NW, Washington, DC 20006; (202) 628-9484, Fax (202) 628-1837.

HOWARD UNIVERSITY

Art Dept., 2455 Sixth St., NW, Washington, DC 20059; (202) 806-6942, Fax (202) 806-9258.

FLORIDA

ART INSTITUTE OF FORT LAUDERDALE

Photography Dept., 1799 S.E. 17th St., Ft. Lauderdale, FL 33316-3000; (305) 463-3000, Fax (305) 523-7676.

DAYTONA BEACH COMMUNITY COLLEGE
Daytona Beach/Year-round

This 2-yr college awards an AS degree in photography. Accredited by SACS. Calendar: semester. Curriculum: core/photography. Admission dates: Jan, Aug. Total enrollment: 140; 40 enrollees each admission period; 100% of applicants accepted; 17 students/instructor; 83% of graduates obtain employment in field; 30% pursue further education. Enrollment is level.

Courses: Fundamentals, Fine Art, Photojournalism, Portraiture, Commercial. 60 hrs of photography-related courses required for graduation. Emphasis: commercial. Related courses & activities: history class, campus museum. School-related employment opportunities: work-study.

Faculty: 5 full time, 2 part time. Qualifications: MFA, field work.

Costs: Tuition is $35.80/cr hr, $130 out-of-state. Other expenses: $95 lab fee.

Location: 50 miles from Orlando.

Contact: Patrick Van Dusen, Program Mgr., Daytona Beach Community College, Visual Arts Dept., 1200 Int'l. Speedway, Daytona Beach, FL 32120; (904) 255-8131, Fax (904) 254-3044.

MIAMI-DADE COMMUNITY COLLEGE NORTH
Miami/Year-round

This 2-yr college awards 2-yr AA & AS degrees & a 4-yr BA degree in photography. Program started 1964. Accredited by SACS. Calendar: semester. Curriculum: core. Admission dates: Aug, Dec, Apr. Total enrollment: 125; 30 enrollees each admission period; 100% of applicants accepted; 15 students/instructor; 100% of graduates obtain employment in field; 7% pursue further education. Enrollment is increasing by 5%.

Courses: B&W, Color, Studio Lighting, View Camera and Digital Imaging. 15 credits of photography-related courses required for graduation. Emphasis: studio lighting. School-related employment opportunities: internships.

Faculty: 3 full time, 2 part time. Qualifications: MFA.

Costs: Tuition is $35/cr hr. Other expenses: $25 lab fee/class.

Contact: Charles Hashim, Miami-Dade Community College North, Art Dept., 11380 N.W. 27th Ave., Miami, FL 33167; (305) 237-1435, Fax (305) 237-1480.

PALM BEACH COMMUNITY COLLEGE

3160 PGA Blvd., Palm Beach Gardens, FL 33410; (407) 624-7222, Fax (407) 625-2475.

GEORGIA

ANDREW COLLEGE

Photography, Cuthbert, GA 31740; (912) 732-2171, Fax (912) 732-2176.

ART INSTITUTE OF ATLANTA

3376 Peachtree Rd. N.E., Atlanta, GA 30326; (404) 266-2662, Fax (404) 266-1383.

ATLANTA COLLEGE OF ART

Photography Dept., 1280 Peachtree St., NE, Atlanta, GA 30309; (404) 733-5001, Fax (404) 733-5201.

GEORGIA STATE UNIVERSITY

School of Art & Design, University Plaza, Athens, GA 30303; (404) 651-2257, Fax (404) 651-1779.

PORTFOLIO CENTER
Atlanta/Year-round

This school offers a 2-yr program in advertising photography. Program started 1979. Accredited by SACS. Calendar: quarter. Curriculum: photography. Admission dates: quarterly.

Courses: View Camera, Lighting, Set Construction, Food Styling, Special Effects, Non-

Silver, Editorial Photography, Multiple Exposure, Portraiture, Fashion, Annual Report. Students spend 4 hrs daily in class & 4-8 hrs on individual projects. Other activities: field trips to studios & suppliers, Student Award Show each quarter.

Faculty: Nearly 50 artists, writers, designers, & photographers. Qualifications: Many have won awards & are full-time working professionals.

Costs: Tuition is $2,750/qtr.

Contact: Admissions Dept., Portfolio Center, 125 Bennett St. NW, Atlanta, GA 30309; (800) 255-3169 or (404) 351-5055, Fax (404) 355-8838.

SOUTHEASTERN CENTER FOR THE ARTS
Atlanta/Year-round

This trade school awards an 18-mo diploma in photography. Program started 1979. Accredited by SACS. Calendar: quarter. Curriculum: photography. Admission dates: Jan, Apr, July, Oct. Total enrollment: 125; 40 enrollees each admission period; 95% of applicants accepted; 8 students/instructor; 88% of graduates obtain employment in field; 5% pursue further education. Enrollment is increasing by 10%.

Courses: numerous. Emphasis: day-5 majors, evening-1 major. School-related employment opportunities: externships, lab assistants, library assistants.

Faculty: 2 full time, 35 part time. Qualifications: professional photography graduate, minimum 2 yrs in field.

Costs: Tuition is $1,975/qtr day, $1,400/qtr evening. Other expenses: $40 application fee.

Contact: Fred W. Rich, Director, Southeastern Center for the Arts, 1935 Cliff Valley Way, NE, Atlanta, GA 30329; (404) 633-1990, Fax (404) 728-1590.

IDAHO

COLLEGE OF SOUTHERN IDAHO
Twin Falls/August-May

This 2-yr college awards an AA degree in photography. Program started 1971. Calendar: semester. Curriculum: core. Admission dates: Aug, Jan. Total enrollment: 40; 20 enrollees each admission period; most of applicants accepted; 15 students/instructor; some of graduates obtain employment in field; many pursue further education. Enrollment is increasing by 40%.

Courses: Beginning, Intermediate, B&W, Art Studio. 4 hrs + major of photography-related courses required for graduation. Emphasis: art. School-related employment opportunities: work-study.

Faculty: 1 full time. Qualifications: MFA.

Costs: Tuition is $600/sem.

Location: 120 miles from Boise.

Contact: Russell Hepworth, College of Southern Idaho, Art Dept., 315 Falls Ave., Twin Falls, ID 83303; (208) 733-9554, Fax (208) 736-3014.

RICKS COLLEGE
Rexburg/Year-round

This 2-yr college awards an associate degree in photography. Program started 1960.

Calendar: semester. Curriculum: core. Admission dates: Jan, Aug. Total enrollment: 45; 20-25 enrollees each admission period; 100% of applicants accepted; 12 students/instructor; 15%-20% of graduates obtain employment in field; 75%-80% pursue further education. Enrollment is increasing by 8%.

Courses: Basic, Intermediate, B&W, Color, Commercial, Studio, Portrait. 15 hrs of photography-related courses required for graduation. Related courses & activities: yearbook, school paper. School-related employment opportunities: internships, lab assistants.

Faculty: 1 full time, 1 part time. Qualifications: MFA, MA, fine art & journalism photographers.

Costs: Tuition is $900/sem. Other expenses: materials.

Contact: Gary Pearson, Ricks College, Art/Photo Dept., Romney #55, Rexburg, ID 83460-0525; (208) 356-1934.

ILLINOIS

BRADLEY UNIVERSITY

Photo Area, Heuser Art Center, , Peoria, IL 61625; (309) 677-2967.

CITY COLLEGES OF CHICAGO, OLIVE-HARVEY COLLEGE

Photography, 10001 S. Woodlawn Ave., Chicago, IL 60628; (312) 291-6506, Fax (312) 291-6304.

CITY COLLEGES OF CHICAGO, RICHARD J. DALEY COLLEGE

Photography Dept., 7500 S. Pulaski Rd., Chicago, IL 60652; (312) 838-7599, Fax (312) 838-7524.

COLLEGE OF DU PAGE
Glen Ellyn/Year-round

This 2-yr college awards a certificate & AAS degree in photography. Program started 1968. Accredited by NCA. Calendar: quarter. Curriculum: photography/core. Admission dates: open. Total enrollment: 200; 50 enrollees each admission period; 100% of applicants accepted; 18 students/instructor; 70% of graduates obtain employment in field; 20% pursue further education. Enrollment is increasing by 5%-8%.

Courses: numerous. 45 hrs of photography-related courses required for graduation. Related courses & activities: graphic arts, advertising, design. School-related employment opportunities: co-op education program.

Faculty: 3 full time, 10 part time. Qualifications: MA, MFA, BA, professional photographers.

Costs: Tuition is $25/cr hr. Other expenses: $8 lab fee, materials.

Location: 20 miles from Chicago.

Contact: Jeffrey Curto, Coordinator, College of Du Page, Photo-Technology Dept., 22nd St. & Lambert Rd., Glen Ellyn, IL 60137; (708) 858-2800, Fax (708) 858-5409.

ILLINOIS STATE UNIVERSITY

Art Dept., Center for the Visual Arts, Normal, IL 61761; (309) 438-5621, Fax (309) 438-8318.

NORTHERN ILLINOIS UNIVERSITY

Art Dept., , DeKalb, IL 60115; (815) 753-7851, Fax (815) 753-7701.

PRAIRIE STATE COLLEGE

Arts, Humanities, and Social Sciences Div., 200 S. Halstead St., Chicago Heights, IL 60411; (708) 709-3697, Fax (708) 755-2587.

SCHOOL OF THE ART INSTITUTE OF CHICAGO

Photography Dept., 37 S. Wabash St., Chicago, IL 60603; (312) 443-3751, Fax (312) 332-5859.

UNIVERSITY OF ILLINOIS
Champaign/Year-round

This university awards a BFA degree & MFA degree in photography. Program started 1975. Accredited by NASAD. Calendar: semester. Curriculum: core. Admission dates: open. Total enrollment: 33; 10 enrollees each admission period; 60% of applicants accepted; 15 students/instructor; 90% of graduates obtain employment in field; 20% pursue further education.

Courses: Black and White, Color, View Camera, Studio, Video, Digital, Alternative Processes, Critical Theory, Photo Sculpture, Artist on the Internet. 42 hrs of photography-related courses required for graduation. Emphasis: fine art. School-related employment opportunities: MFA - assistantships; BFA - internships in Chicago studios.

Faculty: 4 full time, 1 part time. Qualifications: All have MFA degree.

Costs: Tuition is $2,760/yr. Other expenses: $1,000 resource fee.

Location: 2 hours from Chicago.

Contact: Bea Nettles, Chair, Photography Program, University of Illinois, Art & Design, 408 E. Peabody Dr., Champaign, IL 61820; (217) 333-7713, Fax (217) 244-7688.

UNIVERSITY OF ILLINOIS AT CHICAGO

Art Dept., P.O. Box 4348, Chicago, IL 60680; (312) 996-3337, Fax (312) 413-2333.

INDIANA

INDIANA STATE UNIVERSITY

Fine Arts, Rm. 108, , Terre Haute, IN 47809; (812) 237-2630, Fax (812) 237-4369.

INDIANA UNIVERSITY

Herron School of Art, 1701 N. Pennsylvania, Indianapolis, IN 46202; (317) 923-3651.

IVY TECH STATE COLLEGE - NORTHCENTRAL

1534 W. Sample St., South Bend, IN 46619; (219) 289-7001, Fax (219) 236-7165.

IVY TECH STATE COLLEGE - SOUTHCENTRAL

Photography, 8204 Hwy. 311, Sellersburg, IN 47172; (812) 246-3301, Fax (812) 246-9905.

IVY TECH STATE COLLEGE - SOUTHWEST

3501 First Ave., Evansville, IN 47710; (812) 426-2865, Fax (812) 429-1483.

IVY TECH STATE COLLEGE
Columbus/Year-round

This 2-yr college awards an AAS degree in photography. Program started 1976. Accredited by NCA. Calendar: semester. Curriculum: core. Admission dates: Aug, Dec. Total enrollment: 50; 20 enrollees each admission period; 15 students/instructor; 85% of graduates obtain employment in field; 5% pursue further education. Enrollment is level.

Courses: Basic, Intermediate, Studio Lighting, Principles of Color, Professional Portrait, Commercial, Business Practices, Computer Graphics, Electronic Imaging. 48 hrs of photography-related courses required for graduation. Emphasis: commercial, portrait, electronic/computer graphics. School-related employment opportunities: internships and assistantships.

Faculty: 1 full time, 3 part time. Qualifications: MFA, BFA, BA.

Costs: Tuition is $57.45/cr hr. Other expenses: film, paper, electronic media.

Location: 35 miles from Indianapolis (southern IN).

Contact: Jonathan Wilson, Master Instructor, Ivy Tech State College, Visual Communications/Photography, 4475 Central Ave., Columbus, IN 47203; (812) 372-9925 (phone/fax).

SAINT MARY'S COLLEGE

Art Dept., Notre Dame, IN 46556-5001; (219) 284-4631, Fax (219) 284-4716.

UNIVERSITY OF NOTRE DAME

Art Dept., Notre Dame, IN 46556; (219) 239-7602.

IOWA

HAWKEYE COMMUNITY COLLEGE
Waterloo/Year-round

This 2-yr college awards a 4-sem AA degree in photography. Program started 1967. Accredited by NCA. Calendar: semester. Curriculum: core. Admission dates: Fall. Total enrollment: 75; 60 enrollees each admission period; 15 students/instructor; 75+% of graduates obtain employment in field; 5% pursue further education. Enrollment is decreasing by 5%.

Courses: Fundamentals of Photography, Photo Design, Print Presentation Techniques, Color Negs & Prints, Large Format, Portraiture, Commercial, Photo Reproduction, Wedding, Photojournalism, Visual Communication. 72 hrs of photography-related courses required for graduation. Emphasis: commercial, portrait, photojournalism. Related courses & activities: Photography as General Education. School-related employment opportunities: faculty only.

Faculty: 4 full time, 1 part time. Qualifications: 6 yrs professional experience.

Costs: Tuition is $1,890/sem for Iowa residents. Other expenses: course fees, equipment and supplies.

Contact: Richard Kraemer, Hawkeye Community College, Applied Art & Human Services, 1501 E. Orange Rd., Waterloo, IA 50704-8015; (319) 296-2320, Fax (319) 296-2874.

IOWA LAKES COMMUNITY COLLEGE

Photography Dept., Estherville, IA 51334; (515) 576-7201.

UNIVERSITY OF NORTHERN IOWA

Art Dept., 104 Kamerick Art Bldg., Cedar Falls, IA 50614; (319) 273-2077.

KANSAS

HUTCHINSON COMMUNITY COLLEGE

1300 N. Plum St., Hutchinson, KS 67501; (316) 665-3358, Fax (316) 665-3310.

KENTUCKY

WESTERN KENTUCKY UNIVERSITY
Bowling Green/Year-round

This university awards a BA degree in photography. Program started 1975. Accredited by ACE-JMC, SACS. Calendar: semester. Curriculum: core. Admission dates: Aug, Jan. Total enrollment: 160; 25 enrollees each admission period; 80% of applicants accepted; 17 students/instructor; 90% of graduates obtain employment in field; 10% pursue further education.

Courses: Basic, Intermediate, Color, Photojournalism, Advanced Photojournalism, Advanced Picture Editing, Photomanagement, Photo Editing. 21 hrs of photography-related courses required for graduation. Emphasis: photojournalism, photo editing. Related

courses & activities: Mountain Workshop on Photojournalism. School-related employment opportunities: internships.

Faculty: 3 full time. Qualifications: professional experience, appropriate degrees.

Costs: Tuition is $840/sem.

Location: 50 miles from Nashville, TN.

Contact: Mike Morse, Western Kentucky University, Photojournalism, 215 Garrett Conference Center, Bowling Green, KY 42101; (502) 745-6292, Fax (502) 745-6207.

LOUISIANA

LOUISIANA STATE UNIVERSITY

School of Art, Baton Rouge Campus, Baton Rouge, LA 70803; (504) 388-5411, Fax (504) 388-5424.

LOUISIANA TECHNICAL UNIVERSITY
Ruston/Year-round
This university awards BFA & MFA degrees in photography. Program started 1973. Accredited by NASAD & SACS. Calendar: quarter. Curriculum: core/photography. Admission dates: year-round. Total enrollment: 20; 100% of applicants accepted; 20 students/instructor; 50% of graduates obtain employment in field; 5% pursue further education.

Courses: B&W, Concepts, Alternative Process, Color ,Lighting, Commercial, History. 36 of photography-related courses required for graduation. Emphasis: fine art, commercial. Related courses & activities: computer art. School-related employment opportunities: graduate assistantships, internships.

Faculty: 2 full time. Qualifications: MFA, exhibitions.

Costs: Tuition is $76/sem. Other expenses: $30 art enhancement fee, $25 lab fee.

Location: 60 miles from Shreveport.

Contact: Dean Dablow, Professor, Louisiana Technical University, Art Dept., School of Art and Architecture, Ruston, LA 71272; (318) 257-3909, Fax (318) 257-4890.

MAINE

MAINE COLLEGE OF ART
Portland/Year-round
This 4-yr art college awards a BFA degree in photography. Program started 1969. Accredited by NASAD, NEASC. Calendar: semester. Curriculum: core. Admission dates: Sept, Jan. Total enrollment: 25; 5-10 enrollees each admission period; 60% of applicants accepted; 10 students/instructor; 75% of graduates obtain employment in field; 40% pursue further education. Enrollment is increasing by 5%.

Courses: Intro, Aesthetics & Techniques, Color, View Camera, Alternatives to the Single Image, Advanced Studio. 48 hrs of photography-related courses required for graduation. Emphasis: fine art. School-related employment opportunities: internships, studios, galleries, museums.

Faculty: 2 full time, 1 part time. Qualifications: MFA.

Costs: Tuition is $10,000/yr.

Contact: Admissions Director, Maine College of Art, 97 Spring St., Portland, ME 04101; (207) 775-3052, Fax (207) 772-5069.

THE MAINE PHOTOGRAPHIC WORKSHOPS
(see workshop listing and display ad on page 59) **Rockport/Year-round**

In addition to its workshop program, this private educational institution offers a 2-yr AA degree and Certificate of Completion. Program started 1973. Calendar: semester. Curriculum: Photography. Total enrollment 48; 25 enrollees each admission period; 20 students per instructor. Enrollment is increasing.

Courses: Intro, Inter, and Adv Craft, History, Philosophy, Color, Alternative Processes, Studio Lighting, View Camera. Special emphasis on black & white and color craft.

Faculty: Three full- and 1 part-time instructor. Qualifications: MFA and professional experience.

Costs: Tuition is $3,500 per semester. Housing, meals, and materials are additional.

Location: The seacoast village of Rockport, 65 miles from Portland.

Contact: David Lyman, The Maine Photographic Workshops, 2 Central St., Rockport, ME 04856; (207) 236-8581, Fax (207) 236-2558.

UNIVERSITY OF MAINE AT AUGUSTA

46 University Dr., Augusta, ME 04330; (207) 621-7131, Fax (207) 621-3293.

MARYLAND

ANNE ARUNDEL COMMUNITY COLLEGE
Arnold/Year-round

This 2-yr college awards a certificate & AAS degree in photography. Program started 1968. Calendar: semester. Admission dates: open. 20 enrollees each admission period; 15 students/instructor; 50% of graduates obtain employment in field; 50% pursue further education. Enrollment is increasing by 0.5%.

Courses: Black and White, Color, Photo Lighting, Alternative Photographic Processes, Adobe Photoshop and Digital Imaging. 15 hrs of photography-related courses required for graduation. Emphasis: wide variety of traditional and non-traditional methods. Related courses & activities: Multi-Image, Multi-Media. School-related employment opportunities: lab technicians.

Costs: Tuition is $58/cr hr for county residents; $106 out-of-county; $202 out-of-state. Other expenses: $20 lab fee.

Location: 2 miles from Annapolis.

Contact: Prof. Joyce E. Drewanz, Anne Arundel Community College, Communication Arts Technology, 101 College Pkwy., Arnold, MD 21012; (410) 541-2433.

CATONSVILLE COMMUNITY COLLEGE

800 S. Rolling Rd., Catonsville, MD 21228; (301) 455-4304.

CECIL COMMUNITY COLLEGE

1000 N.E. Road, North East, MD 21901; (410) 287-6060, Fax (410) 287-1026.

DUNDALK COMMUNITY COLLEGE

Media Technology/Photography Dept., 7200 Sollers Pt. Rd., Baltimore, MD 21222; (410) 282-6700, Fax (410) 285-9665.

HARFORD COMMUNITY COLLEGE

401 Thonas Run Rd., Bel Air, MD 21014; (410) 836-4200, Fax (410) 836-4198.

MARYLAND INSTITUTE COLLEGE OF ART

Photography Dept., 1300 Mount Royal Ave., Baltimore, MD 21217; (301) 225-2296.

MONTGOMERY COLLEGE-ROCKVILLE CAMPUS

51 Mannakee St., Rockville, MD 20850; (301) 972-2000.

MASSACHUSETTS

ART INSTITUTE OF BOSTON

Photography Dept., 700 Beacon St., Boston, MA 02215; (617) 262-1223.

ENDICOTT COLLEGE
Beverly/Year-round

This 4-yr college awards a 1-yr certificate, 2-yr AS degree, & 4-yr BFA in photography. Program started 1939. Accredited by NEASC. Calendar: semester. Curriculum: core. Admission dates: rolling. Total enrollment: 18; 12-15 enrollees each admission period; 75% of applicants accepted; 11 students per instructor; 60% of graduates obtain employment in field; 20% pursue further education. Enrollment is increasing.

Courses: Photojournalism, Portrait, Color, Advertising, Photo History, Business Photography, Commercial. 24 hrs of photography-related courses required for AS, 45 hrs for BFA. Emphasis: photojournalism, commercial/advertising, fine art. Related courses & activities: Visual Communications, Digital Imaging. Two 1-mo internships required for AS, three 1-mo & one 5-mo internship for BFA.

Faculty: 1 full time, 4 part time. Qualifications: all working photographers with degrees.

Costs: Tuition is $10,910/yr. Other costs: $600/yr expenses, $5,890 rm & bd.

Location: 21 miles from Boston.

Contact: Prof. Bill Graham, Endicott College, Photography Dept., 376 Hale St., Beverly, MA 01938; (508) 927-0585, Fax (508) 927-0084.

GREENFIELD COMMUNITY COLLEGE

Photography, 1 College Dr., Greenfield, MA 01301; (413) 771-3131, Fax (413) 774-5129.

HALLMARK INSTITUTE OF PHOTOGRAPHY
Turners Falls/Year-round

This trade school awards a 10-mo certificate in photography. Program started 1975. Accredited by ACCSCT, state. Curriculum: photography. Admission dates: rolling. Total enrollment: 80; 80 enrollees each admission period; 75% of applicants accepted; 12 students/instructor; 87% of graduates obtain employment in field; 10% pursue further education. Enrollment is increasing by 20%.

Courses: Portraiture, Commercial, Industrial, Photojournalism, Fashion, Retouching. 1,400 hrs of photography-related courses required for graduation. Emphasis: preparation to own/manage photographic business. Related courses & activities: pricing, advertising, career observations, PR, finance. School-related employment opportunities: evening/weekend work with alumni and pros.

Faculty: 6 full time, 2 part time. Qualifications: 5-8 yrs field experience; most have owned photo businesses.

Costs: Tuition is $10,450/yr. Other expenses: $2,500 materials.

Location: 60 miles from Springfield.

Contact: William Chenaille, Dir. of Admissions, Hallmark Institute of Photography, Admissions, Airport, Turners Falls, MA 01376; (413) 863-2478.

HOLYOKE COMMUNITY COLLEGE
Holyoke/year-round

This 2-year college awards an AA degree in photography. Program started 1976. Calendar: semester. Curriculum: core. Admission dates: Sept, Jan. Total enrollment: 30-40; 15-20 enrollees each admission period; 100% of applicants accepted; 16 students/instructor; 10%-20% of graduates obtain employment in field; 80%-90% pursue further education. Enrollment is increasing by 5%-10%.

Courses: Basic Still Photography, Advanced Black and White, Photojournalism, Color Photography, A Critical Survey of Photography, Independent Study. 9-12 hrs of photography-related courses required for graduation. Emphasis: documentary, fine art, photojournalism. Related courses & activities: photography clubs, literary-visual magazine, visual arts club. School-related employment opportunities: internship and lab assistant.

Faculty: 1 full time. Qualifications: MFA.

Costs: Tuition is $2,890/yr.

Location: 40 miles from Hartford, CT (western MA, near Springfield).

Contact: Robert Aller, Assoc. Prof., Holyoke Community College, Art, 303 Homestead Ave., Holyoke, MA 01040; (413) 538-7000.

MASSACHUSETTS COLLEGE OF ART

Photography Dept., 621 Huntington Ave., Boston, MA 02115; (617) 232-1555, Fax (617) 566-4034.

NEW ENGLAND SCHOOL OF PHOTOGRAPHY
Boston/Year-round

This trade school awards a 2-yr certificate in photography. Program started 1968. Accredited by ACCSCT. Calendar: trimester. Curriculum: photography. Admission dates: Feb, Oct. Total enrollment: 104; 60 enrollees each admission period; 85% of applicants accepted; 10 students/instructor. Enrollment is increasing by 10%.

Courses: B&W, Color, Fashion, Photo History, Business, Corporate, Editorial, Advertising, Photojournalism and Portraiture. 1,800 hrs of photography-related courses required for graduation.

Faculty: 18 part time. Qualifications: must be working professionals in field.

Costs: Tuition is $8,400/yr.

Contact: Martha Hassell, New England School of Photography, 537 Commonwealth Ave., Boston, MA 02215; (617) 437-1868, Fax (617) 437-0261.

SCHOOL OF THE MUSEUM OF FINE ARTS, BOSTON

Photography Dept., 230 The Fenway, Boston, MA 02115-9975; (617) 267-6100, Fax (617) 424-6271.

UNIVERSITY OF MASSACHUSETTS
N. Dartmouth/Year-round

This university awards BFA & MFA degrees in photography. Program started 1972. Accredited by NASAD, state. Calendar: semester. Curriculum: core. Admission dates: Sept, Jan. Total enrollment: 60; 30 enrollees each admission period; 15 students/instructor; many graduates obtain employment in field; 20% pursue further education. Enrollment is increasing by 15%.

Courses: Photo I-VI, Special Processes , History of Photography, Seminar and Electronic Imaging I-IV. 30 hrs of photography-related courses required for graduation. School-related employment opportunities: internships, contract learning, multi-disciplinary major.

Faculty: 4 full time, 5 part time. Qualifications: all MFA graduates.Costs: Tuition is $3,000/yr in-state. Other expenses: student & lab fees.

Location: 30 miles from Boston (southeastern MA).

Contact: Alma de la Ronde, Professor, University of Massachusetts, Photographic/ Electronic Imagery, Group 6, Old Westport Rd., N. Dartmouth, MA 02747; (508) 999-8559.

MICHIGAN

CENTER FOR CREATIVE STUDIES
Detroit/Year-round

This 4-yr college awards a BFA degree in photography. Program started 1964. Accredited by NCA, NASAD. Calendar: semester. Curriculum: core. Admission dates: Mar. Total enrollment: 70; 30 enrollees each admission period; 80% of applicants accepted; 10 students/instructor; 85% of graduates obtain employment in field; 5% pursue further education. Enrollment is decreasing by 30%.

Courses: Basic, Intermediate, Advanced, Photo Thesis Project, Photo History, Color, Audio Visual, Video, Photojournalism, Alternative Printing Process, Digital Imaging, Photo Seminar and Biomedical. 75 cr hrs of photography-related courses required for graduation. Emphasis: applied, fine art, biomedical. Related courses & activities: internships, guest artists. School-related employment opportunities: internships, externships, assistantships.

Faculty: 4 full time, 6 part time. Qualifications: working professionals and teaching experience.

Costs: Tuition is $11,850/yr.

Contact: Robert Vigiletti, Chair, Center for Creative Studies, Photography Dept., 201 E. Kirby, Detroit, MI 48202; (313) 872-3118, Fax (313) 872-8377.

CRANBROOK ACADEMY OF ART

Photography Dept., P.O. Box 801,500 Lone Pine Rd., Bloomfield Hills, MI 48013; (810) 645-3301, Fax (810) 646-0046.

KELLOGG COMMUNITY COLLEGE

Photography Dept., 450 North Ave., Battle Creek, MI 49017; (616) 965-3931, Fax (616) 965-4133.

LANSING COMMUNITY COLLEGE
Lansing/Year-round

This 2-yr college awards an AAS degree in photography. Program started 1972. Accredited by NCA. Calendar: semester. Curriculum: core. Admission dates: open. Total enrollment: 150; 25-50 enrollees each admission period; 100% of applicants accepted; 15 students/instructor; 67% of graduates obtain employment in field; 20% pursue further education. Enrollment is level.

Courses: B&W, Color, Design, Lighting, Small/Medium/Large Format, Portrait, Photo Communication, Fine Art, Commercial, Film Making, Computer Imaging, Alternative Processes. 54 hrs of photography-related courses required for graduation. Emphasis: commercial, portrait, commercial illustration, filmmaking, photo communication, fine art, hybrid imaging. Related courses & activities: topical seminars, Focus on Hybrid Imaging workshop/seminar. School-related employment opportunities: internships with public and private employers.

Faculty: 7 full time. Qualifications: BFA, MFA.

Contact: Dorothy Potter Barnett, Lansing Community College, 3662 Photo, Box 40010, Lansing, MI 48901; (517) 483-1673, Fax (517) 483-1997.

SIENA HEIGHTS COLLEGE

1247 E. Siena Heights Dr., Adrian, MI 49221; (517) 263-0731, Fax (517) 265-3380.

UNIVERSITY OF MICHIGAN

Art Dept., 2000 Bonisteel Blvd., Ann Arbor, MI 48109-2069; (313) 763-4093.

WASHTENAW COMMUNITY COLLEGE

4800 E.Huron River Dr.,Box D-1, Ann Arbor, MI 48106-0978; (313) 973-3516.

WESTERN MICHIGAN UNIVERSITY

Art Dept., Kalamazoo, MI 49008; (616) 387-2438, Fax (616) 387-2477.

MINNESOTA

HENNEPIN TECHNICAL COLLEGE
Eden Prairie/Year-round

This 2-yr college awards 5-qtr (minimum) diplomas in commercial photography, industrial photography, product/advertising photography, and portrait/wedding photography. Program started 1973. Accredited by state. Calendar: quarter. Curriculum: photography. Admission dates: quarterly. Total enrollment: 50-70; 30 enrollees each admission period; 100% of applicants accepted; 5-30 students/instructor; 100% of graduates obtain employment in field; 5% pursue further education. Enrollment is increasing by 5%-10%.

Courses: numerous. 80 of photography-related courses required for graduation. Emphasis: commercial, industrial, product/advertising, wedding/portrait. Related courses & activities: certificate option photo assistant. School-related employment opportunities: internships.

Faculty: 1 full time, 2 part time. Qualifications: 35 yrs professional experience, 30 yrs photo teaching.

Costs: Tuition is $37.35/cr hr. Other expenses: some lab courses $5/credit, for average student additional $40/cr.

Location: 10 miles from Minneapolis.

Contact: James L. Voris, Lead Instructor, Hennepin Technical College, Professional Photography Program, 9200 Flying Cloud Dr., Eden Prairie, MN 55347; (612) 944-2222, Fax (612) 550-3147.

MANKATO STATE UNIVERSITY

Art Dept., Mankato, MN 56001; (507) 389-6413, Fax (507) 389-5887.

MINNEAPOLIS COLLEGE OF ART AND DESIGN

Photography Dept., 2501 Stevens Ave. S., Minneapolis, MN 55404; (612) 874-3618.

MOORHEAD STATE UNIVERSITY
Moorhead/year-round

This university awards BA & BFA degrees & an MA degree in photography. Program started 1975. Accredited by NASAD. Calendar: semester. Curriculum: core. Admission dates: Aug, Mar. Total enrollment: 15-20; 5 enrollees each admission period; 80% of applicants accepted; 20 students/instructor; 90% of graduates obtain employment in field; 40% pursue further education. Enrollment is increasing by 2%.

Courses: Basic Photography, Photo Studio 200, 300, 400, Studio Lighting, Color. 39 of photography-related courses required for graduation. Emphasis: fine art. Related courses & activities: foundation courses, drawing, design 3-D, desktop publishing. School-related employment opportunities: internships with individuals and companies.

Faculty: 1 full time. Qualifications: MFA from accredited university.

Costs: Tuition is $55.15/cr hr. Other expenses: film, paper, cameras, etc..

Contact: Prof. D. B. McRaven, Moorhead State University, Art, 1104 7th Ave. S., Moorhead, MN 56560; (218) 236-2151.

ST. CLOUD STATE UNIVERSITY
St. Cloud/Year-round

This university awards a BS degree in photography. Program started 1964. Accredited by NCA, ACE. Calendar: quarter. Curriculum: core. Admission dates: year-round. Total enrollment: 25; 10 enrollees each admission period; 80% of applicants accepted; 10 students/instructor; 95% of graduates obtain employment in field; 2% pursue further education. Enrollment is increasing by 5%.

Courses: Basic B&W and Color, Sensitometry, Photo Chemistry, Photo Mechanisms, Advanced Photo, Photographic Electronics, Safety and Quality Assurance. 45 hrs of photography-related courses required for graduation. Emphasis: imaging engineering technology. Related courses & activities: teacher summer workshop. School-related employment opportunities: internships, assistantships.

Faculty: 4 full time. Qualifications: MS and industrial experience.

Costs: Tuition is $42.35/cr hr. Other expenses: books and materials.

Location: 80 miles from Minneapolis.

Contact: Professor John Gammell, St. Cloud State University, Technology, HH 216, 720 4th Ave. S., St. Cloud, MN 56301; (612) 225-2107, Fax (612) 654-5122.

SCHOOL OF COMMUNICATION ARTS
Minneapolis/Year-round

This trade school awards a 6-mo diploma in photography. Accredited by ACCSCT. Calendar: quarter. Curriculum: photography. Admission dates: Jan, Mar, July, Sept. Total enrollment: 60; 90% of applicants accepted; 20 students/instructor; 75% of graduates obtain employment in field; 5% pursue further education. Enrollment is increasing by 20%.

Courses: Portraiture, Advertising Illustration, Corporate Report Photography, B&W and Color, Darkroom Techniques. 720 hrs of photography-related courses required for graduation. Emphasis: lighting and design. School-related employment opportunities: work-study program.

Faculty: 1 full time, 1 part time. Qualifications: working professional photographers.

Costs: Tuition is $6,190/6 mos. Other expenses: $275 supplies fee.

Contact: Admissions Officer, School of Communication Arts, Photography, 2526 27th Ave. S., Minneapolis, MN 55406; (612) 721-5357, Fax (612) 721-6642.

WILLMAR TECHNICAL COLLEGE
Willmar/September-June

This 2-yr college awards a diploma & AAS degree in photography. Program started 1971.

Accredited by NCA. Calendar: quarter. Curriculum: core. Admission dates: Aug. Total enrollment: 40; 25 enrollees each admission period; 80% of applicants accepted; 20 students/instructor; 88% of graduates obtain employment in field; 2% pursue further education. Enrollment is level.

Courses: Portrait, Commercial, Electronic Imaging. 86-90 cr hrs of photography-related courses required for graduation. School-related employment opportunities: internship.

Faculty: 2 full time.

Costs: Tuition is $38/cr hr. Other expenses: $15/cr lab fee.Location: 100 miles from Minneapolis.

Contact: Keith Grothem, Willmar Technical College, Photography Dept., 2101 15th Ave, NW, Willmar, MN 56201; (612) 235-5114, Fax (612) 235-0601.

MISSISSIPPI

MISSISSIPPI STATE UNIVERSITY
Mississippi State/Year-round
This university awards a 4- & 5-yr BFA degree in photography. Program started 1970. Accredited by NASAD. Calendar: semester. Curriculum: core. Admission dates: Aug, Jan. Total enrollment: 25; 8 enrollees each admission period; 100% of applicants accepted; 10 students/instructor; 40% of graduates obtain employment in field; 60% pursue further education. Enrollment is increasing by 5%.

Courses: Basic & Advanced B&W, Color, Dye Transfer, Alternative, Film & Video, Digital. 15 hrs of photography-related courses required for graduation. Emphasis: digital. Related courses & activities: computer animation.

Faculty: 1 full time, 2 part time. Qualifications: MFA degrees.

Costs: Tuition is $2,500/sem.

Location: 35 miles from Columbus (northeast MS).

Contact: Marita Gootee, Associate Professor, Mississippi State University, Art Dept., P.O. Box 5182, Mississippi State, MS 39762; (601) 325-2970, Fax (601) 325-3850.

NORTHEAST MISSISSIPPI COMMUNITY COLLEGE

Booneville, MS 38829; (601) 728-7751.

MISSOURI

KANSAS CITY ART INSTITUTE

Photo/Video Dept., 4415 Warwick Blvd., Kansas City, MO 64113; (816) 561-4852, Fax (816) 561-6404.

ST. LOUIS COMMUNITY COLLEGE – MERAMEC

Photography, , Kirkwood, MO 63122; (314) 984-7609, Fax (314) 984-7117.

ST. LOUIS COMMUNITY COLLEGE–FLORRISANT VALLEY
Ferguson/Year-round

This 2-yr college awards an AA degree in photography. Program started 1985. Accredited by NASAD. Calendar: semester. Curriculum: core. Admission dates: fall, spring, summer. Total enrollment: 45; 10 enrollees each admission period; 100% of applicants accepted; 18 students/instructor. Enrollment is level.

Courses: B&W, Color, Bookmaking, Photojournalism, Artificial Light, Field, History. 67-69 hrs of photography-related courses required for graduation. Emphasis: fine art. Related courses & activities: photo club.

Faculty: 1 full time, 5 part time. Qualifications: MFA.

Costs: Tuition is $40/cr hr. Other expenses: $3/cr hr student activities.

Location: 10 miles from St. Louis.

Contact: Kim Mosley, St. Louis Community College, Arts Dept., 3400 Pershall Rd., Ferguson, MO 63135; (314) 595-4371, Fax (314) 595-4544.

ST. LOUIS COMMUNITY COLLEGE – FOREST PARK

5600 Oakland Ave., St. Louis, MO 63110; (314) 644-9100, Fax (314) 644-9752.

MONTANA

MILES COMMUNITY COLLEGE

2715 Dickinson Ave., Miles City, MT 59301; (406) 232-3031, Fax (406) 232-5705.

ROCKY MOUNTAIN SCHOOL OF PHOTOGRAPHY
(see also page 76) **Missoula/Summer**

In addition to its year-round workshop program, this school offers a 10-week summer intensive career program. Students start with the basics and end with a portfolio of their best work. The schedule includes classroom, darkroom, and studio work, with field shooting outdoors.

Costs: Tuition is $3,350.

Contact: Jeanne Chaput de Saintonge, RMSP, Box 7697, Missoula, MT 59807; (406) 543-0171 or (800) 394-7677, Fax (406) 543-0171.

NEBRASKA

METROPOLITAN TECHNICAL COMMUNITY COLLEGE

P.O. Box 3777, Omaha, NE 68103; (402) 449-8418.

UNIVERSITY OF NEBRASKA
Lincoln/Year-round

This university awards BFA & MFA degrees in photography. Program started 1968. Accredited by NASAP. Calendar: semester. Curriculum: core. Admission dates: Aug, Jan.

Total enrollment: 200; 75 enrollees each admission period. 12 students/instructor; 35% pursue further education. Enrollment is increasing by 10%.

Courses: Fine Art. 24 hrs of photography-related courses required for graduation. Emphasis: fine arts. Related courses & activities: art major, 72 hours studio, 15 art history for BFA. School-related employment opportunities: graduate assistantships, work-study.

Faculty: 2 full time. Qualifications: MFA.

Costs: Tuition is . Other expenses: $25 lab fee/sem.

Contact: Dave Read, University of Nebraska, Art/Art History Dept., 207 Woods Hall, Lincoln, NE 68588-0114; (402) 472-5542.

NEVADA

CLARK COUNTY COMMUNITY COLLEGE

North Las Vegas, NV 89030; (702) 651-4000, Fax (702) 643-6427.

COMMUNITY COLLEGE OF SOUTHERN NEVADA

3200 E. Cheyenne Ave., North Las Vegas, NV 89030; (702) 651-4153, Fax (702) 643-6427.

UNIVERSITY OF NEVADA, LAS VEGAS

Arts Dept., 4505 Maryland Pkwy., Las Vegas, NV 89154; (702) 739-3237.

NEW HAMPSHIRE

WHITE PINES COLLEGE
Chester/August-May

This 2-yr college awards an AA degree in photography. Program started 1965. Accredited by NFASC. Calendar: semester. Curriculum: core. Admission dates: Sept, Jan. Total enrollment: 38; 19 enrollees each admission period; 70% of applicants accepted; 10 students/instructor; 95% of graduates obtain employment in field; 12.5% pursue further education. Enrollment is increasing by 10%.

Courses: Numerous. 12 photography-related courses required for graduation. Emphasis: commercial photo. School-related employment opportunities: part time jobs.

Faculty: 2 full time, 2 part time. Qualifications: MFA.

Costs: Tuition is $7,500/yr. Other expenses: $300 books/yr.

Location: 10 miles from Manchester.

Contact: James Mulligan, White Pines College, Admissions Dept., 40 Chester St., Chester, NH 03036; (800) 974-6372, Fax (603) 887-1777.

BURLINGTON COUNTY COLLEGE

Route 530, Pemberton, NJ 08068; (609) 894-9311.

COUNTY COLLEGE OF MORRIS

Photography Dept., 214 Center Grove Rd., Randolph, NJ 07869; (201) 328-5450, Fax (201) 328-1282.

JERSEY CITY STATE COLLEGE
Jersey City/Year-round

This 4-yr college awards BA & BFA degrees in photography. Program started 1969. Accredited by NASAD. Calendar: semester. Curriculum: core. Total enrollment: 75; 10 enrollees each admission period; 12 students/instructor; 80% of graduates obtain employment in field; 25% pursue further education. Enrollment is level.

Courses: B&W, Photo History, Large Format, Studio Lighting, Color, Advanced Darkroom, Photojournalism, Alternative Technique, Fashion, Architectural, Advertising, Fine Art, Digital Photography. 34 hrs BA, 41 hrs BFA of photography-related courses required for graduation. Emphasis: two tracks: commercial or fine art. Related courses & activities: internship, independent study. School-related employment opportunities: co-op education, experience in studios or with professional photographers.

Faculty: 3 full time, 5 part time. Qualifications: MFA degree or equivalent professional experience.

Location: 10 miles from New York City metropolitan area.

Contact: Mauro Altamura, Jersey City State College, Art, 2039 Kennedy Blvd., Jersey City, NJ 07305; (201) 200-3285.

MERCER COUNTY COMMUNITY COLLEGE

P.O. Box B, Trenton, NJ 08690; (609) 586-0505, Fax (609) 586-6744.

MIDDLESEX COUNTY COLLEGE

Edison, NJ 08818; (201) 548-6000.

MONTCLAIR STATE UNIVERSITY
Upper Montclair/Year-round

This university awards BA, BFA, & MA degrees in photography. Program started 1965. Accredited by MSA and NASAD. Calendar: semester. Curriculum: core. Total enrollment: 25; 5+ enrollees each admission period; 60% of applicants accepted; 12 students/instructor; 75+% of graduates obtain employment in field; 33% pursue further education. Enrollment is level.

Courses: Basic/Advanced Color, Commercial, Special Processes. 25+ hrs of photography-related courses required for graduation. Emphasis: art orientation. Related courses & activities: Computers, Film, Video. School-related employment opportunities: co-op, internships, externships.

Faculty: 2 full time, 1 part time. Qualifications: MFA.

Costs: Tuition is $2,284 in-state, $3,456 out-of-state. Other expenses: $2,100+ fees/yr.

Location: 12 miles from New York City.

Contact: Klaus Schnitzer, Professor, Montclair State University, Fine Art, Normal Ave., Upper Montclair, NJ 07043; (201) 655-4320.

NEW MEXICO

INSTITUTE OF AMERICAN INDIAN ARTS

Photography, 1600 St. Michaels Blvd., Santa Fe, NM 87504; (505) 988-6430.

NEW YORK

ADIRONDACK COMMUNITY COLLEGE

Bay Road, Queensbury, NY 12804; (518) 743-2200, Fax (518) 745-1442.

ALFRED UNIVERSITY

School of Art & Design, , Alfred, NY 14802; (607) 871-2441, Fax (607) 871-2490.

COLUMBIA-GREENE COMMUNITY COLLEGE
Hudson/September-May

This 2-yr college offers a 15-wk photography program. Calendar: semester. Admission dates: Aug, Jan. 80% of applicants accepted; 12 students/instructor; 2% of graduates obtain employment in field; 40% pursue further education.

Courses: Introduction to Photography, Intermediate Photography, Color Photography. elective of photography-related courses required for graduation. Emphasis: black and white and color.

Faculty: 1 part time. Qualifications: MA in related field.

Contact: Peter Donahoe, Columbia-Greene Community College, Arts and Humanities, Box 1000, Hudson, NY 12534; (518) 828-4181, Fax (518) 828-8543.

COOPER UNION

School of Art, 41 Cooper Sq., New York, NY 10003; (212) 353-4203, Fax (212) 353-4345.

FASHION INSTITUTE OF TECHNOLOGY

Photography Dept., Seventh Ave. at 27th St., New York, NY 10001; (212) 760-7665, Fax (212) 760-7160.

HERKIMER COUNTY COMMUNITY COLLEGEZ

Herkimer, NY 13350; (315) 866-0300, Fax (315) 866-7253.

INTERNATIONAL CENTER OF PHOTOGRAPHY
(see also page 86) **New York/September-June**

The ICP offers two 10-mo certificate programs: General Photographic Studies and Photojournalism and Documentary Photography. Established 1974. Calendar: 3 terms. Curriculum: photography. Admission date: September. Total enrollment: 30 in General Studies, 15 in Photojournalism & Documentary; 20% of applicants accepted (based on portfolio); 15 students/instructor.

Courses: General Studies courses include Photography as Installation, Problematic Portrait, Advanced Color Printing, Large Format, Visual Diaries, Daily Exposure, Polaroid, Photo Bookmaking. Photojournalism and Documentary courses include Visual Biography, Assignment Photojournalism, Editorial Color, New Documentary Editorial Processes, and Photo Essay. Other activities: workshops, lecture series, master seminars, symposia, project for publication, final exhibition. Museum internships available.

Faculty: 45 working photographers, critics, and historians; visiting artists.

Costs: Tuition for each program is $7,200. Other expenses: $200 lab fee; room, board, transportation, and supplies can exceed $1,000.

Location: On Manhattan's Upper East Side, bordering Central Park. Facilities include B&W and color labs, non-silver process areas, library, and gallery.

Contact: Beth Eisgrau, International Center of Photography, Education Dept., Full-Time Studies Program, 1130 Fifth Ave., New York, NY 10128; (212) 860-1776, ext. 153.

LAGUARDIA COMMUNITY COLLEGE-CUNY
Long Island City/Year-round

This 2-yr college awards a 1-yr certificate & 2- to 2.5-yr AAS degree in commercial photography. Program started 1987. Accredited by MSA, state. Calendar: modified semester. Curriculum: core. Total enrollment: 200+; 50-60 enrollees each admission period; 100% of applicants accepted; 20 students/instructor; 80% of graduates obtain employment in field; 50% pursue further education. Enrollment is increasing by 15-30%.

Courses: Beginning-Intermediate B&W, Color I&II, History, Studio Lighting I&II, Photojournalism, Com Photo Wkshop, Com Photo Sem, Computer Art. Emphasis: commercial photography, related fields. Related courses & activities: history, fine art. School-related employment opportunities: students must do 3 co-op internships.

Faculty: 2 full time, 7 part time. Qualifications: professionals.

Costs: Tuition is $85/cr hr, $1,050/yr.

Contact: Prof. Bruce Brooks, Dir. of Photography Programs, LaGuardia Community College-CUNY, Photography/Humanities Dept., 31-10 Thomson Ave., Long Island City, NY 11101; (718) 482-5696, (718) 349-4028, Fax (718) 482-5599.

MOHAWK VALLEY COMMUNITY COLLEGE
Utica/Year-round

This 2-yr college awards a certificate & AAS degree in photography. Program started 1986. Accredited by MSA. Calendar: semester. Admission dates: fall, spring, summer. Total enrollment: 110; 48 enrollees each admission period; 95% of applicants accepted; 15

students/instructor; 76% of graduates obtain employment in field; 50% pursue further education. Enrollment is increasing by 15%.

Courses: Fundamentals, Commercial, Studio, Color, Advanced Darkroom, Photojournalism, Seminar, Digital Photo, History of Photography. 48 hrs of photography-related courses required for graduation. Emphasis: commercial. Related courses & activities: internship. School-related employment opportunities: mandatory internship in photography degree program.

Faculty: 3 full time, 5 part time. Qualifications: Master's degree.

Costs: Tuition is $1,200/sem.

Location: 50 miles from Syracuse (between Rochester and Albany).

Contact: Ronald Labuz, Mohawk Valley Community College, Visual Communication, 1101 Sherman Dr., Utica, NY 13501; (315) 792-5446, Fax (315) 792-5666.

NEW YORK UNIVERSITY - TISCH SCHOOL OF THE ARTS
New York/Year-round

This university offers a 4-year BFA degree in photography. Program started 1982. Accredited by NASAD. Calendar: semester & summer. Curriculum: core. Admission dates September for freshmen; January for transfer students (must complete 2 yrs at Tisch). Total enrollment 110; 36 enrollees/yr; 15%-20% of applicants accepted; 15 students/instructor; 70% of graduates obtain employment; 30% pursue further education. Enrollment is increasing (current enrollment is maximum).

Courses: 36 photo production credits and 20 photo history credits. Emphasis: fine art, documentary, computer imaging. Internships available.

Faculty: 5 full-time, 15 part-time instructors. Qualifications: advanced degrees, national reputation.

Location: Greenwich Village.

Contact: Tisch School of the Arts, New York University, 721 Broadway, 8th Fl., New York, NY 10003; (212) 998-1930.

ONONDAGA COMMUNITY COLLEGE
Syracuse/Year-round

This 2-yr college awards an AS degree in photography. Program started 1986. Accredited by MSA. Calendar: semester. Curriculum: core. Admission dates: open. Total enrollment: 50; 25 enrollees each admission period; 80% of applicants accepted; 16 students/instructor; 75% of graduates obtain employment in field; 25% pursue further education. Enrollment is level.

Courses: General Photo, B&W, Color Neg, Slides, Photo Finishing, Digital Imaging, Studio, Journalism. 9 photography-related courses required for graduation. Emphasis: general, photo finishing. Related courses & activities: photo club, field trips, overseas study. School-related employment opportunities: internships, co-op, work-study.

Faculty: 1 full time, 4 part time. Qualifications: professional photographers, journalist.

Costs: Tuition is $1,200/sem. Other expenses: lab fee, materials, supplies.

Location: 2 miles from Syracuse.

Contact: Victor Lisnyczyj, Chair, Onondaga Community College, Photography Dept., Rt 173, Syracuse, NY 13215; (315) 469-2154.

PARSONS SCHOOL OF DESIGN
New York/September-May

This university awards a BFA degree in photography. Program started 1933. Calendar: semester. Curriculum: core. Admission dates: rolling. Total enrollment: 150; 33% of applicants accepted; 20 students/instructor. Enrollment is increasing.

Courses: Black and White, Color, Non-Silver Processes, Studio, Documentary and Electronic Imaging. 90 hrs of photography-related courses required for graduation. School-related employment opportunities: internships, job listings.

Faculty: 50 part time.

Costs: Tuition is $15,000/yr. Other expenses: lab and materials fees.

Contact: , Parsons School of Design, Admissions, 2 W. 13th St., New York, NY 10011; (212) 229-8910.

PRATT INSTITUTE
Brooklyn/Year-round

This university awards a 4-yr BFA degree & 2-yr MFA degree in photography. Accredited by MSA. Calendar: semester. Curriculum: core. Admission dates: rolling. Total enrollment: 60; 15 students/instructor. Enrollment is increasing.

Courses: 3-Dimensional Design, Color Photography, Optics, History of Photography, Large Format, Non Silver/Platinum, Studio Photography. 67 cr hrs of photography-related courses required for graduation. Emphasis: fine art. Related courses & activities: Advanced B&W, Editorial Workshop, Electronic Photography. School-related employment opportunities: internships, career services.

Faculty: 2 full time, 13 part time. Qualifications: practicing artist photographers.

Costs: Tuition is $12,345/yr. Other expenses: $2,000 for books & supplies, $5,565 for housing.

Location: 20 miles from Manhattan.

Contact: Office of Admissions, Pratt Institute, 200 Willoughby Ave., Brooklyn, NY 11205; (800) 331-0834, Fax (718) 636-3670.

ROCHESTER INSTITUTE OF TECHNOLOGY
Rochester/Year-round

This 4-yr college awards AAS, BS, BFA, & MS degrees in photography. Program started 1930. Accredited by NASAD. Calendar: quarter. Curriculum: core. Admission dates: rolling. Total enrollment: 850; 250 enrollees each admission period; 15 students/instructor; 70%-98% obtain employment; 40% pursue further education. Enrollment is shifting from science to commercial at a rate of 10%.

Courses: Fine Art, Applied, Photojournalism, Biomedical, Photo Technology, Film, Video, Electronic Imaging, Computer Animation, Image Systems Management. 110 qtr hrs of photography-related courses required for graduation. Comprehensive co-op & internship program.Faculty: 42 full time, 25 part time. Qualifications: MFA, MS.

Costs: Tuition ranges from $4,000-$4,300/qtr. Room & board are approximately $1,700/qtr.

Location: Suburban Rochester.

Contact: Nancy Stuart, Rochester Institute of Technology, School of Photographic Arts

& Sciences, 70 Lomb Memorial Dr., Rochester, NY 14623; (716) 475-7401, Fax (716) 475-5804.

SAGE JUNIOR COLLEGE OF ALBANY

Fine Arts Division, 140 New Scotland Ave., Albany, NY 12208; (518) 445-1778, Fax (518) 436-0539.

SCHOOL OF VISUAL ARTS
New York/Year-round *(see also page 91)*

This 4-yr art college awards BFA & MFA degrees in photography. Program started 1968. Accredited by MSA, NASAD, AISAD. Calendar: semester. Curriculum: core. Admission dates: fall, spring (freshmen only). Total enrollment: 325-400; 80 enrollees each admission period; 18 students/instructor; 80% of graduates obtain employment in field; 10% pursue further education. Enrollment is increasing by 20%.

Courses: Black and White, Color, Studio, Digital, Alternative Process, History, Critique Seminars, Still Life, Fashion, Location, Business of Photography. 70 hrs of photography-related courses required for graduation. Related courses & activities: lectures, exhibitions. School-related employment opportunities: placement office, some work-study and assistantships.

Faculty: 70 part time. Qualifications: working professionals.

Costs: Tuition is $6,000/sem. Other expenses: registration fee $40, lab fee $300, other fees $60, health ins $85, supplies $1,800-$2,000/yr.

Contact: School of Visual Arts, Admissions Office, 209 E. 23rd St., New York, NY 10010-3994; (800) 436-4204, (212) 592-2100.

SKIDMORE COLLEGE

Art Dept., Saratoga Springs, NY 12866; (518) 584-5000, Fax (518) 584-3023.

SULLIVAN COUNTY COMMUNITY COLLEGE
Loch Sheldrake/Year-round

This 2-yr college awards an AAS degree in photography. Program started 1972. Accredited by MSA. Calendar: semester. Curriculum: core. Admission dates: Sept, Jan. Total enrollment: 40; 20 enrollees each admission period; 100% of applicants accepted; 10 students/instructor; 25% of graduates obtain employment in field; 75% pursue further education. Enrollment is level.

Courses: numerous. 39 hrs of photography-related courses required for graduation. Emphasis: commercial. School-related employment opportunities: work-study, assistantships.

Faculty: 2 full time. Qualifications: MA, working professionals.

Contact: Larry G. Appel, Sullivan County Community College, Commercial Art & Photo Dept., Box 4002, Loch Sheldrake, NY 12759-4002; (800) 577-5243, Fax (914) 434-4806.

SUNY-BUFFALO
Buffalo/Year-round

This university awards BA, BFA, & MFA degrees in photography. Accredited by NASAD. Calendar: semester. Curriculum: core. Admission dates: Fall. Total enrollment: 48; 10 enrollees each admission period; 18 students/instructor. Enrollment is increasing.

Courses: numerous. 30-33 cr of photography-related courses required for graduation. Emphasis: fine art. Related courses & activities: lecture series, visiting artists. School-related employment opportunities: internships, externships.

Faculty: 4 full time. Qualifications: MFA.

Contact: Marion Faller, Dir. of Photography Program, SUNY-Buffalo, Dept. of Art, 202 Center for the Arts, Buffalo, NY 14260; (716) 645-6878, Fax (716) 645-6970.

VILLA MARIA COLLEGE
Buffalo/Year-round

This 2-yr college awards a certificate and 2-yr associate degree in photography. Calendar: semester. Curriculum: core. Total enrollment: 40; 15 enrollees each admission period; 80% of applicants accepted; 15 students/instructor; 60% of graduates obtain employment in field; 40% pursue further education. Enrollment is decreasing by 5%-10%.

Courses: Introduction, Color, History, Intermediate, View Camera Techniques, Studio Lighting, Photo Imaging. Emphasis: 50% fine art. Related courses & activities: photo club, design classes. School-related employment opportunities: internship last semester.

Faculty: 1 full time, 1 part time. Qualifications: MFA graduates, experienced in field, published.

Costs: Tuition is $500. Other expenses: lab fees.

Location: 10 miles from Buffalo.

Contact: Diane Bush, Villa Maria College, Photography Dept., 240 Pine Ridge Rd., Buffalo, NY 14225; (716) 896-0700.

NORTH CAROLINA

ANSON COMMUNITY COLLEGE

P.O. Box 126, Polkton, NC 28135; (704) 272-7635, Fax (704) 272-8904.

BREVARD COLLEGE

400 N. Broad St., Brevard, NC 28712; (704) 883-8292, Fax (704) 884-3790.

CARTERET COMMUNITY COLLEGE
Morehead City/Year-round

This 2-yr college awards a 2-yr associate degree in photography. Program started 1985. Accredited by SACS. Calendar: quarter. Curriculum: core. Admission dates: Fall. Total enrollment: 40-50; 20 enrollees each admission period; 100% of applicants accepted; 15 students/instructor; 50% of graduates obtain employment in field; 25% pursue further education. Enrollment is increasing by 10%.

Courses: Basic, Studio, View Camera, Color, Graphics, Photojournalism, Commercial, Portfolio. 85 hrs of photography-related courses required for graduation. Emphasis: art, commercial, photojournalism, portrait. Related courses & activities: computer, business. School-related employment opportunities: second year internships, work-study.

Faculty: 2 full time, 1 part time. Qualifications: MFA.

Costs: Tuition is $185/qtr. Other expenses: $1,505 non-resident.

Location: 90 miles from Wilmington.

Contact: Cathy Crowell, Coordinator, Carteret Community College, Photography Dept., 3505 Grendell St., Morehead City, NC 28557; (919) 247-6000, Fax (919) 247-2514.

MCDOWELL TECHNICAL COMMUNITY COLLEGE
Marion/Year-round

This 2-yr college awards an AAS degree in photography. Program started 1989. Accredited by SACS. Calendar: quarter. Curriculum: core. Admission dates: Sept. Total enrollment: 35; 20 enrollees each admission period; 100% of applicants accepted; 8 students/instructor; 90% of graduates obtain employment in field; 10% pursue further education. Enrollment is increasing by 20%.

Courses: Photojournalism, Studio Lighting, Commercial, Portfolio, Basic & Advanced B&W, Color. 80 hrs of photography-related courses required for graduation. Emphasis: photo field preparation. Related courses & activities: exhibition design, field trips. School-related employment opportunities: internships.

Faculty: 1 full time, 3 part time. Qualifications: MFA, widely published.

Costs: Tuition is $190. Other expenses: $350 supplies/qtr.

Location: 40 miles from Asheville.

Contact: Benjamin Porter, Curriculum Coordinator, McDowell Technical Community College, Photography Dept., Rt. 1, Box 170, Marion, NC 28752; (704) 652-6021, Fax (704) 652-1014.

RANDOLPH COMMUNITY COLLEGE
Asheboro/Year-round

This 2-yr college awards an AAS degree in photography. Program started 1968. Accredited by SACS. Calendar: quarter. Curriculum: core. Admission dates: Aug. Total enrollment: 130; 65 enrollees each admission period. 85%+ of graduates obtain employment in field; <10% pursue further education. Enrollment is level.

Courses: numerous. 93-100 qtr hrs of photography-related courses required for graduation. Emphasis: professional photography and photo-finishing. Related courses & activities: digital imaging and photofinishing. School-related employment opportunities: biomedical, commercial and photojournalism interns, part time jobs.

Faculty: 7 full time, 4 part time.

Costs: Tuition is $192.70/qtr. Other expenses: film/paper/mount materials, books (no lab fees).

Location: 25 miles from Greensboro.

Contact: Robert Heist, Jr., Dept. Chair, Randolph Community College, Photographic Technology Dept., Box 1009, Asheboro, NC 27204; (910) 629-1471, Fax (910) 629-4695.

OHIO

ANTONELLI INSTITUTE OF ART & PHOTOGRAPHY

124 East Seventh Street, Cincinnati, OH 45202; (513) 241-4338, Fax (513) 241-9396.

ART ACADEMY OF CINCINNATI

1125 St. Gregory St., Cincinnati, OH 45202; (513) 562-8750.

BOWLING GREEN STATE UNIVERSITY

School of Art, Bowling Green, OH 43403; (419) 372-8380, Fax (419) 372-2544.

CLARK STATE COMMUNITY COLLEGE

P.O. Box 570, Springfield, OH 45501; (513) 325-0691, Fax (513) 328-3853.

CLEVELAND INSTITUTE OF ART

Photography Dept., 11141 E. Boulevard, Cleveland, OH 44106; (216) 421-7000.

LAKELAND COMMUNITY COLLEGE
Kirtland/Year-round

This 2-yr college awards an AA degree in photography. Program started 1970. Calendar: quarter. Curriculum: core. Admission dates: quarterly. Total enrollment: 20; N/A enrollees each admission period; 100% of applicants accepted; 18 students/instructor. Enrollment is level.

Courses: History, Portraits, Commercial, Food Photography, Photojournalism, Color Print Transparency, Medical, Electronic Image, Zone System. 33 qtr hrs of photography-related courses required for graduation. Emphasis: commercial. Related courses & activities: electronic imaging-photoshop. School-related employment opportunities: lab assistants.

Faculty: 1 full time, 8 part time. Qualifications: BA, Ph.D..

Costs: Tuition is $40/cr hr for county residents. Other expenses: $18 lab fee/course.

Contact: Bruce Cline, Dept. Coordinator, Lakeland Community College, Photo Dept., 7700 Clocktower, Kirtland, OH 44094-5198; (216) 953-7218, Fax (216) 953-9710.

OHIO INSTITUTE OF PHOTOGRAPHY AND TECHNOLOGY
Dayton/Year-round

This 2-yr college awards a 1-yr diploma & 2-yr associate degree in photography. Program started 1971. Accredited by ACCSCT. Calendar: quarter. Admission dates: Sept, June, Apr, July. Total enrollment: 191; 35 enrollees each admission period; 75% of applicants accepted; 12 students/instructor; 86% of graduates obtain employment in field; 2% pursue further education. Enrollment is increasing by 40%.

Courses: General Applied Photography, Commercial Photography, Biomedical Photography, Portraiture, Professional Imaging Technologies, Desktop Media. 72 hrs of photography-related courses required for graduation. Emphasis: professional photography. Related courses & activities: Desktop Media. School-related employment opportunities: externships, career relevant part time jobs.

Faculty: 6 full time, 6 part time. Qualifications: minimum 3 yrs professional experience.

Costs: Tuition is $2,168/qtr. Other expenses: $400-$450/qtr books & supplies.

Contact: Cecil W. Johnston, Exec. Dir., Ohio Institute of Photography and Technology, 2029 Edgefield Rd., Dayton, OH 45439; (800) 932-9698, Fax (513) 294-2259.

UNIVERSITY OF AKRON

School of Art, Akron, OH 44325-7801; (216) 972-5960.

UNIVERSITY OF CINCINNATI
Cincinnati/Year-round

This university awards a BFA degree in photography. Program started 1978. Accredited by NASAD. Calendar: quarter. Curriculum: core. Admission dates: Dec. Total enrollment: 35; 12 enrollees each admission period; 15 students/instructor; 30% of graduates obtain employment in field; 45% pursue further education. Enrollment is level.

Courses: Black and White, Color, Small/Medium/Large Format Cameras, Hand-Applied Emulsions, Pinhole, Historic Processes, Instant Processes, Electronic and Electrostatic Imaging. 36 hrs of photography-related courses required for graduation. Emphasis: understanding photography as a drawing tool for the fine artist. Related courses & activities: Interactive Video, Computer Fundamentals. School-related employment opportunities: internships and assistantships in commercial studios.

Faculty: 2 full time. Qualifications: BS, MFA.

Costs: Tuition is $3,125/qtr out-of-state, $1,244 in-state. Other expenses: lab & student activities fees ($159/qtr).

Contact: Director, University of Cincinnati, School of Art, P.O. Box 210016, Cincinnati, OH 45221-0016; (513) 556-2962, Fax (513) 556-2887.

OKLAHOMA

OKLAHOMA STATE UNIVERSITY
Okmulgee/Year-round

This 2-yr college awards an AAS degree in photography. Program started 1987. Accredited by NCAA. Calendar: trimester. Curriculum: core. Admission dates: Oct, Feb, Aug. Total enrollment: 49; 12 enrollees each admission period; 100% of applicants accepted; 20 students/instructor; 80% of graduates obtain employment in field; 5% pursue further education. Enrollment is increasing by 10%.

Courses: Commercial Photography. 51 hrs of photography-related courses required for graduation. Related courses & activities: landscape workshops. School-related employment opportunities: internships.

Faculty: 2 full time. Qualifications: formal degrees, 25 yrs combined experience.

Costs: Tuition is $43.45/cr hr. Other expenses: tools, $650 initially, may vary from $150-$1,500.

Location: 35 miles from Tulsa (east central Oklahoma).

Contact: Gary Borchert, Dept. Head, Oklahoma State University, Visual Communications, 1801 E. 4th St., Okmulgee, OK 74447-3901; (918) 756-6211, Fax (918) 756-1513.

ST. GREGORY'S COLLEGE

1900 West McArthur Dr., Shawnee, OK 74801; (405) 273-9870.

OREGON

OREGON SCHOOL OF ARTS AND CRAFTS
Portland/Year-round

This 4-yr college is accredited by NASAD. Calendar: quarter. Curriculum: arts and crafts. Admission dates: open. 11 students/instructor.

Courses: Black and White, Color and Alternative Processes. Related courses & activities: workshops offered all year.

Faculty: 1 full time, 2 part time. Qualifications: MFA or BFA.

Costs: Tuition is $225/30-hr class. Other expenses: studio fees.

Contact: Rebecca Biggs, Oregon School of Arts and Crafts, Public Relations, 8245 S.W. Barnes Rd., Portland, OR 97225; (503) 297-5544, Fax (503) 297-9651.

PACIFIC NORTHWEST COLLEGE OF ART

Photography Dept., 1219 S.W. Park Ave., Portland, OR 97205; (503) 226-0462, Fax (503) 226-4842.

PENNSYLVANIA

ANTONELLI INSTITUTE
Plymouth Meeting/September-June

This 2-yr college awards a 1-yr diploma & 2-yr associate degree in photography. Program started 1938. Accredited by ACCSCT. Calendar: semester. Curriculum: core. Admission dates: Sept. 40-50 enrollees each admission period; 90% of applicants accepted; 14 students/instructor; 98% of graduates obtain employment in field; 2% pursue further education. Enrollment is increasing by 10%-20%.

Courses: Fundamentals, 4/5 Camera, Basic Lighting, Theory of Composition, PR, Professional Photography, Imaging, Audio Visual, Color Lab, Photo Studio I and II. 1536 hrs of photography-related courses required for graduation. Emphasis: commercial, advertising, portraiture, architectural. Related courses & activities: business courses: Marketing, Accounting, Communication, Public Speaking. School-related employment opportunities: part time and freelance assistants.

Faculty: 2 full time. Qualifications: degree, minimum 3 yrs experience.

Costs: Tuition is $3,800/sem. Other expenses: $25 application fee, dormitory $1,500/semester.

Location: 11 miles from Philadelphia.

Contact: Anthony DeTore, Antonelli Institute, Admissions Department, P.O. Box 570, 2910 Jolly Rd., Plymouth Meeting, PA 19462; (610) 275-3040, Fax (610) 275-5630.

ART INSTITUTE OF PHILADELPHIA
Philadelphia/Year-round

This trade school awards an AST degree in photography. Program started 1981. Calendar: quarter. Curriculum: core. Total enrollment: 110; 25 enrollees each admission period; 90% of applicants accepted; 17 students/instructor; 88.5% of graduates obtain employment in field; 10% pursue further education. Enrollment is increasing by 5%.

Courses: Photojournalism, Advertising, Portraiture, Architecture, Personal and Digital Imaging. 120 hrs of photography-related courses required for graduation. Emphasis: commercial photography. Related courses & activities: art history, photo-history. School-related employment opportunities: lab equipment jobs, internships last 2 quarters.

Faculty: 5 full time, 5 part time. Qualifications: MFA, BFA, BA, AA.

Costs: Tuition is $2,850/qtr.

Contact: Robert Crites, Chair, Art Institute of Philadelphia, Photography Dept., 1622 Chestnut St., Philadelphia, PA 19103; (800) 275-2474, Fax (215) 246-3339.

ART INSTITUTE OF PITTSBURGH

526 Penn Ave., Pittsburgh, PA 15222; (412) 263-6600.

COMMUNITY COLLEGE OF ALLEGHENY, COUNTY SO. CAMPUS

Photography, West Mifflin, PA 15122; (412) 469-6202, Fax (412) 469-6371.

COMMUNITY COLLEGE OF PHILADELPHIA
Philadelphia/Year-round

This 2-yr college awards an AAS degree in photography. Program started 1970. Accredited by MSA. Calendar: semester. Curriculum: core. Admission dates: year-round. Total enrollment: 250; 18 enrollees each admission period; 70% of applicants accepted; 14 students/instructor; 65% of graduates obtain employment in field; 15% pursue further education. Enrollment is increasing by 2.5%.

Courses: Basic Color, View Camera/Zone System, Studio, Portrait, Photojournalism, Video, Film. 24 cr hrs of photography-related courses required for graduation. Related courses & activities: student newspapers, internships, photo club. School-related employment opportunities: work-study.

Faculty: 5 full time, 2 part time. Qualifications: BFA, MFA, M.Ed..

Costs: Tuition is $66/cr hr. Other expenses: film, paper.

Contact: Stan Shire, Dept. Chair, Community College of Philadelphia, Photo Dept., 1700 Spring Garden St., Philadelphia, PA 19130; (215) 751-8320, Fax (215) 751-8762.

LUZERNE COUNTY COMMUNITY COLLEGE
Nanticoke/Year-round

This 2-yr college awards a 1-yr certificate & 2-yr AAS degree in photography. Program started 1968. Accredited by MSA. Calendar: semester. Curriculum: core. Total enrollment: 40-50; 20-25 enrollees each admission period; all of applicants accepted; 12-15 students/instructor; 50% of graduates obtain employment in field; 25% pursue further education. Enrollment is level.

Courses: Studio (portrait & product), Color Printing & Processing, Photojournalism, Fine Art B&W, Portfolio. 36-42 hrs of photography-related courses required for graduation. Emphasis: medium and large format, color printing. Related courses & activities: computer imaging classes, student exhibits. School-related employment opportunities: internships at local photo studios and labs.

Faculty: 1 full time, 3 part time. Qualifications: BA, plus all are professional practitioners.

Costs: Tuition is $48/cr hr. Other expenses: $20 application fee, $25 lab fee/class.

Location: 120 to 140 miles from Philadelphia & New York City.

Contact: Sam Cramer, Dir. of Photography, Luzerne County Community College, Commercial Art Dept., 1333 S. Prospect St., Nanticoke, PA 18634-9804; (717) 829-7319, Fax (717) 735-6130.

MARYWOOD COLLEGE

Art Dept., 2300 Adams Ave., Scranton, PA 18509; (717) 348-6278, Fax (717) 348-1817.

MOORE COLLEGE OF ART & DESIGN

Photography Dept., 20th and The Parkway, Philadelphia, PA 19103; (215) 568-4515, Fax (215) 568-8017.

PENNSYLVANIA STATE UNIVERSITY

School of Visual Arts, 210 Patterson Bldg., University Park, PA 16802; (814) 865-0135, Fax (814) 863-8664.

PHILADELPHIA COLLEGE OF ART AND DESIGN

Photography Dept., Broad and Pine Sts., Philadelphia, PA 19102; (215) 875-1100, Fax (215) 875-2238.

TYLER SCHOOL OF ART, TEMPLE UNIVERSITY

Photography Area, Beech and Penrose Aves., Philadelphia, PA 19126; (215) 782-2715, Fax (215) 782-2799.

WESTMORELAND COUNTY COMMUNITY COLLEGE

Photography, Youngwood, PA 15697; (412) 925-4060, Fax (412) 925-1150.

RHODE ISLAND

RHODE ISLAND COLLEGE

Art Dept., 600 Mount Pleasant Ave., Providence, RI 02908; (401) 456-8054.

RHODE ISLAND SCHOOL OF DESIGN

Two College St., Providence, RI 02903; (401) 454-6128, Fax (401) 454-6320.

SALVE REGINA UNIVERSITY
Newport/September-May

This university awards a BA degree in photography. Program started 1980. Accredited by NASAD. Curriculum: core. Total enrollment: 10; 15 enrollees each admission period; 15 students/instructor; 20% pursue further education. Enrollment is increasing.

Courses: 15-24 photography-related courses required for graduation. School-related employment opportunities: internships.

Faculty: 1 full time, part time. Qualifications: MFA.

Costs: Tuition is $300/cr hr.

Contact: Barbara Shamblin, Salve Regina University, Art Dept., Ochre Point Ave., Newport, RI 02840; (401) 847-6650, Fax (401) 847-0372.

SOUTH CAROLINA

WINTHROP COLLEGE

Art & Design Dept., Oakland Ave., Rock Hill, SC 29733; (803) 323-2126.

SOUTH DAKOTA

UNIVERSITY OF SOUTH DAKOTA, COLLEGE OF FINE ART
Vermillion/Year-round

This university awards a BFA degree in photography. Program started 1974. Accredited by NASAD. Calendar: semester. Curriculum: core. Total enrollment: 20; 5 enrollees each admission period; 15 students/instructor; 90% of graduates obtain employment in field; 70% pursue further education. Enrollment is increasing.

Courses: Beginning Photo, Materials & Techniques, Advanced Studio, Color, Advanced Projects. 75 hrs of photography-related courses required for graduation.

Faculty: 1 full time. Qualifications: MFA from Art Institute of Chicago, 15 yrs teaching experience.

Costs: Tuition is $71/cr hr in-state.

Location: 60 miles from Sioux Falls (eastern SD).

Contact: John Banasiak, University of South Dakota, College of Fine Art, Art, 414 E. Clark St., Vermillion, SD 57069; (605) 677-5636, Fax (605) 677-5988.

TENNESSEE

EAST TENNESSEE STATE UNIVERSITY

Art Dept., Johnson City, TN 37614; (615) 929-4247.

NASHVILLE STATE TECHNICAL INSTITUTE
Nashville/Year-round

This 2-yr college awards a 1-yr technical certificate and 2-yr AAS degree in photography. Program started 1975. Accredited by SACS. Calendar: semester. Curriculum: core/photography. Total enrollment: ; 100% of applicants accepted.

Courses: numerous.

Costs: Tuition is $483 in-state, $1,876 out-of-state. Other expenses: $5 application, $9 activity & parking, books.

Contact: John Chastain, Dept. Head, Visual Communications, Nashville State Technical Institute, 120 White Bridge Rd., Nashville, TN 37209; (615) 353-3397, Fax (615) 353-3428.

UNIVERSITY OF MEMPHIS
Memphis/Year-round

This university awards 4 yr BFA & 2-yr MFA degrees in photography. Program started 1970. Accredited by NASAD. Calendar: semester. Curriculum: core. Admission dates: fall, spring, summer. Total enrollment: 35; 35 enrollees each admission period; 80% of applicants accepted; 15 students/instructor; 75% of graduates obtain employment in field; 30% pursue further education. Enrollment is increasing by 10%.

Courses: B&W, Color, Large Format, Alternative Processes, Studio Lighting, History, Independent Studies. 36 hrs of photography-related courses required for graduation. Emphasis: fine art. Related courses & activities: student exhibitions, workshops, photo society. School-related employment opportunities: undergraduate work-study, graduate assistantships.

Faculty: 4 full time. Qualifications: MFA, national & international exhibition record.

Costs: Tuition is $3,000/sem undergraduate out of state. Other expenses: $50 lab fee/course.

Contact: Prof. Larry McPherson, University of Memphis, Art Dept., 201 Jones Hall, Memphis, TN 38152; (901) 678-2216, Fax (901) 678-3299.

TEXAS

AMARILLO COLLEGE
Amarillo/Year-round

This 2-yr college awards a certificate & AAS, AA, & AS degrees in photography. Program started 1970. Accredited by SACS. Calendar: semester. Curriculum: core. Admission dates: Jan, Aug. Total enrollment: 35; 15 enrollees each admission period; 80% of applicants accepted; 10 students/instructor; 85% of graduates obtain employment in field; 30% pursue further education. Enrollment is decreasing by 5%.

Courses: Basic, Portrait, Illustration, Digital Photo, Creative, Video, Landscape. 36 hrs of photography-related courses required for graduation. Emphasis: professional. Related courses & activities: field trips to New Mexico, Arizona. School-related employment opportunities: cooperative education (work/pay for photo credit).

Faculty: 2 full time, 1 part time. Qualifications: BFA, MA, BA.

Costs: Tuition is $250/sem. Other expenses: $350 supplies/sem.

Location: 350 miles from Dallas.

Contact: Kenneth D. Pirtle, Amarillo College, Photography Dept., Box 447, Amarillo, TX 79178; (806) 371-5000, Fax (806) 371-5370.

ART INSTITUTE OF DALLAS

Photography/Multimedia Dept., 2 Northpark, 8080 Park Lane, Dallas, TX 75231; (214) 692-8080, Fax (214) 692-6541.

ART INSTITUTE OF HOUSTON

Photography Dept., 1900 Yorktown, Houston, TX 77056; (713) 623-2040, Fax (713) 966-2700.

CENTRAL TEXAS COLLEGE

Art. Dept., P.O. Box 1800, Killeen, TX 76540; (817) 526-1572.

COLLIN COUNTY COMMUNITY COLLEGE

Arts & Humanities Dept., 2800 E. Spring Creek Pkwy., Plano, TX 75074; (214) 881-5827, Fax (214) 881-5629.

EL PASO COMMUNITY COLLEGE

P.O. Box 20500, El Paso, TX 79998; (915) 594-2292.

HILL COLLEGE OF THE HILL JR. COLLEGE DISTRICT

P.O. Box 619, Hillsboro, TX 76645; (817) 582-7591.

HOUSTON COMMUNITY COLLEGES-CENTRAL COLLEGE

Visual & Graphic Arts Dept., 1300 Holman, Houston, TX 77004; (713) 630-7223.

KILGORE COLLEGE

Photography Dept., 1100 Broadway, Kilgore, TX 75662; (214) 983-8192.

NORTH HARRIS COUNTY COLLEGE

2700 W.W. Thorn Road, Houston, TX 77073; (713) 443-5645, Fax (713) 443-5402.

ODESSA COLLEGE

201 W. University, Odessa, TX 79764; (915) 335-6400.

SAN ANTONIO COLLEGE

Photography Dept., 1300 San Pedro Ave., San Antonio, TX 78212; (512) 733-2870.

TYLER JUNIOR COLLEGE

Graphic Arts/Photography Dept., P.O. Box 9020, Tyler, TX 75711; (903) 510-2423.

UNIVERSITY OF TEXAS AT SAN ANTONIO

Arts Dept., 6900 N. Loop, 1604 West, San Antonio, TX 78249; (512) 691-4352.

WESTERN TEXAS COLLEGE

6200 College Ave., Snyder, TX 79549; (915) 573-8511, Fax (915) 573-9321.

UTAH

BRIGHAM YOUNG UNIVERSITY

Design Dept., Room 210 BRMB, Provo, UT 84602; (801) 378-2064.

VIRGINIA

JAMES MADISON UNIVERSITY

School of Art & Art History, , Harrisonburg, VA 22807; (703) 568-6216, Fax (703) 568-6598.

NORTHERN VIRGINIA COMMUNITY COLLEGE

Photography Dept., 3001 N. Beauregard St., Alexandria, VA 22311; (703) 845-6287.

THOMAS NELSON COMMUNITY COLLEGE

Photography Dept., P.O. Box 9407, Hampton, VA 23670; (804) 825-2799, Fax (804) 825-2870.

VIRGINIA COMMONWEALTH UNIVERSITY

325 N. Harrison St., Richmond, VA 23284; (804) 828-2787, Fax (804) 828-1695.

WASHINGTON

ART INSTITUTE OF SEATTLE

2323 Eliot Ave., Seattle, WA 98121; , Fax (206) 448-2501.

EVERETT COMMUNITY COLLEGE
Everett/Year-round
This 2-yr college awards an AFA degree in photography. Program started 1954. Calendar: quarter. Curriculum: core. Admission dates: Sept, June, Apr. Total enrollment: 70; 20 enrollees each admission period; 100% of applicants accepted; 15 students/instructor; 40%-60% of graduates obtain employment in field; 40% pursue further education. Enrollment is level.

Courses: Basic, Zone System, Studio, Color, Fine Art, Photojournalism, Electronic, Non-Silver. 40 hrs of photography-related courses required for graduation. Emphasis: commercial, fine art, photojournalism. Related courses & activities: Video, Computer Graphics, Journalism, Creative Writing. School-related employment opportunities: newspaper, industry, in-house.

Faculty: 2 full time, 1 part time. Qualifications: MFA, MA.

Costs: Tuition is $44.60/cr hr. Other expenses: supplies.

Location: 25 miles from Seattle.

Contact: LLoyd Weller, Everett Community College, Photography, 801 Wetmore, Everett, WA 98201; (206) 388-9366, Fax (206) 388-9129.

PHOTOGRAPHIC CENTER SCHOOL
Seattle/Year-round *(see also page 115)*
This independent school awards a Certificate of Photography. Program started 1987. Accredited by NASAD candidate. Calendar: quarter. Curriculum: photography only. Admission dates: rolling. Total enrollment: 10; 5 enrollees each admission period; 9 students/instructor. Enrollment is increasing.

Courses: Portrait, Portfolio, Architectural, Fashion, Documentary, Zone System. 54 cr hrs of photography-related courses required for graduation. Emphasis: fine art, commercial. Related courses & activities: gallery. School-related employment opportunities: monitors to assist in studio & darkroom.

Faculty: 14 part time. Qualifications: BFA, MFA, some self-taught professionals.

Costs: Tuition is $110/cr hr. Other expenses: darkroom fees & supplies.

Contact: Dr. Peggy Jacobson, Photographic Center School, 2617 Fifth Ave., Seattle, WA 98121; (206) 441-7030, Fax (206) 441-8583.

SEATTLE CENTRAL COMMUNITY COLLEGE

Seattle, WA 98122; (206) 587-3800, Fax (206) 344-4390.

SHORELINE COMMUNITY COLLEGE

Photography, , Seattle, WA 98133; (206) 546-4581.

SPOKANE FALLS COMMUNITY COLLEGE

Applied Arts Dept., 3410 W. Ft. Wright Dr., MS3110, Spokane, WA 99204; (509) 533-3500, Fax (509) 533-3433.

MADISON AREA TECHNICAL COLLEGE
Madison/Year-round

This 2-yr college awards an AAS degree in photography. Program started 1979. Accredited by NCA. Calendar: semester. Curriculum: core. Admission dates: Nov. Total enrollment: 50; 20 enrollees each admission period; 50% of applicants accepted; 12 students/instructor; 85% of graduates obtain employment in field; 5%-10% pursue further education.

Courses: Studio, Lighting, Color, Photojournalism, Commercial, Portraiture, Video, Electronic Imaging, Photo Communications. 37+5 support hrs of photography-related courses required for graduation. Related courses & activities: student newspaper, computer animation, audio. School-related employment opportunities: internships, lab assistant, college PR photo.

Faculty: 3 full time, 5 part time. Qualifications: professional work experience.

Costs: Tuition is $62.65 resident or $370.90/cr hr. Other expenses: camera, film, paper.

Location: 70 miles from Milwaukee.

Contact: Jerry Butler, Art Dept. Chair, Madison Area Technical College, Art Dept., 3550 Anderson St., Madison, WI 53704; (608) 246-6002, Fax (608) 246-6880.

MILWAUKEE AREA TECHNICAL COLLEGE

Photography Dept., 1015 N. 6th St., Milwaukee, WI 53203; (414) 278-6708.

MILWAUKEE INSTITUTE OF ART DESIGN
Milwaukee/August-May

This 4-yr art college awards a BFA degree in photography (3 yrs of a 4-yr program. Program started 1980. Accredited by NASAD, NCACU. Calendar: semester. Curriculum: core. Admission dates: Jan, Aug. Total enrollment: 40; 10-20 enrollees each admission period; 90% of applicants accepted; 12 students/instructor; 65% of graduates obtain employment in field; 15% pursue further education. Enrollment is increasing by 11%.

Courses: Basic-Advanced B&W, Color, Alternative Processes, Digital Imaging, Large Format. 36 cr hrs of photography-related courses required for graduation. Emphasis: fine art. Related courses & activities: multi-disciplinary electives. School-related employment opportunities: work-study positions in photo dept./elsewhere.

Faculty: 2 full time, 6 part time. Qualifications: MFA.

Costs: Tuition is $14,000/yr. Other expenses: $25/class.

Contact: Kelly Mark, Milwaukee Institute of Art Design, Admissions, 342 E. Erie St., Milwaukee, WI 53202; (414) 276-7889, Fax (414) 291-8077.

UNIVERSITY OF WISCONSIN-STEVENS POINT

Dept of Art/Design, 2100 Main St., Stevens Point, WI 54481; (715) 346-2669.

WYOMING

CASPER COLLEGE

Visual Arts/Photo Dept., 125 College Dr., Casper, WY 82601; (307) 268-2664.

NORTHWEST COLLEGE
Powell/September-April

This 2-yr college awards an AAS degree in photography. Program started 1976. Accredited by NCA. Calendar: semester. Curriculum: core. Total enrollment: 50; 30 enrollees each admission period; 85% of applicants accepted; students/instructor; 80% of graduates obtain employment in field; 5% pursue further education. Enrollment is increasing by 60%.

Courses: numerous. Emphasis: studio illustration. commercial portrait, photo journalism, digital imaging. School-related employment opportunities: co-op, internships.

Faculty: 3 full time, 1 part time. Qualifications: MA.

Costs: Tuition is $1,178 non-resident. Other expenses: lab fees.

Location: Yellowstone National Park.

Contact: Karl Bear, Dir. of Admissions, Northwest College, 231 W. 6th St., Powell, WY 82435; (307) 754-6601, Fax (307) 754-6700.

WESTERN WYOMING COLLEGE
Rock Springs/Year-round

This 2-yr college awards an AA degree in photography. Program started 1972. Calendar: semester. Curriculum: core. Admission dates: year-round. Total enrollment: 12; 3 enrollees each admission period; 90% of applicants accepted; 12 students/instructor; 33% of graduates obtain employment in field; 73% pursue further education. Enrollment is level.

Courses: 26 hrs of photography-related courses required for graduation. Related courses & activities: workshops, field excursions, guests, club. School-related employment opportunities: work-study.

Faculty: 1 full time. Qualifications: MFA, BA, artist, freelance commercial business.

Costs: Tuition is $430/sem. Other expenses: books, supplies, lab fees.

Location: 185 miles from Salt Lake City.

Contact: Val Brinkerhoff, Western Wyoming College, Photography Dept., 2500 College Dr., Rock Springs, WY 82901; (307) 382-1721, Fax (307) 382-7665.

CANADA

DAWSON COLLEGE
Montreal/Year-round

This 2-yr college awards a 2- & 3-yr Attestation of Collegial Studies in photography. Program started 1976. Accredited by Corp of Master Photographers. Calendar: trimester. Curriculum: core. Admission dates: Nov, May. Total enrollment: 200; 50 enrollees each admission period; 75 of applicants accepted; 16 students/instructor; 80% of graduates obtain employment in field; 15% pursue further education. Enrollment is level.

Courses: Product, Portraiture, Fashion, Advertising, Architecture, Digital. 990 hrs of photography-related courses required for graduation. Related courses & activities: fine arts, graphic design. School-related employment opportunities: stage, assistantship.Faculty: 14 full time, 20 part time. Qualifications: experience, graduate degrees.

Costs: Tuition is C$2.50/cr hr. Other expenses: materials, activities.

Contact: D. Walker, Dawson College, Centre for Imaging Arts & Technologies, 4001 De Maisonneuve W., Montreal, QB, H3W 1KY, Canada; (514) 933-0047, Fax (514) 937-3832.

WESTERN ACADEMY OF PHOTOGRAPHY
Victoria, British Columbia/
September-June

This trade school awards 10-mo diplomas in Professional Photography and Journalism/Photojournalism. Programs started in 1984 & 1990. Registered by the Private Post-Secondary Education Commission. Calendar: semester. Curriculum: core/writing & photography. Admission date: Sept. Total enrollment 36/17; acceptance FCFS; 12-36 students/instructor; 75% of graduates obtain employment; 25% pursue further education. Enrollment is increasing by 10%.

Courses: Basics (Photography, Darkroom, Composition), Advanced (Lighting, Advertising, Photojournalism, Architecture, Fashion, Portraiture, Wedding Nature, Stock, Lifestyle, Computer Imaging). 20-25 hrs of photography courses/wk plus assignments. Emphasis: commercial/journalism. Other activities: business courses leading to business plan. Internship in photojournalism; work assignments.

Faculty: 2 full time, 15 part time. Qualifications: working professional journalists and photographers.

Costs: Tuition is C$6,800 for Professional Photography, C$4,750 for Photojournalism. Other expenses: C$150-C$350/mo for materials.

Location: Near downtown Victoria. Facilities include classrooms, darkrooms, 2 studios, and computers for digital imaging.

Contact: Paul Smyth, Managing Director, Western Academy of Photography, 755A Queens Ave., Victoria, BC, V8T 1M2, Canada; (604) 383-1522, Fax (604) 383-1534.

3

Residencies
and Retreats

CALIFORNIA

THE DJERASSI RESIDENT ARTISTS PROGRAM
Woodside/April 1-October 31

The Djerassi Resident Artists Program, founded in 1979 in memory of painter/poet Pamela Djerassi, invites 50 artists a year to spend 1 to 2 months working on independent or collaborative projects. Applications are accepted from accomplished or lesser known photographers and other artists. The Djerassi Program's award is a residential grant that provides lodging, meals, and studio space to accepted artists.

Admission Policies and Costs: Applicant must return completed forms, résumés, samples of recent work, references, and a description of proposed projects. Application deadline is February 15 for the following year. Previous residents must wait 3 years before re-applying.

Location: A 600-acre site in the foothills of the Santa Cruz Mountains, near the Pacific Coast and one hour south of San Francisco.

Contact: Judy Freeland, Program Assistant, The Djerassi Resident Artists Program, 2325 Bear Gulch Rd., Woodside, CA 94062-4405; (415) 851-8395, Fax (415) 747-0105.

DORLAND MOUNTAIN ARTS COLONY
Temecula/Year-round

Homesteaded in the 1930's by Ellen and Robert Dorland, this primitive 10-acre retreat is set on a 300-acre nature preserve overlooking the Temecula Valley. The colony accepts photographers, artists, writers, playwrights, and composers for residencies of one to three months. Each resident has an individual cottage and may share work in progress at an open studio.

Admission Policies and Costs: Applications are reviewed twice a year by an independent panel of recognized artists, writers, editors, composers, and others. Application deadlines are September 1 and March 1. There is a modest charge.

Location: About 100 miles from Los Angeles and 60 miles from San Diego.

Contact: Admissions Committee, Dorland Mountain Arts Colony, Box 6, Temecula, CA 92390; (909) 676-5039.

VILLA MONTALVO
Saratoga/Year-round

Built in 1912 by former San Francisco mayor James D. Phelan and named for Ordonez de Montalvo, who coined the name California, Villa Montalvo was willed in 1930 to be used for the development of the arts and as a public park. Of the 350 visual artists, writers, and composers who apply each year, 25 to 30 are invited for a residency to concentrate on a creative project. Applicants should have completed formal training and be engaged on a professional level. Five residents at a time can be accommodated in individual private apartments for a period of three months. Requests for 1- to 3-month residencies are considered and applications from former residents are accepted 2 years after prior residency.

Admission Policies and Costs: Applications, which are reviewed by a peer panel of professionals, must be submitted by March 1 for May review, by September 1 for November review, and be accompanied by a resume, a statement of project, five color slides, a $20 non-refundable fee, and a financial assistance form, if appropriate. A refundable $100 security deposit is required upon acceptance. Applicants must provide their own food, supplies, and

living expenses. A stipend is available to artists (two per year) who demonstrate financial need.

Location: On 175 acres in the eastern foothills of the Santa Cruz Mountains, an hour from San Francisco and Berkeley. Most of the estate has been made into an arboretum and bird sanctuary.

Contact: Villa Montalvo, Box 158, Saratoga, CA 95071; (408) 741-3421.

FLORIDA

ATLANTIC CENTER FOR THE ARTS
New Smyrna Beach/Year-round

This interdisciplinary arts facility, chartered in 1979, was created to bring mid-career artists, writers, musicians, and composers together with Master Artists in an informal interdisciplinary residency, where they can experiment and collaborate on new projects. Five to six 3-week residency periods are scheduled each year, with three Master Artists of different disciplines in residence during each period. Master Artists have included Jack Mitchell, Jerry Uelsmann, and William Wegman.

Admission Policies and Costs: Each Master Artist selects his or her residents and sets the application criteria. Applications should be submitted at least 4 months prior to residency. Tuition only for a 3-week session is $200. On-site housing (private room and bath) is available for an all-inclusive fee of $600. Some scholarships are offered.

Location, Facilities: Facilities include an administration/gallery complex, 3 Master Artist cottages, an outdoor amphitheatre, and 28 units of artists' housing (including 4 handicap-accessible). The 67-acre property is located on the east coast of Central Florida.

Contact: Atlantic Center for the Arts, 1414 Art Center Ave., New Smyrna Beach, FL 32168; (904) 427-6975.

GEORGIA

THE HAMBIDGE CENTER FOR CREATIVE ARTS & SCIENCES
Rabun Gap/May-October

Founded in 1934 by textile designer Mary Hambidge, The Hambidge Center for Creative Arts and Sciences provides a balanced living environment for mature people who are engaged in creative work and/or research in artistic, scientific, humanistic, and educational endeavors. Two-week to two-month fellowships, limited to 8 participants at a time, are awarded to 40 to 50 of the more than 150 applicants. Fellows have a private cottage equipped with a kitchen and studio area.

Admission Policies and Costs: In addition to application and non-refundable $20 processing fee, applicants are required to submit samples of work, curriculum vitae, reviews, and three letters of recommendation. Notification takes about two months. Resident Fellows are asked to contribute $125 toward the $400 weekly cost. Review of applications begins in March.

Location: On 600 wooded acres in the northeastern mountains of Georgia, bordering southwestern North Carolina, 120 miles from Atlanta.

Contact: The Hambidge Center for Creative Arts and Sciences, P.O. Box 339, Rabun Gap, GA 30568; (706) 746-5718

HAWAII

KALANI HONUA
Pahoa/Year-round

This 20-acre intercultural conference and retreat center provides four rooms with shared studio space in the conference area. Throughout the year, 80 selected artist and writer applicants can stay at half the regular rate on a space available basis. Rooms in each lodge have kitchen facilities and shared or private bath options. A full food service is also available.

Admission Policies and Costs: Photographers submit application, samples of work, a biographical page, and a statement of interest and goals. Regular daily rate for room with shared (private) bath is $52 ($65) single, $62 ($75) double occupancy. Meals are $26 per day.

Location: On Hawaii Island's southeast coast, near beaches and state and national parks.

Contact: Richard Koob, Artistic Director, Kalani Honua, Box 4500, Pahoa, Hawaii 96778; (808) 965-7828 or (800) 800-6886.

ILLINOIS

RAGDALE FOUNDATION
Lake Forest/January 1-April 30, May 16-December 15

The Ragdale Foundation offers a peaceful place and uninterrupted time for 12 serious artists, writers, and composers to do their work. Accommodations include a library, community rooms, and 4 private visual artists' studios on 2 adjoining estates designed by Howard Van Doren Shaw in 1897. No darkroom facilities are available, however photographers are welcome. Meals, linen, and laundry facilities are provided for up to 12 residents. Applicants may come for periods of 2 weeks to 2 months.

Admission Policies and Costs: Applicants are required to submit a sample of work, curriculum vitae, names of three professional references, and description of work-in-progress. The residence fee is $15 per day. A limited number of waiver and fee reduction scholarships are available. Application deadlines are: Jan. 15 for May-Dec., June 1 for Jan.-Apr. Application fee is $20. Late applications are considered if space is available.

Location: Ragdale is in Lake Forest, 30 miles north of Chicago near Lake Michigan. The estate, which is on the National Register of Historic Places, has a country garden and borders on a 60-acre nature preserve.

Contact: Ragdale Foundation, 1260 N. Green Bay Rd. Lake Forest, IL 60045; (708) 234-1063.

MASSACHUSETTS

FINE ARTS WORK CENTER IN PROVINCETOWN
Provincetown/October-May

The Center was founded in 1968 by a group of eminent artists, writers, and patrons who wanted to encourage and nurture talented young artists and writers at the outset of their careers. Each year, ten visual artists and ten writers are selected from more than 1,000 applicants to spend a seven-month residency, from October 1 to May 1, in a community of their peers. Fellows are provided with a limited monthly stipend, living and studio space, and a resident staff of artists who are available for studio visits. Throughout the season there is an

active series of public slide presentations, readings, and performances by visiting professional artists and writers who also meet with the Fellows on an informal basis. Several established artists are invited for extended residencies.

Admission Policies and Costs: This residency focuses solely on emerging talent and Fellowship awards are based on the quality of the applicant's work. Though there is no age limit, the Center aims to aid those who demonstrate outstanding promise and who have completed their formal training and are working on their own. Detailed information on submission of work for consideration is included in the application form. Applications must be received by February 1.

Location: The Center is housed in historic studios in the small fishing village of Provincetown,within walking distance of the dunes and the beach .

Contact: Fellowship Application, Fine Arts Work Center in Provincetown, 24 Pearl St., Provincetown, MA 02657; (508) 487-9960.

MICHIGAN

ALDEN B. DOW CREATIVITY CENTER NORTHWOOD INSTITUTE
Midland/June-August

Northwood Institute, a private business management college committed to a partnership between business and the arts, was founded in 1959 by Drs. Arthur E. Turner and R. Gary Stauffer. The Creativity Center was founded in 1978 as an outgrowth of the association between the Institute's founders and Alden B. Dow, architect laureate of Michigan. The Center awards an 8-week residency to individuals in any field or profession who wish to pursue a creative idea. Respected professionals are available for consultation to Fellows.

Admission Policies and Costs: Applicants should submit a Project Idea Form, resume, budget, and materials list to the Center by Dec. 31. Selection is based primarily on the quality of the idea.

Location: Midland is a culturally diverse community of 38,000 located in central Michigan's Saginaw Valley area, about 125 miles north of Detroit. Within a 50-mile radius are a state university and three colleges, research centers, museums, and natural history and arts centers.

Contact: Northwood Institute, Alden B. Dow Creativity Center, Midland, MI 48640-2398; (517) 837-4478.

NEW HAMPSHIRE

THE MACDOWELL COLONY
Peterborough/Year-round

Founded in 1907 by the composer Edward MacDowell and Marian Nevins MacDowell, the Colony promotes the Arts by providing a place where creative artists can concentrate on their work. Photographers, visual artists, film and video makers, writers, composers, architects, and interdisciplinary artists may apply. Colonists stay an average of 6 weeks and receive exclusive use of a studio with board. There are 32 studios, 23 of which are open year-round, and 2 darkrooms. Colonists meet for breakfast and dinner while lunches are delivered to the studios. Presentations and open studios are a tradition in the evenings.

Admission Policies and Costs: Admission is based solely on talent and applications

are judged by a panel of artists in each discipline. Ability to pay is not a factor. Residence fees are paid on a sliding scale; the full cost of a residency is $95 per day. Application deadlines are: Sept. 15 for winter-spring, Jan. 15 for summer, and April 15 for fall-winter.

Contact: Admissions Coordinator, The MacDowell Colony, 100 High St., Peterborough, NH 03458; (603) 924-3886, Fax (603) 924-9142.

NEW MEXICO

THE HELENE WURLITZER FOUNDATION OF NEW MEXICO
Taos/April 1-September 30

Since 1954, the Foundation has provided 12 individual furnished studio residences to persons engaged in creative fields in all media. Grants are awarded without respect to age, sex, religion, or ethnic origin for varying time periods, normally three months, which is flexible. The Foundation is open from April 1 through September 30. Facilities are handicapped accessible.

Admission Policies and Costs: The Foundation has no printed brochures, data, program information, or application guidelines. All submitted work must include self-addressed, stamped envelope for return. Following receipt of inquiry letter, application forms and procedures and general information are forwarded. The residences are offered rent- and utility-free and no monetary grants or stipends for living expenses or supplies are awarded.

Location: The residences are located in Taos.

Contact: Henry A. Sauerwein, Jr., The Helene Wurlitzer Foundation of New Mexico, P.O. Box 545, Taos, NM 87571; (505) 758-2413.

NEW YORK

BLUE MOUNTAIN CENTER
Blue Mountain Lake/
June 15-October 15

A working community of established artists and writers who don't require exceptional facilities, the Center provides a peaceful environment to work free of distractions. Although there are no darkroom facilities, photographers are welcome. For six weeks prior to and following the four-week residency sessions, the Center hosts seminars and work groups concerned with social, economic, and environmental issues. The atmosphere is informal and guests are lodged in individual bedrooms/studies. Breakfast and dinner are served in the dining room and lunch is picnic style.

Admission Policies and Costs: Residents are chosen by an admissions committee interested in creative artists and writers whose work addresses social concerns and is aimed at a general audience. Applications are due before Feb. 1 and should include samples of work, copies of reviews, short biographical sketch, and plan for work. Applicants are notified after March 31. There is no cost other than transportation. Residents are asked to make a voluntary contribution to a studio fund.

Location: The facilities of the Center, located in Adirondack Mountains, include tennis courts, lake, boats, and trails.

Contact: Harriet Barlow, Director, Blue Mountain Center, P.O. Box 109, Blue Mountain Lake, NY 12812; (518) 352-7391.

THE MILLAY COLONY FOR THE ARTS, INC.
Austerlitz/Year-round

The Millay Colony, a nonprofit organization, gives one-month residencies year-round to visual artists, writers, and composers, which usually cover a period from the 1st to the 28th of each month. Photographers are welcome, although there are no darkroom facilities. Steepletop, the 600-acre estate of poet Edna St. Vincent Millay and now a national historic landmark, provides accommodations consisting of four bedrooms and separate 14 by 20-foot studios. The Ellis Studio, which was opened in 1974, is a 400-square foot work and living space designed to accommodate one artist at a time.

Admission Policies and Costs: No residence fee is required and the colony provides meals at no cost. The organization depends on gifts for its existence and welcomes contributions. Decisions on applications are made by committees of professional artists and, on Feb. 1, applicants are reviewed for the following June-Sept., on May 1 for the following Oct.-Jan., and on Sept. 1, for the following Feb.-May. Applicants should submit a letter of reference and several examples of work.

Location: Approximately 2-1/2 hours from New York, two hours from Boston.

Contact: Ann-Ellen Lesser, Executive Director, or Gail Giles, Assistant Director, The Millay Colony for the Arts, Inc., Steepletop, P.O. Box 3, Austerlitz, NY 12017-0003; (518) 392-3103.

PALENVILLE INTERARTS COLONY
Palenville/June 1-September 30

This retreat facility, founded in 1982, provides an unpressured, creative environment for recognized and emerging artists in the performing, visual, musical, and literary arts, with a major focus on interdisciplinary projects. The residency includes private room or cabin, all meals, studio space as required, and darkroom and video equipment as needed. The Colony accommodates a maximum of 15 residents, between June 1 and September 30, who stay a minimum of one and a maximum of eight weeks. There is partial handicapped access.

Admission Policies and Costs: Applicants should have a minimum of three years of professional experience. Admission is competitive and selection is based on ability, need for the retreat environment, and creativity of the proposed project. Photographers should submit eight actual photographs, as well as a biographical resume. Applications must be received by April 1 and notification is made within four weeks. A weekly fee of $175 is suggested.

Location: The Colony, set on a rustic 120-acre estate about two hours from New York City, is on the site of America's first colony established by the painters of the Hudson River School and writers such as James Fenimore Cooper and Washington Irving.

Contact: Joanna M. Sherman, Palenville Interarts Colony, 2 Bond Street, New York, NY 10012; (212) 254-4614.

YADDO
Saratoga Springs/Year-round

This 400-acre artists' working community, founded by Spencer and Katrina Trask, provides room, board, and studio space for 200 visual artists, writers, and composers each year. Invitations, issued without respect to age, sex, or race, are offered for 2 weeks to 2 months and guests are expected to have reached the professional level of commitment in their fields.

Admission Policies and Costs: Interested persons should write for application. The

application requests brief background information, a work sample, 2 letters of recommendation, and a $20 filing fee. Deadlines are Jan. 15 for visits between mid-May and February of the following year, and Aug. 1 for visits between October and mid-May of the following year. While there is no fixed charge for a guest stay, voluntary contributions of $20/day are encouraged.

Location: Besides a mansion, a garage building with offices, three smaller houses, and several studios, the estate contains four small lakes, a famous rose garden open to the public, and hundreds of acres of woodland, including a pine and oak grove. Since Yaddo is a working community, it has no formal social activities. A swimming pool, tennis court, and numerous walking trails are located on the property.

Contact: Admissions Committee, The Corporation of Yaddo, P.O. Box 395, Saratoga Springs, NY 12866; (518) 584-0746.

VIRGINIA

VIRGINIA CENTER FOR THE CREATIVE ARTS (VCCA)
Sweet Briar/Year-round

A working retreat for visual artists, writers, and composers, the Virginia Center for the Creative Arts provides residential Fellowships of one to three months in a rural setting, free from distractions and responsibilities. Fellows have private bedrooms in a modern building and separate studios in the Studio Barn, which accommodates eight visual artists at a time. Breakfast and dinner are served in the dining room and lunches are delivered to the studios. Bedrooms and studio complexes are fully handicapped accessible.

Admission Policies and Costs: Admission is competitive and selective, based on a review of the applicant's submitted work. A nonrefundable $20 fee must accompany application, which should include a description of the proposed project and names of two references. Applications for residencies during Jan. to May are due Sept. 15, from May to Sept. are due Jan. 15, and from Sept. to Jan. are due May 15. Notification of status is made two months after deadline. Although the actual daily cost of the residency is more than $60, the standard suggested daily fee is $30.

Location: The VCCA is located at Mt. San Angelo, a 450-acre estate in Amherst County, about 160 miles southwest of Washington, DC. Facilities include a library, gallery, and swimming pool. The VCCA is affiliated with nearby Sweet Briar College, which has a lake, pool, and tennis courts, and offers movies, lectures, plays, and use of the college library.

Contact: Admissions Committee, Box VCCA, Sweet Briar, VA 24595; (804) 946-7236.

WYOMING

UCROSS FOUNDATION
Ucross/January-May,
August-December

The Ucross Foundation Residency Program provides individual workspace, living accommodations, and time to concentrate without distraction in a rural setting in northeastern Wyoming. Residencies in the visual arts, writing, and other disciplines run from 2 weeks to 2 months, with an average length of 6 weeks. Photographers are welcome, although there are no darkroom facilities. Residents stay in the remodeled Ucross Schoolhouse and Ucross Depot, which house 8 at any one time and have private bedrooms and living and dining areas. There is handicapped access.

Admission Policies and Costs: Admission is competitive and based on quality of work. Requests for applications should be accompanied by a self-addressed, stamped envelope. Two residency sessions are scheduled annually. Application deadline dates are March 1 for the fall session, Aug. through Dec., and Oct. 1 for the spring session, Jan. through May. There is no charge for room, board, or studio space and the Foundation does not expect services or products from its guests.

Location: The Ucross Foundation is located 27 miles southeast of Sheridan in a fertile valley among the foothills of the Big Horn Mountains, at the confluence of Piney and Clear Creeks.

Contact: Residency Program, Ucross Foundation, 2836 US Hwy 14-16 East, Clearmont, WY 82835; (307) 737-2291.

CANADA

THE BANFF CENTRE FOR THE ARTS
Banff, Alberta

Established in 1933, the Banff Centre for the Arts provides training and development opportunities for experienced professionals in a variety of disciplines, including media and visual arts, music and sound, writing and publishing, and theatre arts. Media and Visual Arts offer residencies that provide time, studios, and facilities for research, experimentation, and production of artworks and ideas. The program provides a collaborative environment for multi-disciplinary efforts and emphasis is also placed on critical writing and discourse relevant to photography. Other activities includes panels, conferences, and symposia.

Location, Facilities: The Centre is in western Alberta above the town of Banff in the Rocky Mountains. Facilities include darkrooms, lighting studio, print study room, and individual studios.

Contact: Office of the Registrar, The Banff Centre for the Arts, Box 1020-28, 107 Tunnel Mountain Rd., AB, T0L 0C0, Canada; (403) 762-6180, Fax (403) 762-6345.

SASKATCHEWAN WRITERS/ ARTISTS COLONIES AND INDIVIDUAL RETREATS
Saskatchewan/Year-round

The 4 Saskatchewan Colonies, established in 1979 to provide a place where writers could write free from distractions, were expanded to include visual artists. The 2-week February colony and the 6-week summer colony are held at St. Peter's College, a Benedictine Abbey, where guests stay in private rooms and dine in the college facility. Emma Lake offers a 2-week August colony, where residents are housed in separate cabins or single rooms and artists share a large studio space. A 2-week September colony is held at the Mainstay Inn, near Riverhurst, where residents live in a hotel complex with studio space available on the lower floor. Year-round retreats are also offered at St. Peter's Abbey, allowing individuals to choose their own time. Artists and writers are limited to a maximum of 1 month's retreat a year and no more than 3 residents can be accommodated at one time.

Admission Policies and Costs: Applications are welcome from artists anywhere, but priority is given to Saskatchewan residents. Applicants should submit sample work, a resume of past work and description of colony project, 2 references, and a C$100 fee. Deadlines for applications are: Dec. 1 for the February Colony, April 1 for the July and August colonies, and Aug. 1 for the September colony. Artists who prefer an individual

retreat (Abbey) should apply 4 weeks prior to desired date. Colony costs are subsidized by Saskatchewan Lotteries Trust and room and board are $100 per week.

Location: St. Peter's Abbey is outside the village of Muenster; Emma Lake is in a forest region, about 25 miles north of Prince Albert; and the Riverhurst Colony is near Lake Diefenbaker.

Contact: Saskatchewan Writers/Artists Colony, Box 3986, Regina, Saskatchewan S4P 3R9, Canada; (306) 757-6310, Fax (306) 565-8554.

FRANCE

THE CAMARGO FOUNDATION
Cassis/January-May,
September-December

The Camargo Foundation, established in 1967 with an endowment by philanthropist Jerome Hill, maintains a center for study in France and offers fellowships for American scholars who wish to pursue projects in the humanities relative to France. This a residential grant and Fellows are provided with a furnished apartment and access to a reference library and are expected to participate in academic functions that take place during the year and also to submit a progress report and a written report at the end of the stay. Fellows must be in residence at the Foundation. Because of the limited number of studios, only one artist is accepted each semester from early September to mid-December, and from early January to May 31.

Admission Policies and Costs: The selection of fellows is based solely on evaluation of the proposed project and of the applicant's professional qualifications. Applicants may include photographers, visual artists, writers, musicians, members of university and college faculties, secondary school teachers, and graduate students. Applications, including a curriculum vitae, detailed description of project, and three letters of recommendation, must be received no later than March 1 and decisions are announced by mid-April. Photographers should submit sample work.

Location: Camargo, an apartment complex of four buildings, including living quarters, library, music-conference room, darkroom for the photographer in residence, and studios, is located on Hill's former estate in Cassis, France, about a half-hour from Marseille by train or bus. There is no organized entertainment. However, fellows meet several times each month to hear each fellow describe his or her project and there are also occasional visiting lecturers and concerts.

Contact: Documents should be sent to The Camargo Foundation, Ricardo Bloch, W-1050 First National Bank Bldg., 332 Minnesota St., St. Paul, MN 55101.

IRELAND

THE TYRONE GUTHRIE CENTRE
Annaghmakerrig/Year-round

This home of the late theatre director, Tyrone Guthrie, is open to practitioners of all the arts of any age, from Ireland and from abroad, and offers an environment conducive to creative work. Each resident has a private apartment within the Irish Big House, which also offers an extensive library collection. Residences range from three weeks to three months and couples or small groups may stay up to a year in a cottage on the estate, or in new self-catering houses in the old courtyard.

Admission Policies and Costs: Admission is selective and based on level of achievement, the proposed project, and the number of residencies available. Application should include examples of works in progress, a description of work to be done at the colony, and a brief resume of past work including exhibitions. Once accepted, Irish artists are asked to contribute what they can afford. Overseas artists are expected to pay the whole cost of residency, IR£1,200 per month (IR£1,600 from May-August). The Centre provides an official letter of acceptance that the applicant can use to approach philanthropic organizations for funds.

Location: Set on a 400-acre wooded estate in County Monaghan, Republic of Ireland, the house overlooks a large lake and is surrounded by gardens and a working dairy farm.

Contact: Bernard Loughlin, Resident Director, The Tyrone Guthrie Centre, Annaghmakerrig, Newbliss, Co. Monaghan, Ireland; 353-47-54003, Fax 353-47-54380.

ISRAEL

HILAI
Tel-Aviv/Year-round

Founded in 1984 by Tel Aviv writer Corinna, this organization provides a common ground in which Jews, Arabs, Israelis, and foreign guests can meet through artistic endeavor. HILAI maintains two residential working facilities for published or talented visual artists, poets, fiction writers, playwrights, and composers. Each resident is housed in a studio apartment with kitchen and private bathroom. Residencies of two weeks to one month are offered to four artists time in Ma_alot-Tarshiha and six artists in Mitzpe Ramon. Spouses may accompany artists at Mitzpe Ramon, where 2-bedroom studios are available. Residents are asked to plan and participate, up to three to four hours a week, in such community cultural activities as exhibitions, workshops, readings, or literary salons.

Admission Policies and Costs: Application deadlines are January 1, May 1, and September 1. A $15 fee must accompany application and notification of acceptance takes at least ten weeks. Residents are asked to contribute according to their ability to defray costs, a minimum of $25 per week.

Location: Facilities are located at Ma'alot-Tarshiha, in the western Galilee, and at Mitzpe Ramon, in the northern Negev, about a two-hour drive from Tel Aviv or Jerusalem.

Contact: Secratary, The Admission Committee, HILAI, The Israeli Center for the Creative Arts, P.O. Box 53007, Tel Aviv, 61530 Israel; (972) 3 478704.

4

Organizations

ADVERTISING PHOTOGRAPHERS OF AMERICA NATIONAL
Los Angeles, California

This professional trade association, started in 1981 by 50 independent photographers, is dedicated to exchanging information, resolving common problems, and strengthening the relationships between photographers, their clients, and their suppliers. Membership is open to companies supplying the professional photographers, individuals who provide support services for photographers, photographers' assistants, educators, and students. Benefits include a national and local newsletter, the APA National Members Handbook, forums, and surveys.

Contact: Advertising Photographers of America National, 7201 Melrose Ave., Los Angeles, CA 90046; (800) 272-6264, (213) 935-2056, Fax (213) 935-3855.

AMERICAN PHOTOGRAPHIC ARTISANS GUILD (APAG)
Port Clinton, Ohio

This international organization of 400 is dedicated to the advancement of members' accomplishments in the photographic arts. Members include negative and transparency retouchers, those involved in print correction, enhancement, photographic painting, and restorations, and those serving the field as receptionists and lab technicians. Benefits include the *Pallette Page* monthly publication, a speaker and program service, and seminars and workshops taught by nationally known instructors. Members are encouraged to enter PP of A regional and national competitions, where they earn exhibition merits toward APAG degrees. The organization also grants The Service Award to those who perform special services, such as enrolling new members, attending seminars, and writing articles. Annual dues are $40 for U.S. members, $45 for Canadian and Mexican members, and $50 for members from other countries.

Contact: Allyn Riznikove, Exec. Sec'y., APAG, P.O. Box 699, Port Clinton, OH 43452; 419-732-3290.

AMERICAN SOCIETY OF MEDIA PHOTOGRAPHERS (ASMP)
Princeton, New Jersey

Established in 1944 by 8 leading magazine photographers of the day, this organization for established professional freelancers is dedicated to improving the circumstances of the working photographer, cultivating friendship among professionals, and promoting high standards of performance and ethics. Of the more than 5,000 worldwide members are prominent individuals in all aspects of media photography, including editorial, advertising, corporate/industrial, still life, architectural, high-tech, fashion, and annual report. ASMP's 35 chapters in the U.S. serve as support groups, learning centers, and photographers' rights advocates.

Membership benefits include a legal referral system, professional seminars (including the Strictly Business Seminar Series), health and equipment insurance, the *ASMP Business Bible*, the *Stock Handbook*, membership directory, White Papers, and the monthly *ASMP National Bulletin*. ASMP has several membership categories, all of which require professional involvement with photography. General members are photographers with at least three years of professional experience that constitutes the majority of their total professional activity and associate members are photographers with one to three years of experience. A portfolio review and sponsorship by two general members is required for both categories. Affiliate membership, open to those who are not eligible for general or associate membership, does not require portfolio review or proof of publication. Regular affiliates are those who are actively engaged as photographic educators, professional photographers, or assis-

tants; Sustaining affiliates are individuals in organizations professionally associated with photography for publication; and Student affiliates, who require no sponsorship, must be full-time college students, accredited by registrar or supervising faculty member. Contact the national office for information on application and dues.

Contact: ASMP National, 14 Washington Rd., Ste. 502, Princeton Junction, NJ 08550-1033; (609) 799-8300, Fax (609) 779-2233.

ASSOCIATED PHOTOGRAPHERS INTERNATIONAL (API)
Culver City, California

Founded in 1971, this 30,000-member organization is dedicated to helping photographers improve their photographic skills and market their work. Membership is open to all for an annual $30 fee. Services to members include discount photo accessories, press passes, model release forms, photo books, logo stationery and business forms, photo-technique videos, and marketing information and reports. API also sponsors photo contests, publishes the *Photoflash* newsletter 11 times a year, and offers periodic photo seminars.

Contact: API, Green Valley Circle, #109, Culver City, CA 90230; (818) 700-0811.

THE CENTER FOR PHOTOGRAPHY AT WOODSTOCK (CPW)
Woodstock, New York *(see workshop listing and display ad on page 94)*

This nonprofit educational and arts organization was founded in 1977 to support creative photography of all kinds. The summer/fall Woodstock Photography Workshops series features low cost, hands-on intensives taught by prominent photographers. Membership (student $30, individual $35, family $40) benefits include discounts on workshops and lectures; announcement of such special events as parties, benefits, and award programs; invitation to participate in the non-juried Annual Members Show and the juried New York City show and opening reception; four issues of the CENTER *Quarterly*, posters, and exhibition announcements; reduced subscription rate to Aperture magazine, technical advice by staff members, and access to archives, library, and darkroom.

Contact: Colleen Kenyon, Executive Director, The Center for Photography at Woodstock, 59 Tinker St., Woodstock, NY 12498; (914) 679-9957/7747, Fax (914) 679-6337.

EVIDENCE PHOTOGRAPHERS INTERNATIONAL COUNCIL (EPIC)
Honesdale, Pennsylvania

Founded in 1968 to foster the worldwide advancement of forensic photography in civil evidence and law enforcement, this nonprofit organization has approximately 1,000 members in the United States, Canada, and on four other continents. Members include police officers, civil photographers, medical examiners, bio-medical personnel, attorneys, security agents, and other forensic specialists. Annual dues are $60 and membership benefits include the *Journal of Evidence Photography*, which features articles on such topics as accident reconstruction, arson, court photography, documentation of explosions, latent print examination, crime scene photography, and results of member surveys; access to a library with back issues of the *Journal*; regional seminars and workshops; an honors program; and a meeting and seminar in summer and fall. A certification program identifies photographers who have reached a high standard of competence and assist them in marketing their skills.

Contact: EPIC, 600 Main St., Honesdale, PA 18431; (717) 253-5450, Fax (717) 253-5011.

THE FRIENDS OF PHOTOGRAPHY
San Francisco, California

This nonprofit membership organization, founded in 1967 by Ansel Adams, Wynn Bullock, Brett Weston, and Beaumont and Nancy Newhall, is dedicated to the support and encouragement of creative photography. Its current membership of approximately 7,000 makes it the largest membership organization in the world devoted exclusively to fine art photography. Membership is open to anyone and benefits include workshops (page 16), publications, exhibitions, lectures, and grants to photographers. Associate members receive the monthly newsletter, re:view, and the journal, *Untitled,* as well as discounts on workshop tuition, previous publications, books, and lectures. They also have the opportunity to purchase original, signed photographic prints or special-edition posters as part of The Friends' Collector's Print Program. The organization is headquartered in the Ansel Adams Center in San Francisco. Annual dues are $50.

Contact: The Friends of Photography, 250 Fourth St., San Francisco, CA 94103; (415) 495-7000.

INTERNATIONAL CENTER OF PHOTOGRAPHY (ICP)
New York, New York

The ICP was established in 1974 as New York's museum of photography and is supported in part by grants from the New York State Council on the Arts and the Institute of Museum Services. It offers a wide variety of workshops, courses, and programs for both members and non-members (page 86 and 171), sponsors on-site and traveling exhibitions, and features such special events as theatre benefits and an annual awards ceremony. Community outreach programs include group visits and guided tours, gallery tours for school groups, ICP staff visits to classrooms and in-school education programs, and teacher workshops. General membership (individual $50, dual $60, senior $25, foreign $70) benefits include free admission to all exhibitions and films, discounts on education programs and bookstore purchases, and invitations to exhibition previews and Members' Day. Patron memberships range from $125 to $2,500 and include such additional benefits as listing in the Annual Report, advance notice of educational programs, visits to private collections, meetings with photographers, invitations to special events, and gift publications, prints, and photography sessions.

Contact: International Center of Photography, 1130 Fifth Ave., New York, NY 10128; (212) 860-1777.

INTERNATIONAL FIRE PHOTOGRAPHERS ASSOCIATION (IFPA)
Rolling Meadows, Illinois

First organized in 1964 at the Chicago Fire Academy, this 400-member association of professional fire photographers conducted its first conference in 1965. Its primary objectives are to promote professionalism, specifically in the fields of fire and investigative photography; to promote harmonious relations between the fire service, related agencies, and the press, through educational publicity; to conduct seminars and conferences devoted to enhancing techniques and skills in fire photography; and to utilize fire photography to promote public awareness of fire safety and prevention.

Membership is open to anyone actively engaged, directly or indirectly, in the field or who has an interest in these activities. Active members, who are entitled to vote, serve on committees, and hold office, are persons affiliated with the fire service, law enforcement, or related agencies, and whose duties include active photographic assignments for the department or agency. Associate members, who do not vote or hold certain offices but may serve

on special committees, are persons who are involved or interested in fire photography, though not in a professional capacity. Services to all members include a Fire Photographers Certification Program, divided into three levels of knowledge and experience: Journeyman, Craftsman, and Master, the highest level; training programs for members and photographic groups interested in basic and advanced fire photography; and the three to four-day Annual Training Conference, which features classes, a photo contest, and an awards presentation banquet. The 27th annual (1992) Conference is to be held July 15 to 18 in Oklahoma City, Oklahoma. Dues are $20 for U.S. members, $22 for Canadian members, $25 for members overseas.

Contact: IFPA, P.O. Box 8337, Rolling Meadows, IL 60008; (708) 339-2128.

MARIN ASSOCIATION OF PROFESSIONAL PHOTOGRAPHERS (MAPP)
San Rafael, California

This 150-member organization of professional photographers sponsors 2 to 3 annual exhibits that feature members' work, publishes the newsletter *RoadMAPP*, maintains a slide registry of selected members, and sponsors seminars that cover such topics as location and studio lighting, hand coloring, and digital imaging. MAPP also schedules bi-monthly meetings in San Rafael that include panel presentations or discussions with local software and hardware suppliers, business attorneys, and stock agents and buyers. Annual dues are $60 for professional photographers, $30 for (non) semi-professionals; newsletter subscription is $15.

Contact: Michelle McCoskey, MAPP Manager, 816 W. Francisco, San Rafael, CA 94901; (415) 454-1550, Fax (415) 459-3021.

NATIONAL PRESS PHOTOGRAPHERS ASSOCIATION (NPPA)
Durham, North Carolina

Founded in 1946, this professional organization of both print and broadcast photojournalists consists of more than 11,000 members, most of whom are full-time newspaper, magazine, and television photographers, as well as photographer-reporters, freelance news photographers, photography and graphics editors, video news directors and editors, photographic manufacturers' representatives, military news photographers, photojournalism teachers, and their students. Newspapers and television stations can join through a Sustaining Membership program.

Membership benefits include subscriptions to the News Photographer monthly magazine, a regional NPPA newsletter, and *The Best of Photojournalism* book; official NPPA identification card and decal; job bank listings; an annual directory of members, competitions, and benefits; membership in one of eleven geographical regions encompassing the U.S. and Canada; legal advice and public relations assistance; portfolio critique; and discounts on NPPA course fees. Standing and special committees administer such projects as educational programs and workshops and the Audio-Visual Library; work to solve problems facing female photojournalists and accessing information; and sponsor competitions, awards and other forms of recognition.

NPPA educational programs include the Annual Business and Education Seminar, the Annual Flying Short Course, the Annual TV-NewsVideo Workshop, the Electronic Still Photojournalism Workshop, the Digital Photography Conference, and the White Papers, special reports covering important current topics. NPPA also sponsors student programs to encourage aspiring photojournalists. These include the Summer Internship Program, college scholarships, photo contests, and cooperative programs with Kappa Alpha Mu, honorary pho-

tojournalism fraternity. Annual dues are $55 for regular members, $30 for students.

Contact: Charles Cooper, NPPA Executive Director, 3200 Croasdaile Dr. Suite 306, Durham, NC 27705; (800) 289-6772.

NATIONAL STEREOSCOPIC ASSOCIATION (NSA)
Columbus, Ohio

The purpose of this nonprofit organization, founded in 1974, is to promote the study and collecting of stereographs, stereo cameras, and related materials; to provide a forum for collectors and students of stereoscopic history; to promote the practice of stereophotography; to encourage the use of stereoscopy in the visual arts and technology; to foster the appreciation of the stereograph as a visual historical record; and to provide for the Stereoscopic Research Library. Benefits to NSA's 3,500 members include the bimonthly publication, *Stereo World,* which contains stereo reproductions, original research, and articles; a membership directory; regional meetings in the U.S.; an annual summer meeting; and access to the Oliver Wendell Holmes Stereoscopic Research Library, which is located on the campus of Eastern College, in St. Davids, Pennsylvania. NSA is affiliated with the American Stereoscopic Society, which was founded in 1893. Membership is open to all, commencing with the March-April issue of Stereo World. Annual dues range from approximately $22 to $48.

Contact: National Stereoscopic Association, P.O. Box 14801, Columbus, OH 43214.

NORTH AMERICAN NATURE PHOTOGRAPHY ASSOCIATION (NANPA)
Wheat Ridge, Colorado

This nonprofit organization grew out of a 1993 conference that addressed the special concerns of nature photography. NANPA provides education (see page 40), fosters professionalism and ethical conduct, gathers and disseminates information, develops standards, and promotes nature photography as an art form and a medium of communication for the sciences, nature appreciation, and environmental protection.

Membership is open to anyone interested in photography of nature and the environment, specifically professional photographers, editors and publishers, educators, students, and corporations. Benefits include the quarterly newsletter *Currents,* discounts on attendance at NANPA-sponsored events, and a membership directory. Annual dues are $50 for general membership and $25 for student membership. Corporate memberships are $250, $1,000, and $3,000.

Contact: NANPA, 10200 West 44th Avenue, Suite 304, Wheat Ridge, CO 80033-2840; (303) 422-8527.

PHOTOGRAPHIC ART & SCIENCE FOUNDATION
Oklahoma City, Oklahoma

Established in 1965 in the state of Illinois, this nonprofit organization, dedicated to commemorating the past and helping shape the future, encourages educational and scientific activities in all branches of photography. Its major project is the International Photography Hall of Fame and Museum at the Kirkpatrick Center in Oklahoma City. The Foundation commemorates the past by the posthumous election of photographic notables, who include Daguerre, Eastman, Stieglitz, Steichen, Bourke-White, Hasselblad, and Adams. It helps shape the future by sponsoring workshops for elementary, high school, and junior college students.

Membership benefits include free admission to the Hall of Fame and Kirkpatrick Center, invitations to openings, receptions, and special events, a quarterly newsletter, recognition

through acceptance of work in Hall of Fame exhibits and the permanent collection, and lectures and workshops. Membership is open to all individuals and corporations, with annual dues ranging from $30 Student, $50 Supporting member, to $5,000 for a Founder.

Contact: Frederick Quellmalz, President, Photographic Art & Science Foundation, Inc. 111 Stratford Rd., Des Plaines, IL 60016-2105; (708) 824-6855, Fax (708) 824-8877.

PHOTOGRAPHIC SOCIETY OF AMERICA (PSA)
Oklahoma City, Oklahoma

Established in 1934 as an international organization devoted exclusively to the development and support of photography as an art and science, PSA is open to young people and adults of all levels, from beginner to established professional. It serves more than 8,000 members in about 40 countries and each of the United States, approximately 50,000 photographers belonging to more than 600 member camera clubs, and many companies in the photography field. Benefits to individual members include the services and activities of eight special interest divisions, a subscription to the monthly *PSA Journal,* and local chapter events and regional and international conventions. Participation in one or more of the eight divisions — color slide, video and motion picture, nature, photo-travel, photojournalism, pictorial print, stereo, and techniques — can include courses, critique and evaluation, instructional material, experimenters groups, assistance with foreign distribution, workshops, information services, star achievement ratings, competitions, contests, and exhibitions. Competitions and workshops for young people are also offered. The *PSA Journal* features instructional articles on photography, equipment and book reviews, a calendar of PSA-recognized competitions, and a listing of services. PSA has 17 U.S. chapters that sponsor regular meetings, workshops and seminars, and regional and international conventions. Benefits to camera clubs include such educational resources as slide shows, videotapes, and recorded lectures for program use; an advisory service; guidelines for organizing and operating a club; sponsorship of competitions, a film library, and instructional slide sets; a speakers' referral listing of experts who are available for workshops and seminars; and a judging service for club competitions.

The Society bestows awards for both service and proficiency in the field of photography. Recipients of PSA's top award, the Progress Medal, have included Walt Disney, Dr. Edwin Land, Ansel Adams, and Dr. Victor Hasselblad. Individual awards for excellence in the art and science of photography and service to the Society and photography include Society Associate (APSA), Fellow (FPSA), Honorary Member (Hon. PSA), and Honorary Fellow (Hon. FPSA). Annual individual membership dues are $40 in the U.S., Canada, and Mexico ($45 outside North America); camera club dues are 40 ($45).

Contact: Photographic Society of America, 3000 United Founders Blvd., Suite 103, Oklahoma City, OK 73112; (405) 843-1437.

PICTORIAL PHOTOGRAPHERS OF AMERICA (PPA)
New York, New York

Founded in 1916, this 85-member organization strives to aid members in perfecting their photographic techniques by sponsoring lectures, exhibitions, monthly competitions, and social functions and by publishing a monthly newsletter, *Light and Shade.* Membership is open to all persons interested in photography, regardless of ability or experience. Categories are beginners and advanced in black & white, color prints, and color slides. Meetings are held the first and fourth Tuesday of every month, October through June, at

Atelier, 295 W. Fourth St., in Greenwich Village, New York City. The first meeting of the month is devoted to the judging of photographs in the above categories by known professionals, who also offer constructive criticism. Members with winning scores are honored at the Annual Awards Dinner, which is held in June. Membership dues are $40 for an individual resident and $25 for an individual nonresident.

Contact: Pictorial Photographers of America, 299 W.12th St. New York, NY 10014.

PROFESSIONAL PHOTOGRAPHERS OF AMERICA (PPA)
Atlanta, Georgia

Founded in 1880, this 14,000-member organization offers professional photographers and their employees a variety of membership benefits, including publications, professional development programs, meetings, conferences, marketing and public relations assistance, competitions, business services, liability and equipment insurance, resource information, networking, and special services. Members may join in the activities of 5 special interest groups: Commercial/Corporate Advertising, Electronic Imaging, Portrait, Art/Tech (retoucher, lab technician), and Wedding. Publications include the monthly *Professional Photographer* and *Photo-Electronic Imaging* magazines. Professional development programs include courses at Winona and its affiliate schools (page 54) and a degree program that allows members to earn merits for work and service toward the Master of Photography, Photographic Craftsman, and Photographic Specialist degrees. PPA schedules an annual convention and trade show in July, a 4-day marketing and management conference in Las Vegas, and a variety of seminars and workshops for the special interest groups. Members can enter the annual International Print Judging competition for inclusion in the General and Loan Collection.

Contact: Professional Photographers of America, Inc., 57 Forsyth St., N.W., #1600, Atlanta, GA 30303; (404) 522-8600, Fax (404) 614-6400.

SF CAMERAWORK, INC.
San Francisco, California

Established in 1974, this independent, nonprofit artists' organization offers a forum for diverse dialogue about contemporary photography and related visual arts through exhibitions, publications, lectures, and other community services. Subscribing members ($35) receive the SF *Camerawork Quarterly* and discounts on books, copy stand equipment use, and lecture admission fees. A lecture series is held bienially. The Fine Print Program allows members at the Collector level ($250 annually) to select limited edition photographs donated by such nationally recognized photographers as Gay Outlaw, Andrea Modica, Elisabeth Sunday, Kevin Bubriski, Keith Carter, Anne Rowland,, and Shimone Attie. Annual dues categories range from $20 for nonresidents, $35 for subscribing members, to $1,000 and up for corporate and sustaining members.

Contact: SF Camerawork, 70 Twelfth Street, San Francisco, CA 94103, (415) 621-1001.

SOCIETY FOR PHOTOGRAPHIC EDUCATION (SPE)
Dallas, Texas

Founded in 1963, this nonprofit organization provides a forum for the discussion of photography as a means of creative expression and cultural insight. SPE seeks to promote a wider understanding of photography and to foster the development of its practice, teaching, scholarship, and critical analysis. Most members are active photographers, and about 75% teach photography. SPE's 8 regional associations each hold an annual fall conference and

publish a regional newsletter. Benefits include the publication Exposure, the SPE Directory and Resource Guide, eligibility for SPE-sponsored health insurance, the national conference each spring, and a network of working photographic artists. The 4-day national conferences feature lectures, panel discussions, artists' presentations, and evening talks by noted speakers. Annual dues (calendar year) are $55 ($35 for students and retirees).

Contact: SPE, P.O. Box 222116, Dallas, Texas 75222-2116; (817) 273-2845, Fax (817) 273-2846.

UNIVERSITY PHOTOGRAPHERS ASSOCIATION OF AMERICA (UPAA)
Marquette, Michigan

This international organization of professional college and university photographers, founded in 1961 by a small group of university photographers in the New England area, is dedicated to the advancement of applied photography and the reputation of the profession through member interchange. Benefits to its more than 200 members include the periodic *UPAA Newsletter*, clip contests, review of price and wage scales, UPAA Awards, a traveling exhibit of members' Award Prints, and the Annual Technical Symposium, a three-day spring conference hosted by one of the member institutions. Symposium activities include lectures, workshops, presentations of technical papers, and field trips. Award Prints are selected, including the Print of the Year, and a panel may present a Photographer of the Year award for outstanding work. Annual dues are $25 and all photographers engaged in work for colleges or universities are welcome to join.

Contact: Mark A. Philbrick, Brigham Young University, Public Communications, C-389 ASB BYU, Provo, UT 84602.

WEDDING AND PORTRAIT PHOTOGRAPHERS INTERNATIONAL (WPPI)
Santa Monica, California

This 3,500 to 4,000-member organization was established in 1974 to provide wedding photographers with information, programs, and professional services to help increase sales and profits and improve artistry, technical abilities, and services. Membership is open to all and benefits include a monthly association newsletter, a Marketing and Technical Manual, promotional materials, logo stationery, discounts on a variety of educational products, and quarterly packets containing bulletins, sales pieces, and techniques. The Annual World of Wedding and Portrait Photography Convention/Workshop features a trade show, seminars, and judging for the Awards of Excellence. Annual membership dues are $75.

Contact: WPPI, 1312 Lincoln Blvd., P.O. Box 2003, Santa Monica, CA 90406; (310) 451-0090.

WHITE HOUSE NEWS PHOTOGRAPHERS' ASSOCIATION, INC. (WHNPA)
Washington, D.C.

Founded in 1921 by the 17 photographers who regularly covered the office of President Warren G. Harding, this nearly 500-member organization of professional photojournalists is dedicated to: studying and acting upon legislation affecting news photography; advancing all phases of photojournalism with educational programs, financial assistance, and scholarships; fostering cooperation between members and public officials; interacting with other recognized professional news-gathering organizations; and promoting high standards of conduct among its members. Activities include workshops, competitions, exhibitions, college scholarship and grant awards, meetings, the *Photo-Op* newsletter, and an annual awards dinner honoring (and attended by) the President of the United States. To be eligible for Active Membership in the WHNPA, applicant must qualify as a photojournalist, reside in the Washington, D.C., metro-

politan area, and be employed by a recognized news-gathering organization. Associate Membership is open to those who do not meet the criteria for Active Membership.

Application for Active or Associate Membership requires sponsorship by at least two Active Members and submission of two non-member character references and media and job credentials. All applications are subject to a majority vote by the Executive Board.

Contact: WHNPA, P.O. Box 7119, Ben Franklin Stn., Washington, DC 20044-7119; (202) 785-5230, Fax (301) 428-4904.

5

Appendix

Geographic Index of Workshop Locations

SPECIALTY INDEX

Glamour/Fashion

Large Format

Nude

Outdoor/Nature/Travel

PROGRAMS FOR YOUNG PEOPLE

PROGRAMS FOR NON-PHOTOGRAPHERS

INDEX OF ADVERTISERS

6

Master Index

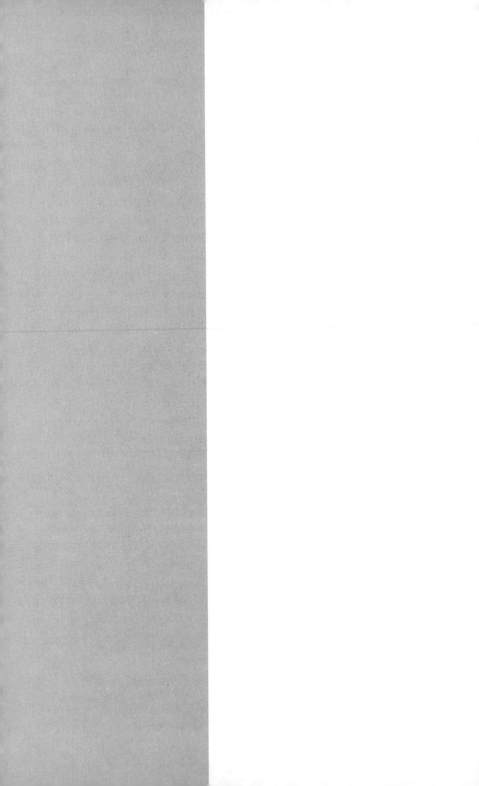

R

S

V

W

Y

Z

*Shaw**Guides***

THE LEARNING VACATION AND CREATIVE CAREER SPECIALISTS

ShawGuides contain descriptions of more than 2,000 programs throughout the world. Detailed listings include program description, daily schedule, faculty credentials, costs and refund policies, and contact information.

☐ **The Guide to Cooking Schools,** 7th (1995) Edition. Contains 315 career programs, 420 nonvocational and vacation programs, 120 earn-as-you-learn apprenticeships, 66 wine courses, and 21 food and wine organizations. Encompasses 47 states and 11 countries. ISBN 0-945834-20-9. **PRICE: $19.95.**

☐ **The Guide to Art & Craft Workshops,** 2nd Edition. Over 400 learning vacations in 45 states and 23 countries. Includes drawing, painting, sculpture, fibers, metals, wood, pottery, decorative art, and boat and house building. Also contains more than 50 artist colonies. ISBN 0-945834-11-X. **PRICE: $16.95.**

☐ **The Guide to Photography Workshops & Schools,** 4th Edition. More than 300 workshops and tours, over 200 career and college programs, 22 artist colonies with photographic facilities, and 24 photography organizations. Worldwide. ISBN 0-945834-19-5. **PRICE: $19.95.**

☐ **The Guide to Golf Schools & Camps,** 2nd Edition. Nearly 200 programs, including 109 schools for adults, 87 camps for youngsters, and 9 career programs in golf facility management. Encompasses 44 states and 13 countries. Also contains information about 11 national, 92 international, and 104 state and local organizations. ISBN 0-945834-17-9. **PRICE: $16.95.**

☐ **The Guide to Academic Travel,** 2nd Edition. Hundreds of mind-expanding vacations sponsored by colleges, universities, museums, and educational organizations. Includes more than 300 sponsors, whose offerings range from archaeology to zoology. Also contains information about 145 total immersion language schools in 26 countries. ISBN 0-945834-12-8. **PRICE: $16.95.**

☐ **The Guide to Writers Conferences,** 4th Edition. Over 370 workshops, conferences, residencies, and retreats in 45 states and 10 countries. Most offer manuscript critique and opportunities to meet editors and agents. Also includes 114 writer organizations. ISBN 0-945834-15-2. **PRICE: $16.95.**

If not available at your local bookstore, use this convenient coupon.

*Shaw**Guides***

P.O. Box 1295, New York, NY 10023

Please send me the books I have checked above.

☐ I am enclosing a check or money order for $ _____
(add $3 postage for 1 book, $1 for each additional).

☐ Please charge to MasterCard, VISA, or American Express.

Card # _____ Exp. Date _____

Signature _____

Name _____

Address _____

City_____ State _____ Zip_____

For faster service on credit card orders, call (800) 247-6553.